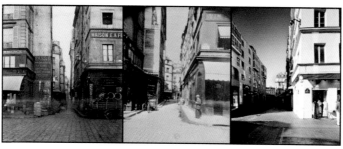

1865 1907 2009

Piercing Time: Paris After Marville and Atget 1865-2012

Intellect Bristol, UK / Chicago, USA

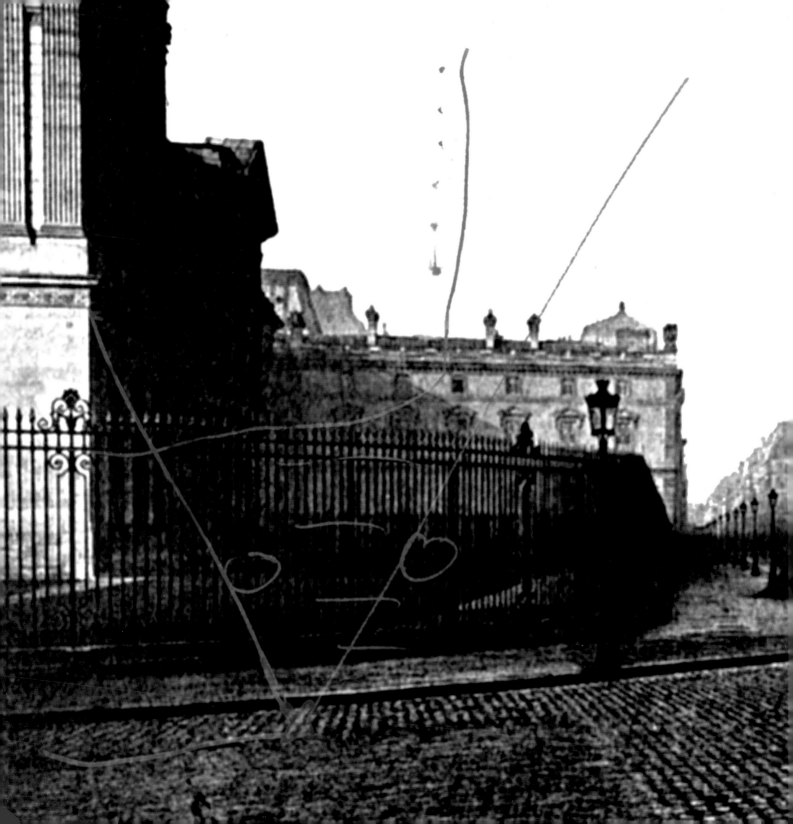

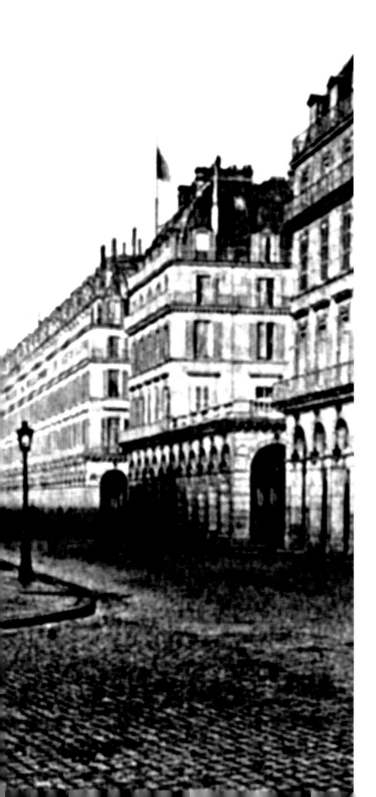

Piercing Time:
Paris After
Marville
and Atget

1865-2012

Peter Sramek

with essays by
Min Kyung Lee and Shalini Le Gall

Piercing Time: Paris After Marville and Atget 1865-2012

First published in the UK in 2013 by
Intellect, The Mill, Parnall Road, Fishponds, Bristol, BS16 3JG, UK

First published in the USA in 2013 by
Intellect, The University of Chicago Press, 1427 E. 60th Street, Chicago, IL 60637, USA

A catalogue record for this book is available from the British Library

Cover image: Peter Sramek, Rue de l'Arbalète, 2009.

Cover designer: Anthony Gerace
Copy-editor: Heather Owen
Design: Peter Sramek
Production manager: Tim Mitchell

Print ISBN (HB): 978-1-78320-033-7
Print ISBN (PB): 978-1-78320-032-0
ePDF ISBN: 978-1-78320-227-0
ePUB ISBN: 978-1-78320-226-3

Printed and bound by: Gomer Press Ltd, UK.

This project was produced with the generous assistance of
the Musée Carnavalet and Parisienne de Photographie/Agence Roger-Viollet.

Table of Contents

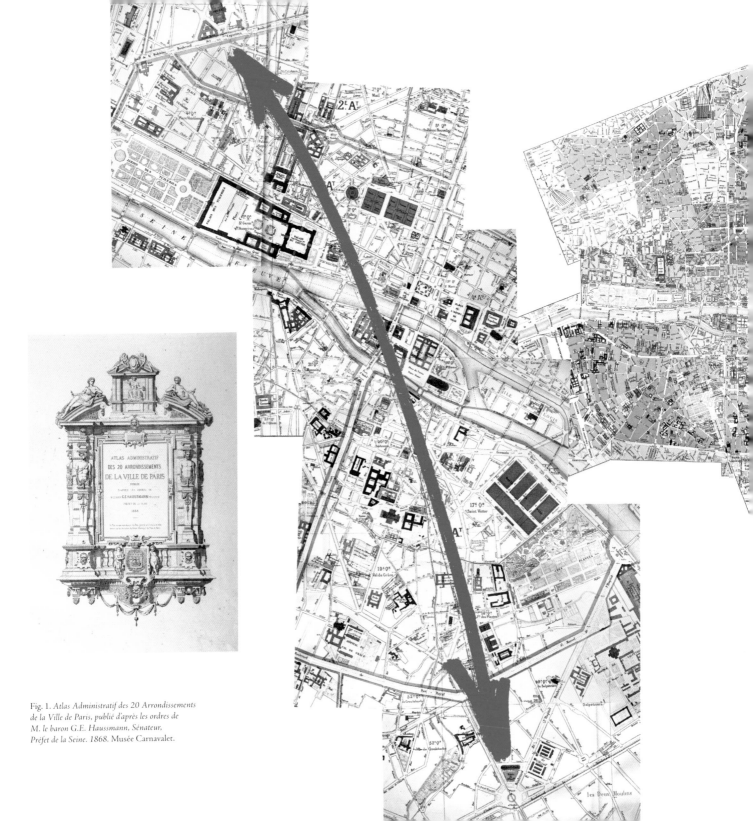

Fig. 1. *Atlas Administratif des 20 Arrondissements
de la Ville de Paris, publié d'après les ordres de
M. le baron G.E. Haussmann, Sénateur,
Préfet de la Seine. 1868. Musée Carnavalet.*

Acknowledgements

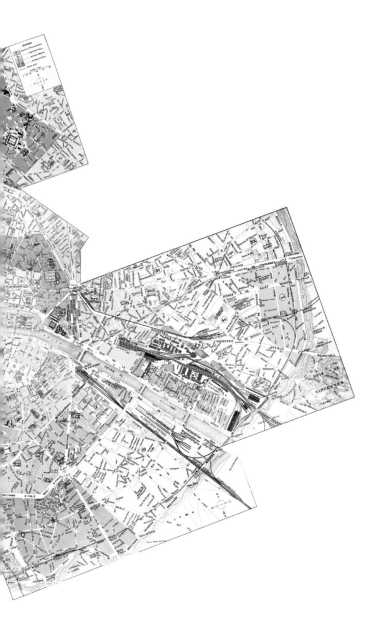

Piercing Time would not have been possible without the assistance and encouragement of many people and two in particular. Françoise Reynaud, Curator of Photography at the Musée Carnavalet and Jean-Baptiste Woloch, Secretary of Documentation, provided access to the Marville and Atget collections along with invaluable knowledge. Their generous assistance provided the necessary grounding for the project and taught me so much. Without their input and support, the work could not have been successful.

Nathalie Doury at Parisienne de Photographie/Agence Roger Viollet has provided access to the majority of the digital reproductions of the historical photographs, both during the development of the project and in the final publication.

Min Kyung Lee has advised on the mapping research and provided guidance in understanding the urban development of nineteenth-century Paris. Shalini Le Gall has researched the history of Marville's *avenue de l'Opéra* photographs. I thank them both for their scholarly contributions to this volume. Others shared their knowledge of Marville through their writings and/or correspondence: Peter Barberie, Sarah Kennel and David Harris, among them. Two important references stand out in the work of Marie de Thézy and Leonard Pitt.

Many thanks are due to Annika Groebner for editing the texts and providing feedback and encouragement at all stages of the project; Miko Sramek for his assistance in the field and with digital work; Zefan Sramek for his insights; Rudy Sramek for reading the drafts; Hana Sramek for her support. Anthony Gerace consulted on the design of the book and Project Assistants Pat Navarro, Melissa Jean Clark, Shanon Fujioka and Raymond Salaber have worked on many aspects of the post-production while Susan Gouinlock spent time on the layout. My thanks to Jana Lapidus and Mathieu Bully who kindly put up with my many stays in Paris.

Masoud Yazdani with his team at Intellect guided the production, playing a crucial role in the editing and design process. Thank you to Tim Mitchell, Holly Rose and Heather Owen.

Of special note has been the support and input of the Parisians with whom I spoke during the making of the photographs. Their words add depth to the context of this volume. Cécile Claris in particular encouraged me in my work and enabled my interviews '*dans le cinquième*'. Alain Roy provided good company and conversation, sharing his knowledge of Paris. Over the time of the project, I recorded conversations with: Brigitte Bénaïna, Melissa Bénaïna, Pierre Cisel, Ludovic Duverneix, François Ferval-Chanut, Michel Nardot, Maryse Noiraud, Marie-Odile Wehr, Alain Romard, Alain Roy, Brieuc Segalen, Henri Segelstein, Fabienne Tocher and Anna C. Walters.

Without the financial support of OCAD University, its Professional Development Committee and Office of Research, and through it, the Social Sciences and Humanities Research Council of Canada, CORUS Entertainment and GRAND NCE, this project could not have been realized. A Google Research Award has funded a major portion of the ongoing work.

Fig. 1a. *Paris-Atlas*, Fernand Bournon, *c.* 1900. Paris: Larousse.
The photographs are arranged in groupings from the northwest to the southeast rather than by *arrondissement*. Appropriate historical maps at the beginning of each section show the locations of the photographs as accurately as possible.

Introduction
Peter Sramek

Slowly making my way through the neighbourhoods of central Paris, carrying a large camera and black cloth on my shoulder, I must have seemed a sight from another century. In a manner of speaking, I was just that: a person intent on picking up threads from the past and recreating a moment through what became, in many ways, a photographic performance. I was focused on identifying as exactly as possible the locations of a series of photographic views made by Charles Marville in the 1860s and 1870s and then rephotographing the same views with a large format camera. It was a way of understanding Marville's photographic thinking and of seeing Paris through the deliberate eyes of a past century.

Marville's photographic record is closely intertwined with the romantic conceptions of Paris, even as his name is not broadly recognized. He was hired to photograph the streets just prior to, during and then after the upheaval of the Haussmann Plan reconfigurations of Paris, which saw more than 27,000 houses demolished to make way for new boulevards and upper middle-class housing (Tung 2001: 295). Whole working class neighbourhoods of crowded pre-nineteenth-century buildings were destroyed and the Paris of our imagination today was created, with its long boulevards and consistent façades.

Walking through Paris with historical images in hand, one is aware not only of the current architectural spaces but also the configurations of the past. Small details come to one's attention as one maps the old image onto the present – a window which has not changed (although the shutter is today closed) or ornamentation which still exists. Often complete buildings have disappeared, yet in some neighbourhoods much is as it was in 1865. As I set the tripod down over and over, a sense of understanding the choices made by my predecessor gradually developed – his systematic plan for representing the city and the changes it was undergoing.

Squinting to compare the details in the old photograph with the scene before me and making adjustments to the camera, I attracted more than a little curiosity. Speaking with people became an important aspect of my experience, especially Parisians proud of their *quartier*. Not the least of it was that I was photographing ordinary street corners, unremarkable and even unphotogenic. And I was doing it slowly, encumbered with an apparatus most equated with the distant past. As one young man said to me, '*Ce n'est pas une photo* [meaning the scene]. *Aujourd'hui, tout le monde veut être une "star"*'. I was the opposite, with no photographs of would-be Paris Idols, major

monuments or even tourist hotspots. In remaking Charles Marville's framing of Notre Dame Cathedral, I focused, as he did, on the street beside the cathedral, catching only the corner of the façade. I hovered between spectator and spectacle, a foreigner in Paris and an odd street fixture of the moment.

I began the Marville project in April 2009, after Françoise Reynaud, Curator of the Photography Collection at the Musée Carnavalet showed me some of the large albumen contact prints by Charles Marville printed in the early 1870s. I had just completed studies of a series of Atget images and also of the Alinari photographs in Florence. When she suggested a new rephotographic project, my fascination with the evolution of Paris and the details in the images combined with the mysteries of location, street names and old

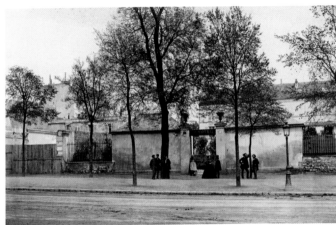

Fig. 2. *Un coin du Boulevard St Jacques* (N° 66) [Marville's studio], Marville, 1865-1868 (CAR/RV).

maps to present an irresistible challenge. Each morning, with the assistance of Jean-Baptiste Woloch, Curatorial and Documentation Assistant of the Photography Collection, I studied the photographs and then walked the city searching out sites.[1] I ranged from the *avenue de l'Opéra* in the northwest to *place d'Italie* in the southeast. With me, I carried Marie de Thézy's comprehensive compendium of Marville's images, a notebook, a street guide, my laptop with the Musée Carnavalet catalogue list and a digital camera.[2] I studied historical maps to find the location of vanished streets. Over the next three years, I returned to Paris periodically to photograph 183 locations on film with a 4x5 view camera.[3] This laborious task gave me a small taste of what photographers of the past went through to produce the image collections

now housed in Paris archives. I compiled cataloguing information, captions, descriptive data, notes on the sites and my own photographic progress. Images were juxtaposed and tracked. The research slowly led to the collection in this publication.

Every photograph hides as much as it reveals. Even in the seemingly simple task of describing the street formations, I found deceptive angles and hidden laneways in Marville's images. Only by visiting the physical site was I able to see what was not evident in the photograph itself. Where major architectural changes have occurred, historical maps were the only recourse.[4] As I continued to work, often revisiting sites multiple times, the pieces of a complex puzzle finally came together. The importance of such direct field research lies partly in the fact that there is almost no written record of Marville's commission. What official documents might have existed in the 1860s were destroyed in the 1871 fire of the Hôtel de Ville. One letter from 1873 exists in which he proposes to reprint his series. Even the details of his later commission to photograph the new boulevards are unclear.

Much has been written about Baron Georges-Eugène Haussmann and his grand plan for bringing Paris into a modern urbanized era. However, very little of a critical nature has been published that discusses the full extent of Marville's undertaking, despite the fact that, when nineteenth-century Paris is addressed, Marville's photographs are used for visual support. Unfortunately, his topographic record has been eclipsed by that of Eugène Atget, who is the better-known documentarian of Paris. This publication juxtaposes these two archives in hopes of creating a dialogue on the photographic representation of urban change. I was particularly intrigued to identify convergent sites photographed by Atget, thirty to sixty years after Marville and compare the working methods of these two documentarians, who both systematically photographed the Paris of their time. Such a study might provide a visual timeline of urban change over the past 150 years.[5]

Piercing Time is a continuation of many years of my own photography which has explored the representation of historical sites, including previous rephotographic projects carried out in Prague, Paris and Florence (Sramek 2009). My interest in photographing such sites lies partly in the history of the cities themselves, but more than that, in how cities come to embody cultural memory and represent the past in people's imaginations. A society's history can seem to be literally written into the stones of its cities. John Reader (2005: 1) puts it this way: 'Cities are the defining artifacts of civilization. All the achievements and failings of humanity are here.'

Since its invention, photography has been turned to the task of recording, used by both historians and popular audiences as a window onto the past. Rephotography as a strategy is one key to unravelling what is hidden in old photographs. By revisiting sites, a wealth of information can be inferred. Marville made two series, one decade apart, which document the streets of Paris. Eugène Atget crossed paths with Marville's record and he occasionally took very similar views, while he, himself, repeated his own images. This book considers how rephotography has been used in these various forms.

In examining these images from three eras, the reader is invited to study the transformation of the architectural environment of Paris and to compare the differing approaches of the three photographers in representing the city.[6] The historical context of the images in relation to urban planning is discussed, while contemporary thoughts are presented through Parisian voices. A trajectory of change and preservation can be found in the photographs, maps and commentaries and, it is hoped, the reader will consider what re-photographing a site can reveal about the passage of time, about the city and about the role of photography in relation to these.

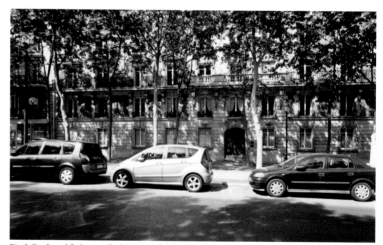

Fig. 3. Boulevard St-Jacques (looking towards No.56, on the spot where Marville's studio was once located), Sramek, 17.05.2011.

A Paris Diagonal
Peter Sramek

Peter Sramek

The Second Empire period, which saw the urban renewal of Paris under Napoleon III and his Prefect, Georges-Eugène Haussmann, also gave rise to the photographic record which Charles Marville was commissioned to complete. His documentation of the streets slated for demolition led to a methodical recording of Paris as it existed in the mid-1860s. The scale and particularity of this project was unprecedented in the field of urban photography. Artists using drawing, engraving or watercolour had of course done similar illustrative documentation, so the idea of producing a systematic visual record was not new.[7] Putting photography to this task heralded a new world for documenting human endeavours. Peter Barberie (2007), in his work on Marville's earlier commission to photograph the renewed Bois de Boulogne, deconstructs the vision and meanings behind such photographic documentation. When considering urban documentation in particular, other examples of extensive projects also exist elsewhere, such as in the collection of the Fratelli Alinari Studio in Florence, which, although working later in the century, provides an example of a systematic recording of art and monumental architecture, in this case to build a collection of views for commercial sale. The concept of cataloguing, prevalent in this time, was applied naturally to the new medium of photography, which could so readily be put to the task of producing a visual record to be classified, categorized and collected.

Planned urban change by edict was well-known in Paris long before Louis Napoleon drew lines on his great map of the city. Going back to Charles V (1364-1380) and his establishing of the Administration des Bâtiments Royaux (Tung 2001: 292) one can trace urban projects initiated by a series of monarchs. One thinks of the creation of the *place des Vosges* in 1605 and the *rue de Rivoli* in 1801. Tung (2001: 277) points out that '[t]he general concept of comprehensive planning was associated with the exercise of absolute autocratic power' and this was an underlying understanding as Napoleon III and Baron Haussmann took control of Paris. Nonetheless, the creation of new mandated streets under Haussmann, with his severe cutting through of existing buildings, had never been experienced on such a scale. It is no surprise that photography was engaged to record such radical urban change.

More unusual in the context of such dramatic urban planning may be Marville's assigned task of documenting the old before it disappeared, rather than representing the process of renewal itself. However, interest in 'Old Paris' was not new when Marville was commissioned by the Services des Travaux Historiques. This department was created in 1865 under Napoleon III and immediately undertook a compendium publication on *vieux Paris*. Photographs and engravings were to play an important role in this publication. This was later abandoned in 1871 with the fall of the Second Empire and the materials dispersed to various archives, including the Musée Carnavalet. It is unclear if Marville was directly involved in any way with this project, but it reflects the interest in documenting historical Paris even in the midst of a push to modernize.[8] Despite his radical approach to urban renovation, Haussmann displayed an interest in preserving a record of the past, suggesting the purchase of the Hôtel Carnavalet to establish a new museum of the history of the city. Although we now equate old photographs with a nostalgia for and romantic

vision of the past, these sensibilities were present in Paris before the birth of the medium that could stop time so eloquently. The 1830s had seen a rising consciousness of issues related to preservation and there was a growing concern with the loss of the character of the city. In 1831, Victor Hugo had published *Notre-Dame de Paris* ('The Hunchback of Notre Dame') in which he rails against the degradation of historical architecture:

> There remains today but a very imperceptible vestige of the Place de Grève, such as it existed then; it ... would soon have disappeared, perhaps submerged by that flood of new houses which so rapidly devours all the ancient façades of Paris. (Book 2, Chapter II)
>
> If we had leisure to examine with the reader, one by one, the diverse traces of destruction imprinted upon the old church, time's share would be the least, the share of men the most, especially the men of art, since there have been individuals who assumed the title of architects during the last two centuries ...The centuries, the revolutions, which at least devastate with impartiality and grandeur, have been joined by a cloud of school architects, licensed, sworn, and bound by oath; defacing with the discernment and choice of bad taste. (Book 3, Chapter I)

There were those of course who championed the modern future of the city and for them the photograph represented the new industrial age, an age of scientific certainties and observable proofs. With its ability to record detail in such a 'scientific' manner, it is no surprise that photography was so quickly engaged to both capture the old and herald the new.[9] The impetus to have Marville record the streets about to be demolished may just as likely have been motivated by the desire to preserve proof of positive change as to build a visual record of heritage lost. With attitudes prevalent on both sides, photography could provide material for either. Under Haussmann, Marville was only commissioned to photograph the old, rather than to record the

de l'Opéra. In other quarters, such as the slopes of *Montagne Ste-Geneviève*, some streets have changed little over the centuries. In his later commission in the mid-1870s, Marville photographed the broad, empty boulevards, newly completed. Although very much the same today, these are now filled with motorized traffic. *Les Halles* was rebuilt in the nineteenth century and then experienced major demolitions in the 1970s. Now, in 2012, this heart of the city has once again seen renovation. In planning my trajectory, I decided to find sites which provided this range of histories and chose to mimic the form of Haussmann's *percements*, taking a broad diagonal, covering *quartiers* which have seen a variety of transformations. The term *percement* or 'piercing' was

forward march of demolition and reconstruction. Demolitions only come to the fore in his images from the late 1870s, when he was asked by the city to photograph for the Universal Exposition. For this commission, the objective was explicitly to illustrate modernization and he photographed new boulevards across Paris and the, then current, demolitions for the completion of the *avenue de l'Opéra* (see Le Gall in this volume).

When viewed today, Marville's photographs provide a comprehensive visual record of Paris as it existed at this focal point of change. Unlike maps, with their quasi-temporal layers of information and their distillation of location into line,[10] photographs show what was there in front of the lens – at least the stationary elements.[11] The world of the past can still be read in the buildings, the signage, the mix of old and new and the evidence of demolition and new construction.

The selection of sites for this rephotographic project involved a careful review of the prints in the Musée Carnavalet related to Marville's topographic survey commission. What became evident, on visiting the locations, was that changes have occurred in different forms at various times over the last 150 years. In some locations, wholesale demolition in the 1860s and 1870s resulted in total alteration of the architecture and street configurations, as in the *avenue*

applied to the approach used in Haussmann's pattern of driving new, straight streets through the existing, more irregular, network with little regard for the existing configurations. Following the concept of the *percement*, I traced a diagonal which crosses the heart of the old city, encompassing neighbourhoods completely rebuilt by Haussmann and those which managed to escape, some only to experience great change later on. My attempt was to remake all of the Marville images along this broad diagonal. The drawing of a line came to represent the act of walking across Paris, but was also borrowed from an archaeological strategy, whereby the revelations of a strategically-selected cross section can represent the totality of a site. The choice of a comprehensive selection of images reflected a nineteenth-century belief in cataloguing empirical, 'scientific' data. And, yet again, the concept of a *percement* represented a slice through time based on a comparison of Marville with Atget, and with today. With such an approach, layers beyond the merely photographic and descriptive begin to open – historical, cultural, social, and political.

To engage physically with urban space means to move through configurations of buildings and streets and the best way to know Paris is to walk. Anthony Tung suggests,

> Paris was designed to be experienced from its streets. One discovers the notes of its architectural symphony simply by walking – in virtually any direction … Paris developed over several centuries as it grew from a medieval town to the cultural and political center of Europe in the Age of Enlightenment and, finally, in the era of industrialization, a city of tree-lined boulevards, unified streetscapes, and magnificent vistas … (Tung 2001: 287)

In developing *Piercing Time*, I chose to walk my diagonal through the centre of the city. One sees, street by street, where changes have occurred, buildings demolished, new configurations constructed or, conversely, the old Paris spared, still visible under the embellishments of age and contemporary life. The passage of time is palpable as one unravels interlacings of stasis and change. Although change is seen in all cities, this is particularly visible in Paris because the organic structure of older street patterns is intercut with the sudden disruption of a newer conception of urban organization which the Haussmann plan brought in the 1850s-1860s. A combination of photographs, maps and one's physical presence allows one to understand this often confusing network as layers in time. By chance, my selection of a diagonal roughly coincides with a path which Haussmann himself walked as a young student and which he describes in his memoirs. For him, just as for the legendary *flâneurs* (Gluck 2005), walking through the city allowed for observation and contemplation.

> Leaving at seven in the morning from the *quartier de la Chaussée-d'Antin*, where I lived with my family, I first reached, after many detours, *rue Montmartre* and the *pointe Saint-Eustache*; I passed the square of *les Halles*, then open to the sky, through the great red umbrellas of the fishmongers; then *rues des Lavandières, Saint-Honoré* and *Saint-Denis*. The *place du Châtelet* was quite wretched at this time, the fame of the Veau Qui Tette restaurant overshadowing its historical memories. I crossed the old *pont-au-Change*, which later I had to have rebuilt, lowered and widened, then followed the line of the former Palace of Justice, on my left the sorry huddle of low dives that then dishonoured the *Ile-de-la-Cité*, which I would have the joy of razing completely-a haunt of thieves and murderers, who seemed able there to brave the correctional police and the court of assizes. Continuing my route by the *pont Saint-Michel*, I had to cross the poor little square where waters of the *rues de la Harpe, de la Huchette, Saint-André-des-Arts* and de *l'Hirondelle* all spilled, like a drain and at the end of which appeared, discordantly, the sign of the celebrated perfumer, Chardin. Finally, I sunk into the meanderings of *rue de la Harpe* before climbing the *Montagne Sainte-Geneviève* and arriving – via the Hôtel d'Harcourt, *rues des Maçons-Sorbonne, place Richelieu, rue de Cluny* and *rue des Grès* – on the *place du Panthéon*, at the corner of the École de Droit.
>
> The beautiful perspective of the Fontaine Saint-Michel which one now has from the new bridge, on arriving at the *place*, enlarged, raised, cleaned and framed by magnificent houses, is my revenge on the melancholy spectacle that had to confront during my four years of study. (Haussmann 1888: 535 in Choay 2000: 1104; see also Hazan 2010: 17)

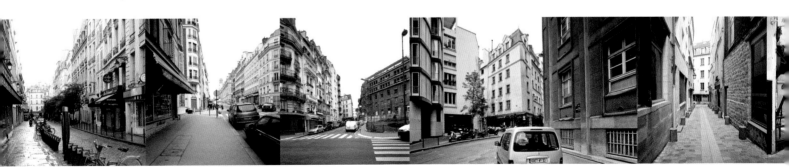

Fig. 4. A Paris Diagonal
Pointe St-Eustache to *rue de la Parcheminerie* (preceding page),
Rue de la Harpe to *le Panthéon* (above), Sramek, 2009-12.

Parti, le matin dès sept heures, du quartier de la Chaussée-d'Antin, que j'habitais avec ma famille, je gagnais d'abord, après bien des détours, la rue Montmartre et la Pointe Saint-Eustache ; je traversais le carreau des Halles, alors à ciel ouvert, au milieu des grands parapluies rouges des marchandes de poisson ; puis, les rues des Lavandières, Saint-Honoré et Saint-Denis; la Place du Châtelet était bien mesquine à cette époque, et la renommée du restaurant du «Veau-qui-Tête» en éclipsait les souvenirs historiques ; je franchissais le vieux Pont-au-Change que je devais plus tard faire également reconstruire, abaisser, élargir ; je longeais ensuite l'ancien Palais de Justice, ayant à ma gauche l'amas ignoble de tapis francs 58 qui déshonorait naguère encore la Cité, et que j'eus la joie de raser plus tard, de fond en comble, – repaires de voleurs et d'assassins, qui semblaient là braver la Police correctionnelle et la Cour d'Assises. Poursuivant ma route par le Pont Saint-Michel, il me fallait franchir la pauvre petite Place où se déversaient, comme dans un cloaque, les eaux des rues de La Harpe, de la Huchette, Saint-André-des-Arts et de l'Hirondelle, au fond de laquelle apparaissait, comme une discordance, l'enseigne du célèbre parfumeur Chardin. Enfin, je m'engageais dans les méandres de la rue de La Harpe, pour gravir ensuite la Montagne Sainte-Geneviève et arriver, par le passage de l'Hôtel d'Harcourt, la rue des Maçons-Sorbonne, la Place Richelieu, la rue de Cluny et la rue des Grès, sur la Place du Panthéon, à l'angle de l'École de Droit !

 La belle perspective de la Fontaine Saint-Michel, qu'on a maintenant du nouveau pont, en arrivant sur la Place, agrandie, relevée, assainie et encadrée de maisons magnifiques, est ma revanche du mélancolique spectacle que je dus affronter quatre ans de suite pour conquérir mes grades. (Haussmann 1888. 535 in Choay 2000. 1104)

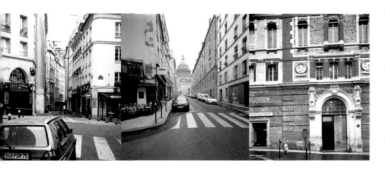

Visual documentation of architecture usually accompanies urban development, both in the presentation of proposed projects and in the recording of the completed works. Urban planning itself, especially on the scale that Napoleon III and Haussmann undertook, requires spaces to be coherently documented in visual form in order to explain, justify and record both proposed and completed projects. Maps and drawings have long provided such visualization tools, ideally supported by the use of surveys.[12] By the mid-nineteenth century, photography was able to function as an additional tool with its convincing detail and sense of presence. Charles Marville was one of the first to be commissioned to use the camera to create such an extensive urban documentation in the context of urban planning. We now take such documentary images for granted but, when he set out in 1865 to record the vast network of streets, he must have faced the challenge of how to structure a representation of the city. He most certainly required a coherent system appropriate for the commission, just as his cumbersome photographic process needed an efficient methodology to make so many exposures. Without it, the sheer number of possible images would make the project insurmountable or chaotic at best. At the very least, his project could not be based on simply selecting the photogenic. Marville did have earlier experience documenting the renovated Bois de Boulogne where the idea of moving through the park was used to organize his subsequent albums (Barberie 2007). Judging by the ordering of the portfolios in the Musée Carnavalet, it appears as though a topographic sequence was followed in shooting the images of 1865, but this is not certain.[13]

For the photographer today, the concept of moving through an environment in a series of views seems logical as a working process, and as a presentation sequence. In the photography of cities one finds other precedents. Eugène Atget had his methodical approach of photographing progressively along a street (Harris 1999); Josef Sudek (1959) sequenced his book *Praha Panoramitická* as though one were walking through the city. Today, 150 years after Marville, we are also used to the common cinematic tropes in which the camera moves us visually through a space in a continuous flow, as though we were physically present and walking ourselves. In shooting the contemporary photographs for *Piercing Time*, this concept of movement, so central to the experiencing of urban space, informed both the selection of images to be remade and the progress of photographing. Following the chosen route, the 183 rephotographs made here represent nearly all of the images which Marville took along, or near to, the chosen diagonal.

Rephotographic Practices
Peter Sramek

Rephotography in its contemporary usage is a process by which one consciously repeats earlier photographic moments in revisiting their locations and setting the camera in the same position, deliberately and as accurately as possible. The framework of rephotography as a conceptual practice forms the basis of the contemporary photographs in this collection and provides the rationale for juxtaposing the images. The act of remaking Marville's images developed my understanding of his methodology while consideration of how Marville and Atget recorded urban change led to my thinking about how their approaches differed, despite superficial similarities. Ultimately, the progressive photographing of the same locations by the three photographers forms an historical timeline, allowing for study of the sites themselves.

Rephotography is a well-established practice today, with a wide range of exemplars from the highly accurate and scholarly to the popular and touristic. Most contemporary art projects essentially consider the nature of photographic documentation and its ability to record time.[14] In returning to historical materials, one can address a range of concepts about stasis and change, human activity, geological time, memory, the historical significance of place, and more. Rephotography leads to questions about why it was important to photograph a particular scene at the time, what factors influenced how it was represented and what it means to re-do it now.

Although one thinks of major rephotographic concepts as entering the art vernacular with Mark Klett's rephotographic survey of the American west, *Second View* (Klett 1990), there are earlier books which have used rephotography as a structure, such as Yvan Christ's *Les métamorphoses de Paris* from 1967.[15] Christ commissioned photographers to revisit old photographs of Paris, including many by Marville. And, because Marville's images are so central to visualizing nineteenth-century Paris, they have often been used to illustrate travel guides and histories of the city. Guidebooks such as Leonard Pitt's *Walks through Lost Paris* (2006; see also 2008) draw heavily on historical photographs and Pitt supports his suggested walks with his own contemporary images of the sites, providing excellent descriptions of the architectural details found in the old photographs. In addition to these examples, many publications using new photographs of old views are found in popular or touristic media. These are about satisfying our seemingly universal desire to see 'then and now' and support historical descriptions of places and events. Unfortunately, many do not respect the integrity of the originals and often crop them severely, so the potential for study of the photographs themselves is limited.

This present volume aims to reproduce the historical images as accurately as possible so that it may be used for further academic inquiry.

Having knowledge of the past when visiting historical sites makes it easier to project oneself into that past and remaking an historical photograph focuses the experience into a specific time and place – the one in which the original was made. It is an attempt to stand in the earlier photographer's shoes and relive the photographic act, to recognize the impulse to record that particular scene. In the case of photographers such as Charles Marville, who created an extensive and methodical collection, it is to try to understand the intensity of the extended ritual of mapping locations, selecting a series of viewpoints and making the exposures. In addition, rephotography provides a framework, one which sidesteps a dilemma found in locations where thousands of images have been made and new images are photographed every day. In such places, it is next to impossible to take a traditional documentary or aesthetic approach seriously without resorting to irony, conscious commentary on the touristic eye, or some other conceptual starting point. In remaking an existing photograph, the question of what view to photograph is taken out of one's hands and the resulting images reflect decisions made decades before for a variety of reasons, which might become apparent or remain unfathomable. The freedom of this approach is palpable in the face of an over-photographed environment. With a mission to discover and remake the collection of Marville views, I was focused, free of the distraction of the thousands of possible photographs and questions such as why select this or that subject or why this particular angle of view. The feeling was similar to that evoked in Victor Hugo's (1831: Chapter IV) description of how, in *Notre-Dame de Paris*, Gringoire followed Esmeralda through the dark streets of the city:

> There was in this voluntary abdication of his freewill, in this fancy submitting itself to another fancy, which suspects it not, a mixture of fantastic independence and blind obedience, something indescribable, intermediate between slavery and liberty ...

Finding as exactly as possible where Marville stood was the main challenge, requiring me to focus on detailed observation as I slowly located sites, referencing the structures of the past, constantly comparing the old photographs with the present and noting details from maps of various decades. I worked primarily by visual alignment, but more complex techniques of triangulation are documented by various rephotographers (Maciejewski 2003).

Neither Marville nor Atget simply wandered the streets hoping to find an enticing subject. Their cataloguing followed rational plans and, in Marville's

case, his was a mapping of the city based on Haussmann's projects.[16] As well, Marville's approach to composing photographs followed a visual structure, which can be seen in a study of the images. His choices pre-determined my choices and, in discerning his camera position, I looked for details, for what was still there beneath the changes and how specific elements in the scene aligned. Each time I stopped to photograph, I was searching for something specific, although an observer would be hard-pressed to follow my rationale. Why this street-corner? Why two metres out from the sidewalk standing in the traffic? It was as though I were seeing something others could not. And, in fact, I was in another century, often imagining what was no longer there.

Preparatory research was extremely important. It involved consultation of various sources for captions, street names, dates and other identifying descriptions. Sometimes there were discrepancies and errors, even on the original labels. The most reliable were Marie de Thézy's book, *Marville Paris* (de Thézy 1994), and the descriptions in the Musée Carnavalet catalogue, but even these were missing some information that I found elsewhere. Exact alignment is the key to rephotographic work and consulting historic maps explained many mysteries. I used those from 1835, 1860, 1868 and 1900 to look for old and new street names and to match old intersections with the new configurations, particularly when the original streets had completely vanished. This is, of course, counter to the original photographer's process. Marville applied his compositional methodology to the scene, while I mapped the scene with his image to discover his methodology.

In beginning this work on Marville, one of my questions was whether or not Atget might have specifically revisited Marville's photographs of 30 years before in order to document changes. I also wondered if Marville, in taking on a second commission to photograph Paris, consciously revisited his own earlier images. Atget's photographs inevitably crossed paths with those of his predecessor, but did he model his topographic series after Marville's grand commissions? Could *his* work be considered rephotographic in this sense? Rather than confirming an intentional relationship between Atget and Marville, the research shows their differing methodologies. There are examples where both Marville and Atget returned to locations that they had photographed earlier, but they did not work in the same way that we now think of as exacting rephotography. In fact, Marville did not purposefully remake specific views, and although there are a few images to the contrary, when Atget returned to a site multiple times, he usually shot from different angles. Thus, the discussion here considers how each photographer's form of returning to a subject provides insights into how they thought about documenting change and ways in which photography can be used to reveal urban transformation.

Fig. 5. *Rue de la Montagne Ste-Geneviève*, Marville, 1865 (CAR/RV) (pl. 5.25).

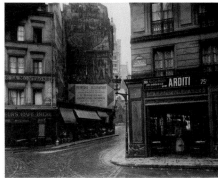

Fig. 6. *Rue de la Montagne Ste-Geneviève*, Atget, 1898 (CAR/RV) (l.), 1925 (MOMA) (r.).

Marville Rephotographs Paris: 1865 and 1877

It is not known if Marville's original commission was meant primarily in the interest of creating an historical record as a form of cultural preservation, but it is now often presumed to have also been for the purpose of providing future proof of the terrible conditions of pre-Haussmann Paris and the positive results of the redevelopment.[17] Understood in this context, his later commission of 1877 under the Third Republic clearly fulfilled a political function and was meant to show off the new roadways with their open, tree-lined views in opposition to images of the older, crowded streets of 1865. This new commission primarily captured major axial views and intersections related to new boulevards. A selection of 'before' and 'after' was to be exhibited in the *1878 Exposition universelle*.

successive spring times. Aside from new plantings and taller branches, the chief difference in the second photograph is the addition of caryatid columns on the portico of the prefect's house. The two views repeat each other even in the detail of the guard standing at attention in the driveway. Why include both views of the house and tower in the album? Marville made two versions of one other view, a scene of ponds, with similar attention to details (Sirot Album, no.9). But in that case the second exposure was seemingly made to replace a broken negative – the two views do not appear together in any album or archive. Presumably, in the case of the prefect's house, Davioud or somebody else wanted a view of the house with its new caryatids… Perhaps Marville placed these photographs together in the album to demonstrate before-and-after improvements. (Barberie 2007: 146)

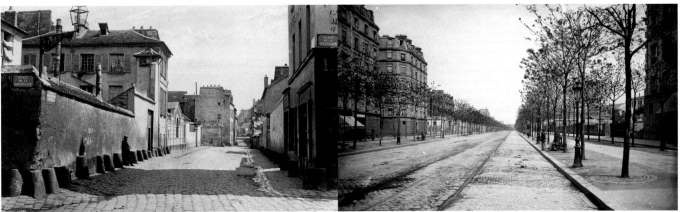

Fig. 7. *Rue des Francs-Bourgeois-St-Marcel*, Marville, 1865 (CAR/RV) (l.),
Boulevard Saint-Marcel, Marville, c.1877 (BHVP/RV) (r.).

Inevitably, when Marville photographed in 1877, some views were made in the vicinity of his images from the previous decade. Although this would have been a perfect situation for specific comparisons, an exacting concept of rephotography was not part of his thinking. In his dissertation, Peter Barberie (2007) notes that Marville did repeat two scenes quite intentionally in his Bois de Boulogne series.

The tower appears twice in the Sirot album, in duplicate photographs placed on succeeding pages (nos. 48, 49). Marville stood in very nearly the same spot for both views, in what seems to have been

Nevertheless, after reviewing both groupings of street documentation, one cannot say that Marville structured his 1877 series as a remaking of the earlier views. One does find a few examples where one can compare the old street with the entirely new boulevard from approximately the same angle. The view along *boulevard Saint-Marcel* near *avenue des Gobelins* provides an example (fig. 7; pls. 7.12-7.13). However, his two views looking south from *place Maubert* (pls. 4.27; 4.32), which centre first on *rue de la Montagne Ste-Geneviève* and then, in 1877, on *rue Monge*, are more typical. Although he was shooting in 1877 from within a few metres of the earlier position, rather than remake the same view, Marville focused on the new thoroughfare, indicating that in

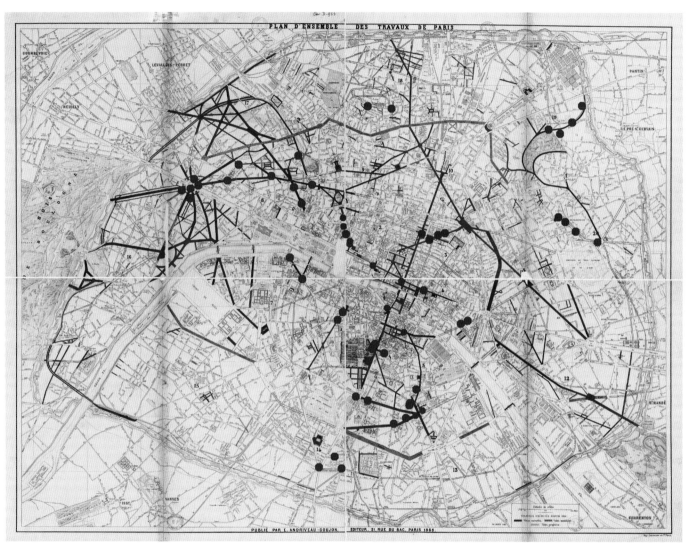

Fig. 8. *Plan d'Ensemble des Travaux de Paris* published in 1868 by Andriveau-Goujon (BnF GE D-933).
Superimposed blue markers show locations of photographs by Marville c. 1877.

1877 it was interest in the new road which mattered, suggesting that any exact repositionings one might find in the collection were circumstantial.

As discussed by Shalini Le Gall in her essay in this volume, it was also in the later commission that Marville photographed the demolitions which allowed completion of the *avenue de l'Opéra*. Although he had photographed many streets in this area a decade before, there was no attempt to photograph from the same positions and, indeed, it would have been difficult to do so in the midst of the demolition work underway.

specific previous photographic views? Presumably the commission would have stipulated that there was to be a comparison of old and new. The initial series was guided by Haussmann's plans, but by 1877 there were many new streets which could have been photographed and Marville did not repeat his earlier comprehensive cataloguing. It is quite unlikely that he was simply asked to photograph some new boulevards and so chose these randomly. Intriguingly, a plotting of the images onto the *1868 Plan d'Ensemble des Travaux de Paris* published by Andriveau-Goujon (Pinon and Le Boudec

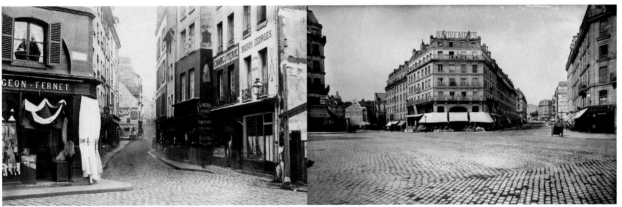

Fig. 9. *Rue Mouffetard*, Marville, 1865 (CAR/RV) (l.),
Rue de Bazeilles and *rue Monge*, Marville, c.1877 (BHVP/RV) (r.).

Thus, although the concept of rephotography was not present in Marville's two series, the 1877 commission was clearly meant to record change by presenting 'before' and 'after' in order to demonstrate urban development. This is particularly well realized in two groupings (fig. 9) consisting of the five views in *square Saint-Médard* from 1865 (pls. 6.12-6.16) followed by three images from 1877 of the new confluence of *rue Claude-Bernard, rue Monge, rue de Bazeilles* and *avenue des Gobelins* (pls. 6.28-6.30). In both sequences, Marville exhibits his practice of making an image for each street entering the intersection, although missing the view towards the new *avenue des Gobelins*. The new intersection bypasses what was the previous hub of the *quartier* at the bottom of *rue Mouffetard* and reflects the shift of importance away from community and commerce to one of circulation and traffic. Intriguing here, is how the offset of the later intersection results in the two spaces continuing to exist today, with the same contrasting functions.

The question does arise as to how Marville selected his sites in 1877. How was this decided if he was not going back to examine the changes to

2004: 111) suggests that a map such as this was used in planning a spread of images across the city (see preceding page, fig. 8). This map represents a commercial publication, based on an earlier, larger original, which imposes, in red, the construction projects of the preceding decade under Napoleon III, both completed (in solid lines) and only proposed (in outline). All sixty of the photographs which I have seen from 1877 align with the red markings of either completed or proposed construction, suggesting that such a map was used to plan Marville's second series. For example, one clearly sees markings for the incomplete *avenue de l'Opéra* where Marville's photographs of the demolitions took place in 1877. In addition, there are examples where Marville photographed exactly from either end of one of the red line sections on the map. Even some out-of-the-way photographs taken in the outskirts, of no apparent architectural or visual importance, sit on red tracings on the Andriveau-Goujon map.[18] We have little information about Marville's process and this conjunction is significant, as it suggests a systematic selection of sites based on available cartography.

Atget and Rephotography

In searching the archives, one discovers that Eugène Atget photographed many of the same locations as Marville, although only occasionally from the same point of view. Whether or not Atget directly referenced Marville's plates is not known, but his project, which he titled *Topographie du Vieux Paris*, stemmed from his commission from the Bibliothèque Historique de la Ville de Paris to update Marville's documentation of the centre of the city (Harris 1999: 11). When comparing images, however, there is again no indication of a systematic relationship of revisiting specific Marville photographs. What is more certain is that Atget's work was in response to a climate of nostalgia for old Paris, one which reflected attitudes about the results of Haussmannization (1999: 10).

Atget certainly did return to rephotograph locations he himself had documented previously, as in the example of *rue de la Montagne Sainte-Geneviève* and there seem to be various possible motivations for this. Was it primarily an economic factor that made him return to a site to make a new negative, or was there something which drew him to a site? Reference to replacing negatives, which he had previously sold to various archives, is common in discussions of his practice (Harris 1999:13). However, locations such as *rue Galande* (fig. 11; pl. 4.10), which Atget photographed on at least three occasions, were popular artists' motifs of *vieux Paris* and a location such as *place Saint-Médard* (pl. 6.16) had its crowds of shoppers which clearly interested Atget. Harris posits Atget's growing interest in an aesthetic use of photography and points to the series of images taken over time in *place Bernard-Halpern* with its church and pattern of trees (Harris 1999: 88; Sramek 2009). With many of these sites, Atget often made more than one image at one time

and when returning to the location his concern appears to stem from an engagement with the subject matter. His framing varies in these examples and rephotography can only be understood here as a revisitation of the subject rather than as a conscious replication of an exact view. Of particular interest, however, is an examination of how Atget did return to certain sites that were slated for, or undergoing, demolition. Over a period of 30 years he made multiple images, indicating an interest in documenting change and his concern for the loss of *vieux Paris* (Harris 1999: 14). There seems to be an interest in the destruction of buildings that he had photographed earlier or, at least, in following the progression of demolition. At the same time, Atget is not interested in photographing the new architecture in order to contrast it *with* the old, in the way Marville's last commissions asked of him.

Prime examples of Atget's following of demolitions include the area around the church of Saint Séverin (pl. 4.09), the intersection of *rue de Lanneau* and *impasse Chartière* (fig. 10; pl. 5.19) and the space in front of the church of

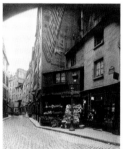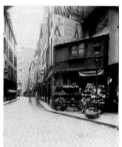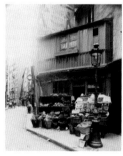

Fig. 11. *Rue Galande*, Atget, 1899, 1902 and 1906 (CAR/RV).

Saint Nicolas-du-Chardonnet (pls. 5.01; 5.14) created by the construction of *rue Monge*. These locations underwent demolition over a prolonged period, allowing him to photograph the sites as the work progressed. In the case of his view of the intersection of *rue de Lanneau* and *impasse Chartière*, he takes Marville's viewpoint once in 1899 and then again in 1925, along with a number of related photographs which show progressive changes up until 1927. In March and July of 1925, Atget made two identical photographs at the meeting of *rue de Lanneau* and *rue des Carmes* (pl. 5.11), which show a shift in the hoarding that surrounded the demolitions to widen *rue des Carmes*. [19] Here again, Atget's point of view matches Marville's.

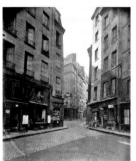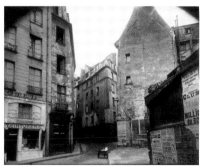

Fig. 10. *Agencement des rues de Lanneau et Chartière*, Atget, 1899 (BnF) (l.) and 1925 (MOMA) (r.).

Methodologies

Bibliothèque Historique de la Ville de Paris, because the prints were usually cropped when they were mounted.[21]

Peter Barberie discusses how Marville approached composition:

> All these things do work together to produce a compelling sense of the space of the view. But the view itself is not arranged to serve up a single pleasing effect so much as a vivid description of all its various elements. The details of buildings and courtyards are put in play with one another – that is the organizing principle of the photograph…
>
> His views, structured around elegant compositional solutions, nonetheless veer away from tableau finish. In my reading, those ideas [about what a photographed view should accomplish] involved rendering the complexities of a place – both built and social – rather than composing a pleasing tableau in the received sense. Photography, for Marville it seems, had other business than finished pictures. (Barberie 2007: 121-26),

As I revisited the sites, often numerous times, I was struck by how Marville must have required a specific plan. I could shoulder my camera and gear, and walk halfway across the city – or take the *Metro*. Marville required a much bigger camera, glass plates, water and chemistry. A methodical, planned set of views was most likely at the heart of his progress. Why he photographed some streets and not others is not documented but, mostly, it can be assumed that he had knowledge of which streets were to be affected by Haussmann's plans and worked from that. Of course, not all of Haussmann's ideas came to fruition and so we have Marville photographs of locations which are unchanged or changed much later by other planners.

Although Marville worked within a confined urban streetscape, there were still various options as to how to visually frame the old city. It is quickly

apparent that he photographed from intersections. His work covers the territory with a measured articulation of the street plan using axial views. Attention is directed to the perspective of the street and the linearity of the building fronts and his compositions do not usually focus on the buildings themselves.[20] One atypical example is seen in the photograph of the Maison Louis XV, home of the *Commissaire de Police du Marché aux Chevaux*, (fig. 12; pl. 7.04). This building, which remains intact today, was also photographed by Atget at least three times and is one of the few monumental or directly architectural photographs by Marville in this series.

Fig. 12. *Maison Louis XV*, Marville, 1865 (CAR/RV).

Marville seldom took photographs part way along a street and each was recorded as seen from its entrance, as it were. Most often the deep axis of the street leads to a point off centre in the photograph and there is a foreground space revealing the curb edge and a section of road in the foreground. This allows us to understand we are in the intersection, in a space outside the depth of the receding perspective. His handling of foregrounds is most clearly seen in the full-frame reproductions taken from the original plates in the

When placing the camera, Marville often aligned one perspective line of the road leading almost directly away. This meant shooting to one side rather than from the centre of the street. Horizontal images in particular were mostly taken standing to one side, although he still maintained a direct angle to the building wall facing him. The camera was level, keeping the vertical lines straight. Only very occasionally did he photograph from high up, *place Dauphine* (pls. 3.01-3.02) being an example of this. One also sees quite often that the focal point of the composition is an important landmark in the distance – the Pantheon or the spire of Notre Dame. This may simply be the circumstance of streets designed to lead towards these locations, but it was an element that Marville took advantage of, placing these at the apex of the linear perspective. It does of course reflect the then current intention of opening views to the major churches and monuments.

When photographing a pattern of streets entering an intersection, Marville did not simply stand in the centre and swivel his camera to make the four or five views, as a surveyor might in triangulating from point to point. Each shot appears to have been explicitly composed and the camera placed appropriately for that angle of view. This becomes apparent when identifying camera positioning in the field. Marville's approach is deliberate and he took time to move the heavy camera for each photograph. Although a rotation might be more efficient, this technique relates more to the panoramic photographer, who, when shooting the multiple images to be placed together, must maintain a singular point of origin. Such an approach to shooting an environment is

prevalent in today's digital photography and may also be equated with the quick swivel of the tourist gaze taking in a scene as if to capture it before moving on. Marville's compositional approach is thus to be differentiated from concepts of the Panopticon and, I suggest, places his work into the context of visual aesthetics as much as that of the surveying gaze.

Marville, for the most part, published one view of each location. As discussed in the appendix, this may have been affected by the technologies available, as each one of Marville's exposures presented a laborious task. My research reveals only two pairs of images which suggest that Marville might have made more than one exposure of a scene. His photographs of *rue du Fouarre* (fig. 13; pl. 4.12) provide a very unusual example of the printing of variant exposures. One version is seen in prints in the Musée Carnavalet and the Bibliothèque Historique de la Ville de Paris collections, while the other is in the Bibliothèque de l'Hôtel de Ville. Both versions were mounted and thus considered publishable. What is not certain is why one folio contains the different version. Presumably, these were sets of images printed and mounted at the same time in approximately 1873. The slight changes – the missing ladder, the different sunlight, the water – suggest these were close in time but not made the same day. The consistent, nearly identical, framing in this pair also suggests that he was not looking for the correct angle of view for the scene by shifting his camera but, rather, might have been concerned

about the carriage's presence, or that of the blurred figures beyond it, and so he made a second photograph. It is possible that he finished with this image one day and returned the next day to continue, for some reason remaking the image of the day before. This example does beg the question of how many exposures Marville might have made of any one site, both successful and spoiled. Unfortunately, the answer is unclear for lack of documentation.

Two photographs in the *rue du Haut-Pavé* (fig. 14; pl. 4.17), one horizontal and one vertical, provide the only other example in the Musée Carnavalet collection where we have evidence of two photographs of the same location,

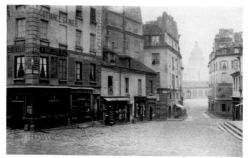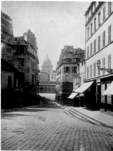

Fig. 14. *Rue du Haut-Pavé*, Marville, c.1865 (l.) and Pierre Émonts, 1869-1902 (r.) (CAR/RV).

taken at different times. Both photographs centre the dome of the Pantheon at the apex of the street perspective and were taken from nearly the same spot. Not having exact dates, it is unclear when these two photographs were made but here, again, details such as the lighting are different enough to indicate that it was not at the same time. The vertical is now attributed to Pierre Émonts, who worked with the Marville plates and may have made some of the existing albumen prints. This likely puts the second photograph at a later date. A few of Émonts' photographs are integrated into the Marville portfolios in the Musée Carnavalet, mounted, labelled and numbered in a similar manner. Of interest here is why the image would have been made and why it was placed in the collection, when there was already a photograph of this site.

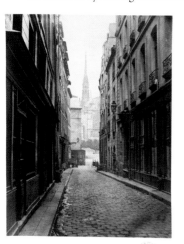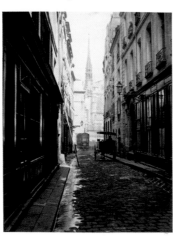

Fig. 13. *Rue du Fouarre*, Marville, with the BHdV variant on the left and Carnavalet on the right.

In juxtaposing Atget with Marville, the goal is not to show only images where Atget photographed the same compositions. He was clearly not intent on explicitly revisiting Marville's views. Rather, the two photographers' interest in Parisian topography crossed paths in certain *arrondissements*. What at first glance appears to be a common approach to the streetscape becomes remarkably dissimilar upon closer examination and, although it would be easy to dismiss them as being of the same historical documentary genre, the intention of the selection presented here is to be comprehensive enough to allow for a considered comparison. Questioning what each chose to photograph and from which viewpoints, how often, and which details they selected, may lead to a fuller understanding of their individual thinking. A broad overview shows that Atget ignored the districts of new architecture where Marville had documented ahead of demolitions. The *avenue de l'Opéra* is a prime example addressed in the trajectory of this book. Marville photographed in this *quartier* twice: once to document the old streets and later, in the 1870s commission, capturing the demolitions for the *percement* which would complete the avenue. For Atget, the new avenue with its regular building fronts held little interest and he made no photographs here. Instead, the two photographers overlap where Haussmannization spared the old city.

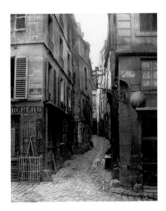 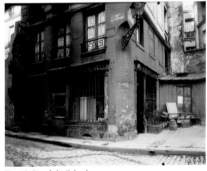

Fig. 15. *Rue de la Colombe*, Marville, 1865 (l.) Atget, 1907 (r.) (CAR/RV).

Like Marville, Atget devised a plan for mapping out the old city in photographs and worked systematically. His choices, however, were different. While Marville photographed the openings of streets from the intersection, Atget most often moved along the street, framing at an angle to focus on a building or particular doorway and, unlike Marville, he included interior courtyards in his surveys. His interest was in more than the street plan itself. Although many of his photographs reveal compositions built on spatial

representation of the configuration of streets, he focused primarily on buildings – façades, architectural and decorative details. Atget was a collector, creating a vast catalogue for the purposes of his trade in documentary records. In this way, he moved along a street slowly recording the elements he wished to preserve. Approaching his mission differently, Marville maintained his axial view of the streetscape. He was a visual cartographer. He did not frame corner angles or details of building fronts the way Atget did. Nor do we find close-ups. Even when Marville was commissioned to photograph the many new lamp posts, urinals and newsstands in modernized Paris, he showed them *in situ*, within the urban space, rather than as excised design details in the manner of Atget, who created many collections of door knockers, stairway railings and other such designed items (Sartre 2002).

The documentation of demolitions provides another comparison. Atget's concentration of such images lies mainly around the church of Saint-Séverin and along *rue Saint-Jacques* (Sramek 2009). This major demolition, prolonged by the First World War, was part of the tail-end implementation of the Haussmann plan before its complete abandonment. Atget made significant sets of images of these demolitions,[22] whereas Marville, for the most part, was either ahead of demolitions or kept them a peripheral element in the composition. It is only in the *avenue de l'Opéra* that we see him focus on the demolition site itself. In the work from the 1860s, aspects of demolition/ construction may be visible but are seldom the focus, reflecting how Marville was presumably only contracted to record what was about to disappear.

Atget's photographs of demolition show how changes continued in historical quarters beyond the time of Haussmann. They often complemented his earlier photographs of the same locations. It appears that Atget was interested in describing change through revisiting such sites. One example is found at the previously mentioned meeting of *rue Jean de Beauvais*, *rue de Lanneau* and *impasse Chartière* (pl. 5.19). In Marville's time, this intersection, labelled *Puits Certain*, also included *rue Fromental*, which is now gone. Atget made two photographs which match Marville's view (vertical 1899; horizontal 1925). As the westward side and *rue Fromental* were eliminated, he came back a number of times and even photographed the open expanse of land following the demolition.[23] In 2012, the structure which replaced the empty lot was again being gutted, while the old corner building which provides the focal point of Marville's original image remains intact.

When first researching the Marville collection in the Musée Carnavalet, I was looking to find a way to work with the images. The photographs were too numerous to be comprehensively rephotographed and my selection needed a rationale. It was only later that I understood the various details which have been outlined above. What I did realize first was that various sectors of the city which Marville photographed had faired quite differently over the past 150 years. The dichotomy of Haussmann-style architecture and that which preceded its regularity is likely the strongest impression one has today when revisiting Marville. This is seen when juxtaposing his photographs with the sites today and also when physically walking through the different *quartiers* of the city. I chose images which inscribed a route which would traverse just such a range of differences.

My initial task was to determine the locations. From the captions on the mounted photographs and the cataloguing information, I had street names, often both past and present. The book *Marville Paris* (de Thézy 1994) provided most locations marked on historical maps and the process of matching these to today's streets took visiting the sites to confirm how locations had changed. I made notes and reference photographs. Most often, altered streets were wider but buildings on one side might be the same. At the core of my experience was the process of searching out what remained of the architecture seen in the old photographs. Learning to see the various layers of older and more recent changes helped me appreciate the complexities of the Parisian topography. Inversely, in hunting diligently for details in the physical scene, I became acutely attuned to the information held in the photographs. When there were major renovations or new buildings, looking carefully for a remaining detail, even in the distance, could confirm Marville's camera position. Sometimes it was seen in a slight curve in the street or a façade which was still present.

The intensity of observation made me acutely aware of how the past and present are physically intertwined and, as I began to understand Marville's approach to composing an image, it became easier to predict where he stood. With careful attention to a photocopy of the original, I visually aligned details at various distances until I found the lens position as closely as I was able. Sometimes it was quite clear but, when there were no reference points, it was only a reasonable approximation and I depended on comparing maps. Where Marville photographed the Haussmann-style buildings, new at that time, these remain in position today. Occasionally, the difficulty was one of not being able to stand where Marville did because there was now a building on the spot or I would find myself in an impossible traffic situation. I did once run into trouble with the police when standing in the middle of a large intersection early one Sunday morning.

The experience of searching for the sites gave me an appreciation for how Marville must have conceptualized his task. His method was, in the end, quite deliberate. Although I moved back and forth across the city more than he did, I followed a daily plan. I marked streets on the map and plotted a route. With a backpack, I could carry film holders for half a day and then had to return to my room to unload and reload film. Much of my shooting was between 6:00 and 9:00 in the mornings as the soft light slowly arrived, while there was less traffic and no direct sunlight. In the afternoons, I had to contend with the harsher light, which did not work for some locations. I worked in the street steadily and deliberately, undisturbed much of the time except for the occasional passerby who stopped to talk. Once I had determined Marville's camera position carefully, I would move the tripod into position to frame a view which had already been decided for me. I did, however, make the choice to use a lens with a wider angle of view in order to show the environment out of which Marville had selected his framing. The wider angle, although it alters perspective, also gives a fuller depth to the space and I allowed myself this aesthetic preference, feeling that it would give my series some autonomy and result in a more dynamic collection.

Working within the context of a modern city meant shifting my awareness back and forth between the present and the past. Vehicular traffic was a constant issue, both for its intrusion into the frame and because I often needed to locate myself in the roadway itself. The most common solutions were to photograph very early in the day or return hoping to find less intrusive vehicles parked in the scene. Delivery trucks were a particular problem, as they might pull up into the frame at any moment and remain for long periods in the middle of the street. Moving figures were less of an issue as the long exposures would turn them into ghosts very similar to those found in Marville's images. His exposures were long enough to turn moving carriages and people into feathery traces. I was usually using exposures of about five seconds, but also up to two minutes at times. Making four exposures or more of a site, I was able to shoot for different configurations of people and moving vehicles and select the best result later. Most often, I aimed to have the suggestion of human presence, usually in the distance and in motion.

Performing the City
Cultural Heritage and Modernity
Peter Sramek

It is a contemporary conception of urban space to consider the city as embodying a complex web of social and political relationships, of individual and collective memories and a spectacle of constructed experiences, now directed mainly by the media environments with which we are surrounded. The rise of modernity in the nineteenth century is most often linked to the rise of consumer capitalism and the modern citizen can be seen as an observer moving through the urban environment to experience the spectacle of goods now offered on view. The increased mobility of the individual consumer, whether pedestrian or vehicular, was a significant development affecting life in the modern city and, as I walked through the city remaking Marville's photographs, this awareness informed my process. I thought of it as a form of 'slow' experience which disrupted that of consuming the spectacle of Paris and as a re-enactment of other previous proposals for understanding urban space, including the projects undertaken by Marville and Atget.

The framework for my movement through the city was essentially disconnected from the present day of purposeful activity – be it economic, practical or touristic – and the flavour was distinctly different from that experienced by the tourist in search of the markers of the spectacle which Paris has become. By virtue of being led by Marville's images, I ignored the veneer of today and also the guidebook histories. I walked multiple times along the network of sites, often more aware of the historical geography than of my present surroundings. Naturally, I felt a tension between feeling like a consumer of history and my desire to discover an authentic experience of the city. I was reminded of other figures who have wandered Paris, Baudelaire's *flâneur*, the surrealists out on their 'expeditions' into the city, and the more recent Situationist proposal of the *dérive*, or drift, in which one walks the city to discover an alternative to the urban experience that has been packaged and presented for us as consumers. 'Situationists, Debord and Jorn, created maps such as the "Naked city" of 1957, which highlighted urban areas, threatened by redevelopment, retaining the parts that they believed were still worth visiting and disposing of the bits that they felt had been spoiled by capitalism and bureaucracy' (Gershfeld 2010; see also Knabb 1981; Sadler 1999). As Debord suggested himself in his *Introduction to a Critique of Urban Geography* (1955):

> Is it illogical or devoid of interest to observe that the district in Paris between Place de la Contrescarpe and rue de l'Arbalète conduces rather to atheism, to oblivion and to disorientation of habitual reflexes? ... The sudden change of ambiance in a street within the space of a few metres; evident division of the city into zones of distinct psychic atmospheres; the path of least resistance which is automatically followed in aimless strolls ... gives rise to feelings as differentiated and complex as any other form of spectacle.

Considered in these terms, my photographic process became a form of urban performance involving a slow trajectory with stops in some unlikely places, particularly where the streets had been completely altered. To onlookers, there probably appeared to be no coherence to my photography as I zigzagged my way with my large camera. I thought about the curious interest which Marville must have faced at a time when taking a photograph was an unusual event. One can sense it in his images where people can be seen staring towards the camera. I was aware that my activity created a disruption of the everyday experience of the city, primarily because in the twenty-first century it is no longer a common sight to find a photographer with a tripod and view camera working in the street. With a black cloth over my head or standing, timing fifteen-second exposures in the middle of traffic, I felt I was playing a part out of history. People stopped and talked, marvelling that someone still used such equipment. They looked at the binder of historical images I carried and commented on the city and its past. In a manner related to that proposed by the Situationists, an unexpected personal interaction was provoked.

> In a derive one or more persons during a certain period drop their usual motives for movement and action, their relations, their work and leisure activities, and let themselves be drawn by the attractions of the terrain and the encounters they find there. (Plant 1992: 59)

Some people spoke of experiences with photography or knew details of the local architecture. Others were simply curious. Usually, they immediately understood the concept of past and present views and, most importantly, many had opinions about the urban change which they saw around them. They told me stories and their own sense of a personal city expressed itself. This phenomenon of spontaneous meetings led me to record conversations with interested passersby, primarily at an annual community flea market in *rue Mouffetard* where I stood at the curb with my book in another form of performance. Their words are threaded through this volume to provide a range of contemporary perspectives which became so important to my experience. Of course, even as I grew accustomed to these encounters, many people ignored me as just another event in the cacophony of the modern city. For one *restaurateur* there was only the commercial value of his 'brand' and this extended to images of his location. He angrily proclaimed his ownership of

the right to make images which included his establishment, forcing me to return at an quieter moment. The power of the photograph to delineate power and ownership asserted itself.

The photographic documentation of Parisian streets over time sits within a broader context of attitudes towards modernity and urban organization. As Shalini Le Gall discusses in her essay, the rapid modernization of the city greatly altered the physical environment for Parisians, but economic, social and political contexts were also shifting. The resulting tensions seemed to be embodied by the streets and buildings themselves, as variegated clusters of façades were autocratically cut through by straight roadways. One Hauss-mannized street appears practically the same as any other, and a requisite conformism reflective of the age was clearly expressed in Haussmann's aligned streetscapes, building heights and architectural detailing. Even at the time, there was a love-hate relationship with this new milieu. On the surface, the modern society was democratic, prosperous, clean, efficient and forward-looking while on the other hand the individual disappeared, becoming a cog in the machine of modernity. During the past 150 years, this drive towards an efficient civic environment has existed in tension with a resistant, organic culture with strong roots in Parisian identities linked to location within the *quartiers* and I suggest that it is useful to consider the undertakings of Marville and Atget in the context of a general ambivalence towards modernization. As my own photography proceeded and I spoke with Parisians, I became aware that these tensions and contradictions continue in the present. An ambivalence towards both historical and contemporary change was apparent. At play is a sense of tradition and the familiarity with what has been, set against the realities of 'progress' with its many competing pressures.

Although struggles between the desires of governing authorities and the populace permeate the history of Paris, this tension found focus in response to Haussmann's alterations of the built form of the city. The city had grown organically over time, developing traditions and identities which the new imposed structure threatened, literally destroying the physical loci of communities and displacing residents. By 1870,

> thousands of buildings in the now familiar grey and anonymous style appeared all over the city. Paris was finally assuming its role as the most advanced and best-designed city in the world but, as artists, writers, engineers, architects, as well as ordinary Parisians protested, this was at the expense of the city's unique identity. (Tung 2001: 293)

This struggle has never been static. Michaël Darin (2009: 7-8) writes, in *La Comédie Urbaine*, that the city is a complex layering of events, always in perpetual movement created by many interests and players. Urban change is at once a gesture towards the future and a party to the past. For nineteenth-century urban planning, building alignment was of particular importance. The irregular mix of building façades was to be straightened and conformed and, as the new avenues were constructed, differences in elevation were to be eliminated. This reflected the desire for a coherent and controlled social order. As Darin articulates through examples, such as a section of *rue Saint-Jacques* (2009: 238), there are often anomalies created as certain buildings were not 'corrected' and proposed plans imperfectly implemented. The resulting irregularity has given parts of Paris a less homogeneous character despite the efforts of urban planners (2009: 238-39). Darin discusses, in particular, how the actual physical changes which occur are the result of these many forces and how often the new urban regulations which dictate the official vision of a period come to 'imperfect' yet more-lively results when plans are blocked, partially implemented or suddenly changed (2009: 30-31). The city is thus always an amalgam of official and organic change.

The Haussmann Plan is a monumental example of the impulse to organize and control but, with its eventual abandonment, many of the older parts of the city slated for demolition were saved. In the photographs, one sees where the plans were fully rendered, as in the *avenue de l'Opéra* (pls. 1.01-1.10) and places where they were stopped, as in *rue de la Harpe*, where one side is pre-Haussmann architecture and the other is rebuilt (pl. 4.01). The Atget series which follows the space in front of the church of Saint Nicolas-du-Chardonnet (pls. 5.01, 5.14) reveals the slowness of progress over the 60 years following Haussmann, demonstrating how Parisians endured decades of architectural change over this period. Darin (2009: 82-3) comments that while some buildings are demolished many remain, continually remodelled and repurposed. On the corner of *rue des Trois-Portes* (pl. 4.23), a contemporary restaurant still has the original decorative ironwork beneath coats of paint, while in *rue de la Montagne-Sainte-Geneviève*, an underground stables is now a restaurant in which one can eat where horses once fed.

In addition to architectural change, the nineteenth century saw the development of new realities for urban life. With modernity came new ideas of what it meant to be a citizen within an industrialized and consumer-oriented society. Post-revolutionary France had lurched back and forth between republicanism and autocracy, between radical chaos and strong-armed order, only to emerge into the optimism of an industrial and mechanized future where capital dominated and the *Exposition universelle* proclaimed the triumph

of progress. Paris was the *City of Lights*. The representation of this new age was paramount and photography rapidly began to play a key role as a powerful instrument of the new science and technology. However, the ambivalences which accompanied developments in the first half of the nineteenth century were publicly expressed by a wide variety of voices, from bohemian artists performing in bars to writers in popular journals and workers fighting the rising bourgeois class, which itself was busy staking its claim to the new prosperity (Gluck 2005). This accelerated new environment needed to be understood and the attention of intellectuals such as Hugo and Baudelaire turned to everyday urban realities. Later in the century, photographers such as Marville and Atget found a role as urban documentarians, although their personal positions within the debates about the new age were not necessarily clear from their work. By the early twentieth century the photographic document would find itself central in representing modernity (Nesbit 1992: 16).

Prior to the advent of photography, there were precedents in Parisian society for the role of observer and recorder. Narrative authors such as Victor Hugo and Eugène Sue had written about everyday life in Paris to great popular acclaim. They romanticized but also brought to light the realities of a wide range of urban characters. Also popular in the 1840s were collections of urban physiologies, both written and illustrative, which delineated the social types in a world of changing roles. '[Their] mission was to provide for future generations an accurate picture of everyday events and ordinary characters of contemporary life' (Gluck 2005: 83). It was at this time that there arose the figure of the *flâneur*, whose casual yet keen eye studied the city while moving through it. Gluck (2005: 69) describes how the typical appearance of the artist/writer of the 1830s changed from a flamboyantly-dressed 'artiste' to an outwardly-conforming, bourgeois gentleman attired as one of the many indistinguishable citizens of the modern urban society. She goes on to articulate that although the exact nature of this mythical figure has been defined so broadly as to describe any idling gentleman, at the time he (and it most assuredly was a male figure) was seen as a writer, a journalist, someone who observed and reported on the life of the modern city. As Walter Benjamin noted, the *flâneur* was connected to 'the world of urban popular culture that was linked to the mass circulation newspaper' (Benjamin, trans. 1999, as cited in Gluck 2005: 67). Despite taking on a conforming appearance, 'the *flâneur* was, in fact, the only figure in Parisian popular culture who could render the labyrinthine urban landscape legible and meaningful to contemporaries' (2005: 75). Although counter to the popular image of the strolling window-shopper, Gluck suggests that the true *flâneur* was a combination of aesthetic sensibility and the keen awareness of a social scientist. For the observant *flâneur*, everyday details were important, as was noting the underlying conditions which these revealed to the discerning eye. Through the *flâneur's* writing, or even through conversation with him in the street, the average citizen could learn to understand the complexities of modern life in Paris (2005: 67; 75).

Marville and Atget's photographs also played an important role in recording the changing urban space. With their attention to the vernacular rather than the monumental, they fit with the spirit of observing the everyday. And, as visual records of an urban environment which was quickly disappearing, they inevitably have become associated with a desire to keep that cultural heritage alive. But, in Marville's case, the task of representing the old provided a means to explain a new way of thinking about Paris and his systematic approach, which efficiently mapped the required streets in a logical manner, was more in accordance with the rational and orderly than with nostalgia for the past. Nonetheless, this highly-structured plan of documentation resulted in images which reveal an aesthetic vision. They are highly consistent, and maybe even conventional, but they are much more than a prosaic record of locations produced by a technician. His camera placements were visually deliberate rather than utilitarian and I suggest they exemplify what would later become an argument for documents as art, despite the clear separation of the two that was expected at the time (Nesbit 1992: 14-19). Peter Barberie writes,

> photography's critics and its practitioners did want to delineate its forms and subjects in the 1850s. If we look at Marville's diverse approaches to the landscape in all his photographs of the Bois de Boulogne, we see him engaged in just that sort of appraisal – experimenting with the pictorial devices he relied on as a printmaker, discovering their adaptability to the medium of photography, encountering the problems specific to making views with a camera and photographic materials. (Barberie 2007: 143)

It is natural, then, that Marville's prior aesthetic knowledge informed his documentary task and this complex character, that of the scientific documentarian combined with the artist suggests a duality which Gluck (2005) ascribes to the character of the *flâneur* as social observer. Furthermore it mirrors the split between the application of rational urban improvements and the emotional connection to the past which faced Parisians in the second half of the nineteenth century.

In Marville's commissions, there exists another contradiction, this one in temporal terms. He created a view of what would soon be the past while proposing to project a positive perspective on the new world. One can only guess what Marville's personal feelings were, but he worked for the side that championed the new. His images accurately describe an environment which was wretched and unhealthy and yet, they record a world steeped in a history about to be demolished, the loss of which was lamented by many. These were images rapidly destined to sit perennially in-between the rational document and the evocative evidence of a past age laden with nostalgia. As one Parisian observed to me when looking at the Marville photographs, 'people in those days were miserable, but they were happy.' One could add, 'the streets were dismal, but there was real life.' Today, Marville's work, rather than announcing the new, connects us to romantic sentiments and one must wonder at the irony of Haussmann's photographer producing an archive so evocative of that which the Baron so vehemently wished to eradicate. Tangentially, such contradictions exist when considering the 'artiste-démolisseur', himself. It was Haussmann who suggested purchasing the Hôtel Carnavalet to establish a museum of the history of Paris and in his memoirs, he challenges his denigrators pointing to how his demolitions created vistas to historical sites.

We are of course looking from our current vantage point and I do not mean to suggest we can know how Marville felt about these changes. Still, as Shalini Le Gall outlines here, there were many who felt the loss of old Paris deeply, even at the time. And, by the end of the century when Atget began his work, there was a market for documentary images of old Paris. He strategically sought out collectors, archives, architects, designers and artists (Nesbit 1992). With the advance of industrial capitalism, the ambivalence towards the modern city which had faced Haussmann in his day was also expressed in clearly political terms, such as in the novels of Emile Zola which addressed the life of working-class Paris. In this context, as well as that of a prosperous urban society, Atget as a figure appears nostalgic and heroic, out to stem the tide of the modernizing world in which he lived. He saw the ongoing loss of Parisian heritage as urgent reason to record as much as possible but, unlike Marville who was 'official', Atget worked at the periphery. He described himself as a maker of *Documents for Artists*, yet more often he has been seen by others as a narrator of dreams.[24] Ironically, he himself never considered his work as art and yet he developed an aesthetic eye (Harris 1999). Conversely the young Surrealists adopted his documents as art that might illuminate their contemporary world. They were attracted to his photographs of the modern city – the shop windows; the famous eclipse photograph which they published (Nesbit 1992) – finding in his photography a key to their own quests.

The struggle between rationalist urban planning and an opposing motivation to create more organic forms for human environments continues in Paris to this day. Major planning trajectories throughout the twentieth century saw architectural incursions into the fabric of the city. Whether these were only conceptualized, as in Le Corbusier's *Plan Voisin* of 1925, or eventually constructed (as in the *Tour Montparnasse, Forum des Halles* and *Jussieu*), the response from many quarters has been heated (see Hussey 2006: 416). Sadler, in *The Situationist City* (1999: 58), points out that, in the post-war redevelopment, 'it has been estimated that at least a third of the old Ville de Paris disappeared.' It was in this context of urban planning that the writings and actions of the Situationists proposed an alternative understanding of the city based in free human experience. Debord's 1959 film of *Les Halles* (also see Sadler 1999), as well as the *psychogeographic* maps which he constructed with Asger Jorn, (Sadler 1999: 62-64) reflect an affinity with the old Paris, places where Atget would have felt at home. Albeit framed within a revolutionary perspective, and on the periphery where practical urban planning was concerned, their proposals voiced feelings felt by many who were angered by autocratic urban developments and the loss of heritage.

Inherent within these struggles about historical and community preservation lie questions of what constitutes authentic experience, or nostalgia or, yet again, tourist spectacle. Historical photographs viewed today evoke just such nostalgia, often subverting the original intentions of the work itself. In Marville's project, what was meant to support a vision of the developing future blends with a sense of loss as the images, which were contemporary documents at the time, rapidly slipped into being signifiers of the past. This is true of all photographs, of course, but because both Marville and Atget photographed a city faced with demolition, this shift must have been almost instantaneous. Even the new and still empty streets, which in 1877 heralded a futuristic optimism, would soon evoke nostalgia for a quieter age.

In speaking with Parisians about their city, a continued sense of impending loss is expressed. During the many hours of making photographs in the street, I spoke with people about the old photographs and about their perception of the city. I would show people my binder of photocopied Marville images, and the concept of comparing the past with the present was for the most part immediately understood. And they would then begin telling me stories, stories of old street names and what shops there used to be, what was new after Haussmann and what was old. Their own family histories came out and how they came to Paris or, often, something of their connection to old photographs. Many people marvelled at my 'ancient' view camera and a surprising number were photographers who used to shoot with one. They

commented on how Paris, like most large cities, has been radically changing economically and commercially.

If one follows the path of images made between *place Maubert* and *place Saint-Médard*, the 5th *arrondissement*, 'le cinquième', provides an example of how change continues in old Paris. Here one finds an overlapping of historical continuity with architectural alteration from various eras and there is a strong sense of personal identification with local roots. Whether born in the *quartier* or coming to settle there, people's experience of the shifting character of this neighbourhood reflects the continued pressures of urban development. The process that saw the wholesale destruction of poor and working-class neighbourhoods under Haussmann continues more quietly through renovation and upgrading, impacting on Parisian life.[25]

Here in the 5th, I recorded interviews with individuals, mostly informally at a street fair in *rue Mouffetard*, and the collision of civic improvement and real estate economics with local identity and community life was clearly expressed.[26] Although there are, of course, those who live fully in a contemporary context, not concerned with the past, most of those who were interested in speaking to me described a feeling that changes had damaged their city. Past events had erased cultural heritage and present pressures were eroding contemporary experiences of community. Admittedly, this was a small sampling of individuals drawn *par hazard* to discuss the idea of this particular photographic project. Nonetheless, for each person there was a strong rootedness in the essence of their local neighbourhood which was linked with the past and, as in the nineteenth century, an ambivalence about contemporary change. Commercialization and the disappearance of local economies along with shifting populations seem to be at the core. Residents spoke of an attachment to their neighbourhood and the depth of family roots and how this was slowly shifting with the encroachment of gentrification into working-class neighbourhoods. They were concerned about the loss of an authentic heritage in this oldest part of the city. The quoted excerpts presented throughout this volume attempt to accurately represent the attitudes and feelings which were expressed to me. Perhaps it is a natural condition of the modern world, with its constant change, that one holds to what once was while being propelled into the future, but there seems to be a very clear feeling that an intimate and relational urban environment, one that connects people, is the desirable essence of Parisian life and that this has existed in the *quartiers* of the central city. One hears in their words that its slow erosion is lamented.

The discussion here only touches the surface and close study of the photographs and maps can reveal much more as the reader brings their own interests to the material, be it the history of documentary photography or that of the growth of Paris. The experience of walking these streets with copies of historical images in hand is a rich journey, which opens the city to the observer in a myriad of ways. In selecting my Paris diagonal, I began to think in terms of similarities, of polarities and of tensions and these became an underlying thread, finding a home in the discussions presented in these texts.

The systematic photography of urban development provides an excellent ground for rephotographic practices and, by considering how the concept of revisiting sites is embedded in the work of Marville and Atget, one can see how they worked differently yet used the passage of time to show the urban landscape evolving. Marville did not remake specific views when he completed his second series, while Atget did return to some sites over three decades, although usually selecting different points of view. My own process of locating and remaking Marville's images followed a plan laid out 150 years earlier and a timeline is created tracing changes from one century into the next.

Within the overall context of contested urban developments, Marville and Atget's positions are indicative of contradictory conditions. As documents, the images purport to show us what 'was' and each individual will ascribe different values to what is seen in them. Atget believed in *Old Paris* and in the image as a form of preservation. Marville worked for the agents of change, representing an official viewpoint, yet produced an archive whose ultimate impact is the opposite: a *détournement* or reversal of sorts, also showing us what was being lost and in need of protection. I have to wonder if Marville also felt a sense of safeguarding the past through images, or if he believed wholeheartedly in the renewal in process around him. The evocative nature of his photographs would suggest the former, but this will never be certain.

In making my photographs, I experienced the deliberate progress of documentation, the shift from one street corner to the next and the repetition of Marville's visual strategy of describing the foreground space, the features of the buildings and the receding road. As I walked my diagonal over and over, an intimacy developed which suggested something of what both Marville and Atget must have shared with their city and maybe I learned something of seeing beyond the spectacle and myth to experience my own form of *psychogeography* of Paris.

Notes

1 It was Françoise Reynaud, Curator of the Musée Carnavalet's Photography Collection, who brought my attention to the Marville archive and who has encouraged and supported my efforts. Jean-Baptiste Woloch, Assistant Curator provided crucial assistance throughout my work, sharing his extensive knowledge and guiding access to the images.

2 In undertaking this research, I owe a great debt to the work of Marie de Thézy (1994), previously of the Bibliothèque Historique de la Ville de Paris and custodian of its Marville collection, which includes his original glass plate negatives. Her book provided a guide to the images along with locations, old and new street names and historical maps.

3 The view camera is similar in function to the wooden nineteenth-century plate cameras, using a cut sheet film holder and producing a film negative which is 4"x5" in size. The camera is bulky, but much smaller than Marville's glass plate camera.

4 Pitt's two volumes (2006 and 2008) provided another excellent source for specific sites with their detailed historical maps and photographs.

5 Some of the Atget views presented here are of the same site but from quite different angles, even from the opposite direction. They are included to allow one to understand the sites more fully as well as how each photographer composed their subject.

6 The photographs reproduced in this book attempt to be faithful to the originals. Recent, high-quality digital copywork is used and the images are presented uncropped as they exist in the various archives. The contemporary photographs were made with a wide angle of view in order to present the broader context of the urban space within which the two previous photographers made their images.

7 An unusual example exists in the series of architectural street views of Prague by Václav Jansa made prior to the demolition and reconstruction of the northern quarter of the old city, including much of the Jewish Ghetto. These were done in watercolour in the late nineteenth century when one would expect photography to have fulfilled this role of documentation. A contemporary project photographed by Ondřej Polák revisits these sites and was exhibited in 2008 in the Prague City Museum.

8 Many discussions with Jean-Baptiste Woloch of the Musée Carnavalet filled in details related to the history of the archive collections.

9 Hugo (1831: Book V) goes on to name 'Printing' as the replacement for architecture as the primary record of the cultural past and this could easily be extended to include the photographic document. 'The past must be reread upon these pages of marble. This book, written by architecture, must be admired and perused incessantly; but the grandeur of the edifice which printing erects in its turn must not be denied.'

10 Maps from this period often have ghostly tracings of proposed reconstruction, some of which happened and some not. Often there is an overlay of details from varying time periods with more or less accuracy. In this sense, the maps are not a snapshot of a particular moment. (For more discussion see Lee 2012; Pinon and Le Boudec 2004).

11 In many nineteenth-century urban photographs the activity of a living city is diminished by the long exposures, hinted at by the blurred figures and vehicles, adding to our romantic interpretations today. Close inspection often does reveal figures and stationary people were regularly placed into scenes for scale or to provide points of interest.

12 Issues of accurate surveys and cartography in nineteenth-century Paris are complex. Reference to other sources is recommended (see Lee 2012; Pinon and Le Boudec 2004).

13 The Musée Carnavalet collection is numbered in a quasi-topographical sequence which is discussed later in the section on the archive.

14 For in-depth rephotographic studies one can look to Klett (1990); Klett et al (2004); Maciejewski (2003); Barta et al (2006) among others .

15 (Christ 1967). This volume was given to me by Cécile Claris who found it on a table in her neighbourhood street sale, the annual *Vide Grenier de la rue Mouffetard*.

16 Unfortunately, all details of how Marville planned his itinerary have been lost, whatever written form they may have taken – maps, lists, dates or contracts.

17 As outlined, this is due to the loss of any early official documents, such as contract letters, along with his first set of prints, in the fire at the Hôtel de Ville in 1871.

18 Although there are issues with its accuracy, it does distil what Napoleon III and Haussmann drew previously in large scale. The series of history-of-construction maps from which this particular map was derived is complex due to the loss of originals in the fire of 1871. Such analysis is beyond the scope of this text, however, one might consider the possibility that, with the grand planning maps destroyed, Marville's commission and plan for photography could have derived directly from reviewing such a map in the mid 1870s.

19 Both locations are well represented in the collection of the Museum of Modern Art and in *The Work of Atget Vol.II: The art of old Paris* (Morris Hambourg 1982).

20 See Lee's discussion here on the role of perspective in representing the new city.

21 Most of the 1877 photographs included here are reproduced from the original plates in the BHVP and therefore show the full image. See de Thézy (1992) for the full-frame reproductions of the 1865 commission.

22 Between 1914 and 1924, Atget made over 100 photographs around Saint-Séverin.

23 In all, research shows at least seven photographs by Atget of this intersection, taken between 1899 and 1927 (Morris Hambourg 1982: 182).

24 The title was his own. It was the Surrealists who first wished to bring his images into the art fold, although this was something he rejected wholeheartedly (Nesbit 1992: 1-5).

25 The city's long history as a social, political and cultural cauldron provides a rich texture which can be studied in many well-researched texts (Gluck 2005; Hazan 2010; Hussey 2006). The architectural preservation and urban planning histories can also be found discussed (Tung 2001; Darin 2009).

26 This was the annual *Vide Grenier*, when local inhabitants set up tables in the streets to 'empty their attics.' Crowds stroll, chat and hunt for bargains. With the help of Cécile Claris, the main organizer and a leader in the local business association, I stood with the book maquette for people to look at and I made audio recordings of our conversations, guided primarily by questions about how the person perceived change in the *quartier* and what meaning the past, as seen in the historical photographs, holds for today. The excerpts here attempt to distill common threads, while maintaining the context of each excerpt.

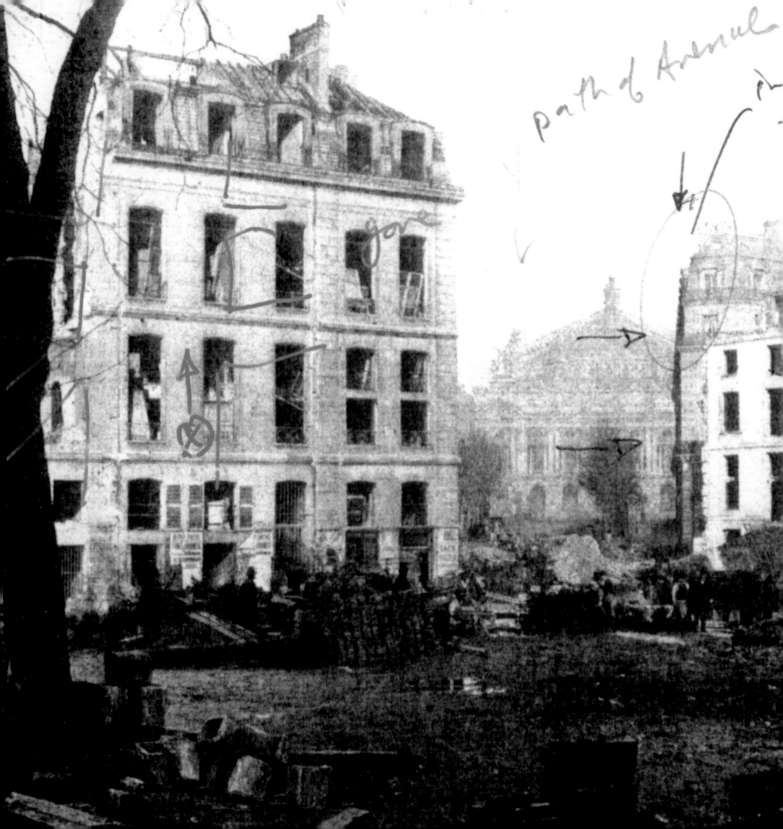

Avenue de l'Opéra

Fig. 16. Locations (overleaf)
Atlas Administratif, 1868
(sites 1865-68),
Paris-Atlas, 1900
(sites c.1877).

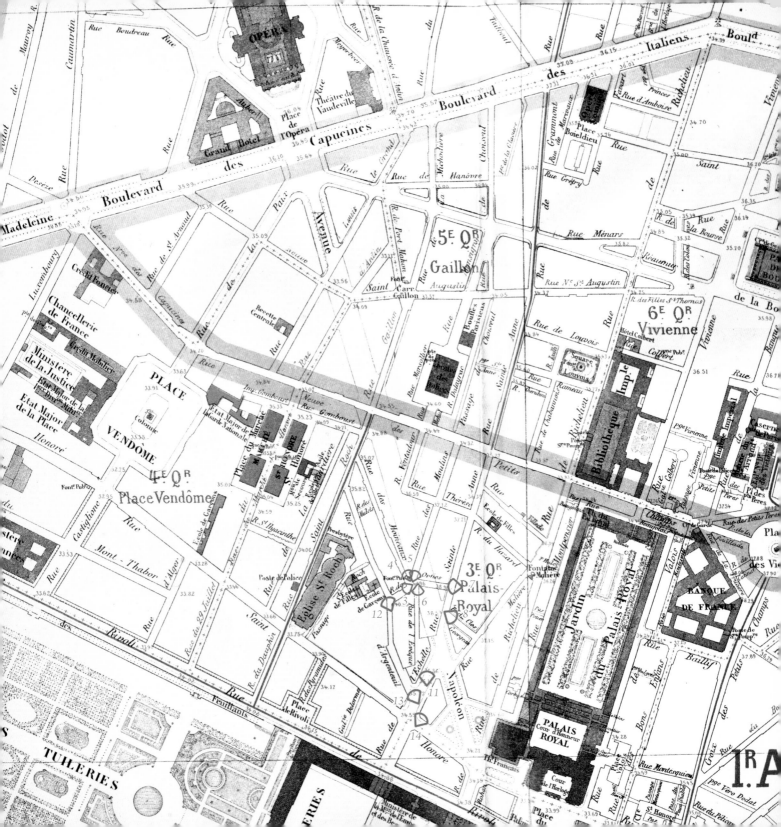

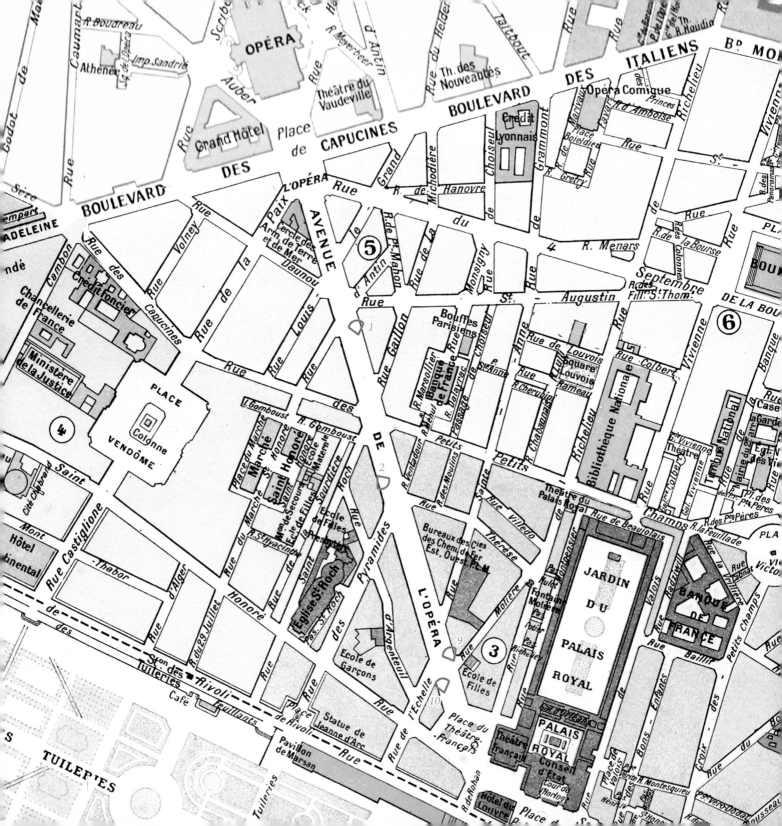

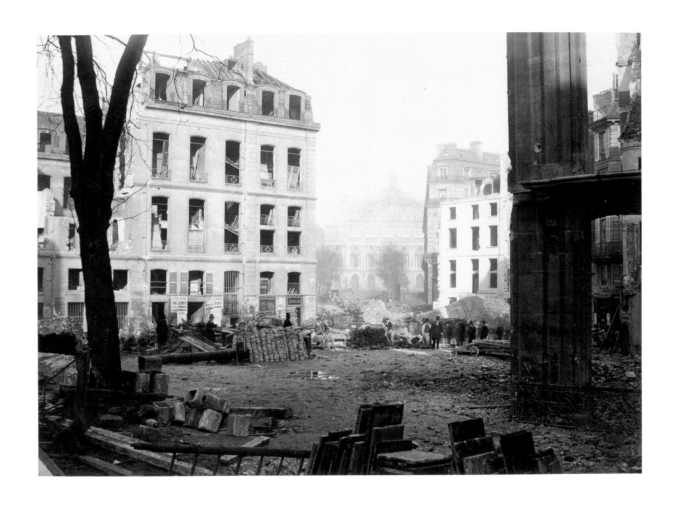

AVENUE DE L'OPÉRA

(Espace compris entre la rue Louis-le-Grand
et la rue d'Antin, vers l'Opéra).

1.01. *Avenue de l'Opéra (Espace compris entre la rue Louis-le-Grand et la rue d'Antin, vers l'Opéra),*
Marville, c.1877 (CAR/RV).

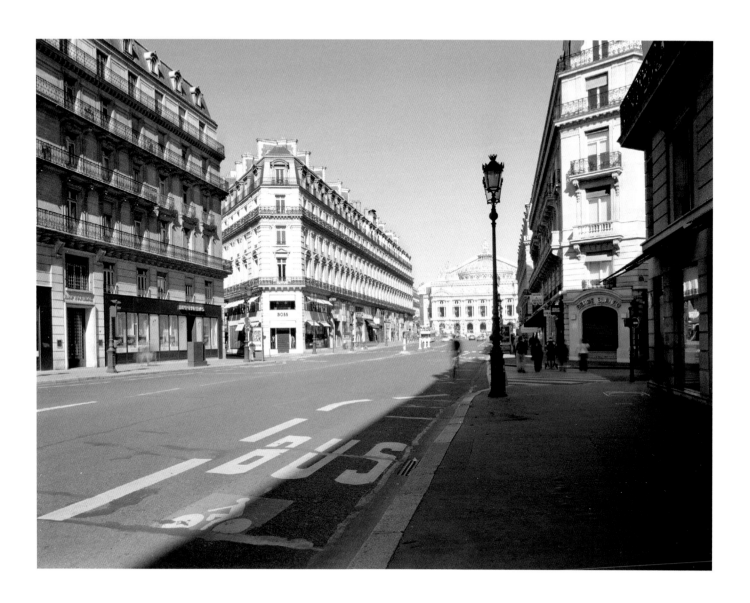

Avenue de l'Opéra (taken from Rue St-Augustin towards the Opera), Sramek, 19.09.2010.

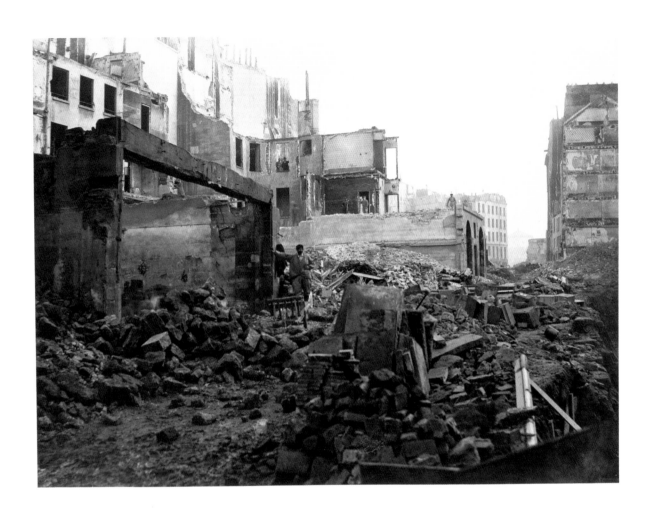

1.02. *Percement de l'avenue de l'Opéra: Butte des Moulins (de la rue Saint-Roch)*, Marville, c.1877 (CAR/RV).

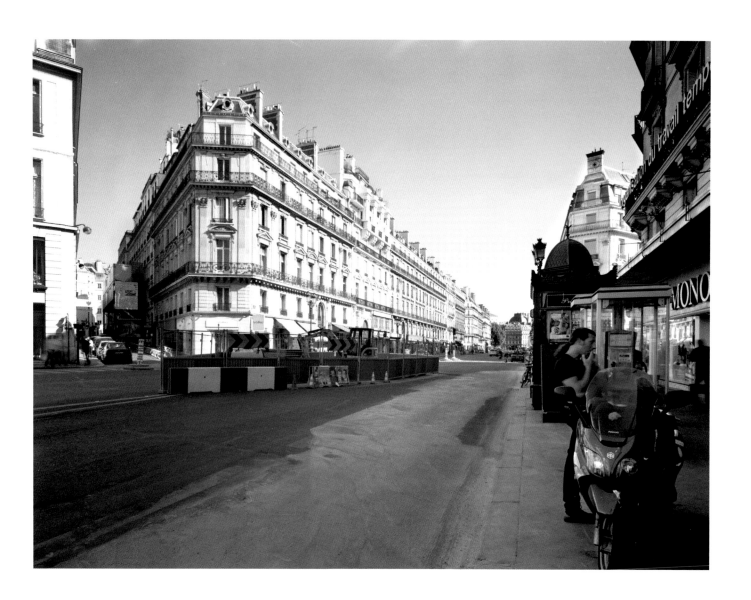

Avenue de l'Opéra (taken from Rue St-Roch towards the Comédie Française), Sramek, 19.09.2010.

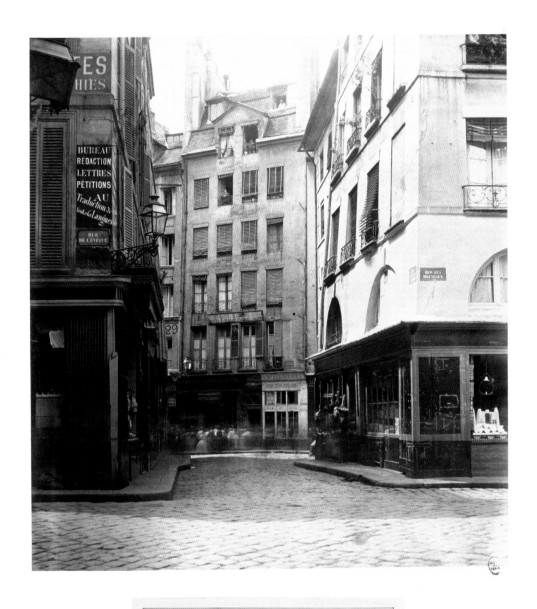

1.03. *Rue des Orties S^t Honoré (de la rue d'Argenteuil)* [ed. actually towards Rue d'Argenteuil], Marville, 1865-1868 (CAR/RV).

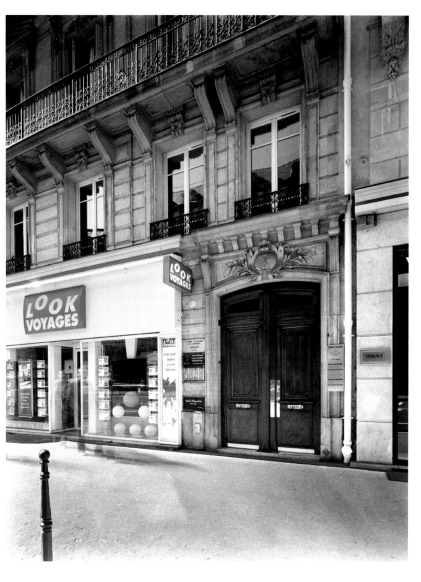

No.11 Avenue de l'Opéra, Sramek, 19.09.2010.

Fig. 17.
Petit Atlas Pittoresque (1834)
No. 24 Opéra, (detail).

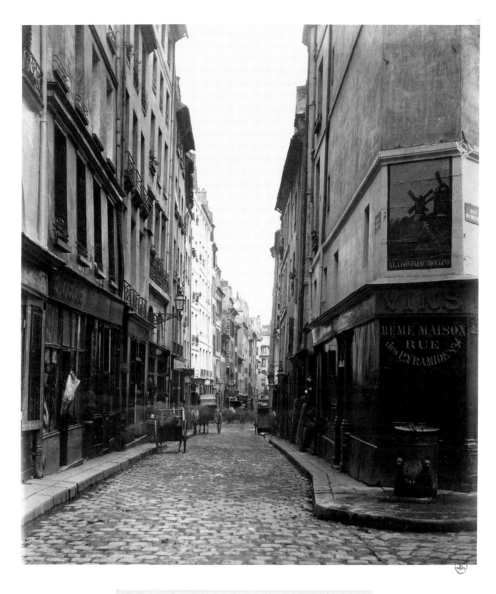

1.04. *Rue des Moineaux (de la rue des Orties)*, Marville, 1865-1868 (CAR/RV).

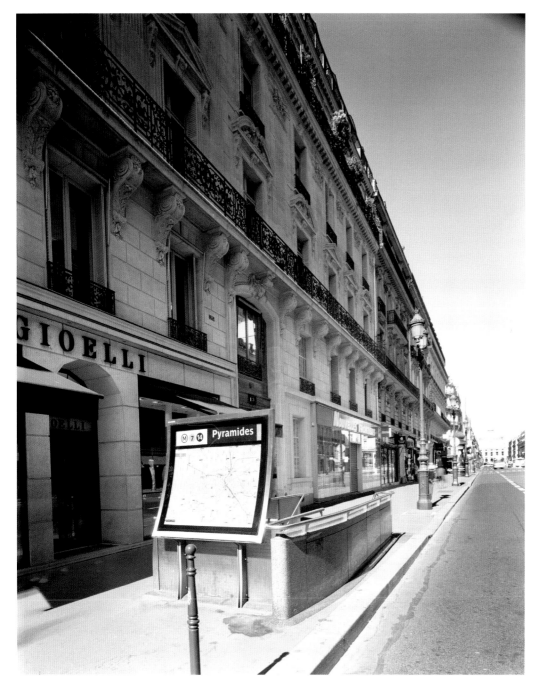

The entirety of *rue des Orties-Saint-Honoré* is gone, along with its intersection with *rue des Moineaux, rue des Moulins* and *rue de l'Evêque*. Here, standing at the top of the *butte des Moulins*, Marville photographed in 1865 the intersection where the five streets met, moving around the circle to capture each direction (see p. 39). The new avenue, not completed until 1877-78, required the removal of the hill and resulted in a single, wide roadway with far less character, but typical of Haussmann's new Paris. *Rue du Clos-Georgeau* (pl. 1.08) which ran off *rue Sainte-Anne* has also now disappeared, filled in with new construction

Today, working with historical maps made it possible to locate many of these sites. The atlas made under Haussmann and published in 1868 was a main reference for me (p. 32). Here, between the Opéra Garnier and the Comédie Française, it shows the streets which Marville photographed in 1865, many of which are now altered or completely gone. Of interest is the way in which this map combines elements both old and new, completed and still only planned. The light lines of the future path of the finished *avenue de l'Opéra* trace over the still-existing buildings. Even so, one must go back to earlier maps to see some of what Marville photographed, as the 1868 map already includes changes made between 1865 and 1868 such as the development of *rue de l'Echelle*. Leonard Pitt's books, *Walks through Lost Paris* (2006) and *Paris: Un voyage dans le temps* (2008) were also a great help in such locations with his well-researched maps, images and descriptions.

Avenue de l'Opéra (near No.11, looking northwest), Sramek, 19.09.2010.,

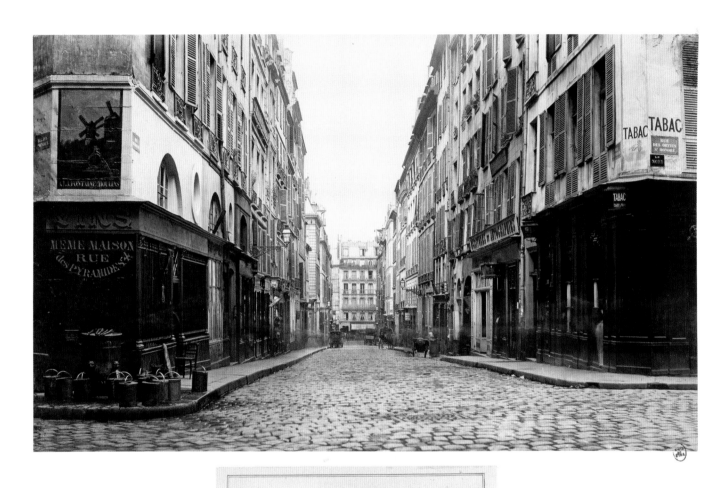

1.05. *Rue des Moulins (de la rue des Orties)*, Marville, 1865-1868 (CAR/RV).

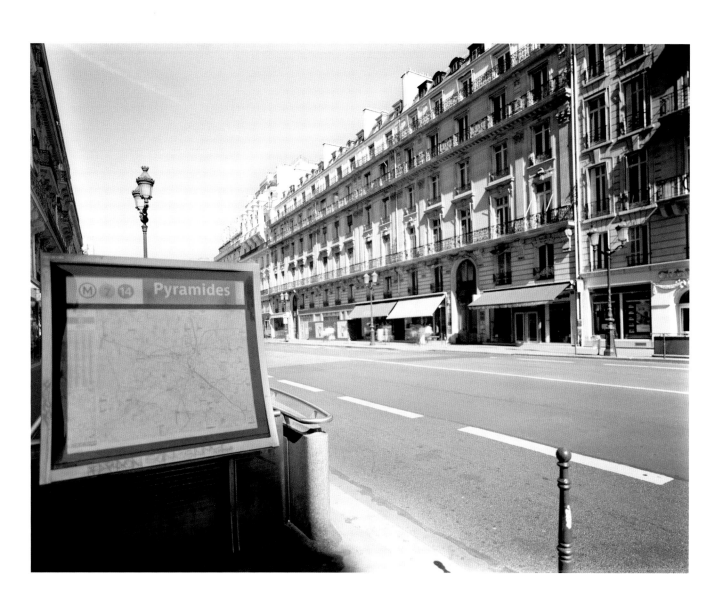

Avenue de l'Opéra (near No.11, looking north), Sramek, 19.09.2010.

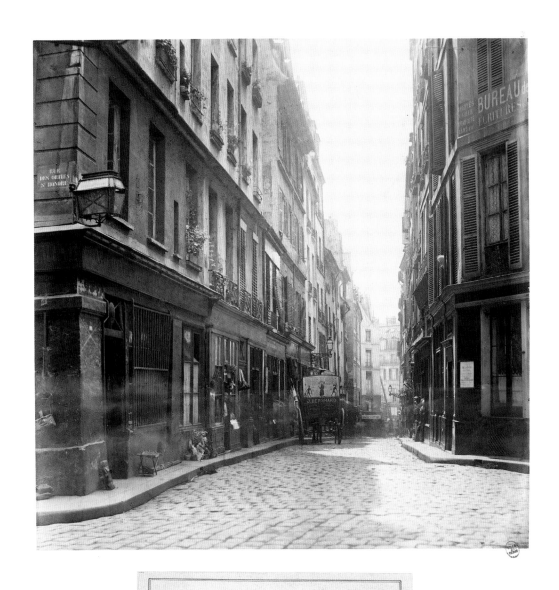

1.06. *Rue de l'Evêque (de la Butte des Moulins)*, Marville, 1865-1868 (CAR/RV).

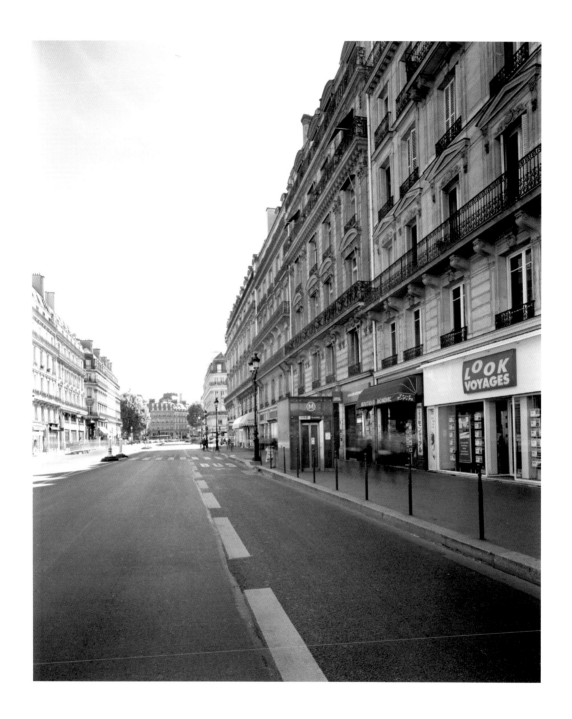

Avenue de l'Opéra (near No.11, towards the Comédie Française), Sramek, 19.09.2010.

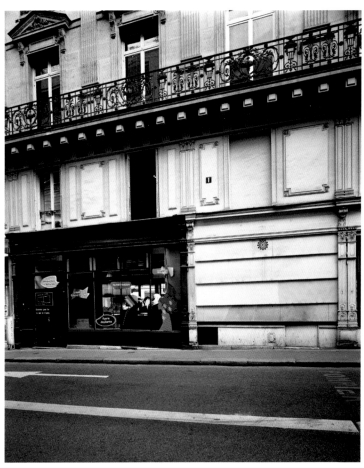

1.07. *Rue des Orties S^t Honoré (de la rue S^{te} Anne),* Marville, 1865-1868 (CAR/RV).

No.1 Rue Sainte-Anne, Sramek, 28.04.2010.

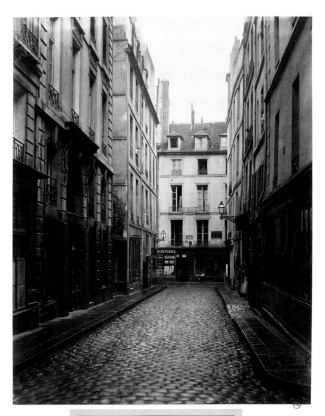

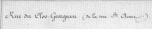

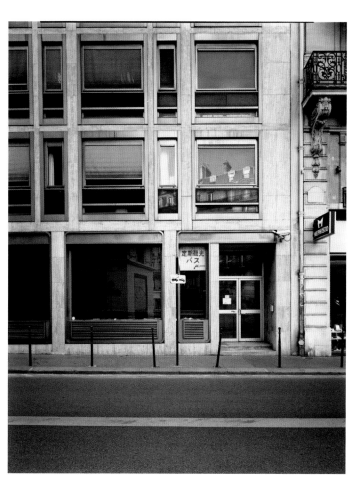

1.08. *Rue du Clos-Georgeau (de la rue S^{te} Anne),* Marville, 1865-1868 (CAR/RV).

No.2 Rue Sainte-Anne, Sramek, 28.04.2010.

1.09. *Percement de l'avenue de l'Opéra: Chantier de la Butte des Moulins du Passage Molière, Marville, c.1877 (CAR/RV).*

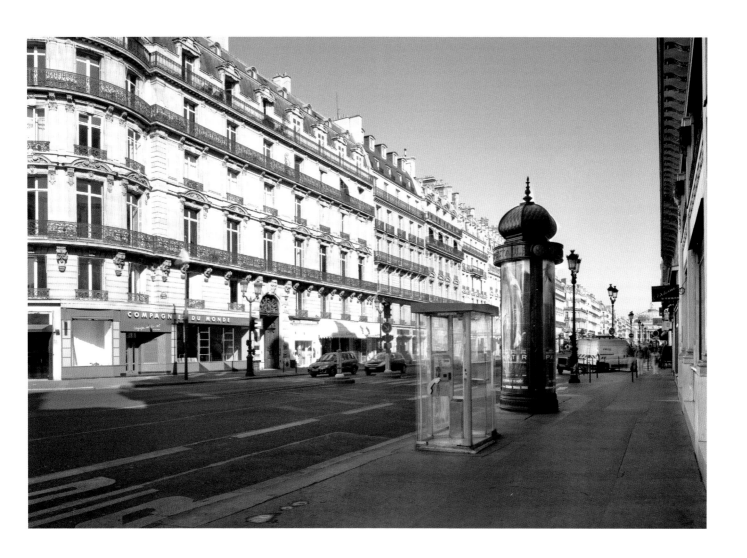

Avenue de l'Opéra (from Rue Ste-Anne), Sramek, 12.08.2009.

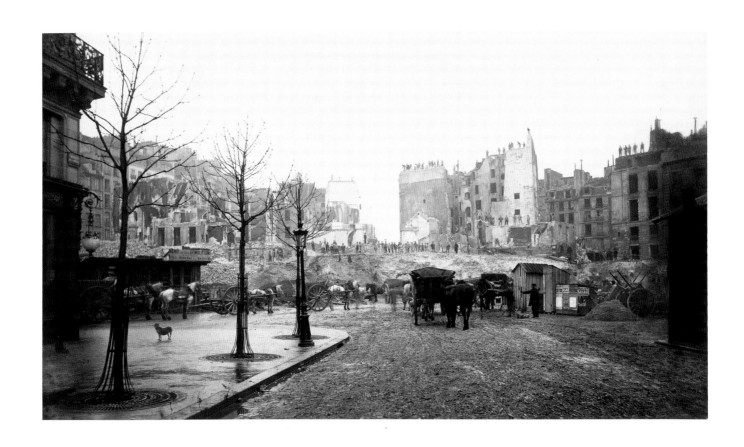

PERCEMENT DE l'AVENUE DE L'OPÉRA : BUTTE DES
MOULINS

(de la rue Saint-Honoré)

1.10. *Percement de l'avenue de l'Opéra: Butte des Moulins (de la rue Saint-Honoré)*, Marville, c.1877 (CAR/RV).

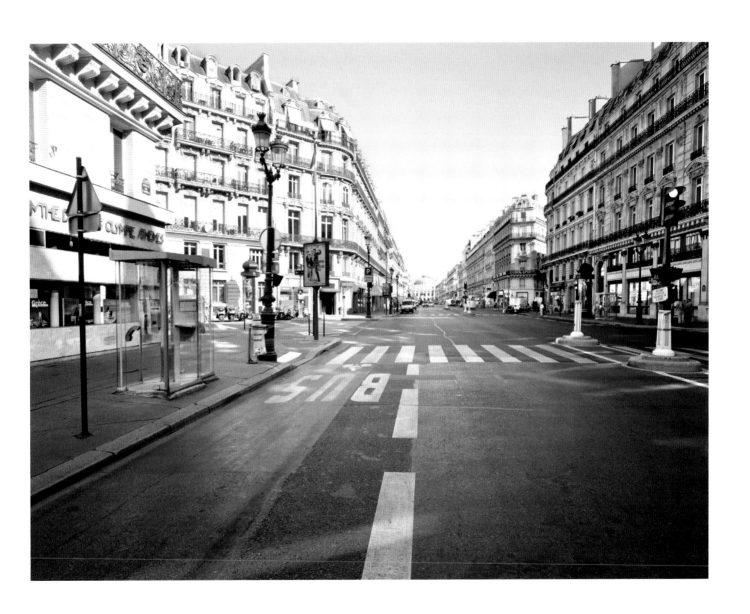

Avenue de l'Opéra (to the left, Rue de l'Echelle), Sramek, 12.08.2009.

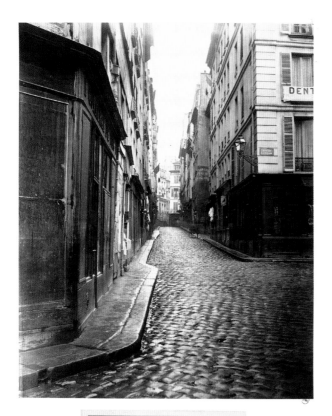

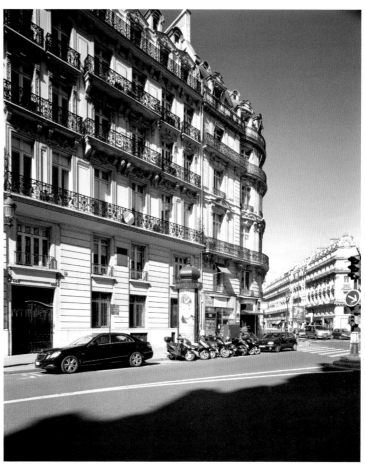

1.11. *Rue de l'Evêque (de la rue des Frondeurs),* Marville, 1865-1868 (CAR/RV).

Rue de l'Echelle (towards Avenue de l'Opéra), Sramek, 19.09.2010.

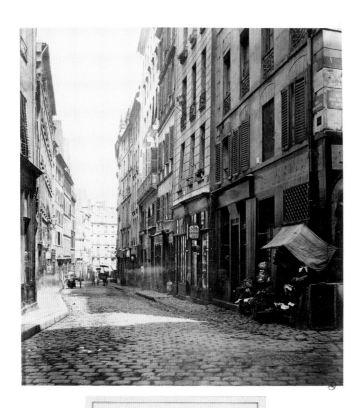

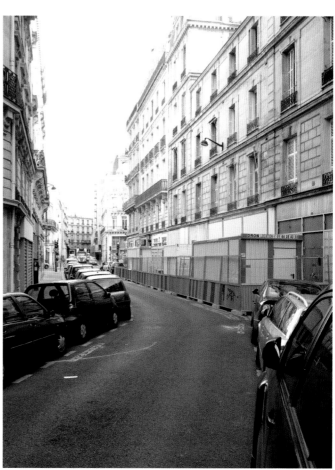

1.12. *Rue d'Argenteuil (de la rue des Orties)*, Marville, 1865-1868 (CAR/RV). Rue d'Argenteuil, Sramek, 12.08.2009.

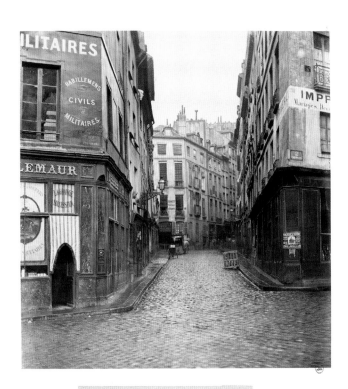

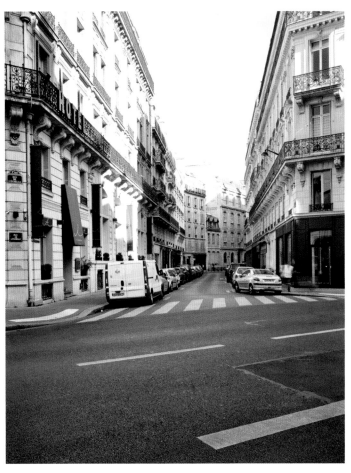

1.13. *Rue d'Argenteuil (de la rue des Frondeurs)*, Marville, 1865-1868 (CAR/RV). Rue d'Argenteuil (from Rue de l'Echelle), Sramek, 12.08.2009.

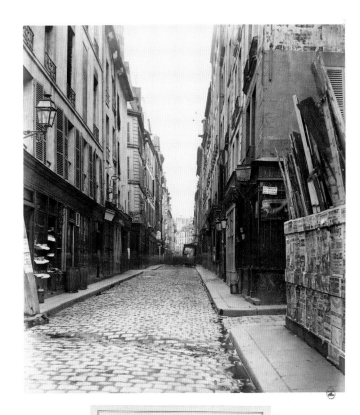

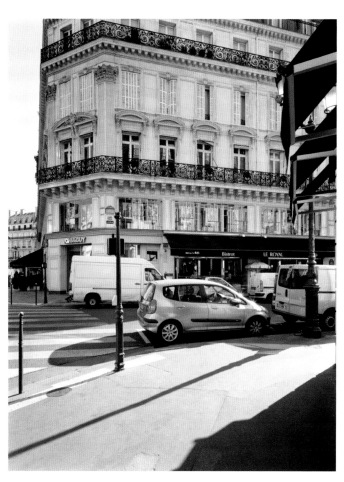

1.14. *Rue Fontaine Molière (de la rue des Frondeurs),* Marville, 1865-1868 (CAR/RV).

Rue Saint-Honoré (from Rue de l'Echelle), Sramek, 12.08.2009.

Le Percement de l'avenue de l'Opéra
Charles Marville and the Aesthetics of Ruins
Shalini Le Gall

Shalini Le Gall

Charles Marville's photographs of the demolitions for the *percement* of the *avenue de l'Opéra* are among the best-known images documenting the renovation of Paris under Baron Georges-Eugène Haussmann. Designed to provide clear sightlines of the Opera and to declare the power of Napoleon III's Second Empire (1852-1870), construction of the avenue necessitated the destruction of streets and buildings in its path. As an ensemble, this grouping of Marville's photographs, made circa 1877, documents the process of demolition and acts as visual evidence that underscores the significant physical consequences of the political decisions underlying both Haussmann's plan and its continuation during the Third Republic. Striking in their framing, balance, perspectival lines, posed figures, and sense of narrative, the photographs, with their stone rubble, hollow buildings, and cluttered streets, inspire reflection on the aesthetics of ruins, evoking a feeling of loss and nostalgia for the past, while at the same time embodying the progress and innovation of modern Paris.

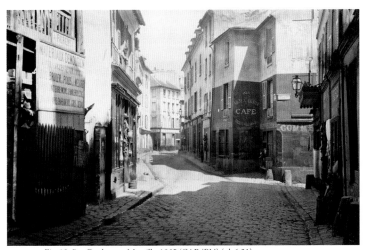

Fig. 18. *Rue Daubenton*, Marville, 1865 (CAR/RV) (pl. 6.21).

Although decided during Napoleon III's reign, the actual construction of the *avenue de l'Opéra* was not completed until after the fall of the Second Empire, marked by the outbreak of the Franco-Prussian War in 1870 and the Paris Commune in 1871. Originally named *l'avenue Napoléon*, a decree

in 1873 provided the new name *avenue de l'Opéra*, which has survived to this day (Pinon 2002: 150). Marville's photographs of the demolitions which prepared for the completion of the avenue were part of a second phase of his topographic documentation of Parisian streets.

Marville, advised by archivists working for the City Council Permanent Subcommittee on Historic Works, was appointed the *'photographe de la ville de Paris'* while employed by Baron Haussmann (Rice 1997: 85; Morris Hambourg and de Thézy 1981). As Prefect of the Seine and working under

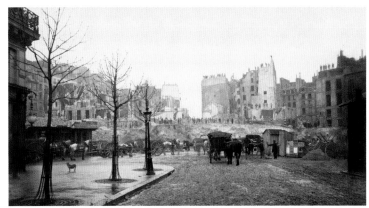

Fig. 19. *Percement de l'avenue de l'Opéra: Butte des Moulins, (de la rue Saint-Honoré)*, Marville, c. 1877, (CAR/RV) (pl. 1.10).

Emperor Napoleon III's direction, Haussmann was in the process of executing the large-scale renovations of Paris of the 1850s and 1860s, now referred to as 'Haussmannization.' These included new boulevards, public parks, sewers, and monuments. Although Marville's early photography was based more in pictorial aesthetic conventions, under Haussmann he was given the specific challenge of creating a 'scientific' document to record the old, thus emphasizing the benefits of Second Empire renovations. He had previously been commissioned to photograph the renovated Bois de Boulogne which was a task much closer to the landscape tradition he came from and, in this commission, he followed an approach which was both aesthetic and rational (Barberie 2007). Many of Marville's 'before' photographs display twisting, winding streets and crumbling decrepit buildings and, in deciding to work with long exposure times, which did not capture the bustling pedestrian traffic, he even further emphasized the historical character of the city (Rice 1997: 86). As Shelley Rice has described, Marville's presence on a particular street 'pointed the finger of death' (1997: 86). The moment of being photographed symbolically

condemned that very street to history, virtually guaranteeing its transformation, or even its destruction. Rice cites the example of Marville's photograph of 'Rue Daubenton' (fig. 18; pl. 6.21), taken from an intersection in the Fifth Arrondissement that would disappear around 1870 (1997: 86). Marville returned to the neighbourhood of *rue Monge* in 1877 and, with revisiting this site, his 'before' and 'after' photographs have come to represent the process of demolition and reconstruction.

This relationship of Marville's photographs to a process of change is particularly strong in his documentation of the *percement* of the *avenue de l'Opéra*. What is different about this set of photographs is the overwhelming presence of rubble, building fragments, and dust. Although some of the other images from the 1860s include vignettes of demolition, the *avenue de l'Opéra* photographs are overwhelmingly defined by views of the demolition in progress. These elements make real the destruction brought about by Haussmannian building projects but, as an artist, Marville also utilizes compositional elements that frame this destruction in an aesthetic manner.

Marie de Thézy describes the artistic quality of Marville's images, writing,

> *De nombreuses vues enfin présentent des chantiers: les plus frappantes sans doute montrent le percement de l'avenue de l'Opéra. Là encore, le talent de Marville sait jouer de la lumière pour accuser l'aspect chaotique du chantier, la lourde masse sombre des plans de murs éventrés, lourdes masses sombres, le caractère presque surréaliste des conduits de cheminée sur un mur mis à nu. Le regard est ici étonnamment moderne. Marville est un témoin, mais aussi un artiste.* (De Thézy 1994: 34)

A close look at several of the photographs verifies de Thézy's claim that Marville approached this series with a particularly modern artistic eye, attuned to the compositional principles frequently found in landscape painting. In the image 'Percement de l'avenue de l'Opéra: Butte des Moulins (de la rue Saint-Honoré)' (fig. 19; pl. 1.10), one observes three bare trees, echoing the destruction ahead, framing the street that provides the perspectival lines of this landscape. A demolition sign is prominently displayed and workers are perched perilously on the edges of buildings. Even the haunting shell of a circular staircase without a destination is visible in the photograph 'Percement de l'avenue de l'Opéra: Chantier de la rue d'Argenteuil, près de la rue du Faubourg Saint-Honoré' (fig. 20). The juxtaposition of old and new is apparent in the photograph 'Avenue de l'Opéra (Espace compris entre la rue Louis-le-Grand et la rue d'Antin, vers l'Opéra)' (fig. 21; pl. 1.01) with building shells in the foreground and Haussmannian buildings in the background, along with the newly constructed Opera.

A number of photographs including 'Percement de l'avenue de l'Opéra: Butte des Moulins (de la rue d'Argenteuil)' (fig. 22; pl. 1.09) contain scenes of workers standing on piles of rubble or wooden planks, displaying their dominance over this presumably chaotic scene. Although these scenes are clearly posed, they still provide much information on the attitudes of workers and passers-by amidst such disorienting demolition. In a particularly striking example of such spectatorship, upper-class figures with walking sticks and top hats peer over a precipice into a work zone 'Percement de l'avenue de l'Opéra: Chantier de la Butte des Moulins du passage Molière' (fig. 23). Such images serve as a reminder that Haussmannian projects dramatically affected the lives of Parisians and were therefore not without controversy (Fournier 2008: 22-3).

Examining the historical development of the *avenue de l'Opéra* project, Pierre Pinon (2002: 144, 149) has described how the initiative for the avenue began in 1853 and 1854, well before discussions finalized the construction

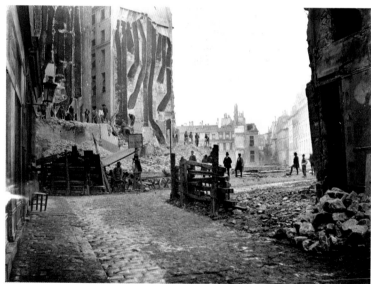

Fig. 20. [*Percement de l'avenue de l'Opéra: Chantier de la rue d'Argenteuil, près de la rue du Faubourg-Saint-Honoré*], c. 1877 (BHVP/RV).

of a new Opera in the early 1860s. Intended to open up the general area around the Louvre, the motivation for the project was twofold. City planners hoped that the avenue would improve the area around the *butte des Moulins*, and also ease access to the St. Lazare train station and the northern boulevards

(2002: 144). Following the purchase, and in many cases the demolition, of nearby properties, construction was finally announced by public decree in 1876, with the final set of buildings erected in 1879 (2002: 150). Financed by a loan, and then by the sale of purchased property, the total cost of the project came to 66 million francs (2002: 150). Decorative details, such as trees, were eventually ruled out to provide an unobstructed view of Garnier's Opera, and a declaration in 1873 made official the name change from the *avenue Napoleon* to the *avenue de l'Opéra*, marking the transition from Napoleon III's Second Empire to the Third Republic (2002: 150).

Across the twenty-year period of discussion surrounding the *avenue de l'Opéra*, one frequently finds references to the supposed public benefits of this type of project, claiming it would reflect the overall spirit of improvement and progress characteristic of Haussmannian renovation. In an article pub-

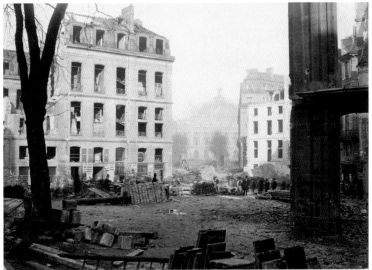

Fig. 21. *Percement de l'avenue de l'Opéra, entre la rue Louis-le-Grand et la rue d'Antin, vers l'Opéra*, Marville, 1876-77 (CAR/RV) (pl. 1.01).

lished in 1854, entitled '*La théorie de villes*', the architects Pierre Landry and Albert Lenoir described the importance of working for the public interest:

> *Centraliser des édifices publics, relier au centre, par une ou plusieurs artères, les constructions édifiées sur des rue isolées, éloigner du centre de la ville les établissements que leur incommodité, leur spécialité ou leur importance ne permettent pas de centraliser, tel est le caractère*

général de l'action communale due à l'intérêt public. (Cited in Pinon 2002: 178)

While there was little dispute that urban renovation should be executed with the public interest in mind, clearly the determination of what constituted '*l'intérêt public*' could be debated. In their description, Landry and Lenoir focus on the construction of '*artères*', designed to make the city easier to traverse, along with the more centralized organization of significant sites. Yet these '*artères*' were at the root of the controversy surrounding Haussmannian renovations because they necessitated the purchase and demolition of existing property. Haussmann himself used the term *percement* to describe the act of literally piercing through existing structures to improve the flow of traffic and pedestrians. As much as the Prefect of the Seine, his architects, and other collaborators defended such action in the name of public good, there were outspoken opponents to this practice as well.

One of the most vocal critics of Haussmannian renovation, Ferdinand de Lasteyrie seriously questioned the supposed public benefits of the *percements* in *Les Travaux de Paris* when he wrote,

> *Assurément il est fort utile d'ouvrir de larges voies à la circulation dans des quartiers populeux, dont les vieilles rues étroites et tortueuses ne répondent plus aux besoins de notre époque. … Mais d'un autre côté, avant d'entreprendre ces grands travaux destinés à changer au moins partiellement la face d'une ville, il faut bien se rendre compte des besoins réels de la population, de ses habitudes, étudier les moyen d'y satisfaire sans jeter une trop grande perturbation dans les intérêts préexistants, et faire en sorte de ne pas substituer des vices, des inconvénients nouveaux à ceux de l'ancien état de choses.* (de Lasteyrie 1861: 37-8)

For de Lasteyrie, the motivation for opening up wide avenues and boulevards was not always clear and he suggests that time was never taken to properly assess the 'public need'.

In his *Mémoires*, Haussmann mentions an additional, if perhaps unintentional, political consequence of the *percements*, one which is most often cited in commentaries on the creation of these new thoroughfares. Describing '*l'éventrement du Vieux Paris, du quartier des émeutes, des barricades, par une large voie centrale,*' (1893: 825), Haussmann identifies the benefits such construction would have on limiting the formation of the barricades, mobs, and riots, that had become characteristic of French uprisings since the revolution in 1789. Haussmann qualifies this political benefit by saying that Napoleon III did not actively search for an urban design that would limit

insurrections, but that this unintended consequence ultimately served the public good. He writes,

> on ne peut nier que ce fût la très heureuse conséquence de tous les grands percements conçus par Sa Majesté pour améliorer et pour assainir l'ancienne ville. Ce résultat servit, concurremment avec nombre d'autres bonnes raisons, à justifier, vis-à-vis de la France, que la tranquillité de Paris intéresse au premier chef, la participation de l'État dans les frais de ces onéreuses entreprises. (Haussmann 1893: 825)

If Haussmann was able to identify a beneficial side effect of the *percements*, he could do little to respond to the criticism that the renovations advanced too quickly, without preparatory research necessary to determine the actual needs and interests of a specific local population. Consequently, according to de Lasteyrie, these sparkling new stone facades excluded those with more modest incomes and simply masked a new host of urban challenges:

> Elles ne sont pas seulement chères, ces prétentieuses maisons … elles doivent être mauvaises. Non-seulement l'ouvrier n'y trouve plus un gîte à sa portée, mais le marchand, le rentier, qui s'y logent à grands frais, n'y trouvent qu'une habitation incommode et parfois même insalubre. (de Lasteyrie 1861: 41)

Here, de Lasteyrie calls attention to the social transformations brought about by these new constructions, with people of more modest income finding themselves displaced and confined to the outer limits of the city, and more affluent citizens faced with poorly-conceived and constructed dwellings.

Incensed as a citizen and taxpayer in the city of Paris, de Lasteyrie reserves his greatest criticism for the construction of the *avenue de l'Opéra* and the surrounding streets. He begins by viciously mocking the avenue that will ultimately connect the Théâtre-Français to the Académie Impériale de Musique, two venues open at different times of day (the one during the day and the other at night), and thus rarely requiring speedy transport from one to the other (de Lasteyrie 1861: 105). To the complaint that the Opera would not have been sufficiently isolated without a new building, de Lasteyrie responds that the old Opera was already protected on three sides, and could have been further enclosed with little construction on the remaining fourth side (1861: 119). Clearly unconvinced by arguments about the public value of the *percements* and the necessity of improving circulation within the city, de Lasteyrie concludes that this project is ultimately motivated by speculation and financial dealings (1861: 119-20). In his opinion, only such financial

motivations could explain the degree of state interest and investment in enriching what was already a fairly wealthy Parisian neighbourhood.

In addition to opponents decrying the financial motives of an authoritarian regime, literary voices rose up against the demolition workers. So clearly present in Marville's photographs of the *avenue de l'Opéra*, these workers attracted the ire of artists, writers, and intellectuals clinging to the nostalgia of the historical city of Paris. Drawing on the historical precedent of Victor Hugo's *Guerre aux démolisseurs* (1832), critics of Haussmannian renovations emphasized the uncivilized, barbaric, and even demonic aspects of the *'démolisseurs.'* Eric Fournier (2008) has discussed how nineteenth-century writers discursively constructed such a nefarious image of a *démolisseur* by looking at texts such as *Les Démolitions de Paris* (1869), in which author Ponson du Terrail describes the boss of a construction project as *'un gros homme qui ne sait ni lire ni écrire, qui a des bagues plein les doigts et des diamants à la chameise [sic]. Il a une veste bleue et un chapeau de paille'* (Fournier 2008: 17). The scorn for these figures carries traces of intellectual snobbery, but also mocks the upper-class aspirations of demolition supervisors in a position to profit financially from the renovations. Like de Lasteyrie, Ponson du Terrail is dubious about the motivations of these construction works. Such criticism

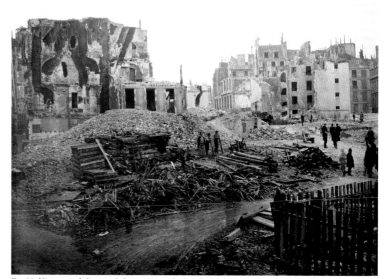

Fig. 22. [*Percement de l'avenue de l'Opéra: Butte des Moulins (de la rue d'Argenteuil)*], Marville, c. 1877 (BHVP/RV).

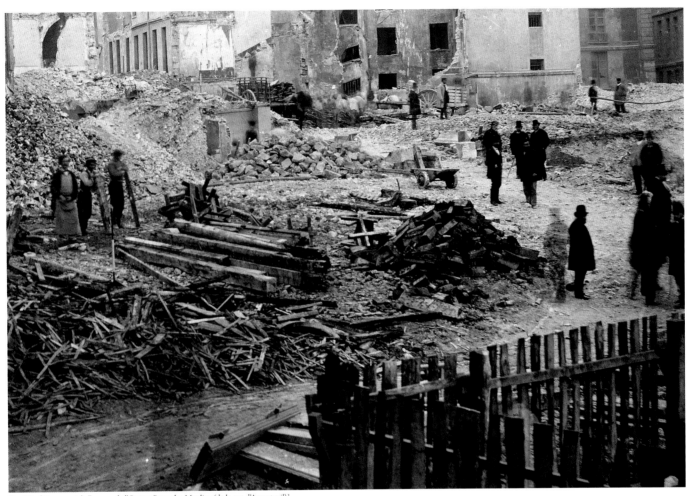

Fig. 22a. [*Percement de l'avenue de l'Opéra: Butte des Moulins (de la rue d'Argenteuil)*],
Marville, c. 1877 (BHVP/RV) (detail).

only grew as the widespread scale of Haussmannian renovations became clear to the Parisian public, with auditory and visual violence invading their daily lives. Fournier astutely studies the political character of these demolitions by examining how the violence carried out on the city became a defining character of the Second Empire, stating,

> *En effet, c'est l'Empire, avant la Commune, qui crée explicitement un lien entre l'appropriation de l'espace parisien et la destruction massive de ce même espace. L'empereur inaugure effectivement, non les boulevards reconstruits, mais les percées, les trouées, les éventrements; un espace où subsistent seulement quelques débris, une ligne droite dont la vacuité même impose l'ordre impérial dans toute son ampleur aux Parisiens.*
> (Fournier 2008: 31)

The popular imperial ceremonies organized around such scenes of debris simultaneously emphasized the power of the Empire in bringing the city to rubble, and the guidance it would assuredly provide in leading Parisians out of such a state of disaster. With such actions, the modernity and progress characterized by Napoleon III's regime appeared incontestable.

Baron Haussmann appropriated to himself the grandeur of the large-scale demolitions in the city by referring to himself as an *'artiste-démolisseur'* (Fournier 2008: 22). For Haussmann, the demolitions that so many Parisians came to critique were simply the first step in a process of creation. Although chiefly motivated by logistical considerations, such as traffic circulation and water supply, Haussmann also publicly insisted that his project preserved objects of artistic significance in the city. Responding to critics in his *Mémoires* Haussmann counters with,

> *Mais, bonnes gens, qui, du fond de vos bibliothèques, semblez n'avoir rien vu, citez, du moins, un ancien monument, digne d'intérêt, un édifice précieux pour l'art, curieux par ses souvenirs, que mon administration ait détruit, ou dont elle se soit occupée, sinon pour le dégager et le mettre en aussi grande valeur, en aussi belle perspective que possible!*
> (Haussmann 1893: 810)

Haussmann's defence here is directly addressed to intellectuals and other individuals that he believed had a tendency to romanticize life in old Paris from their safe comfortable positions, without having had to suffer the difficulties of narrow streets and unreliable water supply. He tries to argue that his

renovations in fact improved visual access to the city's artistic monuments, yet he must have been aware of the controversy that his work would arouse before even beginning the project. In light of these political considerations, Marville's photographs acted as documentary evidence tracing the impact of demolition and reconstruction. By choosing a photographer to carry out their mission of documentation, Haussmann and his staff affirmed nineteenth-century attitudes about photography's ability to faithfully record subjects.

In his well-known diatribe against the artistic value of photography detailed in a review of the Salon of 1859, Baudelaire clearly located the value of photography in its ability to document history.

> Let photography quickly enrich the traveler's album, and restore to his eyes the precision his memory may lack… Let it save crumbling ruins from oblivion, books, engravings, and manuscripts… in all these things, photography will deserve our thanks and applause. But if once it be allowed to impinge on the sphere of the intangible and the imaginary, on anything that has value solely because man adds something to it from his soul, then woe betide us! (Baudelaire 1980: 88)

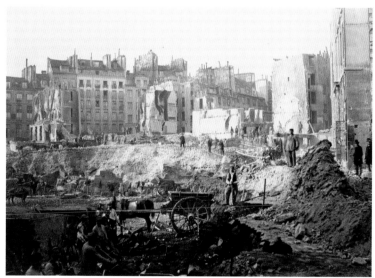

Fig. 23. *Percement de l'avenue de l'Opéra: chantier de la Butte des Moulins du passage Molière,* Marville, c. 1877, (CAR/RV) (pl. 1.09).

Baudelaire's analysis clearly sought to limit the intellectual and personal value of art to the domain of painting, but his description also served to confirm the documentary value of photography. In fact, it was photography's presumed objectivity in representing, imprinting, and recording the existing world that led to Marville's commission to photograph the streets of Paris and enabled him to undertake this vast project of urban representation.

Nevertheless, as described above, the artistic aspects of Marville's photographs are undeniable. Twentieth-century historians of photography have certainly examined the unstable nature of documentary photography, and the influence of artistic concepts on even the most scientifically motivated images, but already in the nineteenth century writers had begun to recognize the overlap between art and photography (see Snyder and Munson 1976. Writing in the late nineteenth century, Peter Henry Emerson, an outspoken defender of the artistic merit of photography, asserts,

> Photographic pictures may have one merit which no other pictures can ever have, they can be relied upon as historical records. … Science destroys or builds up, and seeks only for bald truth. Art seeks to give a truthful impression of some beautiful phenomenon or poetic fact. (Emerson in Trachtenberg 1980: 103)

While reinforcing the unique aspects of the medium, Emerson also encourages photographers to infuse their works with artistic qualities, drawing from the

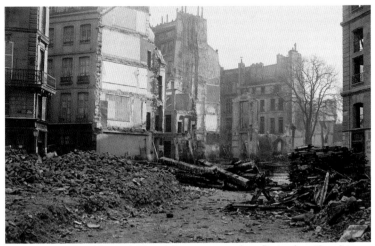

Fig. 24. *Tracé de l'avenue de l'Opéra de l'avenue même, entre la rue d'Antin et la rue Neuve-Saint-Augustin*, Marville, c. 1877 (CAR/RV).

spontaneity and naturalism popular in Impressionist painting of the 1880s. Marville himself, with his background as an artist, brought his understanding of artistic conventions to the task of photographic documentation. In addition, the appearance of 'ruins' specific to the *avenue de l'Opéra* series has artistic precedents. Some eighteenth-century artists, including Hubert Robert (1733-1808) built their careers on painting ruins, which allowed Parisians to contemplate the rise and fall of Rome and other empires, while speculating on their own future (see Dubin 2010).

The eighteenth-century critic Diderot remarked on the superfluity and significance of ruins as a subject in his remarks discussing the Salon of 1767. He wrote,

> *L'effet de ces compositions, bonnes ou mauvaises, c'est de vous laisser dans une douce mélancolie. Nous attachons nos regards sur les débris d'un arc de triomphe, d'un portique, d'une pyramide, d'un temple, d'un palais; et nous revenons sur nous-mêmes; nous anticipons sur les ravages du temps; et notre imagination disperse sur la terre les édifices mêmes que nous habitons. A l'instant la solitude et le silence règnent autour de nous. Nous restons seuls de toute une nation qui n'est plus. Et voilà la première ligne de la poétique des ruines.* (Diderot 1995: 335)

Diderot's remarks highlight the manner in which the imagery of ruins simultaneously sparks a distant historical reflection and a modern self-reflection on the part of the viewer. Applied to Marville's photographs, we can understand why these images still strike the contemporary viewer.

In examining the *avenue de l'Opéra* photographs, one observes elements that seem to rise from the debris and strike the viewer with the power of Roland Barthes' concept of the *punctum* (Barthes 1984: 26): the sign marked 'Bureau de Demolition' or the shell of the circular staircase in 'Percement de l'avenue de l'Opéra: Chantier de la rue d'Argenteuil, près de la rue du Faubourg Saint-Honoré' (fig. 20); the sparkling façade of Garnier's Opera amidst the ruins in the foreground of 'Percement de l'avenue de l'Opéra, entre la rue Louis-le-Grand et la rue d'Antin, vers l'Opéra' (fig. 21; pl. 1.01); or the seemingly insatiable curiosity of a man on top of a ladder peering over the shell of a building in 'Tracé de l'avenue de l'Opéra ... entre la rue d'Antin et la rue Neuve-Saint-Augustin' (fig. 24). As an ensemble, these elements simultaneously echo the shock, curiosity, outrage, banality, and humour of such demolition sites, forcing the viewer to contend with the absence, presence, nostalgia, and hope implied. Perhaps, as Diderot wrote, the ultimate effect is one of a 'douce mélancolie', the result of overwhelming and conflicting emotional responses to such images of destruction.

In the context of demolitions and construction, the concept of melancholy arises easily, while the essential process of producing photographic records also readily evokes such emotions. One finds that in psychoanalysis the clinical state of melancholy is brought about by a subject's inability to properly mourn (Freud 1917) and some aspect of Freud's theory is certainly relevant to the Haussmannian renovations. Baudelaire and others describe an inability to accept, or mourn, the passing of old Paris. And without such resignation, Haussmann could never have hoped that his new Paris would be accepted by those intellectuals nostalgic for the past. The evidence provided by photography adds an additional layer to this clinical notion of melancholy. As Barthes, Susan Sontag, and others have written, photography's ability to capture the 'having been there' aspect of a subject acts as a testimonial, but also implies a type of death (Barthes 1981: 15; Sontag 1973: 5, 11). By photographing, one is freezing, capturing, trapping, embalming. Marville's images, particularly those representing pre-Haussmannized Paris, certainly function in this manner, but so do the works of other urban Parisian photographers, including Eugène Atget. Atget, in photographing 'vieux Paris' (Le Gall 2007) also made images that evoke melancholy and betray an inability to come to terms with the past (Buisine 1994: 178).

The 'finger of death' pointed by Marville's camera was thus both literally part of the process of urban renewal and metaphorical in representing a moment of disjuncture with the past. Today, we are reminded of the distance between our present condition and the history exemplified by the monuments, façades, and boulevards of the city and this distance stirs a type of melancholy that art historian Michael Ann Holly has described as a 'wound' of historical distance (Holly 2002: 668). The undeniable 'factness' of photography forces us, as viewers, to accept the photograph as a unique object, acting as evidence, providing us with a witness, an object which leaves its historical trace. The images of demolition, in particular, make palpable the destruction that characterizes 'vieux Paris' and Haussmann's modern city, framing for us the continuing tension between our attachment to the past and the inevitable movement into the new. They inspire reflection on the connection of human creation with the experience of nostalgia and loss. In describing the transformation of Paris in *Les Tableaux parisiens* (1861), Baudelaire (Meyron and Baudelaire 2001: 48, 51) evoked this feeling of loss by writing, '*Le vieux Paris n'est plus… Paris change! mais rien dans ma mélancolie n'a bougé!*'

References

Barberie, Peter (2007), 'Conventional Pictures: Marville in the Bois de Boulogne', Ph.D. thesis, Princeton, NJ: Princeton University.

Barthes, Roland (1984), *Camera Lucida: Reflections on Photography*, trans. Richard Howard, London: Fontana.

Baudelaire, Charles (1980), 'The Modern Public and Photography,' in Alan Trachtenberg (ed.) *Classic Essays on Photography*, New Haven: Leete's Island Books.

Buisine, Alain (1994), *Eugène Atget ou la mélancolie en photographie*, Nîmes: Éditions Jacqueline Chambon.

Diderot, Denis et al (1995), *Salons III, Ruines et paysages, Salons de 1767*, Paris: Hermann.

De Lasteyrie, Ferdinand (1861), *Les Travaux de Paris, examen critique*, Paris: Michel Lévy Frères.

De Thézy, Marie (1994), *Marville Paris*, Paris: Hazan.

Dubin, Nina L. (2010), *Futures and Ruins: Eighteenth-Century Paris and the Art of Hubert Robert*, Los Angeles: Getty Research Institute.

Emerson, Peter Henry (1980), 'Hints on Art', in Alan Trachtenberg (ed.) *Classic Essays on Photography*, New Haven: Leete's Island Books.

Freud, Sigmund (1917), 'Mourning and Melancholia', SE Vol. 14.

Fournier, Eric (2008), *Paris en ruines: du Paris haussmannien au Paris communard*, Paris: Éditions Imago.

Haussmann, Georges-Eugène (1893), *Mémoires, Tôme III*. in Françoise Choay, ed. (2000) *Haussmann Mémoires: l'édition integrale*. Paris: Editions du Seuil.

Hambourg, Maria Morris and De Thézy, Marie (1981), *Charles Marville*, New York: Alliance Française.

Holly, Michael Ann (2002), 'Mourning and Method', *The Art Bulletin*, 84.

Hugo, Victor (1832), *Guerre aux Démolisseurs*.

Le Gall, Guillaume (2007), 'Apparition du vieux Paris,' in *Atget: une retrospective*, Bibliothèque nationale de France, Paris: Hazan.

Meyron, Charles and Baudelaire, Charles (2001), *Paris 1860, Eaux-fortes sur paris & 'Les Tableaux parisiens'*, Paris: Éditions La Bibliothèque.

Pinon, Pierre (2002), *Atlas du Paris Haussmannien : la ville en héritage du Second Empire a nos jours*, Paris: Parigramme, Le Grand Livre du Mois.

Rice, Shelley (1997), *Parisian Views*, Cambridge, MA: The MIT Press.

Snyder, Joel and Munson, Doug (1976), *The Documentary Photograph as a Work of Art: American Photographs, 1860-1876*, Chicago: David and Alfred Smart Gallery, University of Chicago.

Sontag, Susan (1973), *On Photography*, New York: Farrar, Straus and Giroux.

Halles - Auxerre

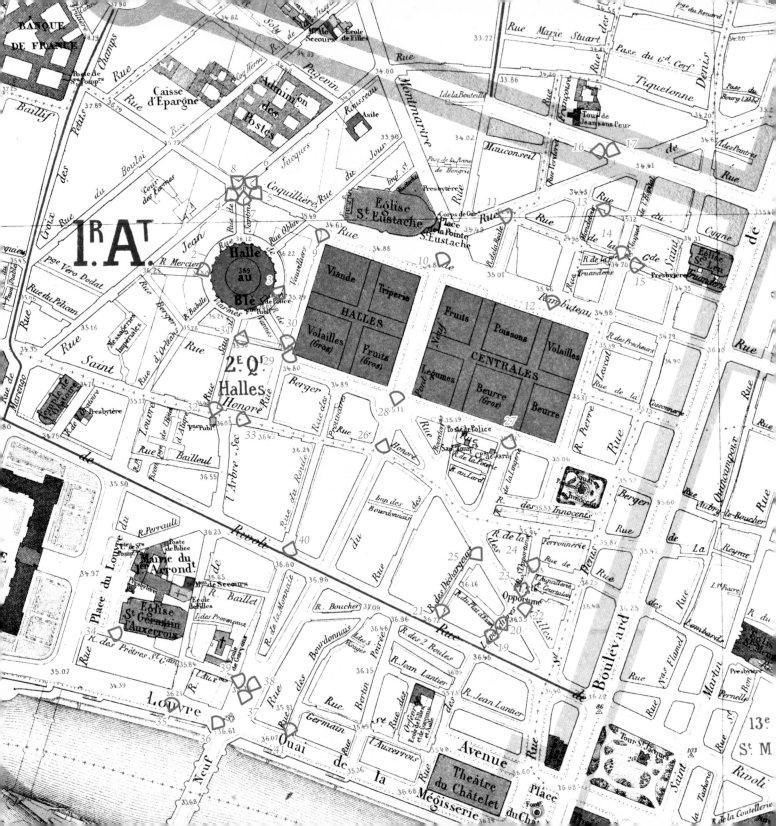

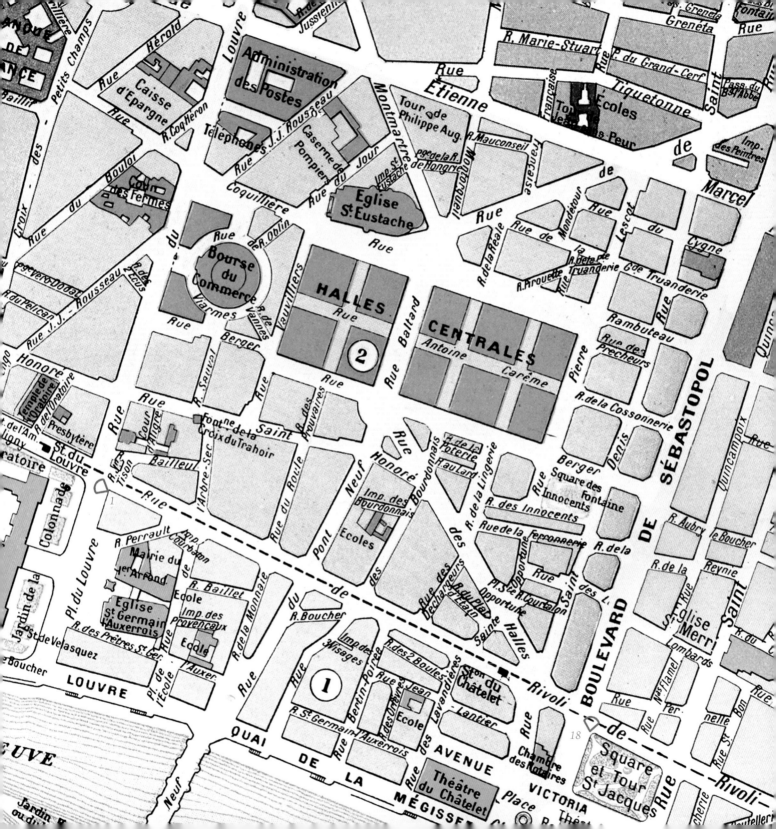

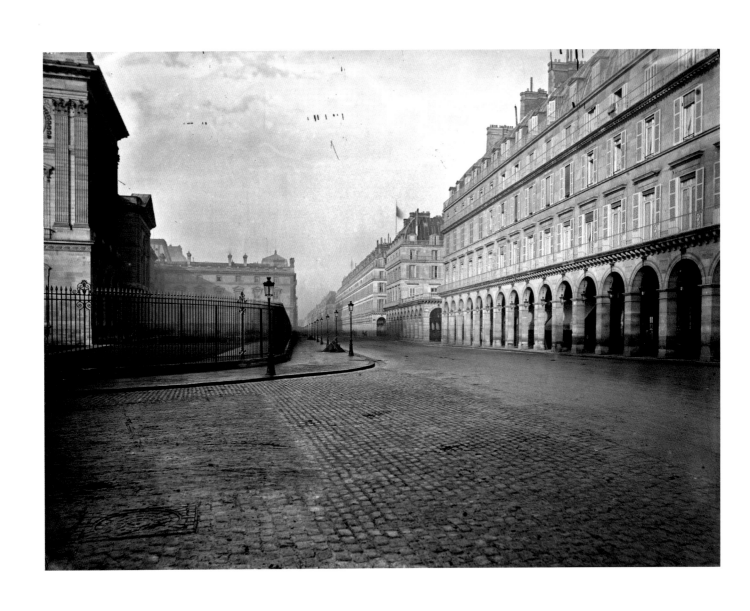

2.01. [*Rue de Rivoli*], Marville, c.1877 (BHVP/RV).

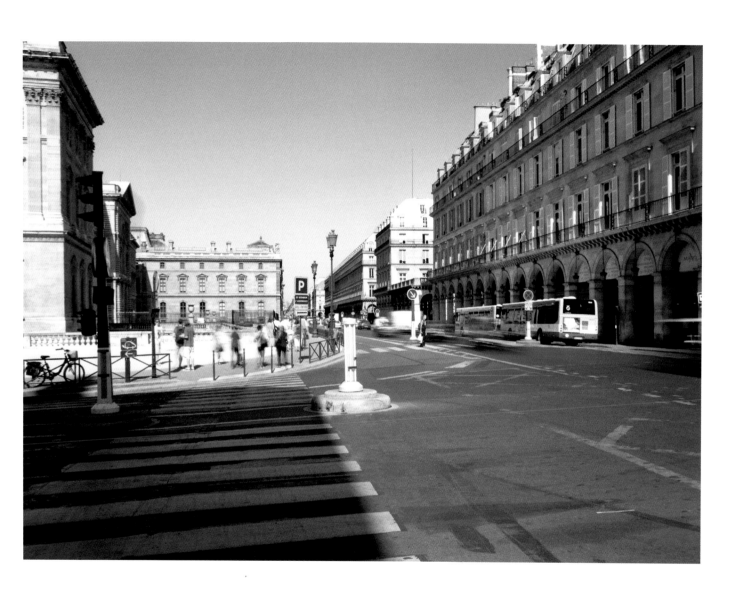

Rue de Rivoli (towards the Louvre), Sramek, 12.08.2009.

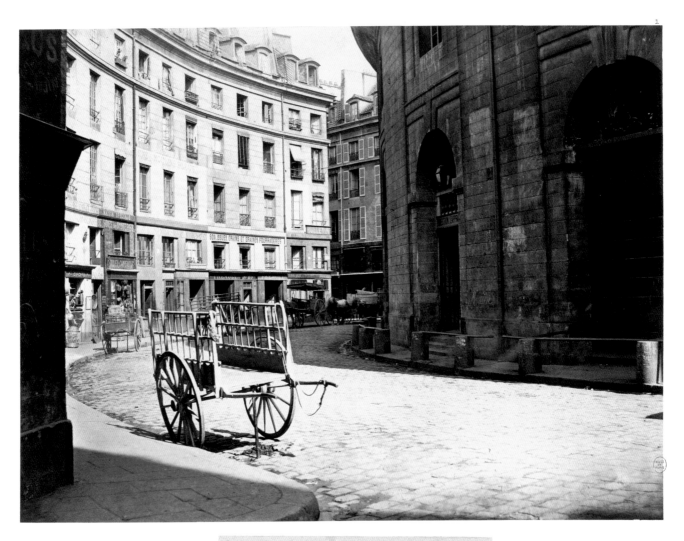

2.02. *Rue de Viarmes (de la rue Mercier)*, Marville, 1865-1868 (CAR/RV).

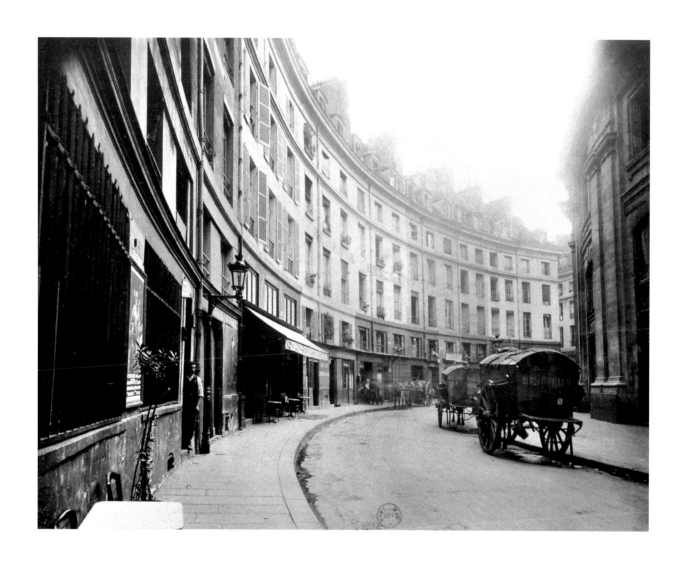

Atget, 1907 (BnF).

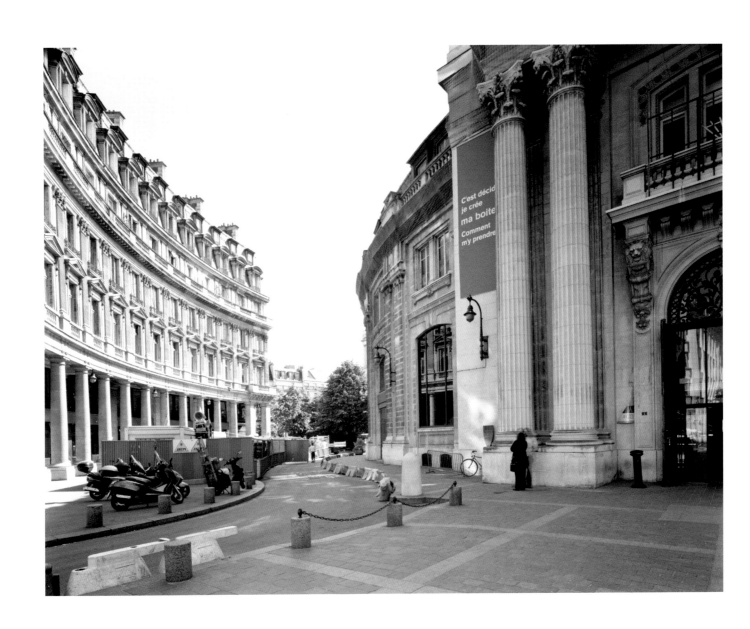

Rue de Viarmes and the Bourse de Commerce, Sramek, 18.05.2011.

The area of the Central Markets exemplifies progressive changes to the urban configuration. The small radiating streets, seen in the atlas of 1835 and documented by Marville, have been overlaid with longer and wider roads, often disappearing in the process. The demolition and reconstruction of one side of a street was also frequently used to widen the otherwise very narrow passageways. The views in *rue de Viarmes* (pls. 2.02-2.03) provide a lesson in observation. Athough the circular street surrounding the Bourse de Commerce (once the Halle au Blé), appears similar, much has now been rebuilt. The façade is actually different from what it was in 1865 and the outer buildings which make the ring are new.

The opening up of space which was created by the plans for urban renewal is apparent in the series of photographs of the intersection of *rue Jean-Jacques Rousseau* and *rue de la Coquillière*. Some streets have been eliminated, others widened, and the broader roadways facilitate the movement of vehicles. Where once the narrow *rue de Grenelle Saint Honoré* and *rue Jean-Jacques-Rousseau* provided for north-south movement, the much larger *rue du Louvre* now carries the main traffic.

It was here that a young man, sleeping in a tent and travelling by bicycle, offered me a bottle of chocolate milk and wondered why I would bother to make photographs of such innocuous views. An older local resident spoke cheerfully about how the colourful street names, such as *rue du Poil-au-con* (now *rue du Pelican*), had been cleaned up to make the city more respectable and how the many brothels had disappeared. *Rue Jean-Jacques-Rousseau* was once *rue Platière*, reflecting the common practice of renaming streets over the years for significant personages.

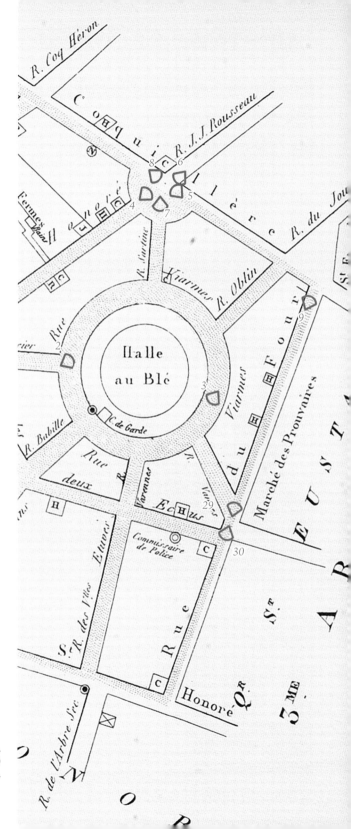

Fig. 26.
Petit Atlas Pittoresque (1834)
No. 34 Banque (detail).

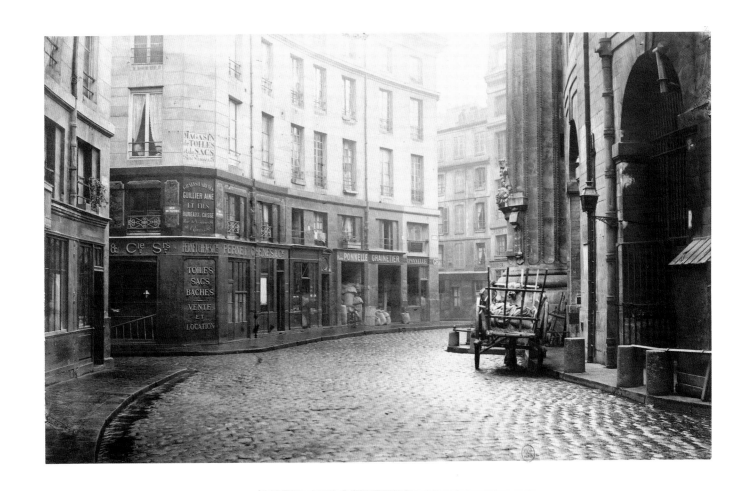

2.03. *Rue de Viarmes et Observatoire de Catherine de Médicis*, Marville, 1865-1868 (CAR/RV).

Allée Louis Aragon, Sramek, 18.05.2011.

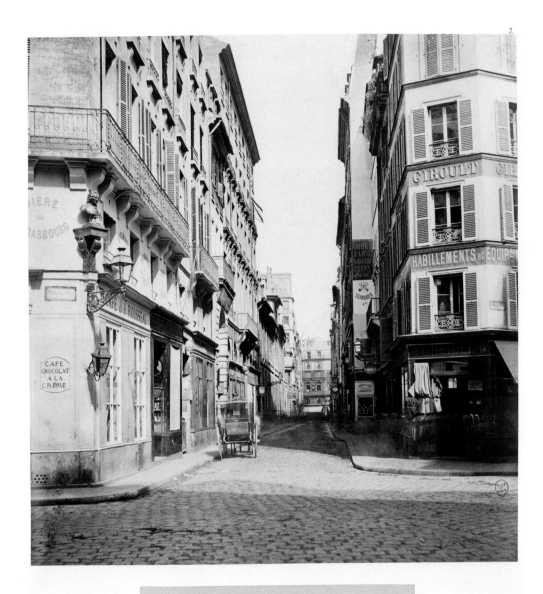

2.04. *Rue J.J. Rousseau (de la rue de Grenelle)* [changed in pencil to: ~~de Grenelle~~ Coquillière], Marville, 1865-1868 (CAR/RV).

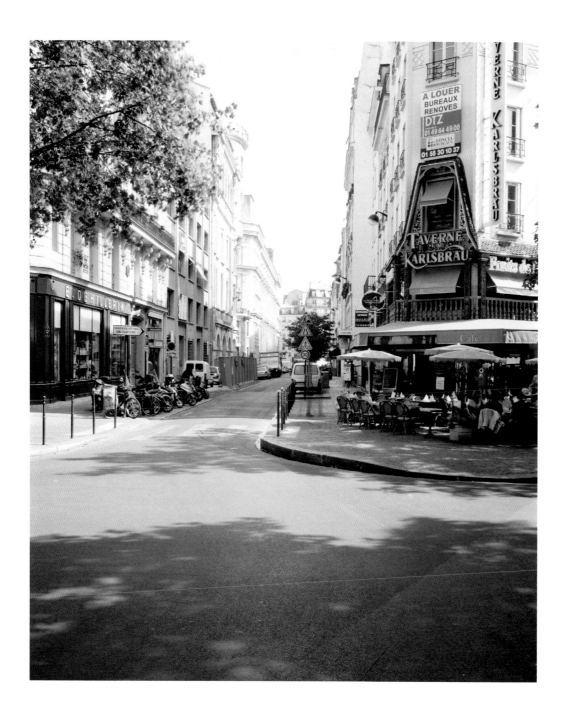

Rue Jean-Jacques-Rousseau, Sramek, 14.08.2009.

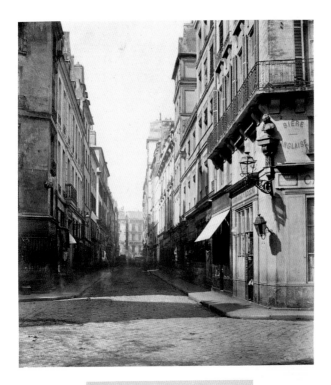

2.05. *Rue Coquillière (de la Banque)* [changed in pencil to: ~~de~~ *vers la Banque de la rue J.J. Rousseau*], Marville, 1865-1868 (CAR/RV).

Rue Coquillière, (from Rue J.J. Rousseau towards La Banque), Sramek, 14-08-2009.

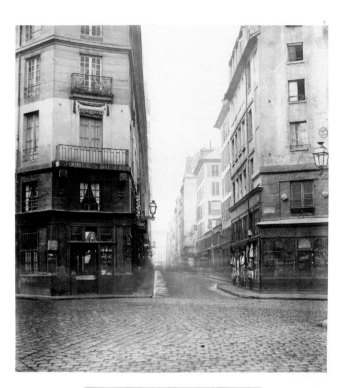

2.06. *Rue de Grenelle S* Honoré *(de la rue J.J. Rousseau)* [changed in pencil to: *ancienne Rue de Grenelle S* Honoré (~~de la~~ actuelle rue J.J. Rousseau) de la rue Coquillière (vers le Louvre)*], Marville, 1865-1868 (CAR/RV).

Towards Rue du Louvre (from Rue J.J. Rousseau), Sramek, 14.08.2009.

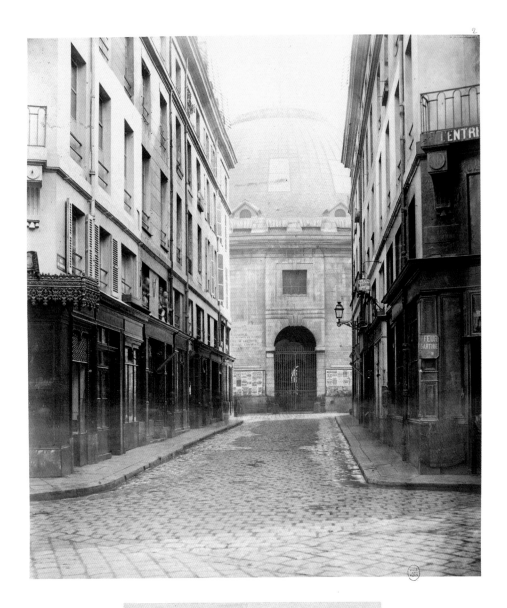

Rue de Sartine (de la rue Coquillière)

2.07. *Rue de Sartine (de la rue Coquillière)*, Marville, 1865-1868 (CAR/RV).

Across Rue Coquillière (towards the Bourse de Commerce), Sramek, 04.02.2012.

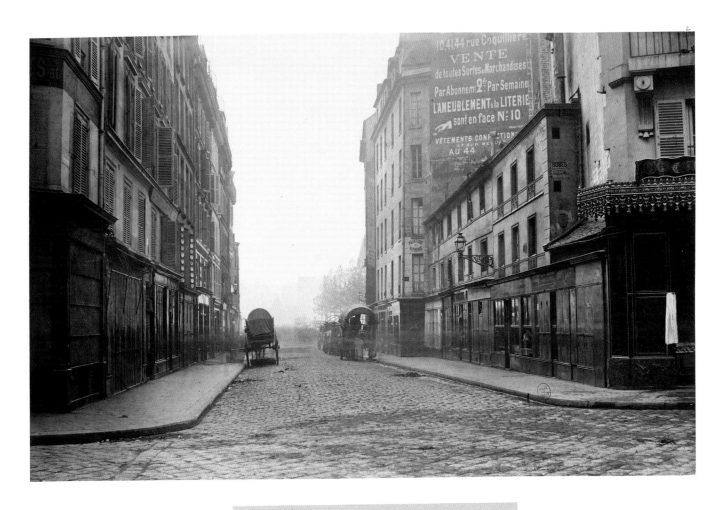

Rue Coquillière (de la rue Jean Jacques Rousseau)

vers les Halles

156

2.08. *Rue Coquillière (de la rue Jean Jacques Rousseau)* [added in pencil: *vers les Halles*], Marville, 1865-1868 (CAR/RV).

Rue Coquillière, (taken from Rue J.J. Rousseau), Sramek, 01.07.2010.

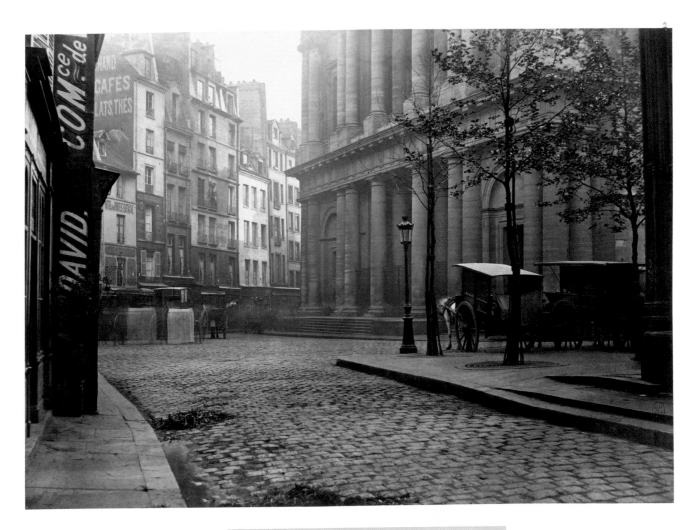

Carrefour du Jour.

2.09. *Carrefour du Jour*, Marville, 1865-1868 (CAR/RV).

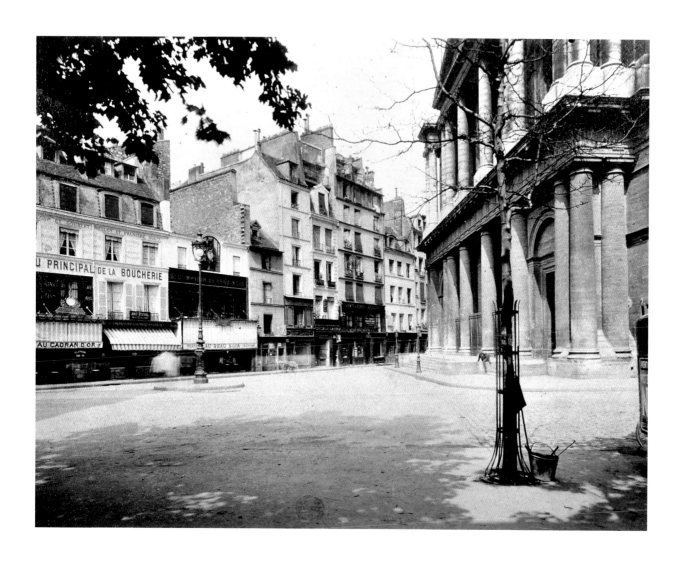

Atget, 1902-03 (BnF).

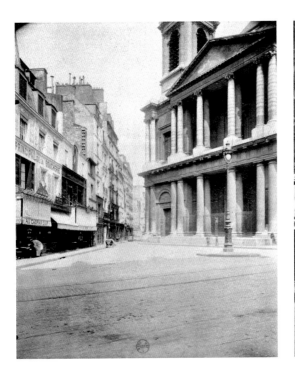

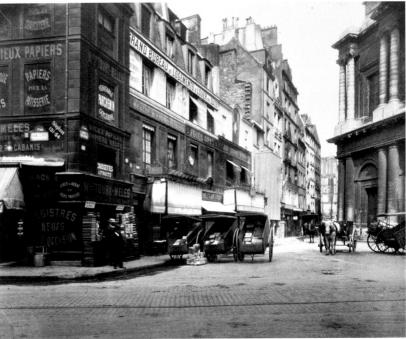

Atget, 1902-03 (BnF). Atget, 1907 (BnF).

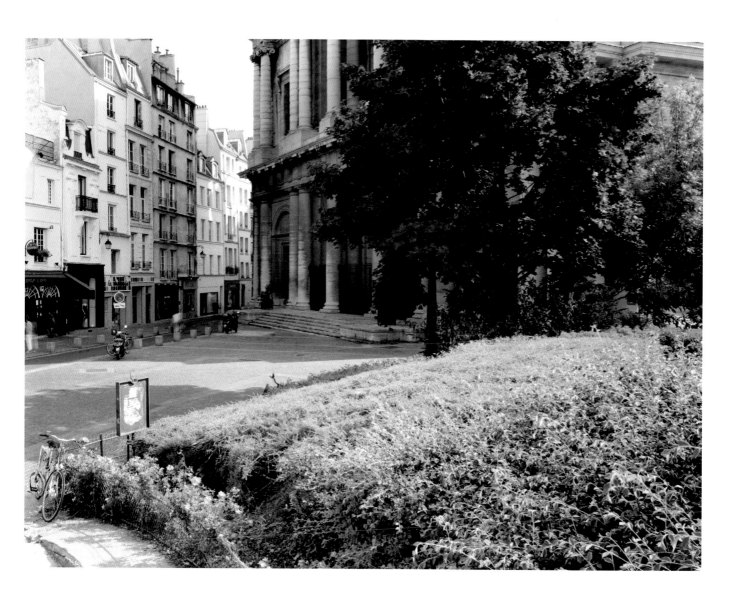

Rue du Jour and the Church of Saint-Eustache, Sramek, 14.08.2009.

Pointe St Eustache et rue Montorgueil.

2.10. *Pointe S¹ Eustache et rue Montorgueil*, Marville, 1865 (CAR/RV).

Pointe Saint-Eustache and Rue Montorgueil, Sramek, 14.08.2009.

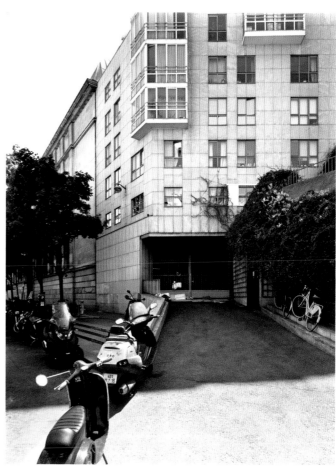

2.11. *Rue de la Grande Truanderie (de la rue Montorgueil),*
Marville, 1865 (CAR/RV).

No. 2 Rue de Turbigo, Sramek, 18.05.2011.

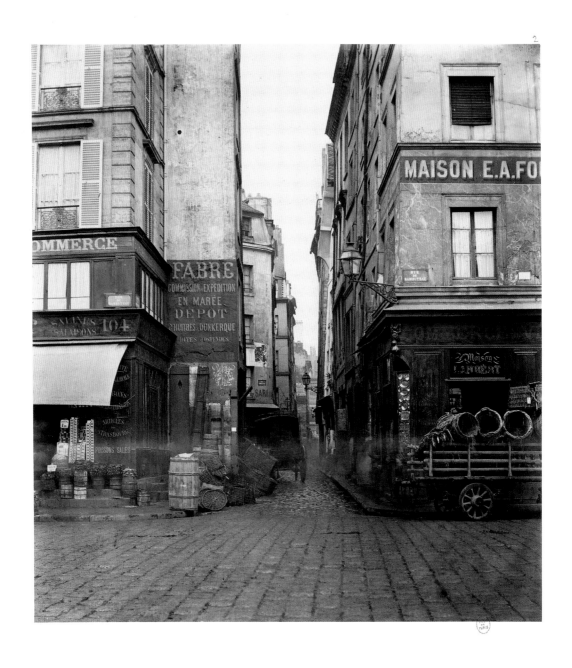

2.12. *Rue Mondétour (de la rue de Rambuteau), Marville, 1865 (CAR/RV).*

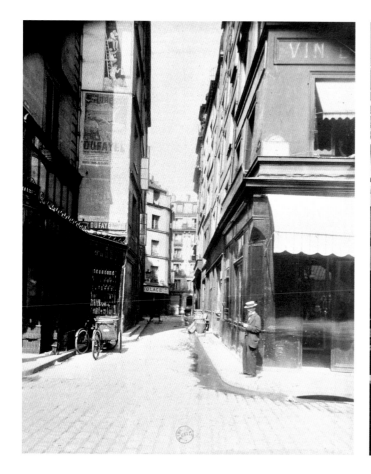

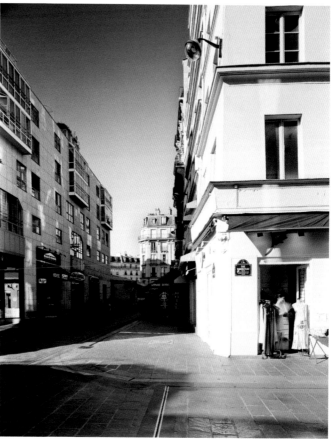

Atget, 1907 (BnF).

Rue Mondétour (from Rue Rambuteau), Sramek, 15.08.2009.

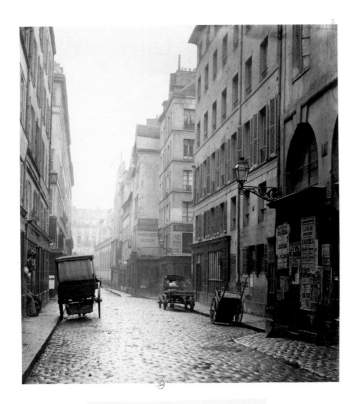

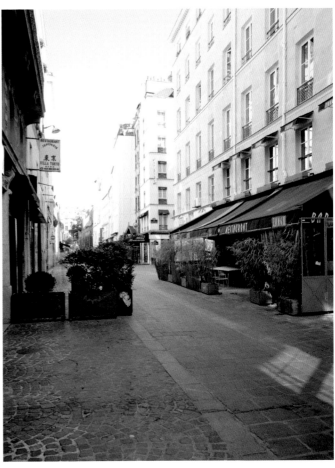

2.13. *Rue du Cygne (de la rue Mondétour)*, Marville, 1866.

Rue du Cygne (from Rue Mondétour), Sramek, 15.08.2009.

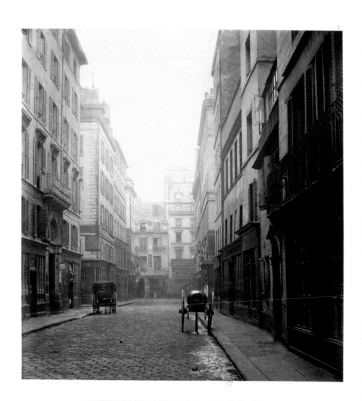

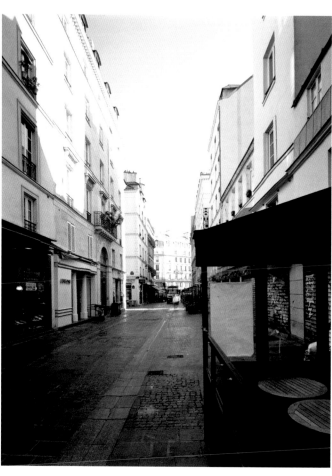

2.14. *Rue du Cloître Saint Jacques. (de la rue de la G^de Truanderie),* Marville, 1865 (CAR/RV).

Rue Pierre-Lescot, Sramek, 23.04.2010.

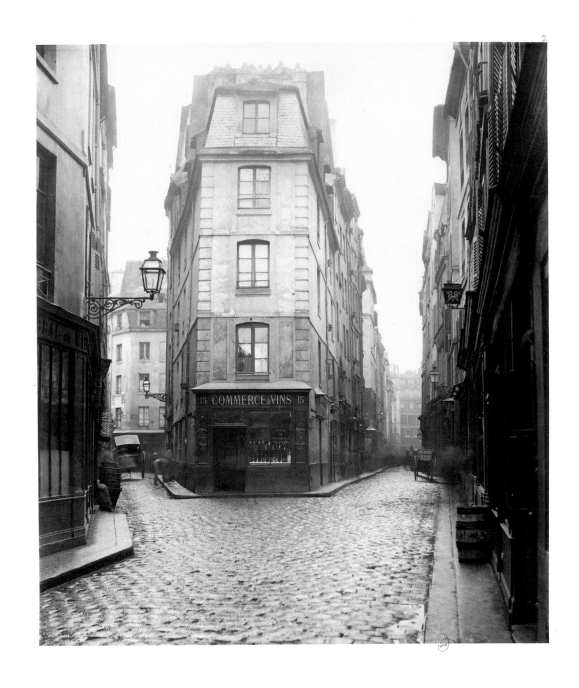

2.15. *Rues de la Petite et de la Grande Truanderie, Marville, 1865 (CAR/RV).*

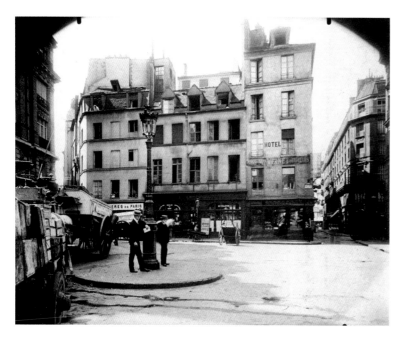

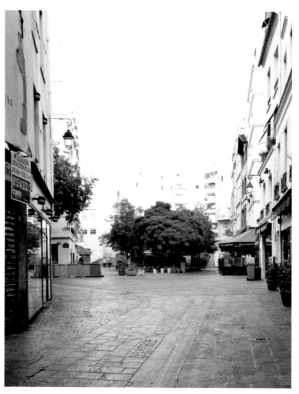

The three photographs of *rue de la Grande-Truanderie* (pl. 2.15) show a progressive demolition of buildings. The corner of the buildings in the Atget photograph are just visible behind the flatiron structure in Marville's and a late twentieth-century apartment complex has obliterated the continuation of the street towards *rue Montorgeuil*. Here in *Les Halles*, movement is now more pedestrian than vehicular and the modern apartments exemplify more recent approaches, not based on Haussmann's standardized façades. Not being locked into the linearity of the street, more variegated forms have been adopted based on twentieth-century concepts of stacking modular living units.

In this area of Paris, I met young men curious about the large camera. They were hanging out in the park or had spent the night in the local bars and clubs. A few wanted to be photographed. One group invited me to drink beer with them as I worked very early on a Sunday morning. It is apparent that despite efforts to sanitize the 'stomach of Paris', the district retains some of its traditional character and the tourists and shoppers still mingle with a rougher crowd, just as they have in past centuries.

Rue Mondétour entre Rue de la Grande-Truanderie et Rue Pirouette [with buildings in Rue Mondétour in the distance], Atget, 1908 (CAR/RV).

Rue de la Grande-Truanderie, Sramek, 16.08.2009.

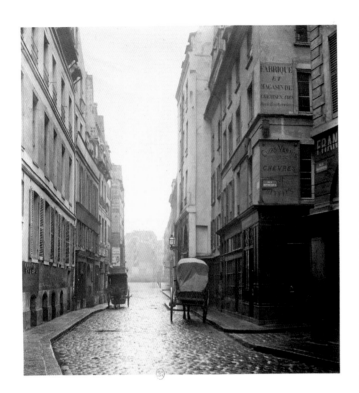

2.16. *Rue Mauconseil (du B^ard Sebastopol)* [incorrect: this is looking towards Blvd. Sebastopol], Marville, 1865 (CAR/RV).

No. 21 Rue Etienne-Marcel (looking east), Sramek, 15.08.2009.

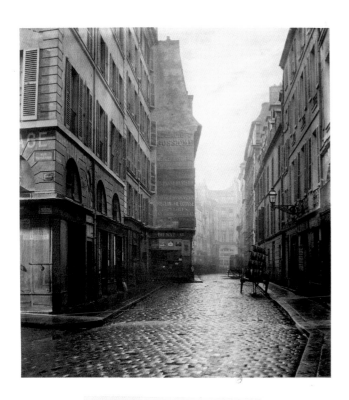

Rue Mauconseil

(de la rue Montorgueil.)

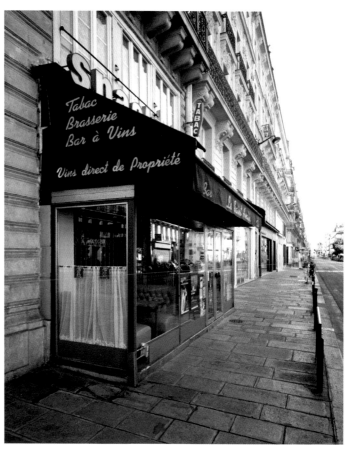

2.17. *Rue Mauconseil (de la rue Montorgueil)* [changed in blue ink to: *au fond:* (de la rue Montorgueil)], Marville, 1865 (CAR/RV).

No. 21 Rue Etienne-Marcel (looking west), Sramek, 15.08.2009.

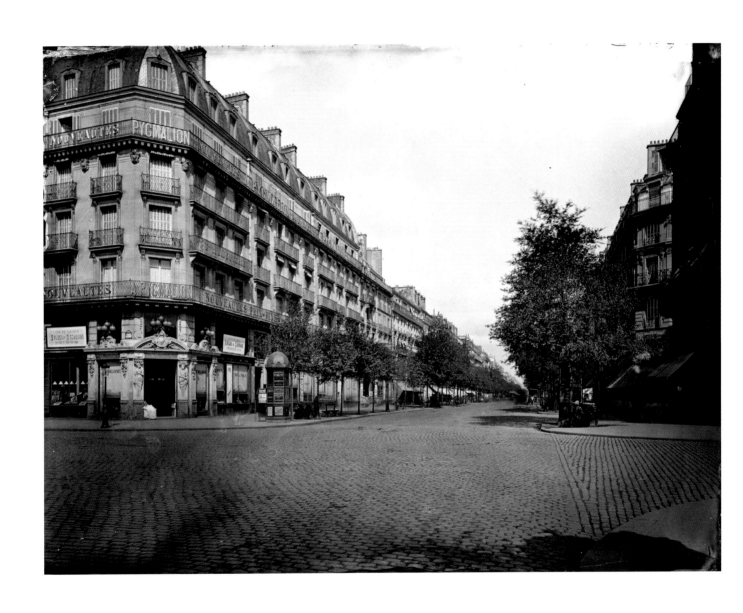

2.18. [*Boulevard de Sébastopol*], Marville, c.1875-1877 (BHVP/RV).

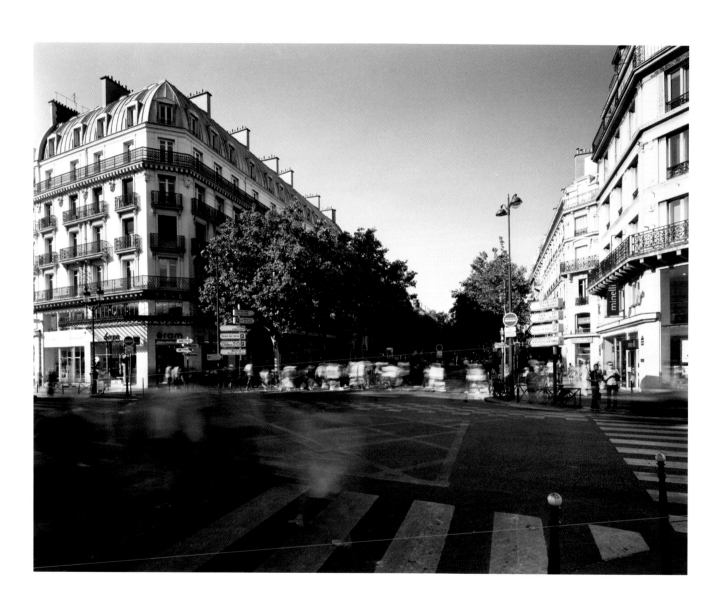

Boulevard de Sébastopol (from Rue de Rivoli), Sramek, 14.08.2009.

Constructing Nineteenth-Century Paris
through Cartography and Photography
Min Kyung Lee

During the nineteenth century, there were two specific media that were vital to the spatial production of Paris: cartography and photography. [1] Mapping was the ground for its planning and on which building was made possible; photography was the means by which that building programme was conveyed to the public. In concert with the development of maps and photographs, the municipal government under the Second Empire and the Third Republic undertook comprehensive urban building projects in Paris using these images and their methods of visualization for the projection of new spaces and their historicization. Most forcefully after 1860, the Parisian

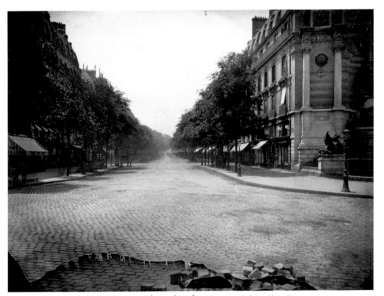

Fig. 27. [*Boulevard Saint-Michel, vers le sud*] looking south from Place Saint-Michel, Marville, 1870-77 (BHVP/RV).

landscape transformed physically and visually into a gridded, spatial experience. Urban space became geometric and rectilinear, contained by buildings that formed a unified façade, spreading out linearly into directed and controlled views.

Through these two kinds of representations – maps and photographs – urban development came to rely on a concept of flatness that was based on

orthogonal drawing. Orthogonality is defined as a geometric method to describe an object at right angles and along parallel lines. It is a process of abstraction, insofar as the representation produced from this method does not pictorially resemble the object but presents the object as a system of reduced planes and diagrammatic lines. The adoption of the orthogonal mode to describe Paris at the end of the eighteenth century composed the city into an object composed of lines and, most importantly, of the empty spaces between the lines, providing a graphic presence to absence.

If the actual planning of Paris rested on an orthogonal representation of space, then its visual reception and experience relied on its perspectival insistence. The construction of perspective is, after all, based on the optical illusion that parallel lines extending into absolute space are perceived to meet at the horizon. New spaces were drawn by architects, engineers, and administrators from a gridded surface of parallel lines on an orthogonal plan and, once built, represented as a receding volume in the photograph. Ultimately, Charles Marville's rigid perspectival views of the transformed city were conditioned by the administration's orthogonal bias of their maps and plans for urban development.

Marville's photographs from 1877 of the new *boulevard Saint-Michel*, whose construction was executed by 1860, present spaces of volumetric extension through perspectival projection (fig. 27). The boulevard unrolls infinitely into the distance all the way to the sloping horizon line. As with most of Marville's compositions, while the street is centred, it is not symmetrical. [2] Two columns of the Fontaine Saint-Michel designed by Gabriel Davioud are clearly visible at the right margin. But Marville only hints at this new monument, for the real subject is the opening in the urban fabric, a *'percement'* that became the emblem of the new city. In another photo of the same boulevard (fig. 28), taken from further south and looking northward towards the Seine, there is a similar composition. The boulevard is again not centred, and the converging point is obscured by the offset point of view of the camera and the tops of the newly-planted trees. The new alignment of the boulevard would have framed a view of the spire of Sainte Chapelle, recently erected by Eugène Viollet-le-Duc and designated an official historic monument in 1862, but Marville hides it by not taking the photograph in the middle of the street but standing to the side. The effect of this off-centred position places primary focus on the opening that is given shape and contained by the buildings and guided by the lines of the curbs. This open space is the central object of the photograph; it empties out the fore- and middle ground of the image into a vast plane, pushing the built forms into the background, transforming the surrounding buildings into a scenography that supports and

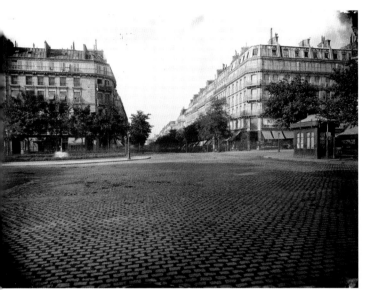

Fig. 28. [*Place Edmond-Rostand du boulevard Saint-Michel*], looking north, Marville, c.1877 (BHVP/RV).

envelopes its volume (see Van Zanten 1994: 198-255).

Boulevard Saint-Michel represented a principal north-south axis for the city and was part of the first phase of three networks in the transformation of Paris. Along with this boulevard on the left bank, the first phase, *le premier réseau*, included the elongation of the *rue de Rivoli* as the east-west axis and *boulevard Sébastopol* on the right bank of the city that all combined to make what was referred to as the 'Grande Croisée.' Its outline was supposedly indicated by Napoleon III on the famous coloured map handed to Haussmann when appointed Prefect of the Seine Department in 1853. The scene and map is memorialized in Haussmann's memoirs: *'une carte de Paris sur laquelle on voyait tracées par Lui-même, en bleu, en rouge, en jaune et en vert, suivant leur degré d'urgence, les différentes voies nouvelles qu'il proposait de faire exécuter.'* (Haussmann 1890-03: II: 53) The map was later retrospectively reconstructed by Charles Merruau (fig. 29), who served as secretary to the administration during the Second Empire. The story implied that the city's modernization was cartographically and comprehensively visualized prior to its building and that its modernity began with a map.

If the myth was that Paris emerged from a medieval agglomeration to become the modern city of light in a single, imperial and cartographic gesture, photography served to further transform this myth into a reality. Marville's photographs of damp, dark, and unpopulated streets were set against light-filled new, wide boulevards, and the immediate legibility of both sets of images seemed to make the argument that there was no friction in the transition from the past to the present. There were only images of instant 'befores' and 'afters.' Moreover, the photograph's seeming fidelity in reproducing a visual scene only contributed to the belief in the image as fact. In omitting their temporal contexts, the photographic images became naturalized. There was no process, only appearance.

In this way, the photographs became a powerful tool for the Paris administration to construct an official history of modernization during the actual transformation, to capture the places that would disappear, and to respond to criticism against the historical architecture that was being cleared away (Barberie 2007: 45). By 1864, Marville was engaged by the Travaux Historique to photograph '*les anciennes voies détruites ou sur le point d'être*' in order for the administration to '*conserver les souvenirs du passé*' (de Thézy 1994: 28). Later, on 12 December 1865, Georges-Eugène Haussmann had sent a request to Napoleon III concerning the Histoire générale de Paris, in which he outlined a proposal '*pour la recherche, la mise en ordre et la publication de documents relatifs à l'histoire administrative et à la topographie ancienne de Paris*' (Travaux Historiques, Paris 1866: 11). Parallel to this project was the multi-volume publication of Topographie historique du vieux Paris in 1866 by Adolphe Berty, official historian of the city of Paris since 1860, and Lazare Maurice Tisserand, the secretary to the Commission des Travaux Historiques.[3] In this context, it is critically important to understand that Marville's photographs are part of an explicit programme of the government to project and control the historiographic representation of its urban development.

The intention of the Travaux Historiques was not to preserve the city but, rather, to project an official memory of Paris composed of images of spaces that were being made to disappear. There was a certain irony to the historiographic endeavour in its use of the photographic medium, for the legibility of images as accurate was based on the ability to compare representation to reality. The smaller the divergence, the greater its claim as objective and accurate. However, in the case of many of Marville's photographs, comparisons were impossible for the views no longer existed. Herein was a visual power that exceeded their function as mere descriptions: because comparisons were not possible, they came to stand in for those lost spaces.

Marville's 425 street views were commissioned with intention to support a first volume of the *Histoire générale de Paris*, described by Napoleon III as,

> *une collection de monographies, de plans, et de documents authentiques, destinée à s'accroître sans cesse, permettra de suivre à travers les siècles la transformation de la Ville, qui grâce au concours intelligent de son conseil municipal et à votre infatigable activité, est aujourd'hui la plus splendide et la plus salubre des capitales de l'Europe.* (Travaux Historiques, Paris 1866: 9, 13)

Haussmann began with an explanation in the form of a compliment, '*Cette persistance d'un souverain a rechercher dans le passé l'explication du présent et la préparation de l'avenir, est la plus haute expression la plus éclatante de tendances modernes*' (Travaux Historiques, Paris 1866: 9; 13). Thus, the construction of a future city was accompanied by the projection of its past through photography, whose subjects were conditioned by new cartographic modes of orthogonal planning.

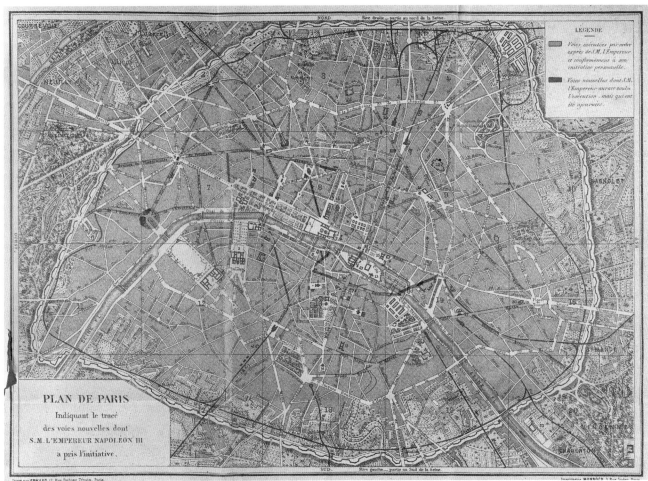

Fig. 29. *Plan des percées voulues par Napoleon III, 1848-1852* published by Charles Merruau, 1875 (CAR/RV).

After the fall of the Second Empire and France's defeat by the Prussians in 1871, the young Third Republic government undertook a specific effort to stamp the city and its history with a republican political ideology by making explicit links to the French Revolution through exhibitions of photographs and maps. Marville's photographs were exhibited in the city's municipal pavilion at the Universal Exposition of 1878, the first triumphant self-presentation in its own capital city of Paris. Here the before-and-after images were shown side by side with no mention of the social upheavals and resistance, planning failures and economic costs, and the political regime that wielded immense power for the city's creation. In the case of the exhibition of Marville's photographs, the images constitute a distinct visual discourse of the city.

The exhibited images were in direct contradiction to the reality of the built environment in the 1870s. Many of the city's monuments were in ruin from the commune and war, including the Hôtel de Ville, which Marville carefully documented. The messiness of the process was sublimated in the simultaneity of the images' comparisons. Hence, what spatial legibility the photograph provided came at the cost of picturing a temporal and real dimension. They were tightly-framed photographs, presenting themselves as visual facts for propaganda and curated to justify Paris' republican origins and modern state. As Rosalind Krauss noted, 'the nineteenth century organized itself increasingly around what could be called the space of exhibition' and where, eventually, a work of art became 'a representation of its own space of exhibition' (Krauss 1982: 312-13). The photographic exhibition presented in 1878 was in many ways a visual projection of what the city was to be, not as it was.

The municipality employed precisely the same strategy in its presentation of maps at the 1889 Universal Exposition. The city prepared a series of historical maps known as the *Atlas des Travaux de Paris, 1789-1889* to argue that the modernization of Paris was the result of republican ideals and that the process of urban transformation was complete. The same argument from 1878 was carried through but, more explicitly, as the centennial celebration of the French Revolution. Composed of 16 plates and organized around functional themes, including water and sewers, public roads, public transport and public buildings, the exhibition began with a plan of Paris dated retrospectively at 1789.

The plans sought to maintain the idea that the modernization of Paris over the course of the century was a technical endeavour and not a political one. There was a linear narrative of progressive evolution, supported by the same base plan and same scale used across all plates, in which each map presented the spaces of a city and their continuous expansion across the surface of the plates. Moreover, each map represented an artificial temporal moment. The building of different streets occurred over varying periods that were then compressed into a synoptic and diagrammatic moment. For example, the history of the Hôtel de Ville, having been burned down in 1871 during the events of Paris Commune, was graphically unacknowledged. New streets suddenly appeared in their totality on certain plates, without any indication of the long periods of their construction. This graphic quality led to their acceptance as technical and scientific, and consequently, accurate and rational, transforming the map's politicized production and presentation through a potent graphic strategy for naturalizing urban change as an inevitable process. Thus, what spatial legibility was afforded came at a cost of any critical formulation of time and social relations. Cartography and photography found their utility for a government keen to make the development of the city into a technological problem as maps and photographs were read as scientific documents, and their rhetorical strategies were contingent upon supporting the myth of the city's instantaneous modernization.

While maps and photography shared representational values as accurate and objective, they were derived from different graphic modalities. The latter was based on the exact visual correspondence between representation and reality; the former was based on their visual difference. This difference between reality and representation in cartography was central to the maps' status as technical objects. Before the seventeenth century, maps were called portraits in that they presented the character of a city through the faces of its significant monuments (Picon 2003: 135-49). In the case of Paris, these portraits depicted the Seine running vertically in order that the façades of monuments could be presented towards the viewer on a ship. Their value as accurate pictures was based on the correspondence of reality to representation, and the image was validated by its pictorial verisimilitude to those real objects. The map was a window through which to see the urban landscape in its singularity.

The eighteenth century witnessed architects, engineers, and administrators working out the map's value and descriptive aims in relation to urban growth and their increasing desire to shape and manage it. The shift to planar views at this time signalled an important change in the status of a map from an illusionistic window to an instrument to project plans based on geometric correspondence. These *'plans projets'* – a category that was not used at that time – became increasingly diagrammatic and devoid of all specific pictorial details (Pinon, Le Boudec and Carré 2004). The representation of the city became composed of lines that were geometrically validated not by how it looked but how the terrain had been measured and surveyed. By the nineteenth century, all cartouches, decrees, and urban profiles that used to decorate the

margins disappeared and, in its stead, were charts, scales, and measures, visually representing a scientific and technological rhetoric. These maps were accurate because of how they were produced, using new geometric methodologies and mechanical instruments, not how they looked. Therefore, if the earlier perspectival and pictorial maps of Paris represented what could be seen, these orthogonal plans represented what had to be drawn in order to be seen. Orthogonality became the primary mode of representing the city for planning by the end of the eighteenth century and throughout the nineteenth century (Lee 2012b: 11-32). An orthogonal projection creates a depthless representation with no volumes and no masses, and used only lines. This shift from perspectival to orthogonal modes of cartographic representations, one that had its links to printing and reproduction practices, compelled a corollary shift in how urban planning was practised and understood. Principally, orthogonal plans allowed descriptions of the terrain and new plans for that terrain to cohere on the same surface at the same scale in the same proportions.

Consider the plan for the extension of the *rue de Rivoli* (fig. 30), in which

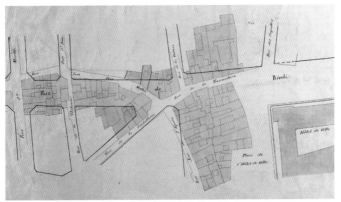

Fig. 30. *Etude du percement de la rue de Rivoli entre la rue Saint-Martin et l'Hôtel de Ville* (BHVP/RV).

coloured blocks outlined in thin black lines describe the actual state of Paris while parallel, thick, black lines of the street project a new urban texture. These two temporal values can cohere on the same page because of its shared orthogonal modality. Moreover, the diagrammatic quality of image reduces the city into a geometric and formal question, and construction becomes simply a matter of erasing old areas. As Haussmann would write about its completion: '*Ce fut une grande satisfaction pour moi que de raser tout cela pour mes débuts à Paris*' (Haussmann 1890-3: III, 40). From 1848 to 1853, under the direction of Haussmann's predecessor, Berger, the Prefect of the Seine opened the project to extend and align the *rue de Rivoli* from the Tuileries to the *rue Saint-Antoine* with a decree of 24 March 1848. An initial sum of about nine million francs was offered by the city to finance the project but, by 1851, another loan of 50 million francs was necessary for expropriation and construction, which had run into unexpected problems. One of the major problems was a miscalculation of the elevation from the *rue des Poulies* and the Hôtel de Ville. From 1853 to 1870, the project fell under the direction of Haussmann as Prefect of the Seine to correct this problem. It was necessary to reconstruct the Pont de Notre Dame and most significantly, to insert a new base under the Tour Saint-Jacques. Many photographers documented this process of *dégagement* of the tower and the area around Châtelet, including Renard, Baldus, Nègre, and, in fact, Berger had hired Le Secq to document the demolitions and renovations, including *rue de Rivoli* (O'Connell 2001: 450-73; see also Rice 1997).

Marville's photograph of the '*Rue de Rivoli*' from 1877 (fig. 31; pl. 2.01) shows no trace of the upheaval caused by the years of construction. It simply presents the completed street with its uniform system of façades that came to be associated with architectural development under Haussmann. Its repetitive order of street lamps, windows, rectangular lots, uniform lines marking each storey emphasizes the perspectival composition of the image. Shadowy traces of horse carriages racing down the street only draw more attention to the ordered and straight lines extending into the horizon and that could allow for such speed. While the lines are more insistent than in the photograph of '*Boulevard Saint-Michel*' (fig. 27) the two photographs are similar in composition: two columns are placed at the margins of both images and a void is created in the fore- and middle ground of the photograph. In the case of the *rue de Rivoli* photograph, two pilasters of Claude Perrault's colonnade frame the left side with the curb swinging around the Louvre's corner and drawing the viewer's eye deeper into the photographic space.

The repetition of the façades directly on the *rue de Rivoli* has an iconographic tradition in architecture that precedes the nineteenth century and relates to those two photographed pilasters. Images of the colonnade from the seventeenth and eighteenth centuries consistently picture the Louvre's eastern façade, with its paired Corinthian columns as a scenographic backdrop to be read left to right, with the right side obscured by objects 'as if to suggest that its double rhythm could extend beyond the frame ad infinitum.' Then continuing her thought, in reference to Perrault's *Les dix livres d'architecture de Vitruve* (fig. 32), Lucia Allais (2005: 55) explains that '[i]t is not the fact of its objecthood (the doubled order as a symbol for architecture) but rather

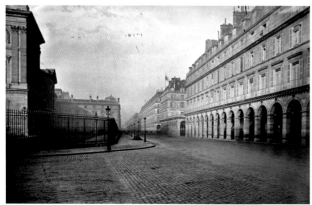

Fig. 31. *Rue de Rivoli*, Marville, 1877 (BHVP/RV) (pl. 2.01).

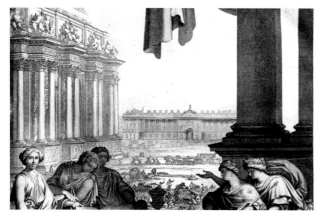

Fig. 32. Frontispiece in Claude Perrault, *Les dix livres d'architecture de Vitruve* (Paris: J.B. Coignard, 1673), engraving by Sébastien Leclerc, detail (CAR/ FA/ Roger Viollet).

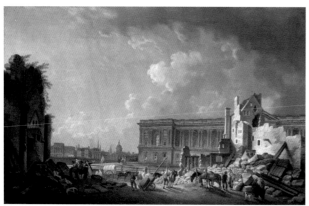

Fig. 33. Pierre-Antoine de Marchy, *Clearing the Area in front of the Louvre Colonnade*, c. 1760, oil on canvas, 60 x 92 cm (CAR/ FA/ Roger Viollet).

the process of constructing a system (the doubling of orders as generative of architecture) that becomes an allegory for architectural creation.' This motif is found again in Pierre-Antoine de Machy's oil painting of the clearing of the area in front of the Louvre from 1760 (fig. 33). Ruined buildings are placed on the right foreground, and the colonnade continues beyond the frame to the right.

By picturing not one column but the pair on the right corner of the colonnade, Marville continues Perrault's motif of repetition and, with the right part of colonnade exposed, there is a suggestion that the repetition is to be picked up by the building façades on the opposite side of *rue de Rivoli* extending into and beyond the horizon so that the repetition and extension is not lateral but deep. The viewer could imagine walking directly onto the street's cobbled stones into the empty space, and following this modern urban rhythm ad infinitum into the horizon.

Beginning in the 1840s, the quarter was under pressure to the north with the reorganization of the Halles Centrales. The impulse to intervene in this area was less about the market itself but about the growing dissonance between the geographic centre of the city and its demographic centre with the increasing displacement of the population towards the northwest, to which Charles Garnier's Opéra building would in a few decades become its architectural jewel. Chantelot, the head of the office of the *grand voirie*, wrote,

> Les Halles doivent occuper le point central de la superficie de la ville et, mieux encore, le point central de la population. Le centre de Paris comme surface est à peu de chose près le Pont-Neuf. Le centre de la population peut être vers la place des Victoires. Les Halles actuelle occupent à peu près le point milieu entre ces deux centres. (Lavedan 1967: 35)

This geographic difference disrupted the assumption of a unified urban centre and raised social and symbolic questions. While the urban intervention was through architectural means, ultimately, *Les Halles* was not the problem; rather, for administrators, architects, and intellectuals, the issue concerned the definition of urban forms and their representational value. Eventually, that definition came in the form of a grid, whose character was specifically commercial (Van Zanten 1994: 218-24). In the 1845 plans for *Les Halles*, Victor Baltard tentatively extended the rectilinear form of the market to its surrounding streets west of the circular Halle au Blé. In successive iterations until 1854, the entire plan became a reified grid system. With the extension of *rue de Rivoli* to the south, *rue du Louvre* (1860) to the west, and *boulevard Sebastopol* (1858) to the east, the quarter developed an orthogonal scheme.

Famously, Baltard's original design of the building called for stone and brick, and represented a first gesture by Napoleon to project a new city. But soon after he was appointed, Haussmann recalled, '*L'empereur, choqué de l'aspect lourd, massif et peu gracieux de cet édifice … ordonna la suspension des travaux, l'abandon du projet en cours d'exécution et ouvrit lui-même une sorte de concours entre divers architectes, auxquels il demanda des projets tout autres*' (Haussmann 1890-03: III: 478). The final design was composed of twelve pavilions in iron- and glass-covered streets with a central one, *rue des Halles*, aligned to the chevet of Saint-Eustache directly to its north, all constructed between 1854 and 1870.

Marville's photograph of '*Rue de la Tonnellerie*' from 1865 (fig. 34; pl. 2.28) provides this view, looking northward towards Saint Eustache. On the right side is a façade of the new markets, mimicking the repeating arcades along *rue du Rivoli*, and on the left are the old buildings, which, significantly, rise above the new pavilions that would eventually be cleared. Thus, this image presents a point of view that is compositionally and temporally in the middle of the old fabric of insalubrious and chaotic buildings and the new encroaching grid system of straight lines, between photographs of the '*Fragment de Piliers*' (fig. 35) and the '*Halles centrales*' (fig. 36). Again, the photograph is not taken in the middle of the street, such that the block on which *Les Halles* rest seems to inch towards the west as the older buildings retreat off the frame. In the image of '*Rue du Four*' (pl. 2.29) from the same year as the photograph of *rue de la Tonnellerie*, the construction of the markets is well documented. The dirty and still pool of water by the curb at the lower left corner of the photograph was soon replaced by a sanitary urban system that managed the circulation of water with a new set of fountains and an extensive underground hydraulic network, and that allowed light into those dank corners with glass roofs. This new, gridded urban fabric and the iron and glass central market was thematized in Emile Zola's *Le Ventre de Paris* from 1873 in which the reader follows Florent into the interior of the city:

> *Mais ce qui le surprenait, c'était, aux deux bords de la rue, de gigantesques pavillons, dont les toits superposés lui semblaient grandir, s'étendre, se perdre, au fond d'un poudroiement de lueurs. Il rêvait, l'esprit affaibli, à une suite de palais, énormes et réguliers, d'une légèreté de cristal, allumant sur leurs façades les mille raies de flamme de personnes continues et sans fin. Entre les arêtes fines des piliers, ces minces barres jaunes mettaient des échelles de lumière, qui montaient jusqu'à la ligne sombre des premiers toits, qui gravissaient l'entassement des toits supérieurs, posant dans leur carrure les grandes carcasses à jour de salles immenses, où traînaient, sous le jaunissement du gaz, un pêle-mêle de formes grises,*

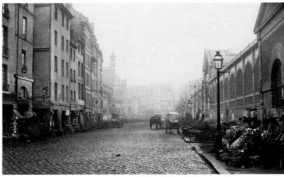

Fig. 34. *Rue de la Tonnellerie*, Marville, 1865 (CAR/RV) (pl. 2.28).

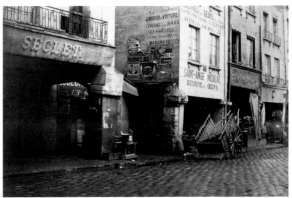

Fig. 35. Pillar fragments of the old covered market, Marville (BHVP/RV).

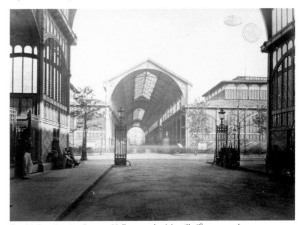

Fig. 36. *Rue Antoine Carême. Halles centrales*, Marville/Émonts, n.d. printed 1880-89 (BHVP/RV).

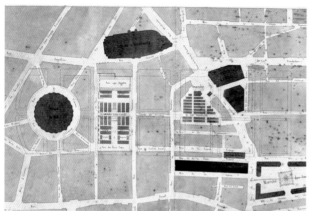

Fig. 37a. *Halles centrales de Paris - plan général des anciennes halles,*
Victor Baltard, architect (CAR/RV).

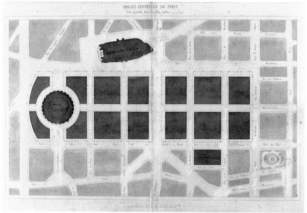

Fig. 37b. *Halles Centrales de Paris - plan général des nouvelles Halles,* Victor Baltard and
Félix-Emmanuel Callet, architects. 1854. (CAR/RV).

Fig. 37c. View of the covered markets, Victor Baltard and Félix-Emmanuel Callet,
architects, 1854 (CAR/RV).

effacées et dormantes. Il tourna la tête, fâché d'ignorer où il était, inquiété par cette vision colossale et fragile; et, comme il levait les yeux, il aperçut le cadran lumineux de Saint-Eustache, avec la masse grise de l'église. Cela l'étonna profondément. Il était à la pointe Saint-Eustache.

Madame François alerts him to further changes:

— Dites donc, s'il y a longtemps que vous êtes absent de Paris, vous ne connaissez peut-être pas les nouvelles Halles? Voici cinq ans au plus que c'est bâti ... Là, tenez, le pavillon qui est à côté de nous, c'est le pavillon aux fruits et aux fleurs; plus loin, la marée, la volaille, et, derrière, les gros légumes, le beurre, le fromage ... Il y a six pavillons, de ce côté-là; puis, de l'autre côté, en face, il y en a encore quatre: la viande, la triperie, la Vallée ... C'est très-grand, mais il y fait rudement froid, l'hiver. On dit qu'on bâtira encore deux pavillons, en démolissant les maisons, autour de la Halle au blé. Est-ce que vous connaissiez tout ça?

— Non, répondit Florent, j'étais à l'étranger ... Et cette grande rue, celle qui est devant nous, comment la nomme-t-on? — C'est une rue nouvelle, la rue du Pont-Neuf, qui part de la Seine et qui arrive jusqu'ici, à la rue Montmartre et à la rue Montorgueil ... S'il avait fait jour, vous vous seriez tout de suite reconnu. (Zola 1873)

Madame François is the first person whom Florent meets on his return to the city after escaping from French Guinea. The significance of this gendered meeting rests on the changing social status of women precisely at this time of industrialization and urbanization. She is a peasant but an independent woman, driving her own wagon filled with carrots and turnips and negotiating their sale in the city. She does not stay long and makes her way back to Nanterre after her goods are sold.

Madame François' counterpoint is found in Marville's photograph of the *rue de la Lingerie.* Scattered around the block are large baskets and containers filled with goods registering the area's character and activity. Originally named after its medieval character as a neighbourhood specializing in the production and sale of textiles, by the time this photograph was taken the area had become used as a granary due to its proximity to the Halle aux Blé. A working-class woman with three other men at the corner of *rues de la Lingerie* and *de la Poterie* (fig. 38) in front of the old Halle aux Draps et Toiles looks at the camera, standing and staring motionlessly while the light imprints her likeness onto the plate. Thickly dressed, wearing an apron and a white bonnet, she wraps her arms around her waist. Working most likely in the grain trade, she represents one presence in the 31 to 41.3 percent of women in the workforce in Paris.[4] She also represented the increasingly unequal economic conditions that by the 1860s had made the employment of women an economic necessity

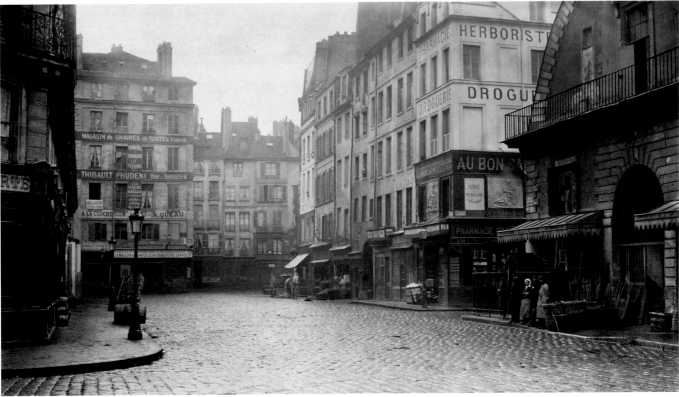

Fig. 38. *Rue de la Lingerie (des Halles)*, Marville, 1865 (CAR/RV) (pl. 2.27).

for working families to meet their living costs and by which employers generally exerted a downward pressure on wage rates (Harvey 2006: 183-94). In this way, her still presence offers an important critique to the government's official story of Paris' transformation and the parts that are omitted and repressed. There was a social cost, exacted on workers, women, and on the spaces they inhabited.

Unlike the photographs of the transformed Paris, such as those of *boulevard Saint-Michel*, these images depict the built environment as masses with no spatial extension through perspective. There is some perspectival recession but it is limited with the cramped space, and consequent lack of distance. This has certain advantages in the quality of the image's description: individual buildings are distinguishable in their particular heights and widths; corners are articulated because of the unaligned streets and buildings; and, generally, greater details are legible because of the compactness of the area. However, there is no extension, only enclosure. Consider for example the image of *rue de la Lingerie*, where there is no spatial extension beyond the frame of the picture. Instead there are built masses pushing into the space. The buildings

are not yet aligned screens and the tight spaces do not allow enough distance to create full perspectival illusions. In a photograph of a nearby intersection, '*Carrefour Sainte-Opportune*' (pl. 2.19), there is a small opening between two buildings that would just barely fit the width of a wagon. So the enclosed space held by these buildings can only escape through this bottleneck but only to reach another tight enclosure, walled in by another mass of buildings visible through the small, lit passage. Even the wares and merchandise seem to push out of the buildings, against their openings.

The goods abundantly present in these 'before' images would eventually find themselves in the new monumental context of the department store, (fig. 39) transforming them into commodities and creating out of them spectacles of consumerism. As Robert Proctor (2006) demonstrates, the department store as a unified monumental architectural form grew out of new social and urban practices related to the expanding scale of industrial capitalism.[5] With new manufacturing methods and a larger consuming public, individual stores were eventually amassed under one roof and in one large retailing block. This manifested directly in the district close to the Louvre

Fig. 39. Advertisement for *les Grand Magasins Dufayel*,
in *Le Sport Illustré* (Paris), 1903, collection of the author.

and *Les Halles*, around the *rue de la Lingerie, rue de Rivoli, Châtelet*, with department stores such as Les Grands Magasins du Louvre and La Samaritaine (pls 2.29-2.31). As a new monumental type, the department store had its origins in the agglomeration economies of the seventeenth and eighteenth centuries, when whole neighbourhoods were identified by specific trades, this particular area having been known for its textiles (Clausen 1985: 26). These iron and glass showcases of new industrial products and celebrations of modern architectural invention expanded and came to define the urban texture

in which a structure occupied an entire block. The buildings offered the admission of light into the interior through glass, and accommodated wide street-like atriums and corridors for display and consumption, also found in *Les Halles*.

Writing on the Universal Expositions, Walter Benjamin described these glass pavilions as 'places of pilgrimage to the fetish Commodity' in which 'the phantasmagoria of capitalist culture attained its most radiant unfurling' (Benjamin 2006: 165-67). Ultimately, the individual shops, with their small

scale and distinct façades gave way to the scenography of a gridded experience and expanding view. The spectacle of consumerism carried through the new boulevards that facilitated the circulation of not only air and water but also people, money and commodities, and themselves becoming important mediums of display and presentation.

The goods that were pictured in the 'before' images circulated inside the new spaces of the Halles Centrales and the department stores and, outside, through the city's new boulevards. Over the course of the Second Empire and Third Republic, the district of *Les Halles* became a gridded urban space that benefited commerce and the movement of commodities. The Paris of 1877 in these 'after' photographss became emptied of the goods themselves, privileging the new openings through which these commodities would move and be exchanged. These images were physically taken from a distance and position that was possible with the construction of the broad and straight *percements*, built from the drawn straight lines on orthogonal plans. Photography and cartography were both products and productive of these new visual and urban practices through their medium and mode of representation, as well as their exposition and presentation. Immediacy was the key factor: the power of photography to represent lay in its truth claim based on the immediate legibility of its visual composition; and the power of maps to plan lay in how their orthogonal mode immediately presented an empty surface. Both in their composition and their reduced visual vocabulary, they excluded the social costs of the massive urban development; they made the city into an object able to be displayed and registered in an instant, and thus visually consumed in the exhibitions at the Universal Expositions. Their capacity to make the city into an object through their representational strategies was what made them useful images for the Paris administrations from the July Monarchy, Second Empire to the Third Republic. In this respect, it is critical to see the planning maps and Marville's photographs as part of an official discourse meant to produce the built forms and to control their reception. Marville was, after all, designated as the 'photographe de la Ville de Paris.'[6]

Notes

1 This essay relies on the dissertations of Jacob W. Lewis (2012) and Sean Weiss (forthcoming). The specific argumentation on orthogonality and the use of cartographic methods in the nineteenth-century planning of Paris is more fully addressed in my dissertation (Lee 2012a).

2 Shelley Rice interprets the streets in the photographs as centred in composition. 'This is in part because of Marville's insistence on classically-balanced pictorial form: the street is centred, the buildings line it on each side, and the structure in the background keeps the eye from wandering aimlessly into deep space' (Shelley Rice, *Parisian Views*, 1997: 94). While they are in the central position between two buildings, the compositions are not symmetrical and this is an important point in my reading of the symbolic significance of perspective that will become evident in the later discussion of the Rue de Rivoli.

3 The Travaux Historiques began publishing two series in the *Histoire générale de Paris*, one of which was the *Topographie historique du vieux Paris* in which Lazare Maurice Tisserand and Adolphe Berty traced in detail the histories of every parish, boundary, street, and building in Old Paris.

4 41.2 percent between 1847-1848, 31 percent in 1860 and 41.3 percent in 1872. These figures did not include domestic workers, and the declining participation in the 1850s is a statistical aberration, since the industrial mix in the suburbs annexed in 1860 was more oriented to male employment (Harvey 2006: 181-82).

5 See especially the section, 'Scale and the logic of expansion,' in Robert Proctor (2006: 396-01).

6 See *Marville: Paris* (de Thézy 1994: 17).

References

Allais, Lucia (2005), 'Ordering the orders: Claude Perrault's ordonnance and the eastern colonnade of the Louvre', *Future Anterior* 2 no. 2, winter.

Barberie, Peter (2007), 'Conventional pictures: Charles Marville in the Bois de Boulogne', PhD thesis, Princeton, NJ: Princeton University.

Benjamin, Walter (2006), *The Writer of Modern Life: Essays on Charles Baudelaire*, Cambridge: Belknap Press of Harvard University Press.

Clausen, Meredith L. (1985), 'The Department Store: Development of the Type', *Journal of Architectural Education* 39, no. 1, autumn.

De Thézy, Marie (1994), *Marville, Paris*, Paris: Hazan.

Harvey, David (2006), *Paris, Capital of Modernity*, New York: Routledge.

Haussmann, George-Eugène (1890-93), *Mémoires du baron Haussmann*, 3 vols, Paris: Victor-Havard.

Krauss, Rosalind (1982), 'Photography's discursive spaces: landscape/view', *Art Journal*, 42, no. 4, winter.

Lavedan, Pierre (1967), *Histoire de Paris*, Paris: Presses universitaires de France.

Lee, Min Kyung (2012a), 'The tyranny of the straight line: mapping and constructing Paris, 1791-1889', PhD thesis, Chicago: Northwestern University.

Lee, Min Kyung (2012b), 'An objective point of view: the orthogonal grid in 18th-century plans of Paris', *The Journal of Architecture*, RIBA 17: 1, *Critical Perspectives on Landscape*, February.

Lewis, Jacob W. (2012), 'Charles Nègre in pursuit of the photographic', PhD thesis, Chicago: Northwestern University.

O' Connell, Lauren (2001), 'Afterlives of the Tour Saint-Jacques: Plotting the perceptual history of an urban fragment', *Journal of the Society of Architectural Historians* 60, no. 4.

Picon, Antoine (2003), 'Nineteenth-century urban cartography and the scientific ideal: the case of Paris', *Osiris* 18, *Science and the City*.

Pinon, Pierre, Le Boudec, Bertrand and Carré, Dominique (2004), *Les Plans de Paris: histoire d'une capital*, Paris: Bibliothèque nationale de France.

Proctor, Robert (2006), 'Scale and the logic of expansion', in Robert Proctor, 'Constructing the retail monument: the Parisian department store and its property, 1855-1914', *Urban History*, 33, no. 2, pp. 396-401.

Rice, Shelley (1997), *Parisian Views*, Cambridge, MA: MIT Press.

Travaux Historiques, Paris (1866), *Histoire générale de Paris*, vol. I, Paris: Travaux Historiques.

Van Zanten, David (1994), *Building Paris: Architectural Institutions and the Transformation of the French Capital, 1830-1870*, Cambridge, UK: Cambridge University Press.

Weiss, Sean (forthcoming), 'Engineering, Photography, and the Construction of Modern Paris, 1857-1911', PhD thesis, New York: The Graduate Center, The City University of New York.

Zola, Émile (1873), *Le Ventre de Paris*, Project Gutenberg ebook, http://www.gutenberg.org/cache/epub/6470/pg6470.html. Accessed 14 June 2012.

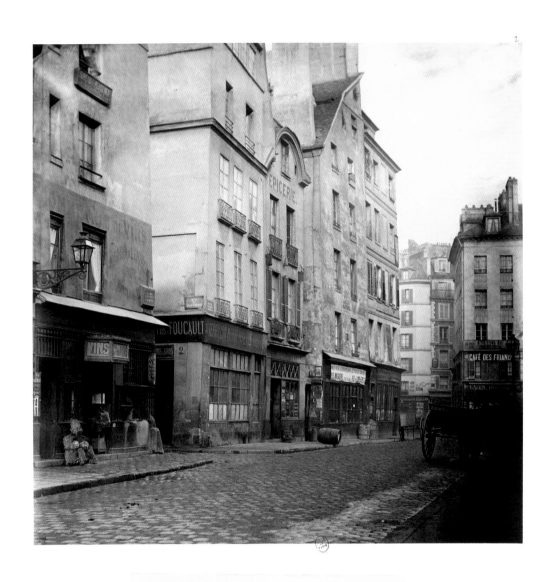

2.19. *Rue des Lavandières Sᵗᵉ Opportune*, Marville, 1865 (CAR/RV).

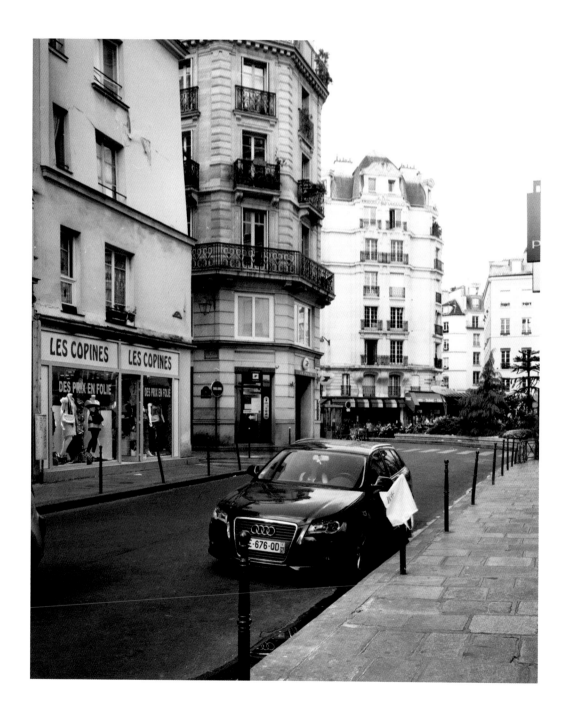

Rue des Lavandières-Sainte-Opportune, Sramek, 26.04.2010.

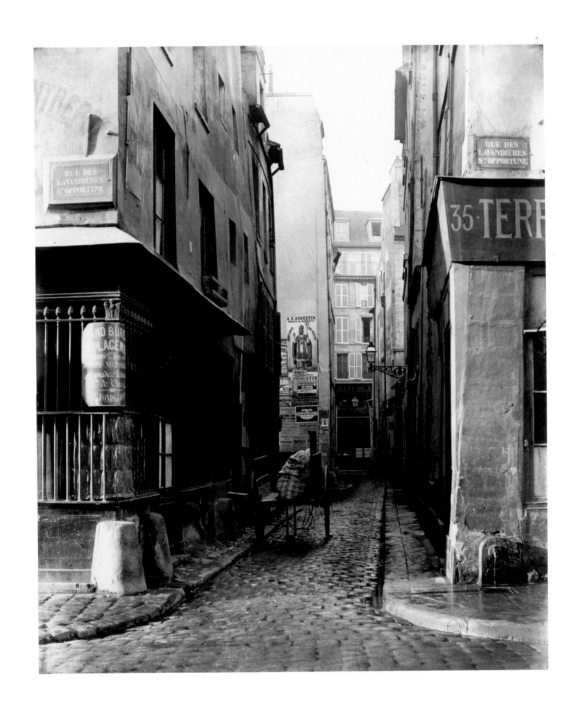

2.20. *Rue du Plat d'Etain (de la rue des Lavandières)*, Marville, 1865 (CAR/RV).

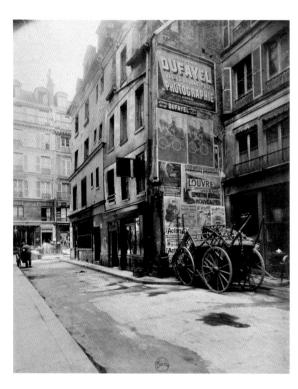

Atget's photograph is taken within the block from the direction of *rue des Déchargeurs* looking back along *rue du Plat d'Étain* and towards the location of Marville's camera in *rue des Lavandières* (pl. 2.20). Note the advertisement on the wall for the Dufayel department store. As discussed in Min Lee's essay (p. 109), Dufayel was an important player in the nineteenth-century development of consumer culture. Posters for Dufayel appear in many of the Atget images reproduced in this book. This particular poster is for Dufayel's photography studios.

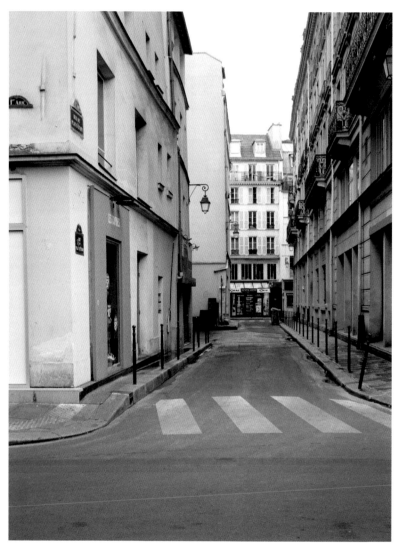

Rue du Plat-d'Etain, 1-3 [towards Rue des Lavandières], Atget, 1908 (BnF).

Rue du Plat-d'Etain (from Rue des Lavandières-Sainte-Opportune), Sramek, 14.08.2009.

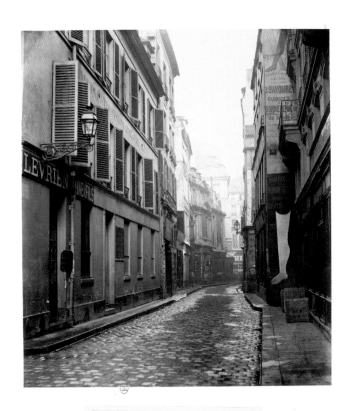

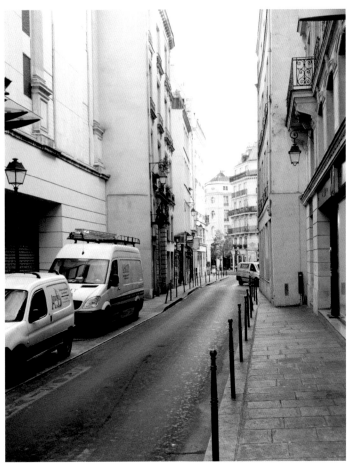

2.21. *Rue des Déchargeurs (de la rue de Rivoli)*, Marville, 1865 (CAR/RV).

Rue des Déchargeurs (from Rue de Rivoli), Sramek, 14.08.2009.

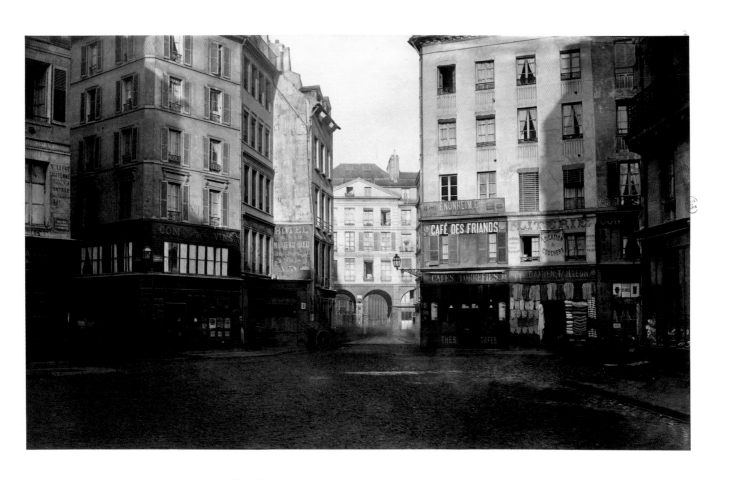

2.22. *Carrefour Sᵗᵉ Opportune (de la rue des Halles),* Marville, 1865 (CAR/RV).

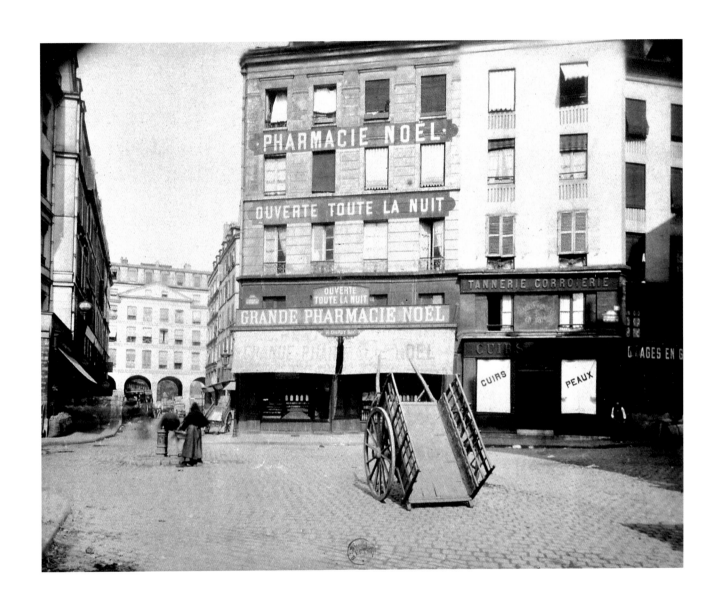

Atget, 1907 (BnF).

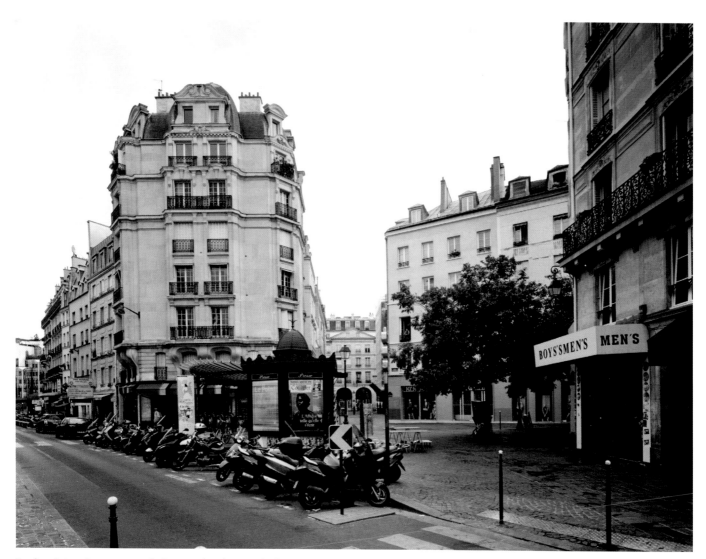

In *place Sainte-Opportune* one finds an enclosed space which maintains the atmosphere of a local, mercantile square while, immediately adjacent, the *rue des Halles* cuts through, with its speeding traffic intent on passing on to more major thoroughfares. The discount BOYS'SMEN'S [sic] clothing store fits with the mercantile history of this neighbourhood but the Haussmann-style façades feel somewhat out of place. Nearby, more recent residences break the mood of the old market quarter entirely. As I photographed in the early morning, one man stood shirtless, casually smoking at the open window surveying the quiet scene below before starting his day.

Place Sainte-Opportune (from Rue des Halles), Sramek, 14.08.2009.

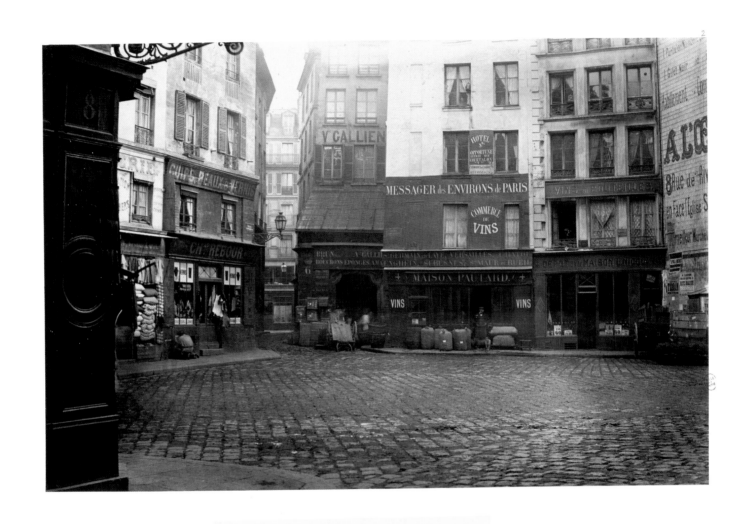

Carrefour Ste Opportune.

2.23. Carrefour S^{te} Opportune, Marville, 1865 (CAR/RV).

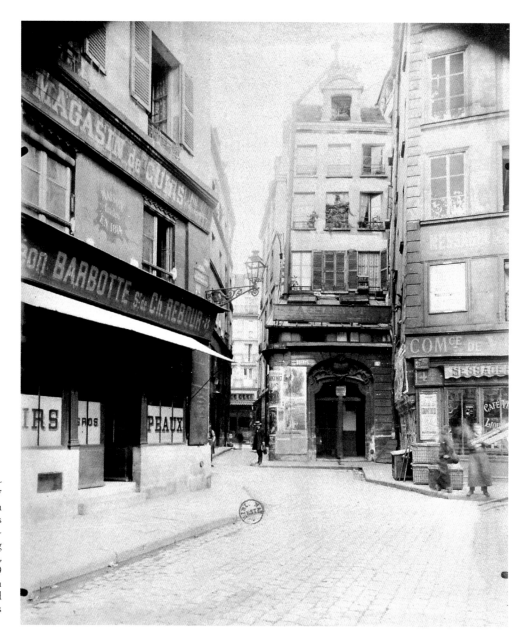

Atget's photographs of *place Sainte-Opportune* were made in 1899 and 1907 and reflect how he would often make a few exposures from different angles and distances, many times with inhabitants, workers or shopkeepers standing in doorways or sitting in windows, watching. This photograph from 1899 was accompanied by one made much closer, with two women standing posed in the far doorway with their arms crossed (BnF collection).

Bureau des Lingères - place Sainte-Opportune, Atget, 1899 (BnF).

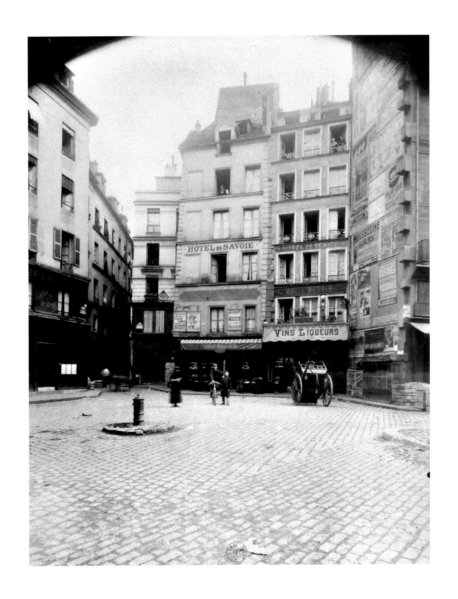

Atget, 1907 (BnF).

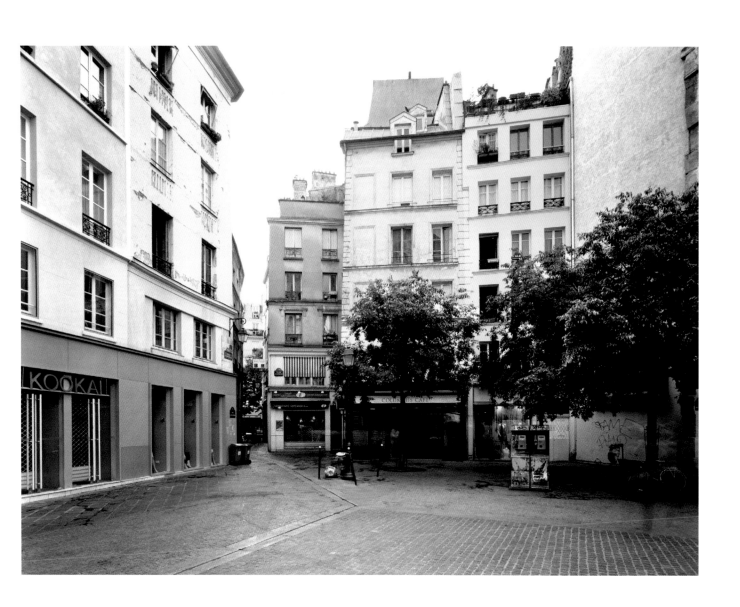

Place Sainte-Opportune (towards Rue Courtalon), Sramek, 14.08.2009.

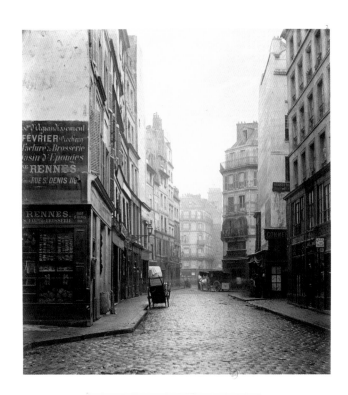

Rue de l'Aiguillerie
(de la rue des Lavandières)

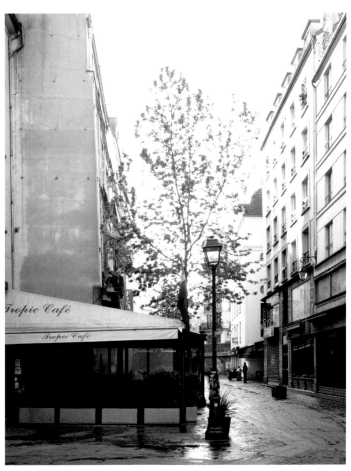

2.24. *Rue de l'Aiguillerie (de la rue des Lavandières)*, Marville, 1865 (CAR/RV). Rue de l'Aiguillerie (from Rue des Lavandières), Sramek, 23.04.2010.

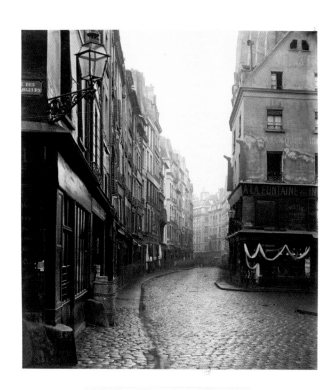

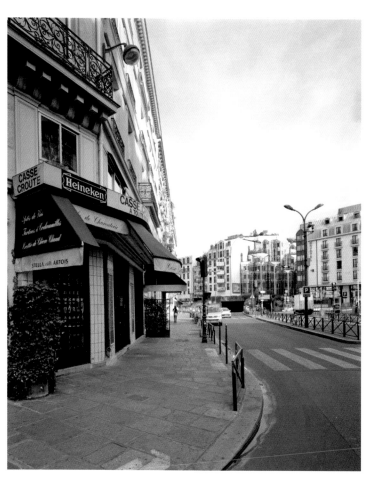

2.25. *Rue S^t Honoré (de la rue de la Ferronnerie)*, Marville, 1865 (CAR/RV). Rue des Halles (from Rue des Déchargeurs), Sramek, 14.08.2009.

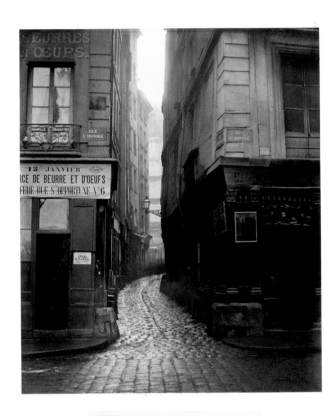

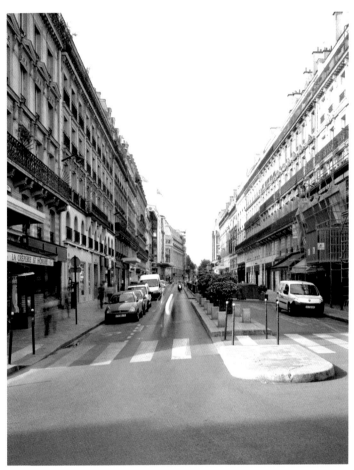

2.26. *Rue Tirechape de la rue S*^t *Honoré*, Marville, 1865 (CAR/RV). Rue du Pont-Neuf, Sramek, 14.08.2009.

At the north end of the *rue du Pont-Neuf* (pl. 2.28), the entrance to the underground Forum des Halles mimics the arches of the old market pavilions and one can faintly see the church of *Saint-Eustache* beyond the glass. A little further along, a section of *rue Vauvilliers* (pls. 2.30-2.31) was once called *rue du Four* which is confusing today because of the other, well-known *rue du Four* on the other side of the Seine. The contemporary photograph shows the start of renovations of the park covering the Forum des Halles which was built in the 1970s with the removal of the Pavillons Baltard. The hoarding takes in part of *rue Berger*, which was widened here in the 1860s to demarcate the boundary of the central markets. This was accomplished by removing the layer of buildings seen in the left foreground of Marville's photograph. The same effect is seen one block to the west along *rue Berger* in the photographs of *rue Sauval* (pl. 2.31). It was here in the park that I met Dimitry, a young black man, who I later photographed. He was one of many unemployed youths who hang out in the city centre with little to do. He thought what I was doing was cool and, in all, I met him three times as I returned to photograph in this neighbourhood.

Although the past and present photographs emphasize comparisons of discrete moments in time, the continuous process of change was apparent when revisiting sites over the period of even a few years. The current large renovation of the park is one example; however, even small changes can be noted. The sculpture in the 2009 photograph of '*Rue de la Lingerie*' (pl. 2.27) was removed only a year later, leaving a slight disruption in the now level brickwork to indicate that something had occurred.

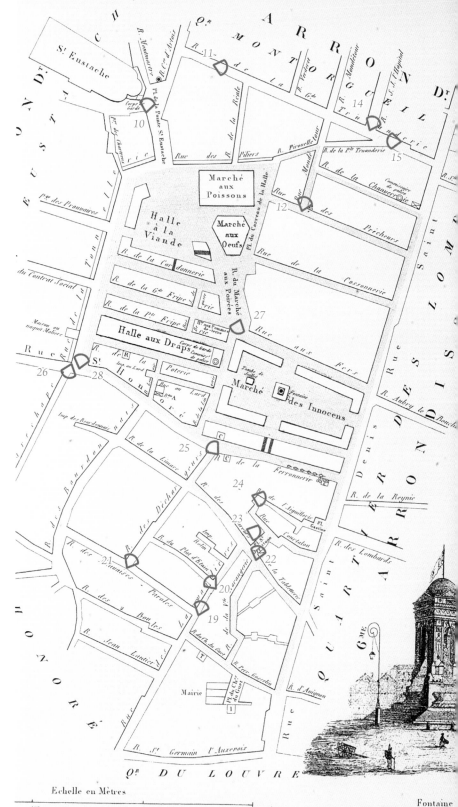

Fig. 40.
Petit Atlas Pittoresque (1834)
No. 33 *Marché* (detail).

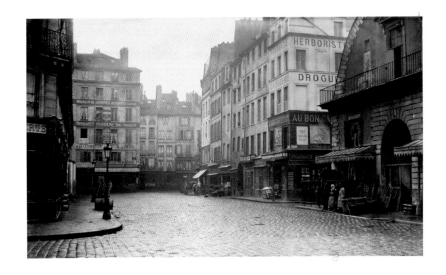

Rue de la Lingerie
(des Halles)

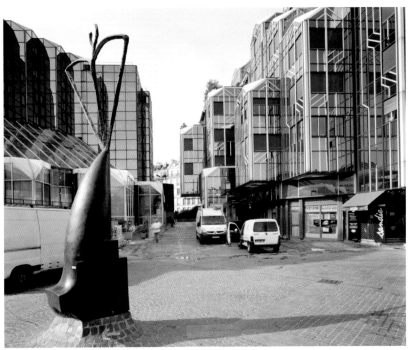

2.27. *Rue de la Lingerie (des Halles)*, Marville, 1865 (CAR/RV) (above).
Passage des Lingères, Sramek, 14.08.2009 (below).

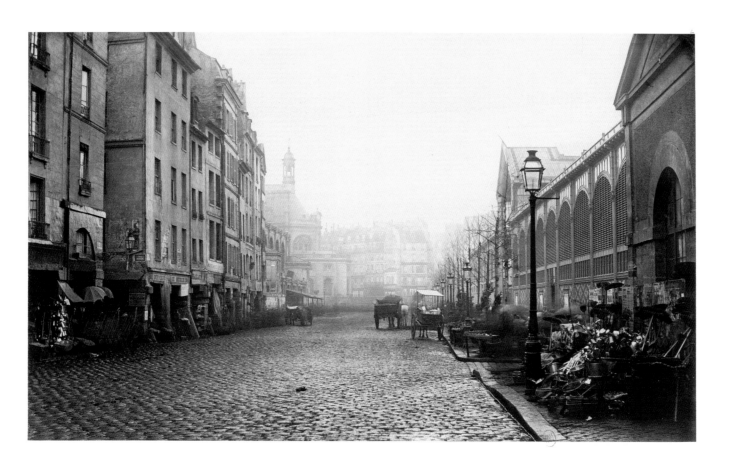

Rue de la Tonnellerie
(de la rue de la Poterie)

2.28. *Rue de la Tonnellerie (de la Rue de la Poterie)*, Marville, 1865 (CAR/RV).

Entrance to Forum des Halles, Sramek, 14.08.2009.

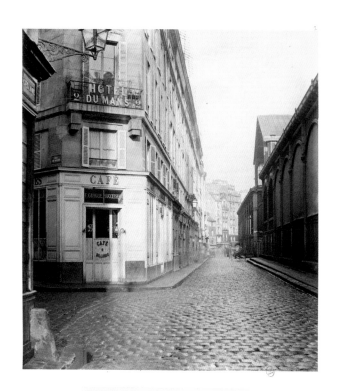

2.29. *Rue du Four (Côté regardant S^t Eustache),* Marville, 1865 (CAR/RV).

Allée Louis-Aragon, Sramek, 14.08.2009.

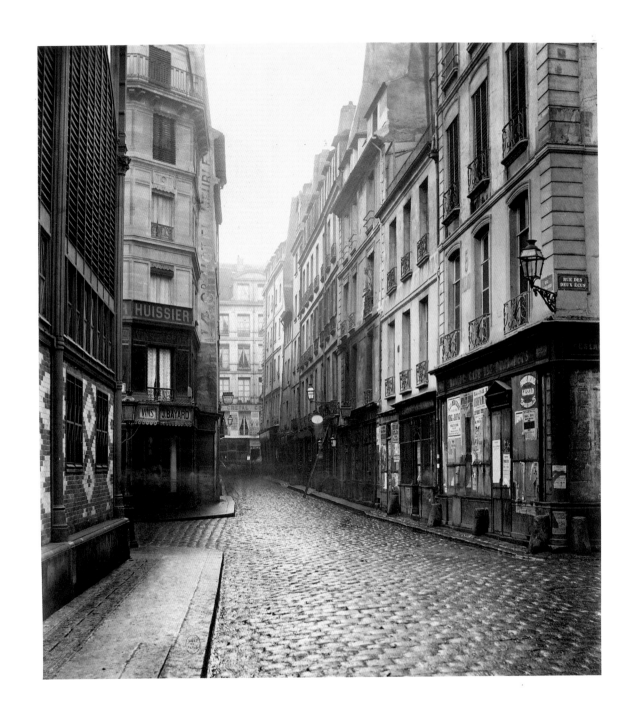

2.30. *Rue du Four (Côté regardant la rue S! Honoré)* [added in pencil: *Vauvilliers*], Marville, 1865 (CAR/RV).

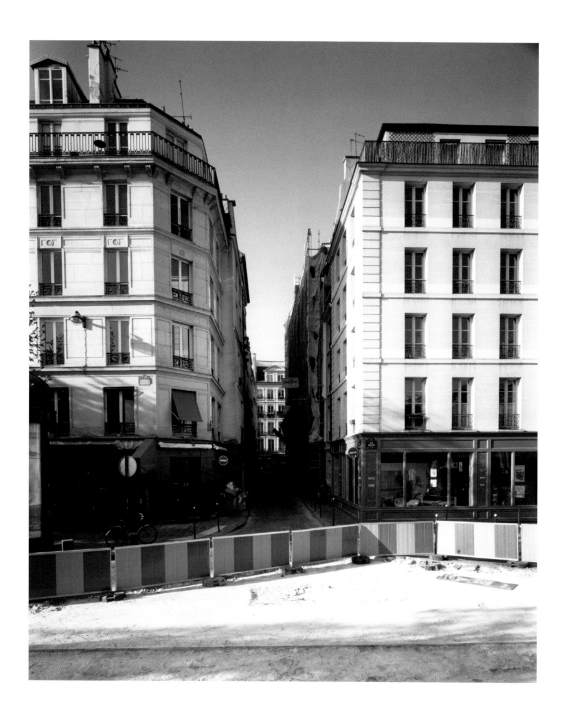

Rue Vauvilliers (from above Rue Berger), Sramek, 23.04.2010.

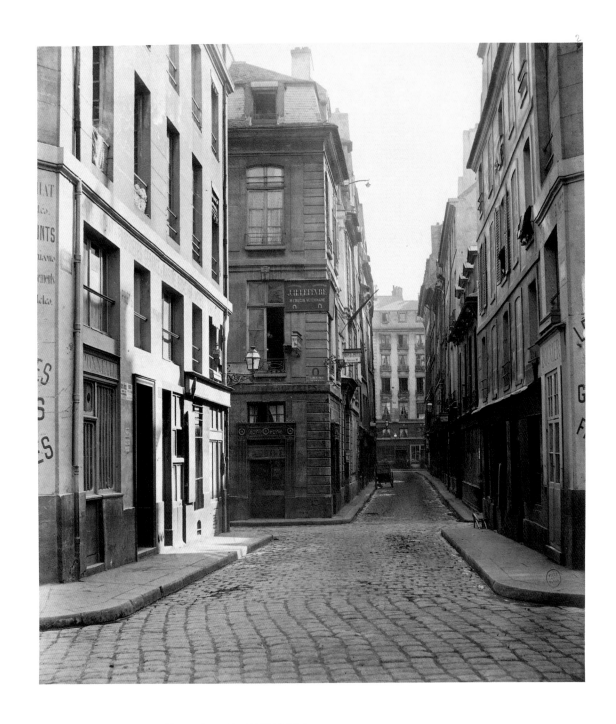

2.31. *Rue Sauval (de la Halle au Blé),* Marville, 1865-1868 (CAR/RV).

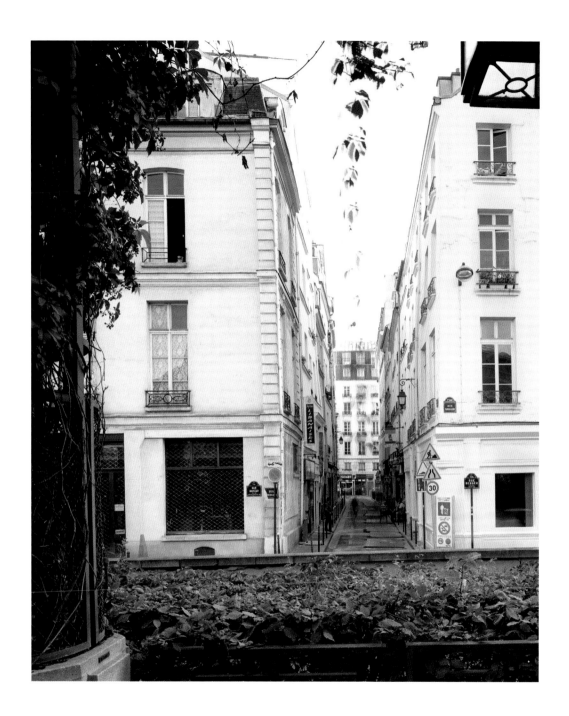

Rue Sauval (from above Rue Berger), Sramek, 14.08.2009.

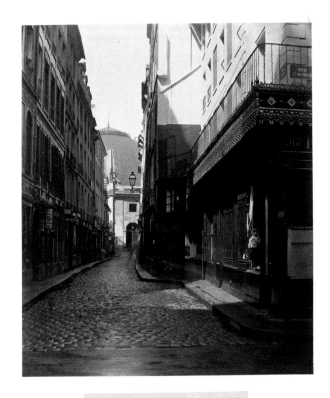

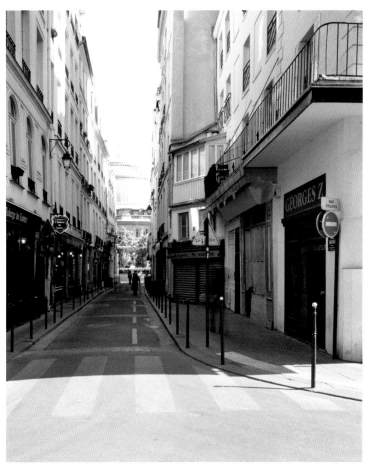

2.32. *Rue Sauval (de la rue St Honoré)*, Marville, 1865-1868 (CAR/RV). Rue Sauval (from Rue Saint-Honoré), Sramek, 18.05.2011.

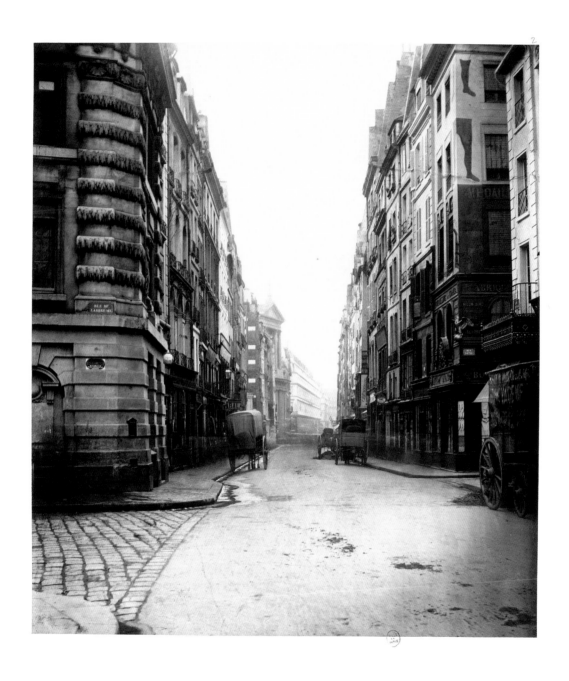

2.33. *Rue S.^t Honoré (de la rue de l'Arbre sec),* Marville, 1865-1868 (CAR/RV).

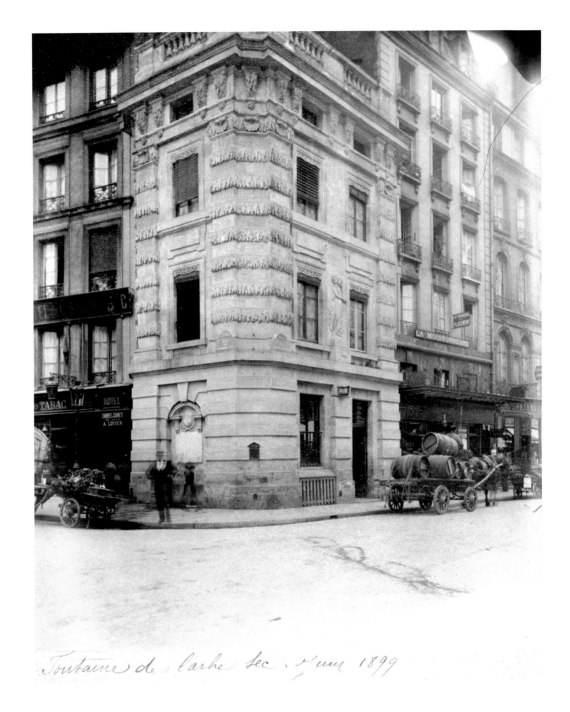

Fontaine de l'Arbre-Sec, Atget, June 1899 (CAR/RV).

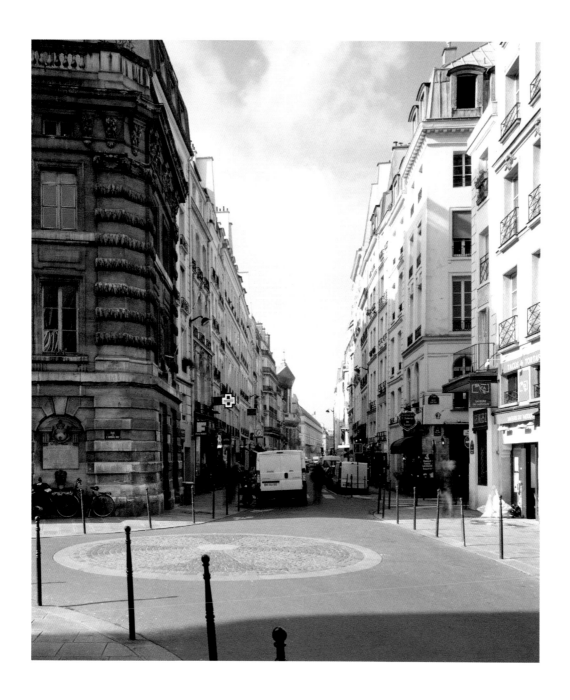

Rue Saint-Honoré (to the left Rue de l'Arbre-Sec, on the right Rue Sauval), Sramek, 22.02.2011.

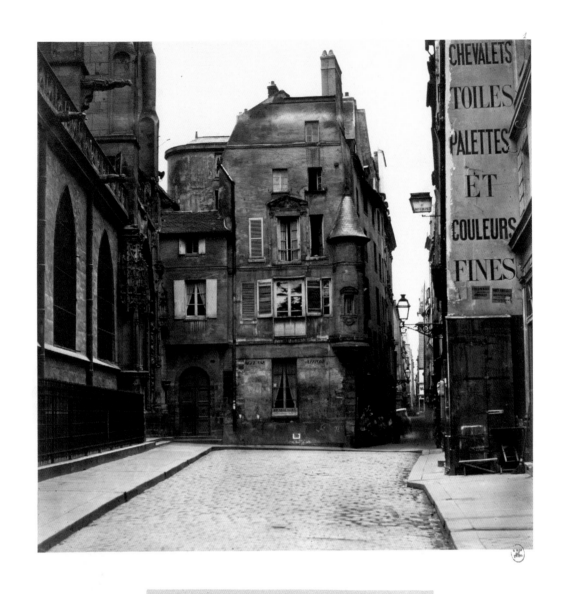

CHEVALETS
TOILES
PALETTES
ET
COULEURS
FINES

Tourelle de la rue des Prêtres S^t Germain l'Aux^{ois}

2.34. *Tourelle de la rue des Prêtres S^t Germain l'Aux^{ois}*, Marville, 1865-1868 (CAR/RV).

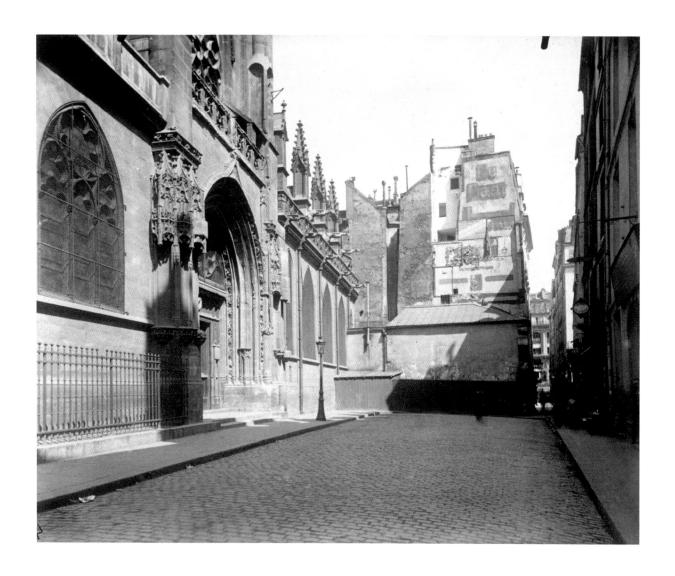

Rue des Prêtres-Saint-Germain-l'Auxerrois, Atget, 1902 (CAR/RV).

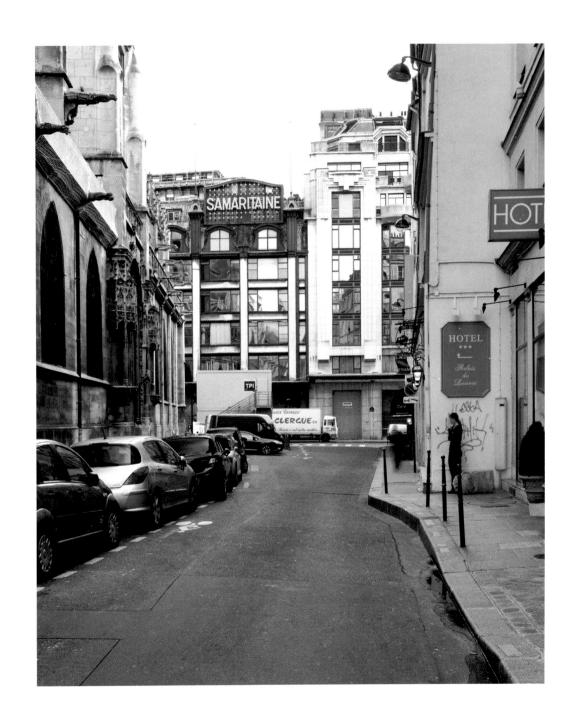

Rue des Prêtres St-Germain l'Auxerrois, Sramek, 22.02.2011.

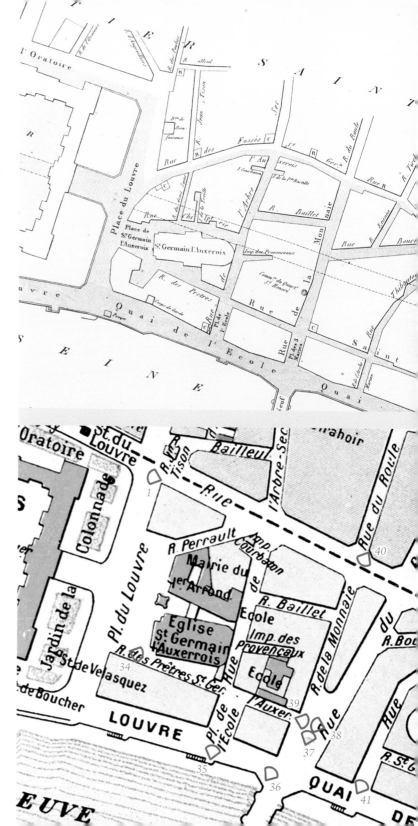

During many hours of making photographs in the street, I spoke with many people about the old photographs and about their perception of how the city has changed. Nearby, on the *quai du Louvre* (pl. 2.35), I spoke with an Englishman whose grandfather was an aerial photographer in the Second World War and taught him photography. He told me his first camera was a tin box with a pinhole. In *rue des Prêtres-St-Germain-l'Auxerrois*, I met an older couple. 'This is history, these old images,' they commented. 'One sees oneself in the past.' They appreciated the proposal to revisit a past they were familiar with and likened it to detective work. In fact, it did feel that way sometimes and occasionally I had to return to a site to reshoot. Alignment of architectural details was a primary clue as to Marville's camera position and in this location I easily miscounted the gargoyles of the church, leading to a serious but not obvious misalignment. When I came back to recalculate properly I found a one Eurocent coin lying exactly where I was supposed to set the tripod, as if Marville's spirit was there guiding me.

It was also here that I met Alain Roy, an amateur photographer with a keen interest in old Paris. He was busily photographing the church itself and we struck up a conversation. We kept in touch and met a number of times during my visits to Paris.

Alain Roy: Haussmann wanted to make a beautiful city – a beautiful capital. It had to evolve with the times. What he did, was develop the capital. He repaired it. It is phenomenal what they managed to do in the end, a complete renewal – modernism. I think they did something very significant.

Today, as well, there are many interesting *quartiers*. I started [to photograph] in the Marais but I saw that there were other *arrondissements* which also had old things, working-class neighbourhoods which were interesting to photograph before being razed to construct modern buildings … There are many *quartiers* which merit knowing – streets, street corners, also parks and gardens … There are modern things of interest as well – maybe not the buildings. La Défense – I find it ruins the landscape and [in *rue du Cardinal Lemoine* (pl. 5.07)] the new construction changes the view completely… It is 40 years that I have been in Paris and I still do not know all of Paris…

Fig. 41 (details).
Petit Atlas Pittoresque (1834)
No. 32 Auxerre (above),
Paris-Atlas, 1900 (below).

2.35. *Place de l'École (du quai),* Marville, 1865 (CAR/RV).

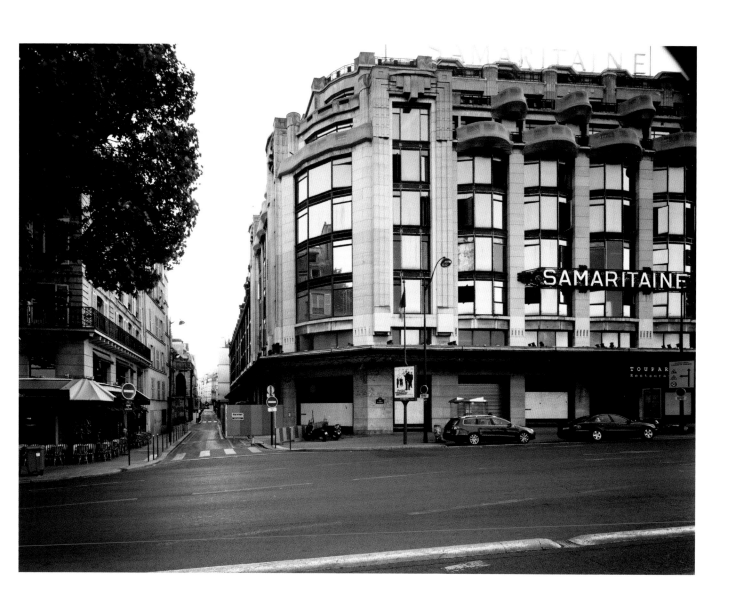

Quai du Louvre (towards Rue de l'Arbre-Sec), Sramek, 01.07.2010.

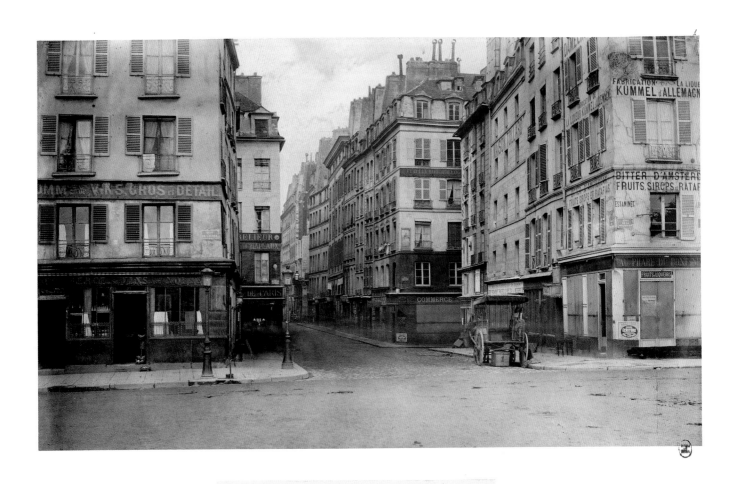

2.36. *Place des Trois Maries (du Pont-Neuf)*, Marville, 1865 (CAR/RV).

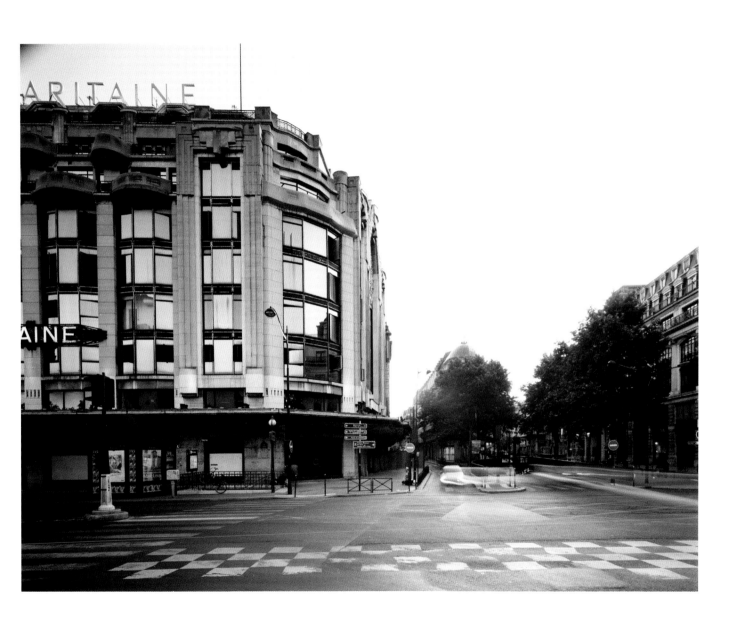

Confluence of Rue de la Monnaie and Rue du Pont-Neuf (from Pont Neuf across the Quai du Louvre), Sramek, 30.06.2010.

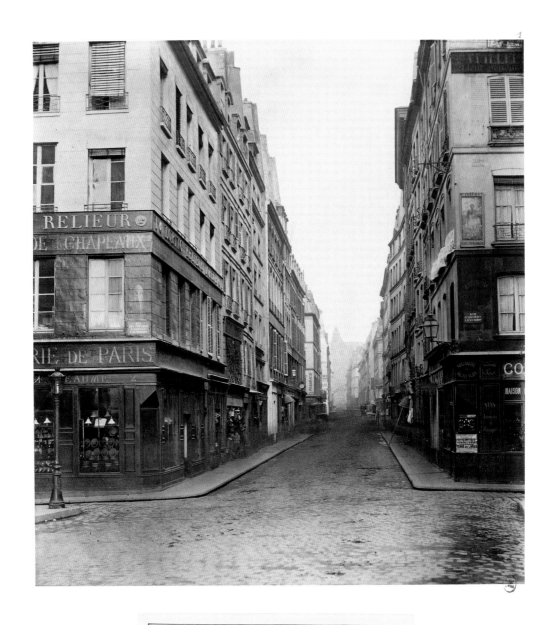

2.37. *Rue de la Monnaie (de la place des Trois Maries)*, Marville, 1865 (CAR/RV).

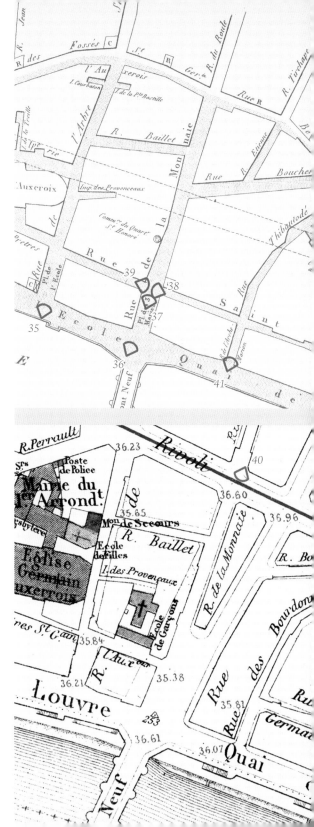

The construction of *rue du Pont-Neuf* created a new, wider path from the bridge to the central markets. Today, the intersection sees a confluence of the old *rue de la Monnaie*, *rue du Pont-Neuf* and the exit from the underground roadway, built in the 1970s, which moves traffic beneath the Forum des Halles.

Although now closed, the Samaritaine department store, like *les grands magasins Dufayel* and others, once took over a number of blocks. It grew progressively, engulfing Marville's streets with its art deco construction. A portion of *rue des Prêtres-St-Germain-l'Auxerrois* was filled in as the original department store expanded towards the river. Later, as they built towards the *rue de Rivoli*, the store incorporated one of the older buildings and, surprisingly, this façade from Marville's day is still visible today as part of the store complex (see pl. 2.40). The secondary Samaritaine building, seen in the left of this photograph from *rue de Rivoli*, mimics the angled entrance of the building of Marville's time. Today, while the main complex of the Samaritaine is under renovation, this building is now home to other fashion stores.

Rue de la Monnaie (from the Quai du Louvre),
Sramek, 20.09.2010.

Fig. 42 (details).
Petit Atlas Pittoresque (1834)
No. 2 Monnaie (above),
Atlas Administratif, 1868 (below).

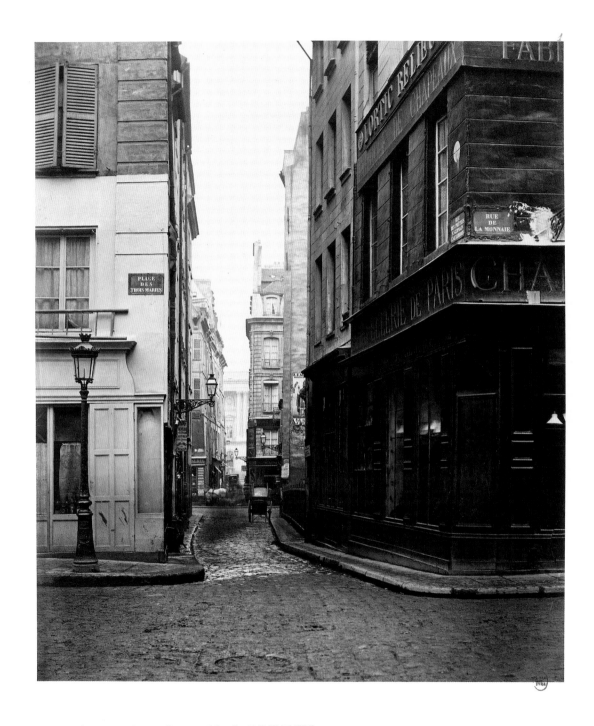

2.38. *Rue des Prêtres St Germain l'Auxerrois*, Marville, 1865 (CAR/RV).

La Samaritaine (from Rue de la Monnaie), Sramek, 20.09.2010.

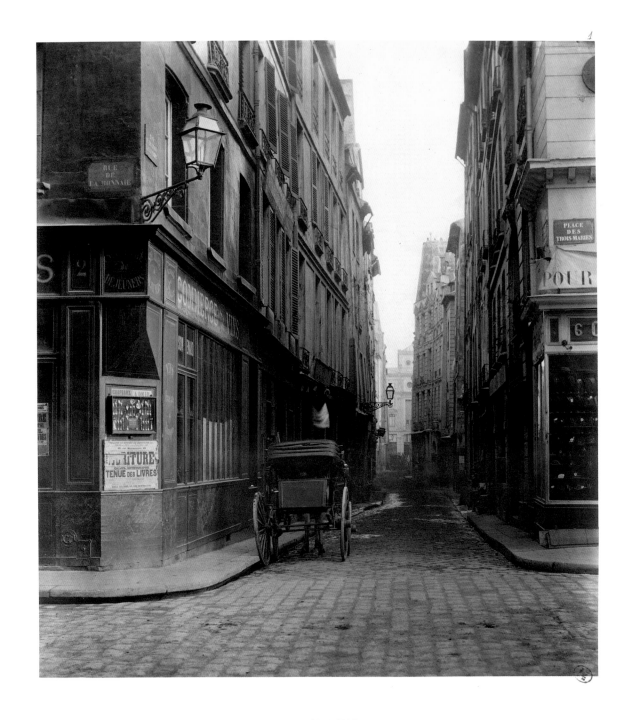

2.39. *Rue S^t Germain l'Auxerrois (de la rue des Prêtres)*, Marville, 1865 (CAR/RV).

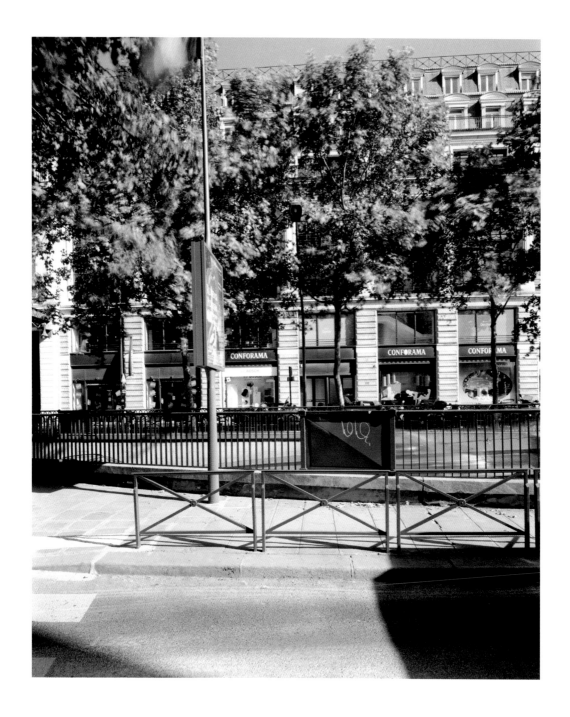

Looking across Rue du Pont-Neuf (from Rue de la Monnaie), Sramek, 20.09.2010.

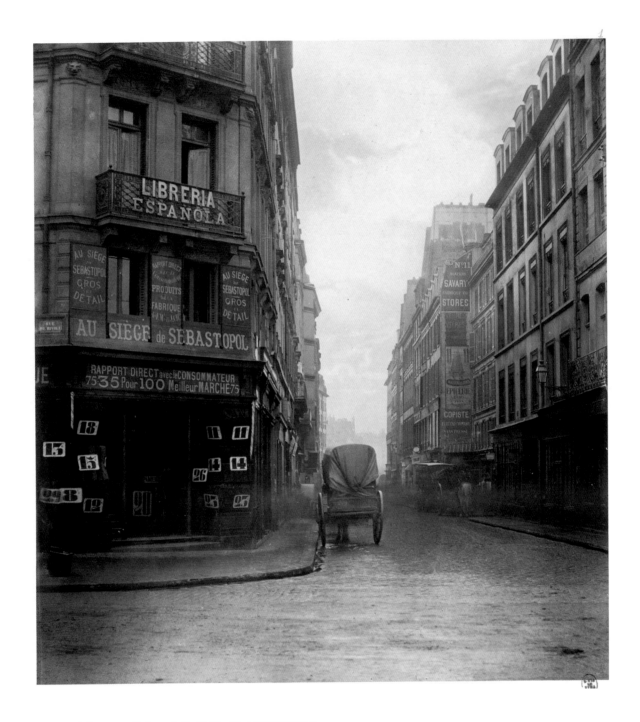

2.40. *Rue de la Monnaie (de la rue de Rivoli)*, Marville, 1865 (CAR/RV).

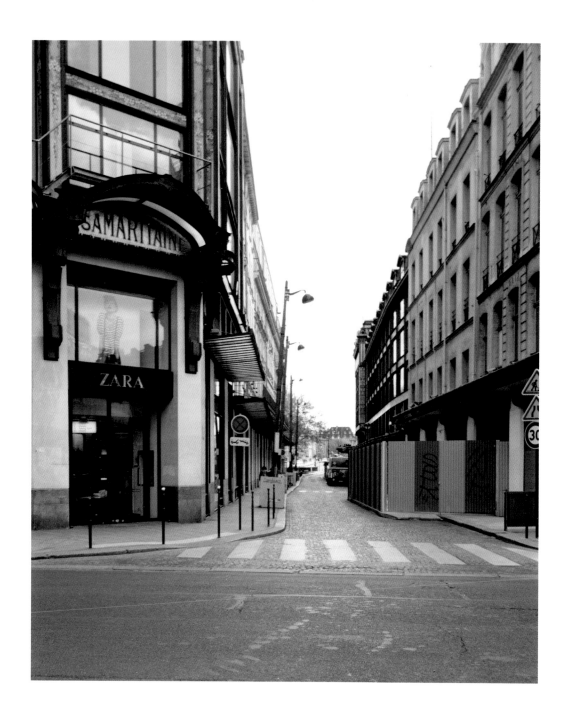

Rue de la Monnaie (from Rue de Rivoli), Sramek, 26.04.2010.

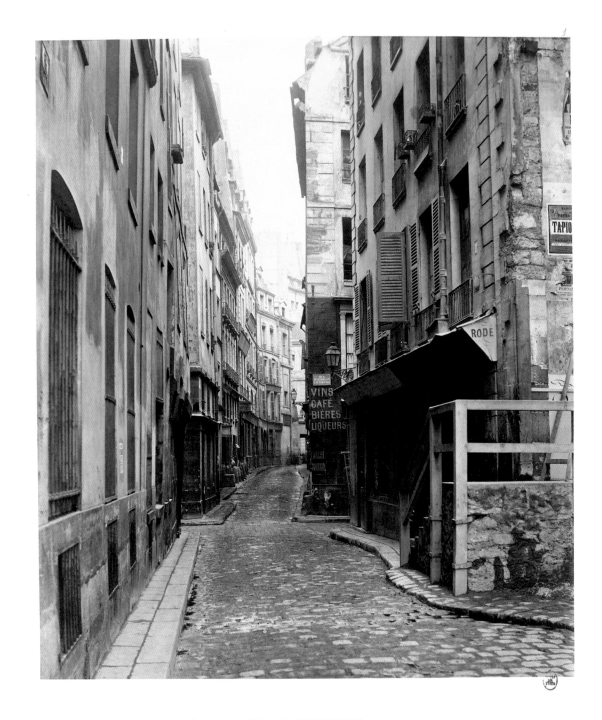

2.41. *Rue de l'Arche-Marion (du quai de la Mégisserie),* Marville, 1865 (CAR/RV).

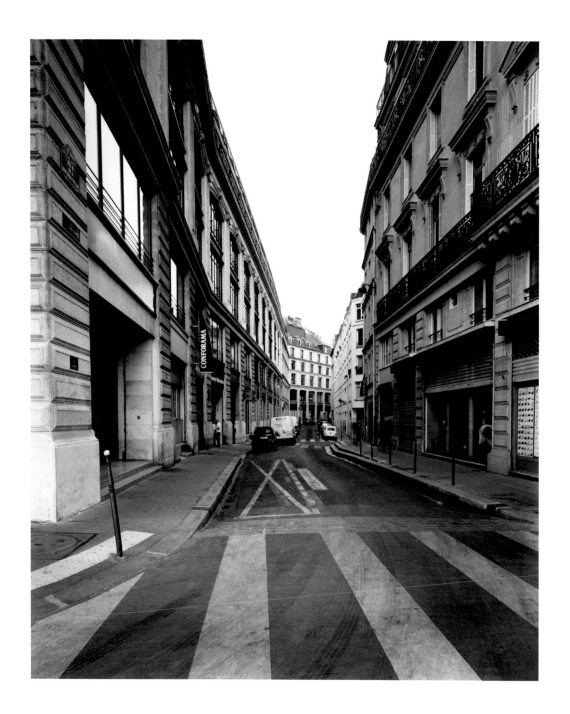

Rue des Bourdonnais (from the Quai de la Mégisserie), Sramek, 26.04.2010.

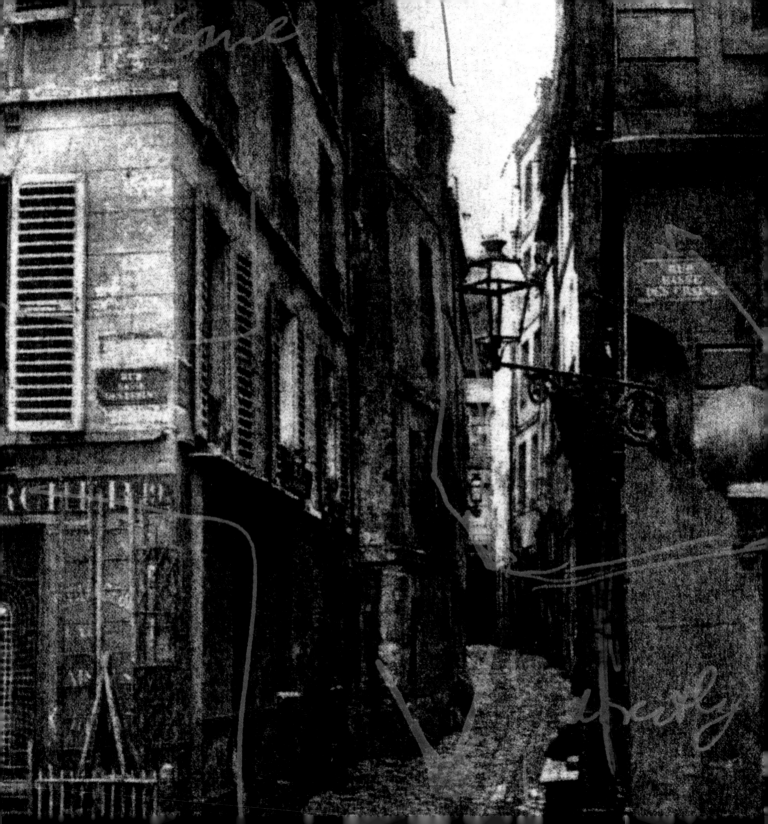

Île-de-la-Cité

Fig. 43. Locations (overleaf)
Atlas Pittoresque (1834)
No. 44 Palais de Justice/No. 35 Cité
(collaged details showing sites 1865-68),
Atlas Administratif, 1868
(sites c. 1877).

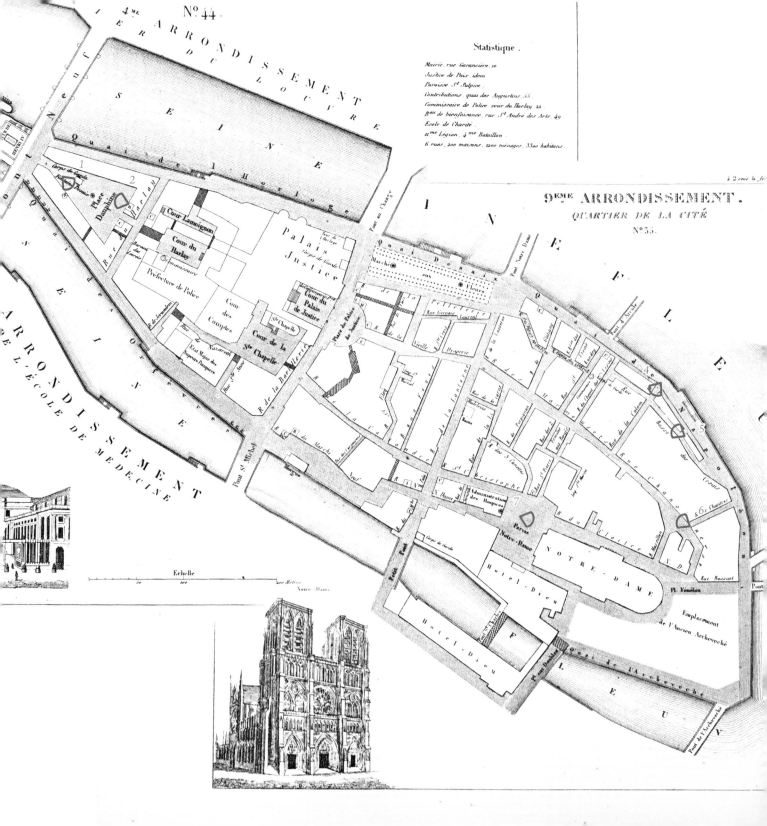

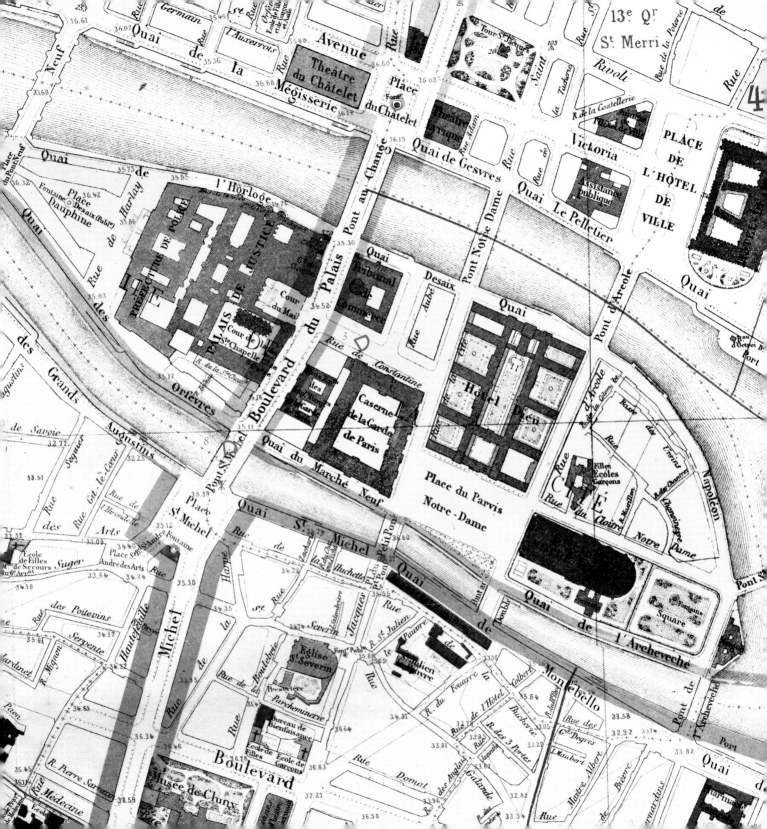

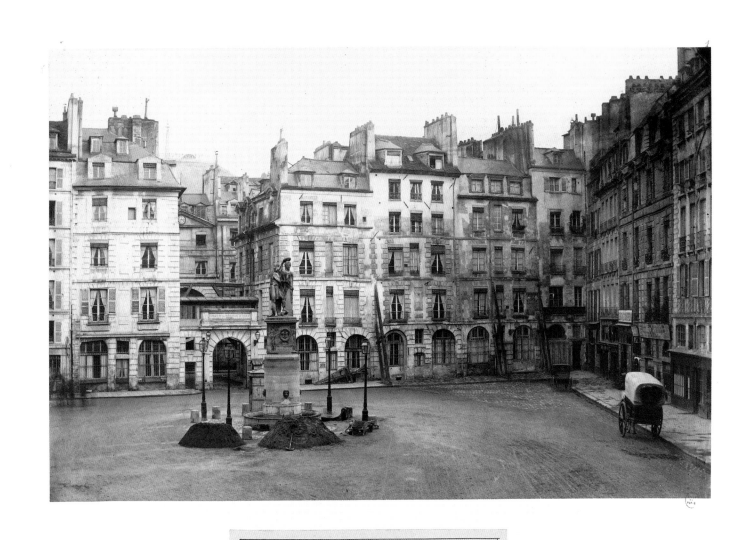

Place Dauphine.

3.01. *Place Dauphine*, Marville, 1865 (CAR/RV).

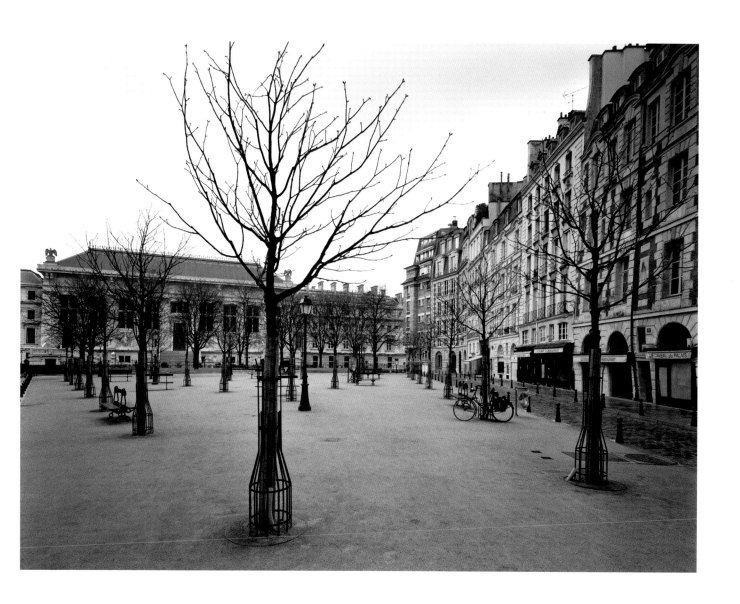

Place Dauphine (looking east), Sramek, 20.02.2011.

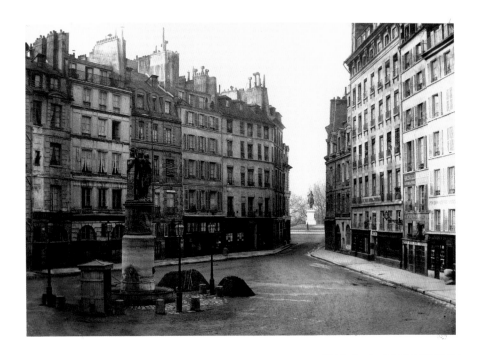

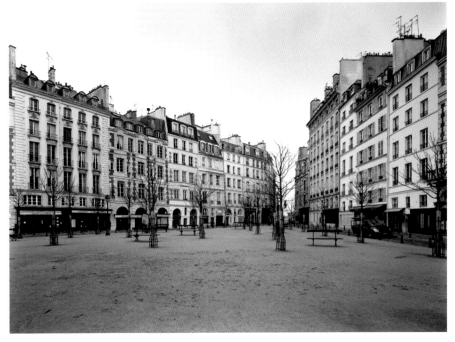

3.02. *Place Dauphine*, Marville, 1865 (CAR/RV) (above).
Place Dauphine (looking west), Sramek, 20.02.2011 (below).

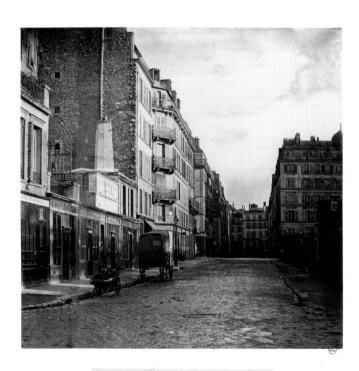

3.03. *Rue Constantine (du B^ard du Palais)*, Marville, 1865 (CAR/RV). Rue de Lutèce, Sramek, 04.02.2012.

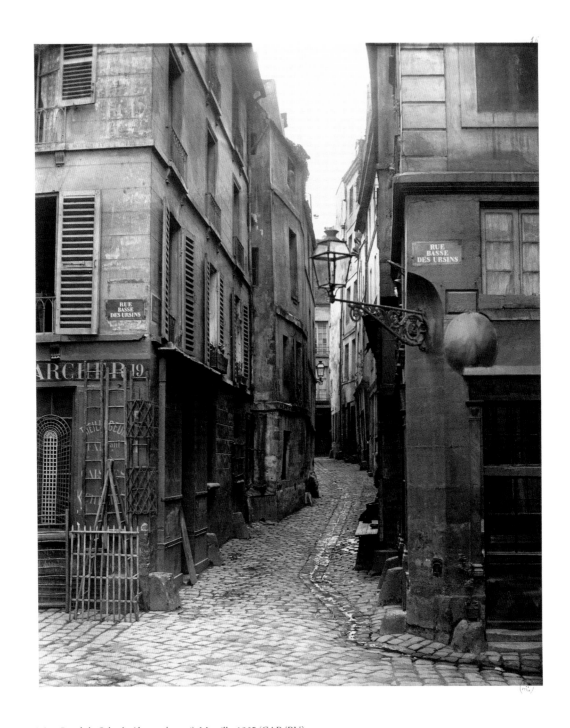

3.04. *Rue de la Colombe (du côté du quai)*, Marville, 1865 (CAR/RV).

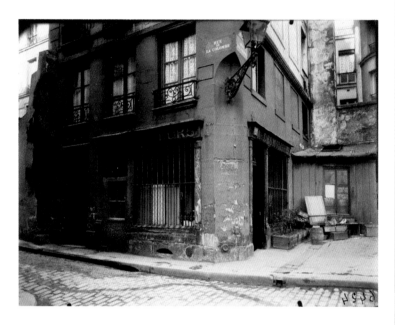

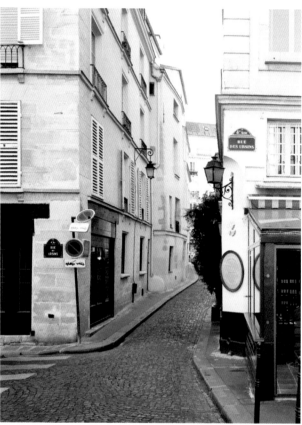

21 Rue de la Colombe, Atget, 1923 (CAR/RV).　　　　　　　　　Rue de la Colombe (from the Quai aux Fleurs), Sramek, 15.08.2009.

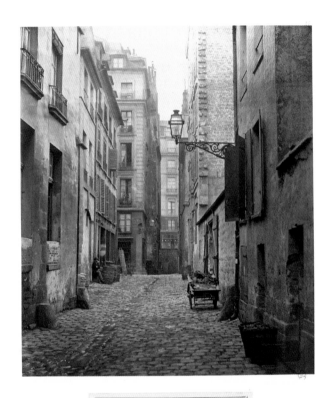

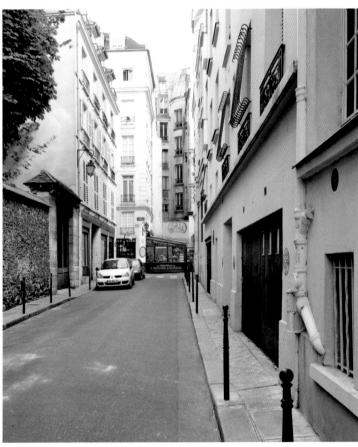

3.05. *Rue Basse des Ursins*, Marville, 1865 (CAR/RV). Rue des Ursins, Sramek, 15.08.2009.

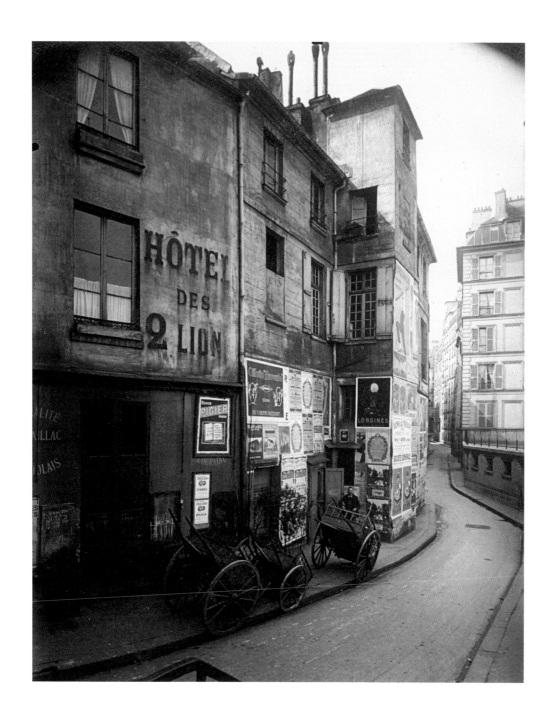

Rue des Ursins, Atget, c.1923 (CAR/RV).

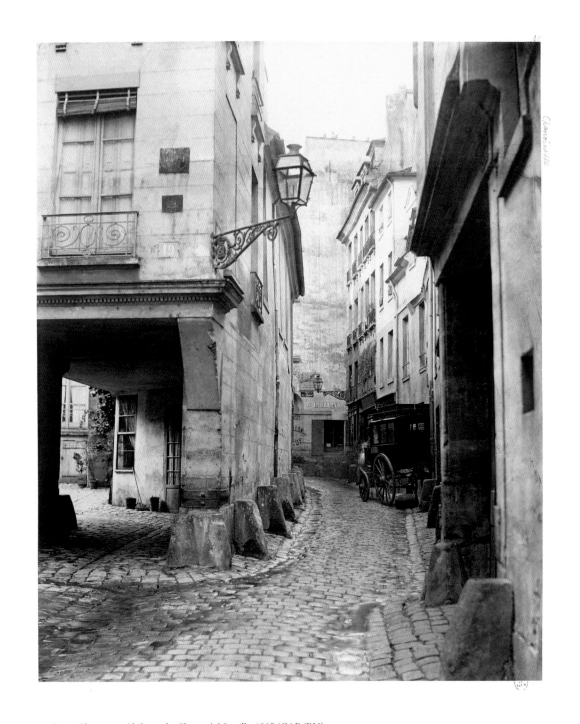

3.06. *Rue Chanoinesse (de la rue des Chantres),* Marville, 1865 (CAR/RV).

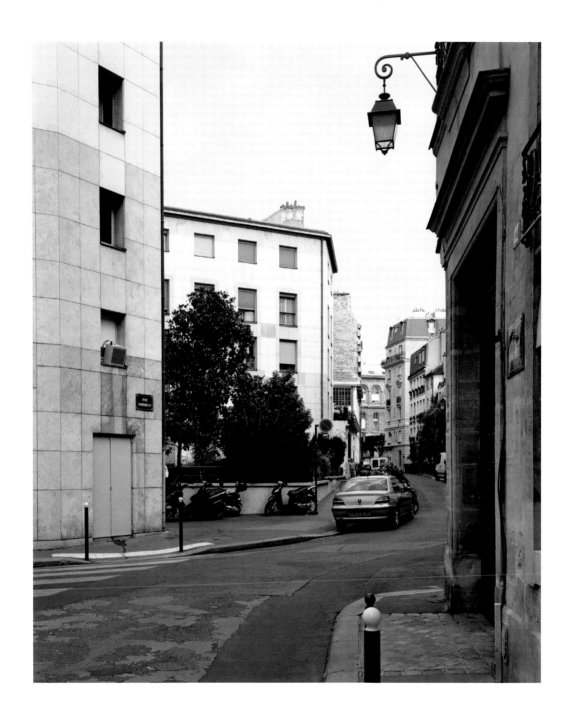

Rue Chanoinesse (from Rue des Chantres), Sramek, 01.07.2010.

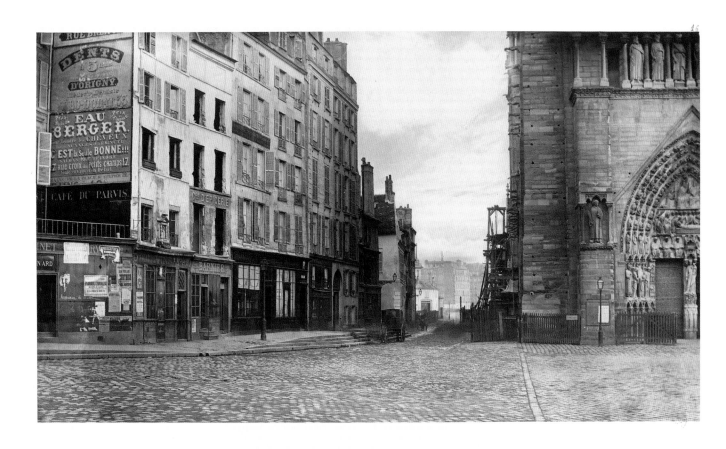

Rue du Cloître - N. Dame
du Parvis.

Marville's photograph which includes Notre Dame makes it clear that, for this particular commission, he was consider-ing the streets much more than the architecture. He did make photographs of the church itself at another time, but here it was not the focus, despite its cultural and historical importance. Monumental architecture, which was often the subject of photographs of the period, was not part of this particular representation of the urban environment.

3.07. *Rue du Cloître-N. Dame du Parvis*, Marville, 1865 (CAR/RV).

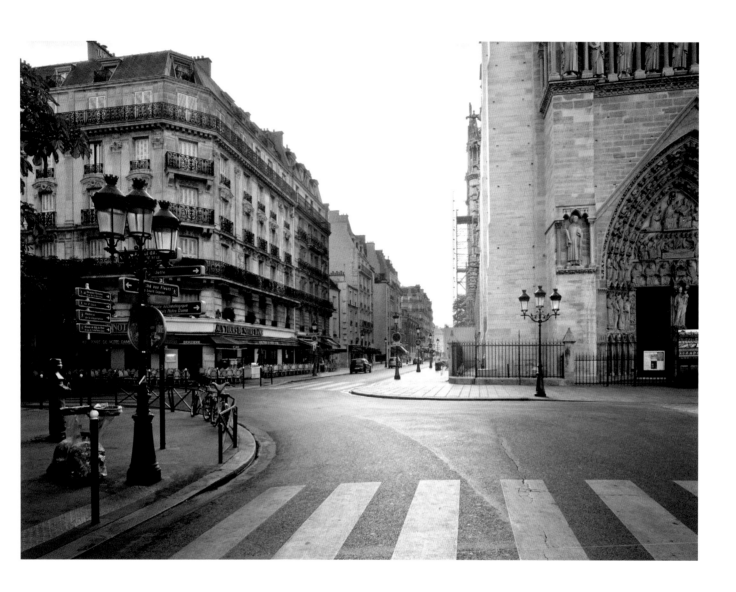

Rue du Cloître-Notre-Dame, Sramek, 16.08.2009.

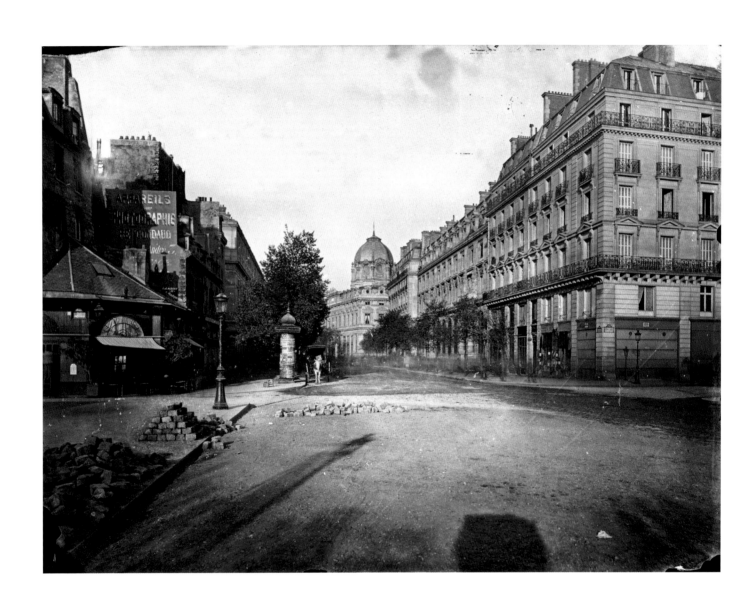

3.08. [*Boulevard du Palais (vue prise du pont Saint-Michel)*], Marville, c.1873-1877 (BHVP/RV).

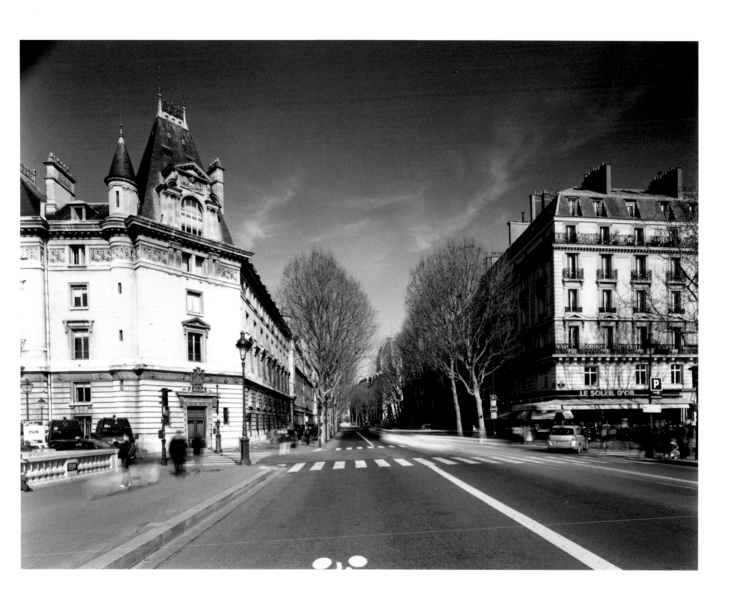

Boulevard du Palais (from Pont Saint-Michel), Sramek, 22.02.2011.

photos
after 585 bldg.
was taken down?
Galande corner
 changed for
 rue Da Grange maitre
this
St. Germain

Saint-Séverin - Place Maubert

Fig. 44. Locations (overleaf)
Atlas Administratif, 1868
(sites 1865-68),
Paris-Atlas, c. 1900
(sites c. 1877).

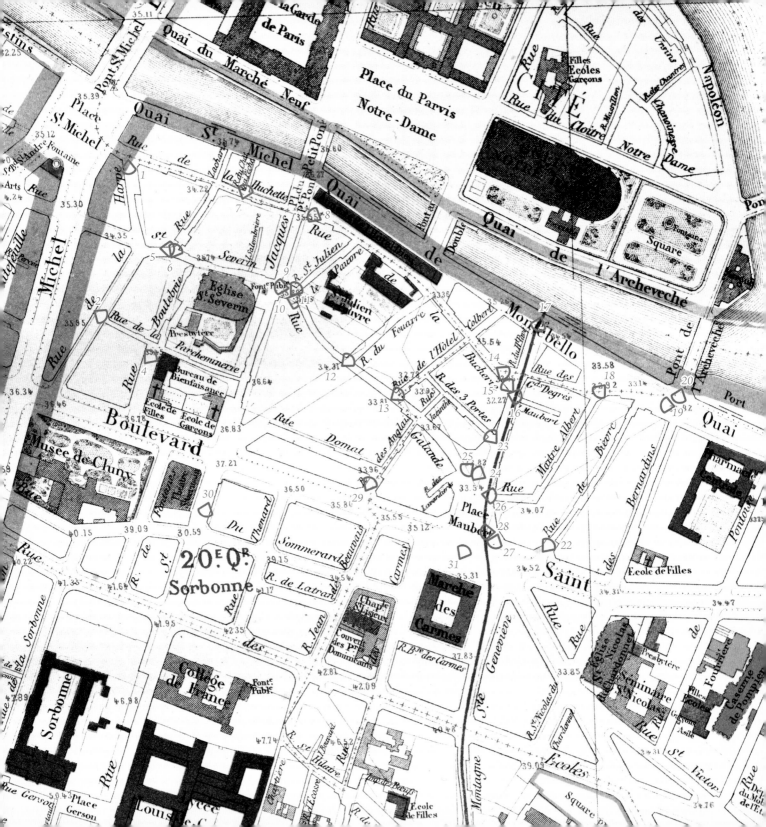

LA CITÉ

LA
du Parvis
-Dame
Statue de
Charlemagne

Rue du Cloître-Notre-Dame

R. Massillon
R. des Chantres
R. Chanoinesse

CITÉ

ÉGLISE
NOTRE-DAME

QUAI

DE L'ARCHEVÊCHÉ

Square
de
l'Archevêché

FLEURS

Pont St Louis

Morgue

Pont de l'Archevêché

QUAI DE BOURBN

Pont Ls Philippe

ville

L'HÔTEL-DE-V

Port

des Ormes

QUAI — DE — BOURBON

R. du Bellay

R. du Regrattier

16

R. Boulard

Quai

Le Regrattier

Rue

ILE

D'ORLÉANS

Rue

Rue Budé

Rue des

Deux Ponts

Comp

Egl. St

École

QUAI

N

Rue

Pont d'Hôpital au Double

Rue Frédéric

Hôtel Colbert

Rue de la Bucherie

Rue de la Bucherie

Rue des 3 Portes

Lagrange

Place
Maubert

St.
d'Étienne Dolet

32 SAINT

Rue des Carmes

Marché
des
Carmes

Rue des Carmes

Maubert

Rue

MONTEBELLO

Rue des
Gds Degrés

Maître Albert

Rue de Bièvre

Église
St Nicolas

Séminaire

Rue St Victor

QUAI — DE — LA — TOURNELLE

Pharmacie
Centrale
des
Hopitaux
Civils

École

Rue R. Cochin

Rue Pontoise

Casserne des
Pompiers de
École Poissy

Imp du Card.
Lemoine

École

GERMAIN

Port de la Tournelle

Pont de la Tournelle

Port

St

Rue du Card.
Lemoine

R. des Chantiers

R. d'Chantiers

Rue Bernard

St Bernard

des fossés St

Touraine

de

Languedoc

21

HA

Rue
Montagne

Square

des

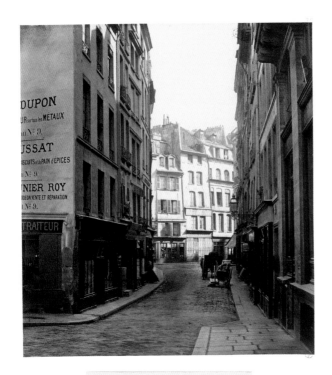

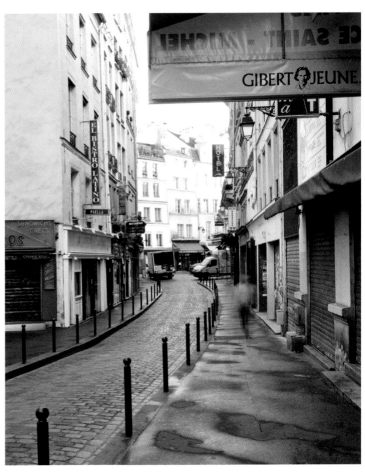

In this area of the Left Bank there is a mix of old and newer street formations and many buildings have changed little. In *rue de la Harpe*, one finds where Haussmann's demolition plans were brought abruptly to a halt even though he likely would have razed it all, given the time. The west side of this street was demolished (on the far side the new buildings front onto *boulevard Saint-Michel*). The east side of *rue de la Harpe* remains as it was. Although Atget did not remake Marville's view of *rue de la Parcheminerie*, it looks towards the streets surrounding the church of *Saint-Séverin* where Atget did photograph intensively over many years, making over 70 photographs in a one block area.

4.01. *Rue de La Harpe (de la rue de la Huchette)*, Marville, 1865 (CAR/RV). Rue de la Harpe (from Rue de la Huchette), Sramek, 15.08.2009.

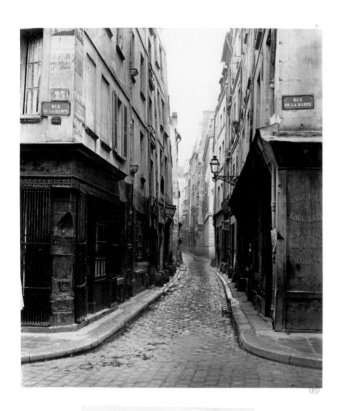

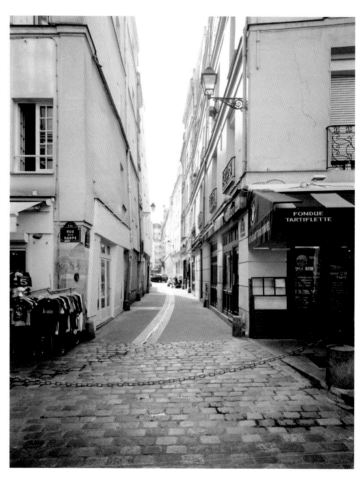

4.02. *Rue de la Parcheminerie (de la rue de La Harpe),* Marville, 1865 (CAR/RV).

Rue de la Parcheminerie (from Rue de la Harpe), Sramek, 01.07.2010.

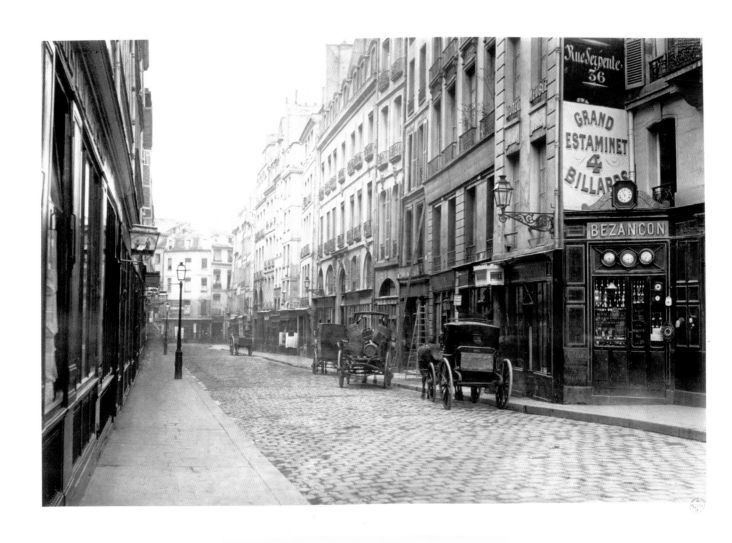

4.03. *Rue de La Harpe (du B^ard S^t Germain)*, Marville, 1865 (CAR/RV).

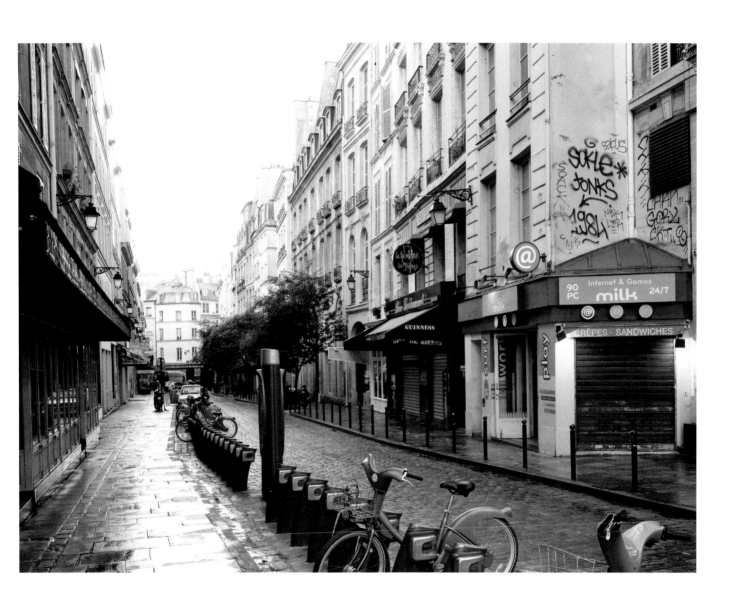

Rue de La Harpe (from Boulevard Saint-Germain), Sramek, 15.08.2009.

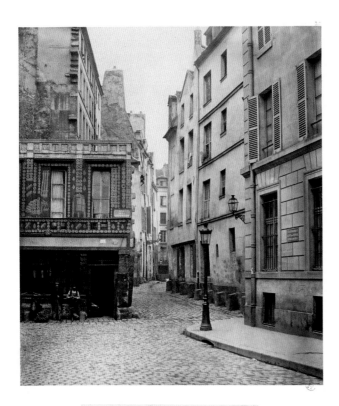

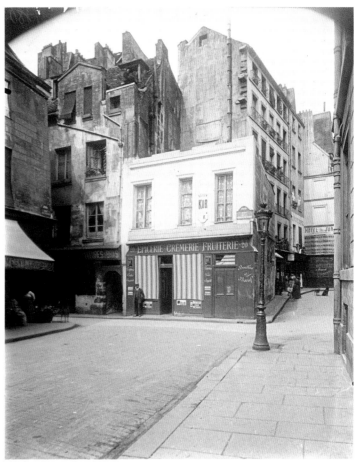

4.04. *Rue des Prêtres S^t Séverin (de la rue Boutebrie), Marville, 1865 (CAR/RV).* *Coin, rue de la Parcheminerie et rue Boutebrie, Atget, 1912 (CAR/RV).*

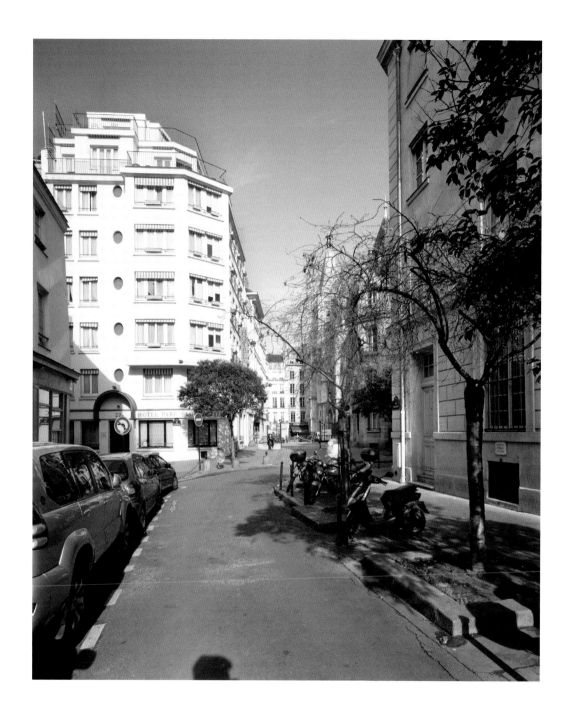

Rue des Prêtres-Saint-Séverin (from Rue Boutebrie), Sramek, 22.02.2011.

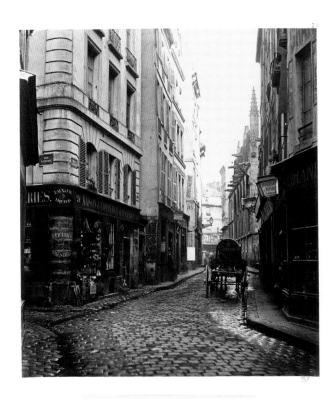

Rue St Séverin
(de la rue de La Harpe)

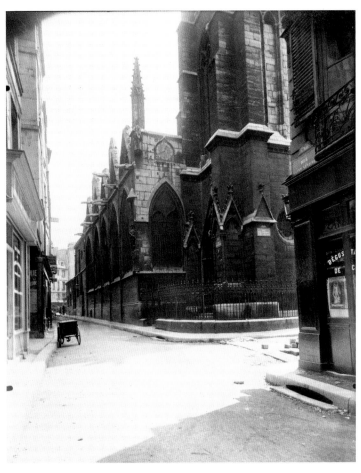

4.05. *Rue Sᵗ Séverin (de la rue de La Harpe),* Marville, 1865 (CAR/RV). *Eglise Saint-Séverin au coin de la rue St-Séverin,* Atget, 1923 (CAR/RV).

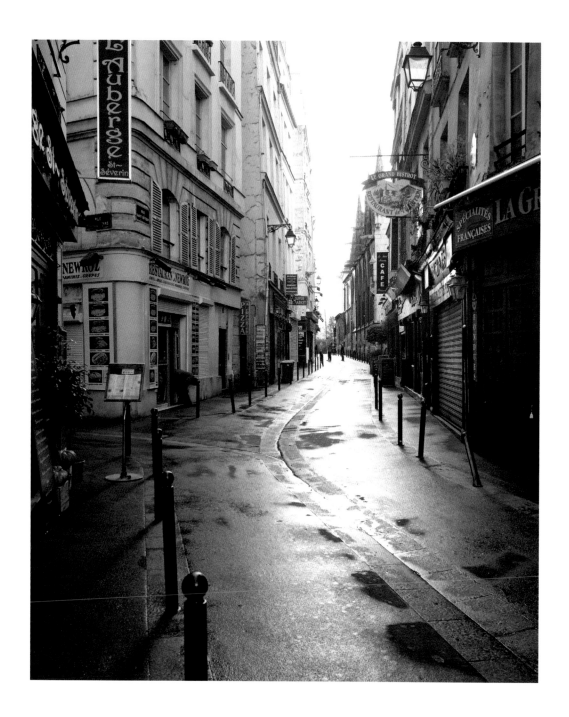

Rue Saint-Séverin (to the left, Rue Xavier-Privas), Sramek, 15.08.2009.

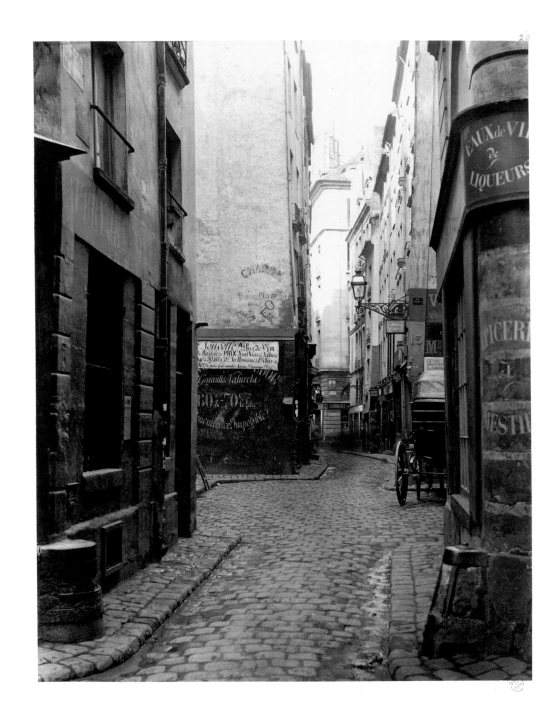

4.06. *Rue Zacharie (de la rue Sᵗ Séverin)*, Marville, 1865 (CAR/RV).

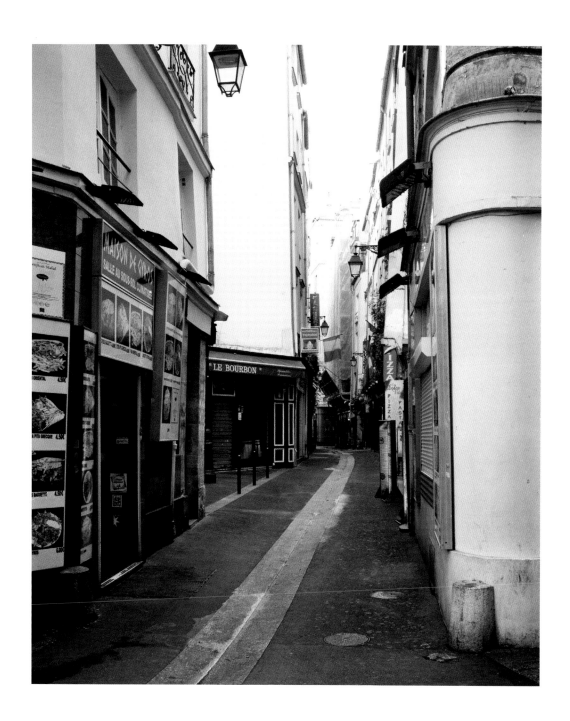

Rue Xavier-Privas, Sramek, 15.08.2009.

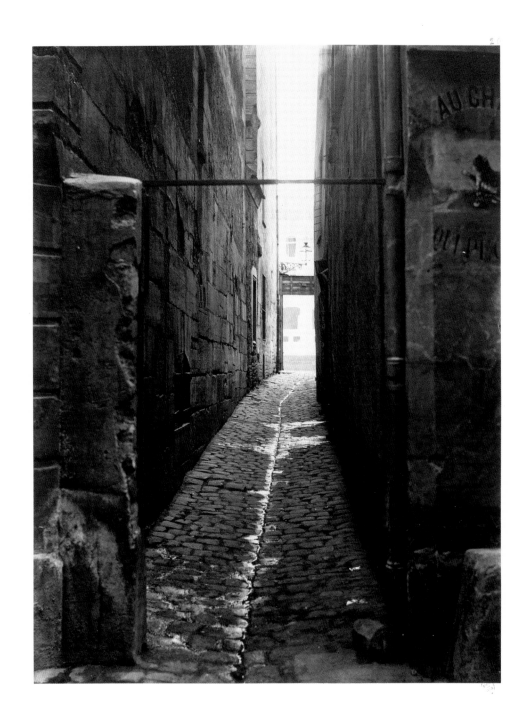

4.07. *Rue du Chat qui pesche (de la rue de la Huchette)*, Marville, 1865 (CAR/RV).

Rue du Chat-qui-Pesche, Sramek, 15.08.2009.

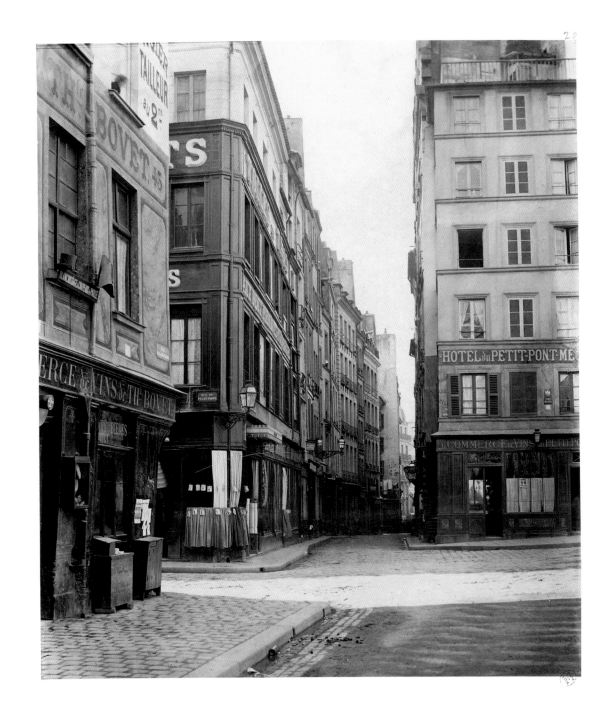

4.08. *Rue de la Huchette (de la rue de la Bucherie)*, Marville, 1865 (CAR/RV).

Rue de la Huchette (seen in the distance from Rue de la Bucherie across Rue du Petit-Pont), Sramek, 24.02.2011.

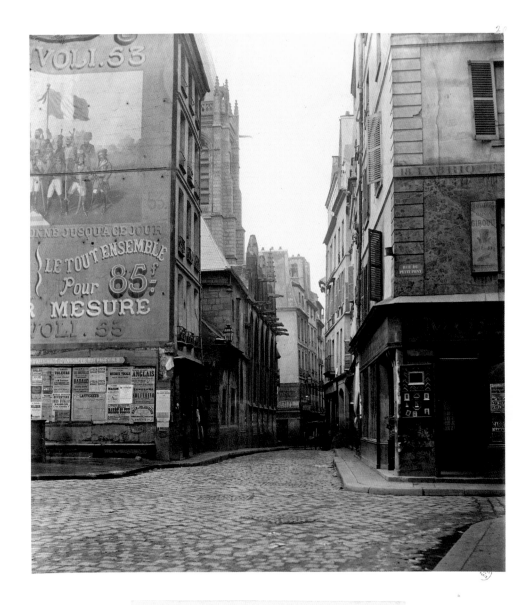

4.09. *Rue S^t Séverin (de la rue Galande)*, Marville, 1865 (CAR/RV).

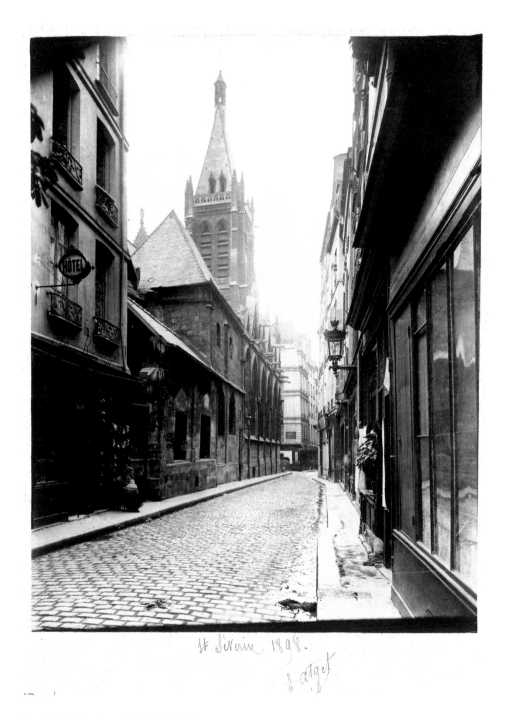

Rue Saint-Séverin, Atget, 1898 (CAR/RV).

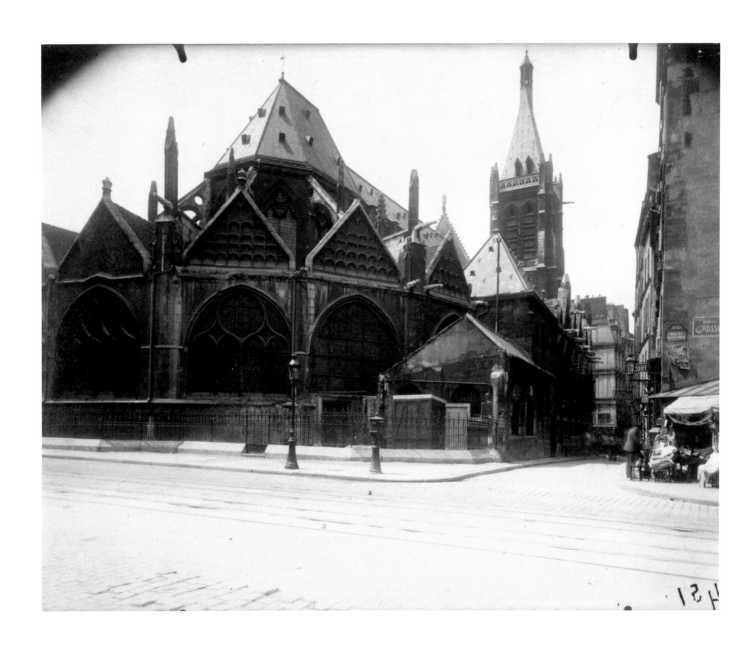

Eglise Saint-Séverin, Atget, 1923 (CAR/RV).

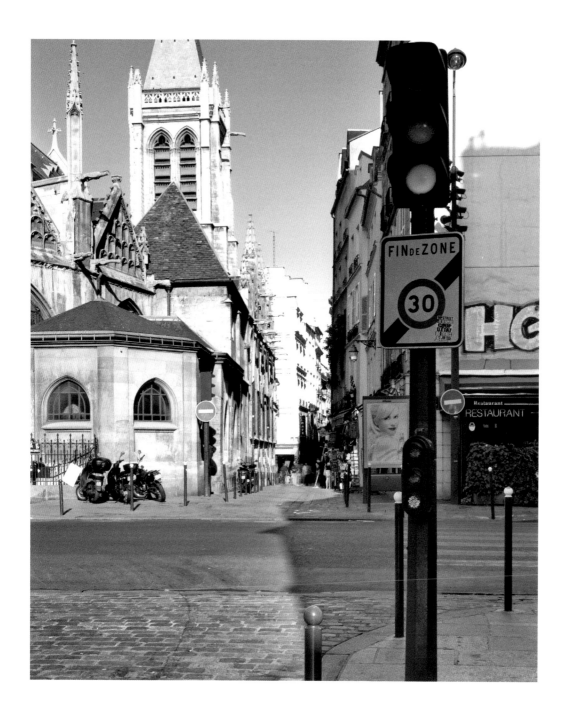

Rue Saint-Séverin (from Rue Galande), Sramek, 15.08.2009.

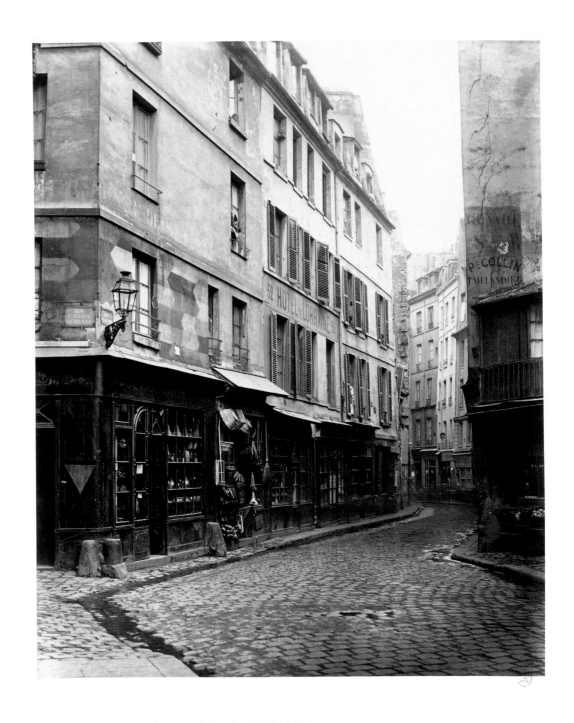

4.10. *Rue Galande (de la rue du Petit-pont)*, Marville, 1865 (CAR/RV).

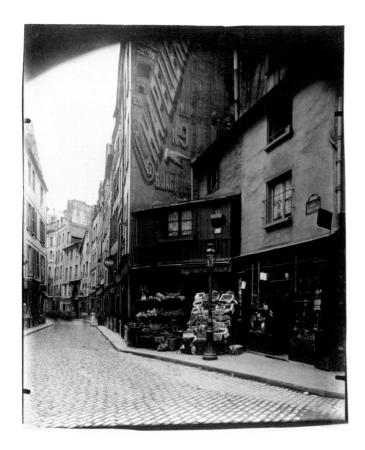

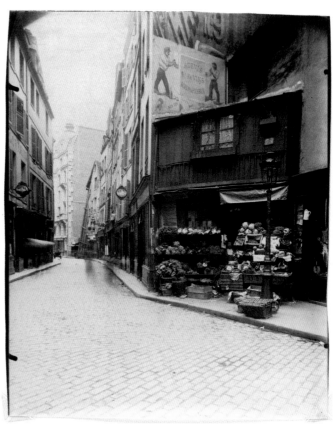

In *rue Galande*, one sees an example of how the widening of the narrow streets was most often accomplished. One side of the street or one layer of buildings was removed, in this case the left corner, along the east side of *rue St-Julien-le-Pauvre* (pl. 4.11) up to where it meets *rue Galande*. This provides the current view of the historic chapel, which was hidden behind the buildings, but leaves the blind wall which has been exposed. The small angled building on the right was a well-known *'vieux Paris'* motif when Atget photographed it three times over a number of years, coming back to more or less the same angle of view.

77 Rue Galande, Atget, May 1899, (CAR/RV).

Atget, 1902 (CAR/RV).

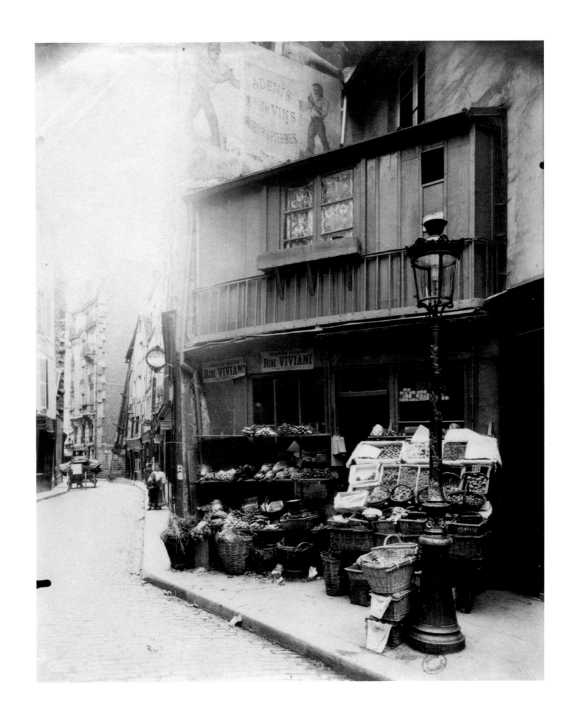

Atget, 1906 (CAR/RV).

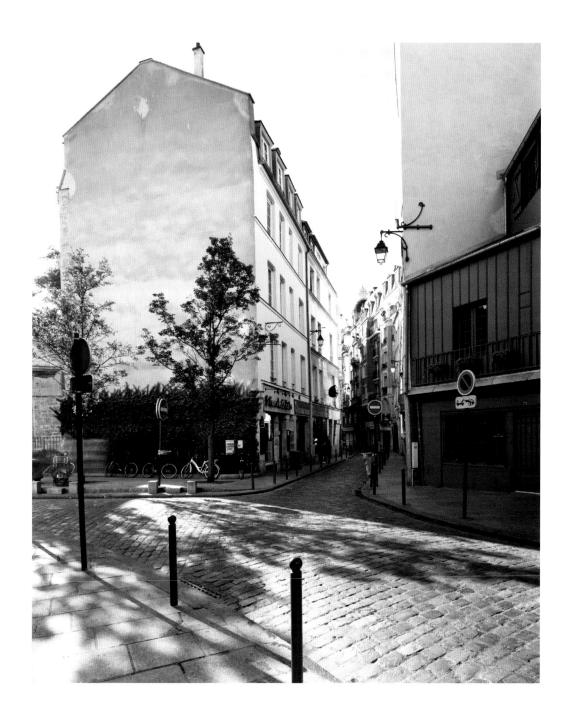

Rue Galande (from Rue du Petit-Pont), Sramek, 15.08.2009.

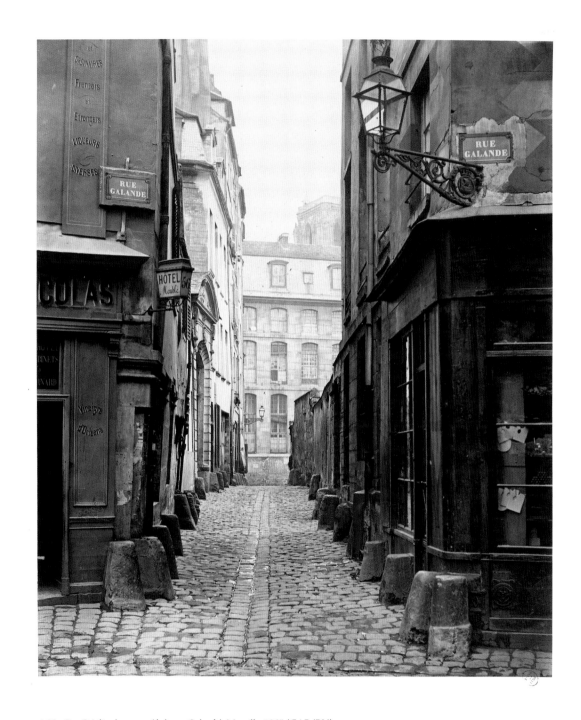

4.11. *Rue S[t] Julien le pauvre (de la rue Galande)*, Marville, 1865 (CAR/RV).

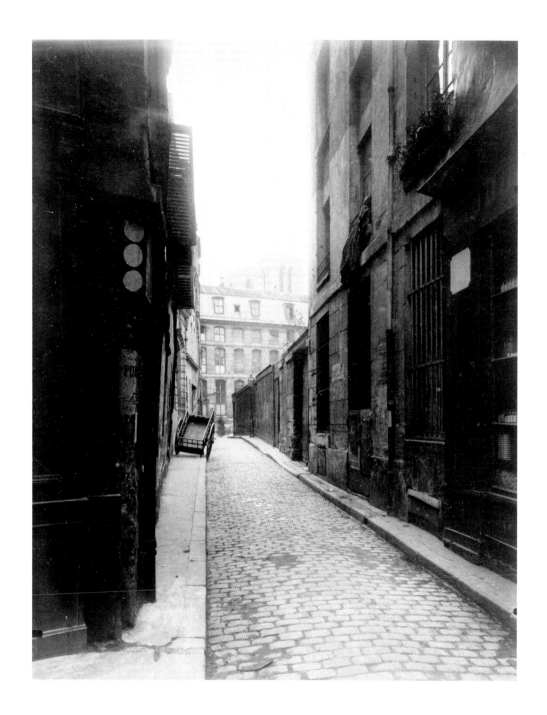

Atget, 1898 (CAR/RV).

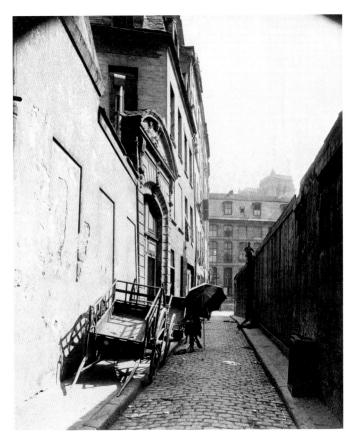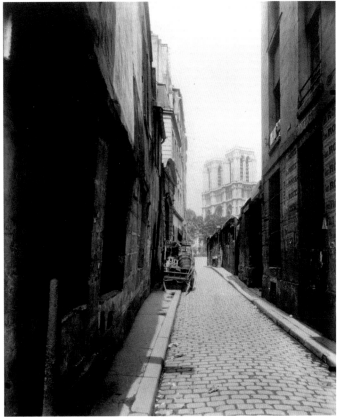

Hôtel d'Isaac de Laffemas, 14 rue Saint-Julien-le-Pauvre, Atget, Aug. 1899 (CAR/RV). Atget, 1912 (CAR/RV).

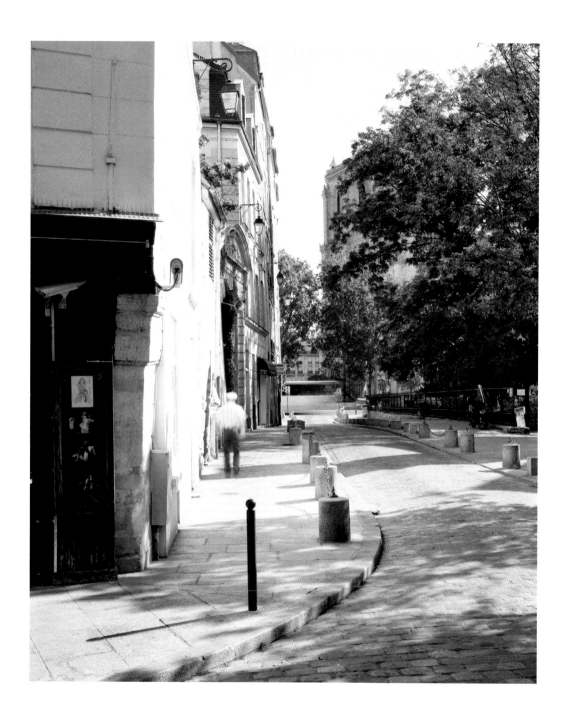

Rue Saint-Julian-le-Pauvre, Sramek, 15.08.2009.

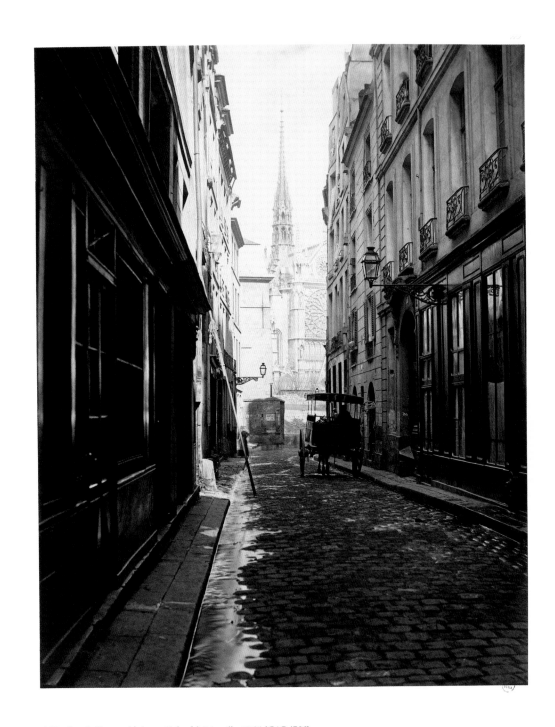

4.12. *Rue du Fouarre (de la rue Galande)*, Marville, 1865 (CAR/RV).

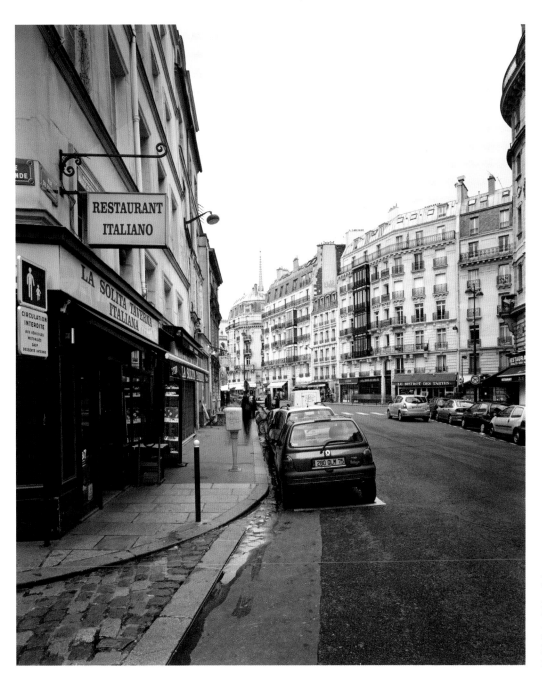

Rue du Fouarre, now *rue Dante*, was truncated by the construction of *rue Lagrange* which cuts right across, leading traffic on its way from *place Maubert* to the Seine. In fact, fully one half of the length of *rue Galande* has been superseded by this fast-moving thoroughfare (pl. 4.24).

Rue Dante (from Rue Galande), Sramek, 20.02.2011.

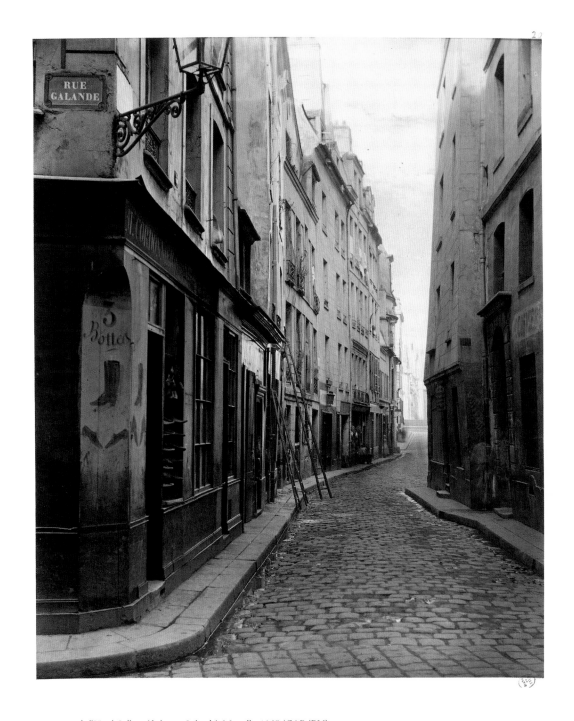

4.13. *Rue de l'Hôtel Colbert (de la rue Galande)*, Marville, 1865 (CAR/RV).

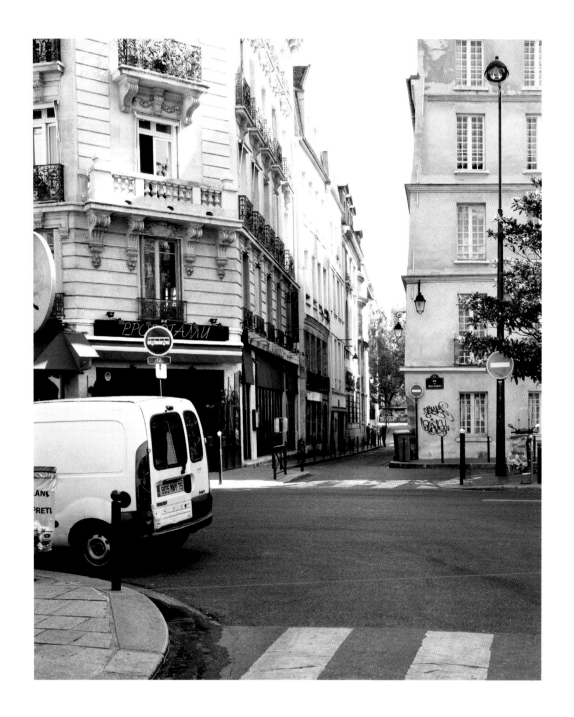

Rue de l'Hôtel-Colbert (looking across Rue Lagrange from Rue Galande), Sramek, 15.08.2009.

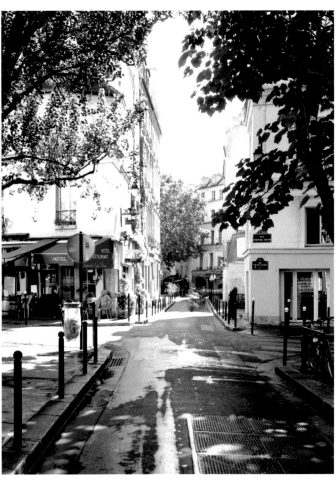

4.14. *Rue des Grands degrés (de la rue de la Bucherie),* Marville, 1865 (CAR/RV). Rue des Grands-Degrés (from Rue de la Bûcherie), Sramek, 15.08.2009.

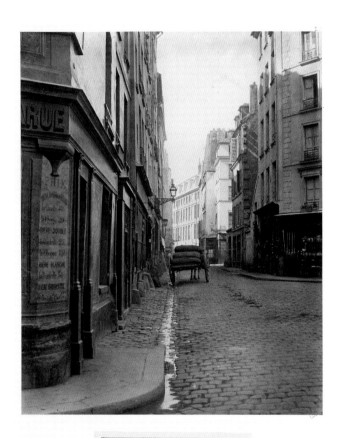

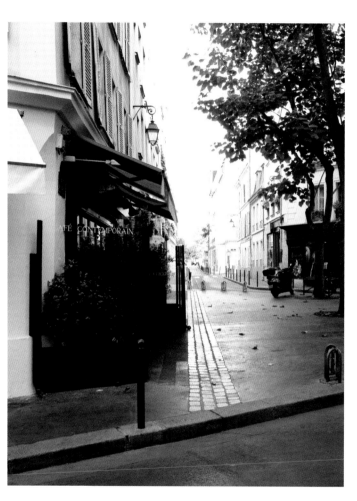

4.15. *Rue de la Bucherie (du Cul-de-sac St Ambroise)*, Marville, 1865 (CAR/RV).

Rue de la Bûcherie (from Impasse Maubert), Sramek, 15.08.2009.

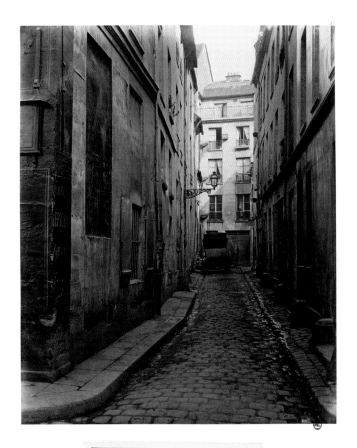

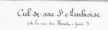

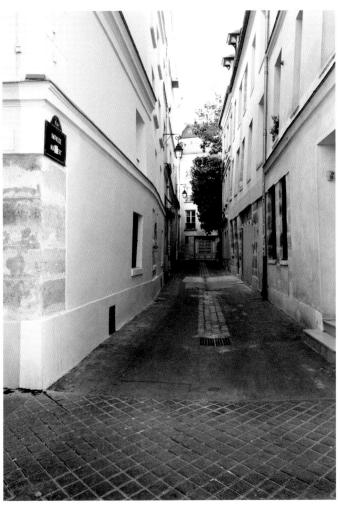

4.16. *Cul-de-sac St Ambroise (de la rue du Haut-pavé)* [added in pencil: *d'Amboise*], Marville, 1865 (CAR/RV).

Impasse Maubert, Sramek, 04.02.2012.

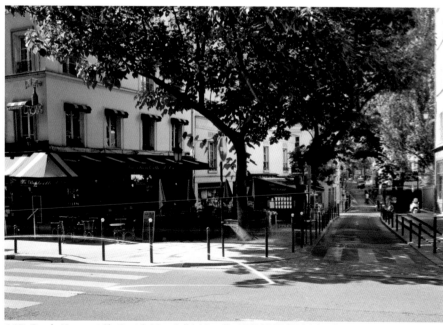

4.17. *Rue du Haut pavé (du Quai de Montebello)*, Marville, 1865 (CAR/RV) (above).
Rue Frédéric-Sauton (from Quai de Montebello), Sramek, 15.08.2009 (below).

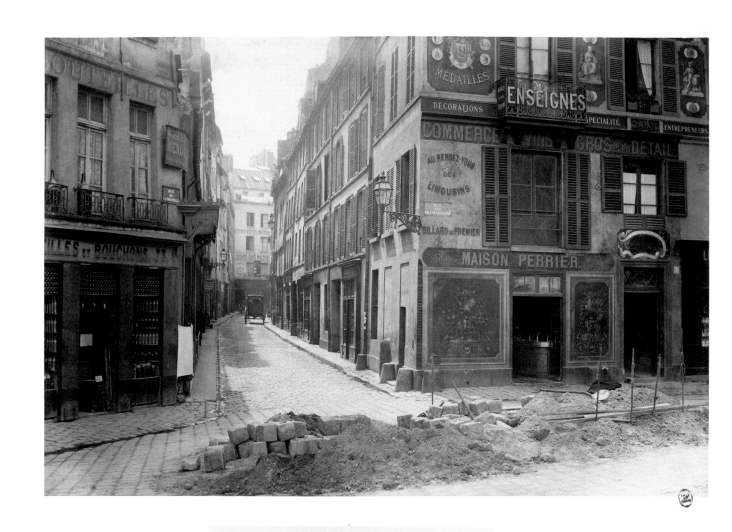

4.18. *Rue Maître-Albert (du quai de la Tournelle)*, Marville, 1865 (CAR/RV).

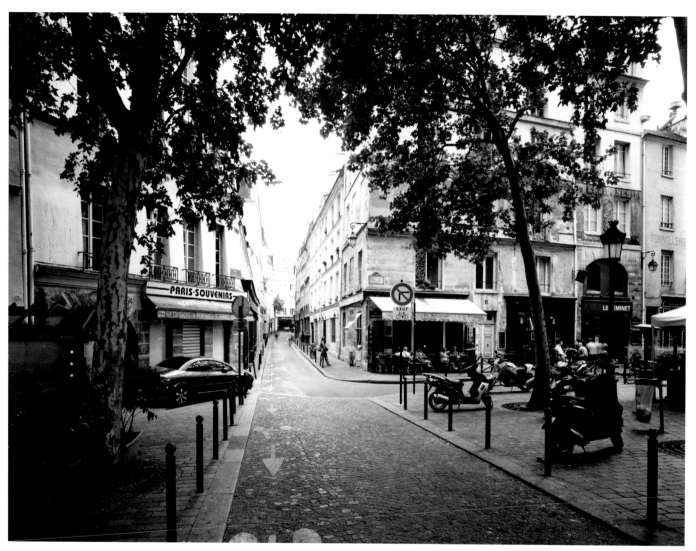

In *rue Maître-Albert*, I was approached by an older resident, a photographer who told me that many years ago she worked with a large format camera, a Linhof. The aspect of using what now appears to be outmoded technology reappeared many times during the making of this series. Passersby would suddenly say, 'I used to work with one of those,' or 'I have one at home but I have not used it in a long time' or simply, '*Une chambre à l'ancienne!* What an antique!'. This particular lady lives in *rue Maître-Albert* and is recorded as a ghostly figure in the photograph as she turns to enter her doorway. She mentioned how the building next to hers with the four lamp fixtures was a brothel in the past.

Rue Maître-Albert (from Quai de la Tournelle), Sramek, 28.06.2010.

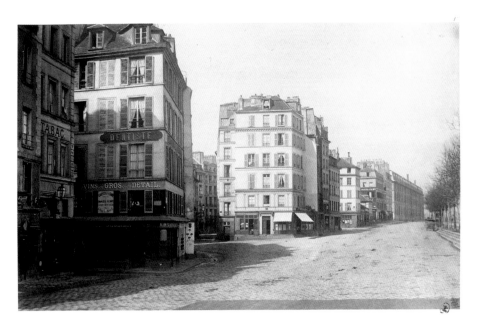

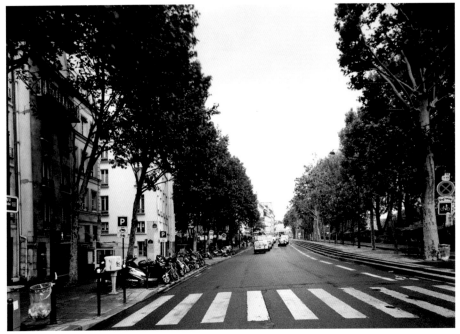

4.19. *Quai de Montebello (du quai de la Tournelle)*, Marville, 1865 (CAR/RV) (above).
Quai de Montebello (from Quai de la Tournelle), Sramek, 29.06.2010 (below).

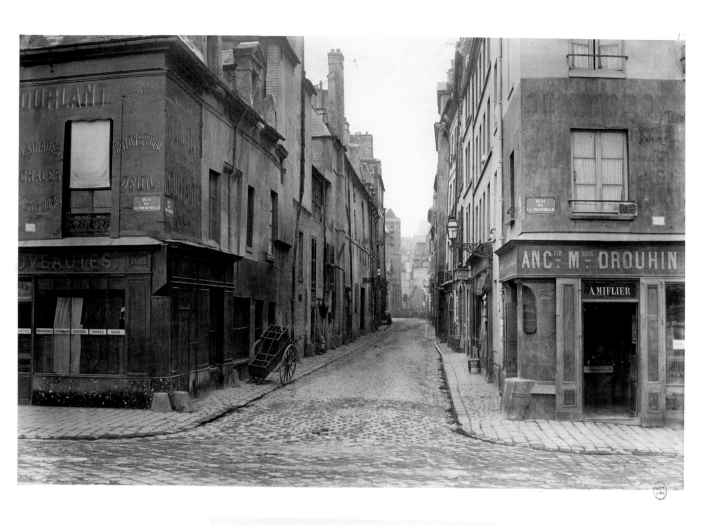

4.20. *Rue des Bernardins (du quai de la Tournelle)*, Marville, 1865 (CAR/RV).

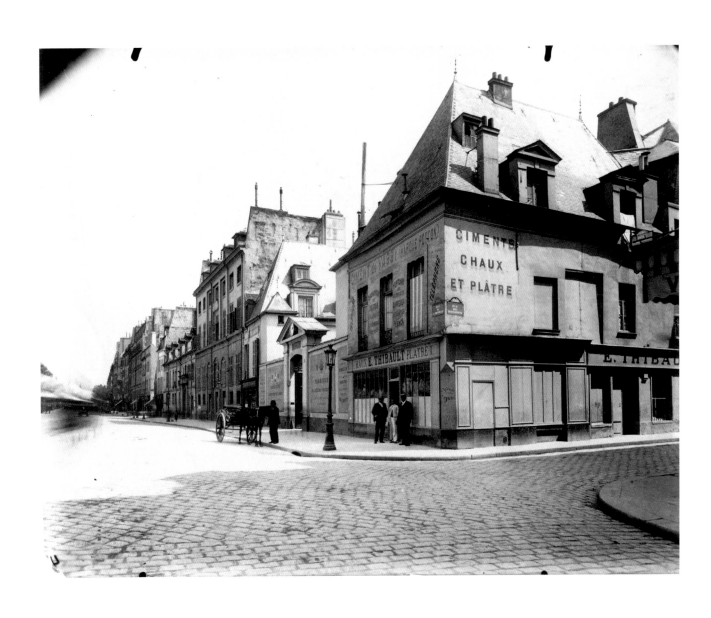

Hôtel de Nesmond, 57 quai de la Tournelle, Atget, 1902 (CAR/RV).

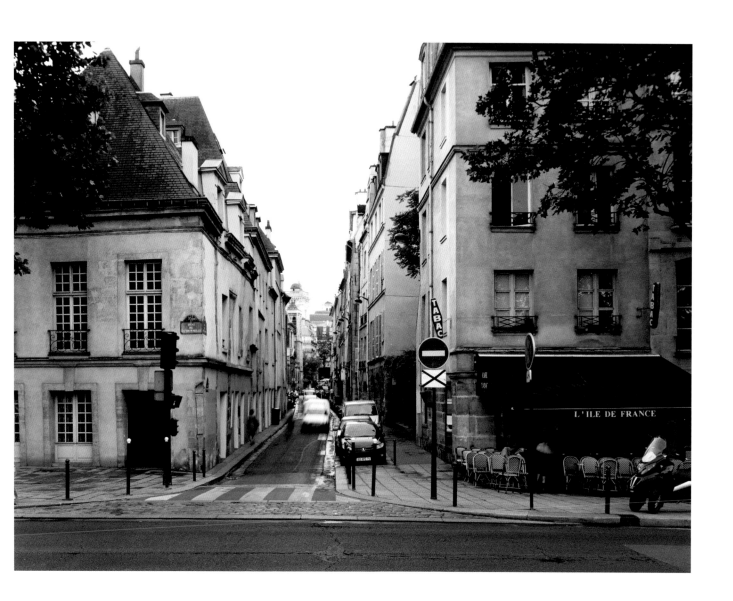

Rue des Bernardins (from Quai de la Tournelle), Sramek, 29.06.2010.

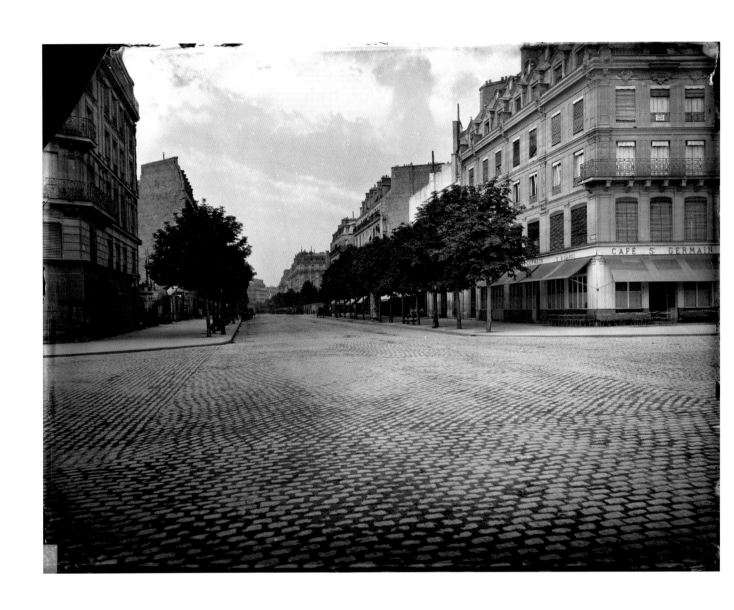

4.21. [*Boulevard St Germain (vue prise de la Halle aux Vins)*], Marville, 1877 (BHVP/RV).

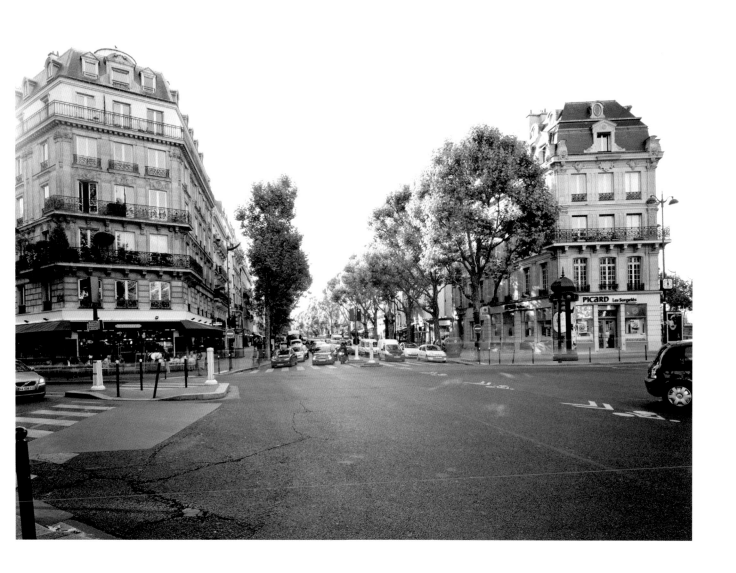

Boulevard Saint-Germain (on the left, Rue des Fossés-St-Bernard), Sramek, 20.09.2010.

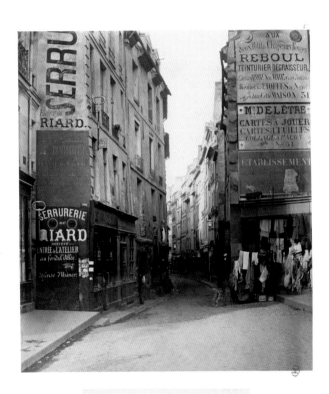

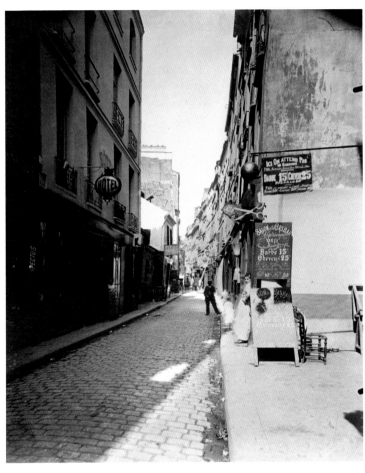

4.22. *Rue de Bièvre (du boulevard S^t Germain)*, Marville, 1865 (CAR/RV). Atget, 1900 (CAR/RV).

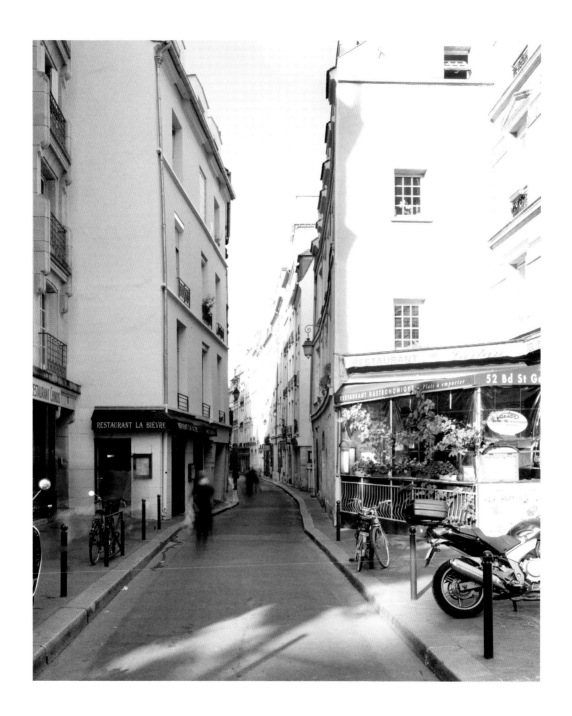

Rue de Bièvre (from Boulevard Saint-Germain), Sramek, 20.09.2010.

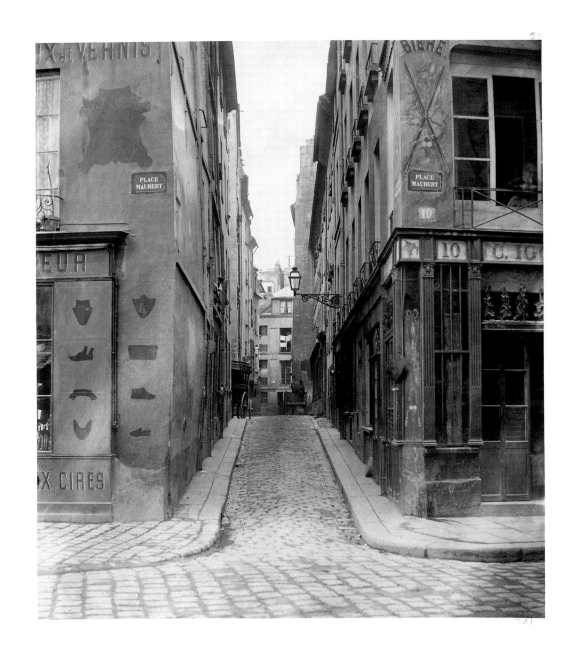

4.23. *Rue des Trois portes (de la place Maubert)*, Marville, 1865 (CAR/RV).

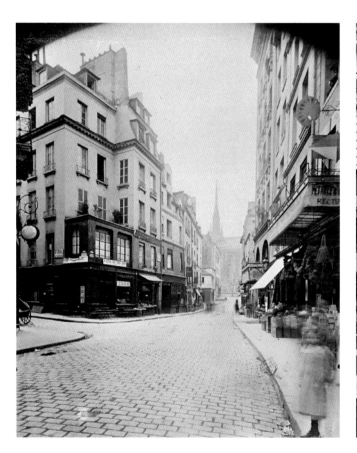

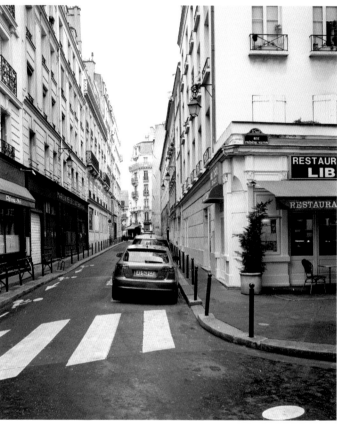

Buildings that were not demolished in Marville's time often have experienced many changes to the architectural details. Still, remnants of the past are also present. In the façade of what is now a Lebanese restaurant on the corner of *rue des Trois-Portes*, one can still find the old ironwork underneath coats of paint. The Atget photograph provides another view of this corner building from a distant angle.

Place Maubert, Atget, 1899 (BnF).

Rue des Trois-Portes (from Rue Frédéric-Sauton), Sramek, 20.02.2011.

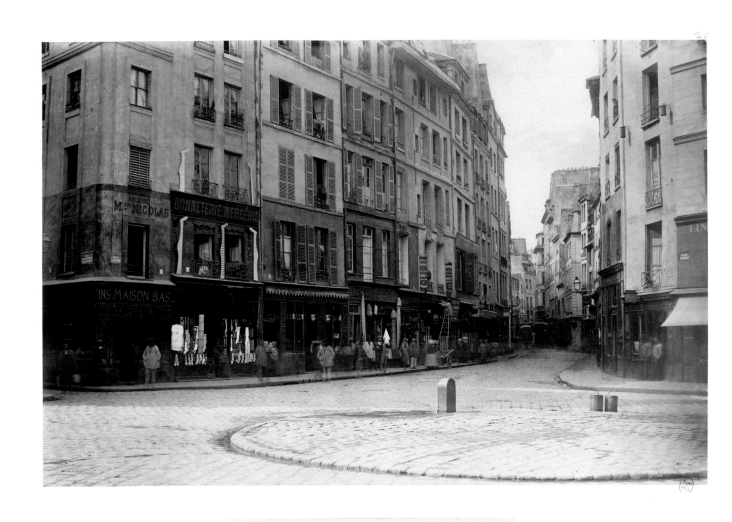

Rue Galande
(de la place Maubert)

4.24. *Rue Galande (de la place Maubert)*, Marville, 1865 (CAR/RV).

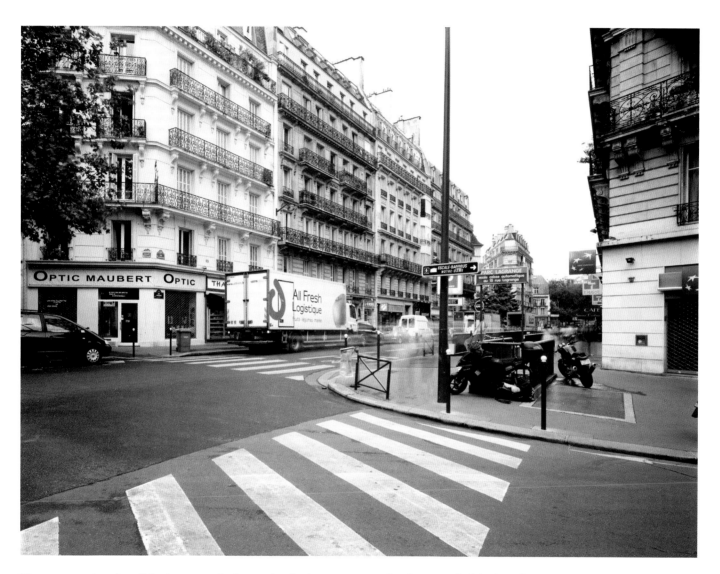

The eastern section of *rue Galande* was completely overtaken by the construction of *rue Lagrange* which leads traffic from *place Maubert* directly to the *quaie* rather than meandering towards the church of Saint-Séverin. *Rue Galande*, where it exists, is still the domain of strolling pedestrians, while the newer street is filled with speeding vehicles.

Rue Lagrange (from Place Maubert), Sramek, 29.06.2010.

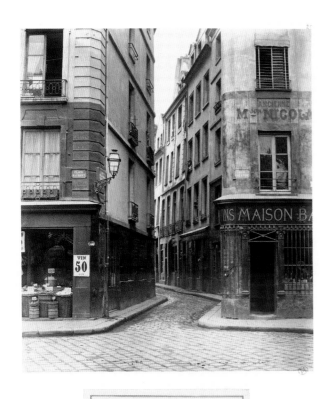

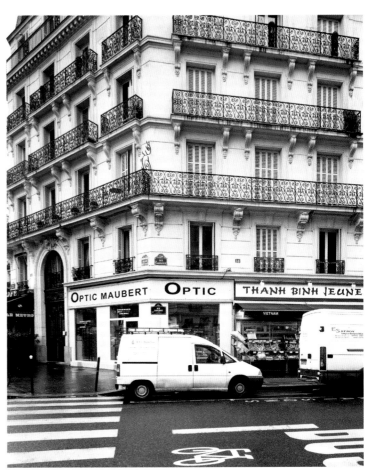

4.25. *Rue des Lavandières (de la place Maubert)*, Marville, 1865 (CAR/RV). No. 18 Rue Lagrange, Sramek, 29.06.2010.

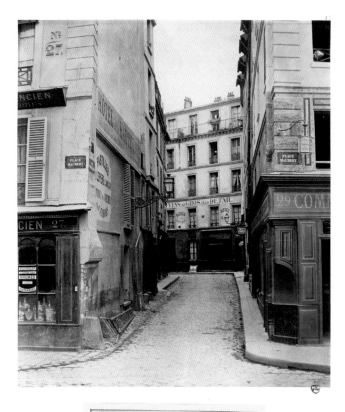

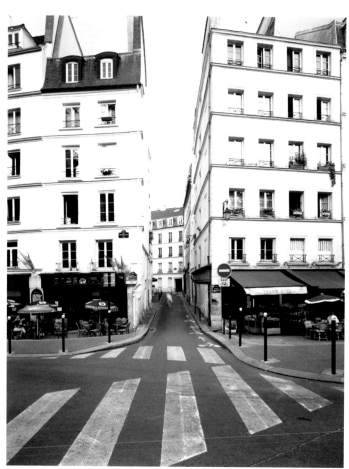

4.26. *Rue Maître-Albert (de la place Maubert)*, Marville, 1865 (CAR/RV). Rue Maître-Albert (from Place Maubert), Sramek, 28.06.2010.

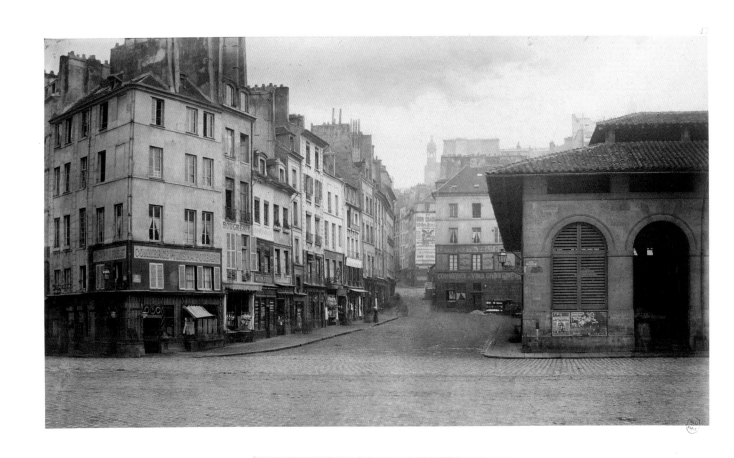

4.27. *Rue de la Montagne S^{te} Geneviève (de la place Maubert)*, Marville, 1865 (CAR/RV).

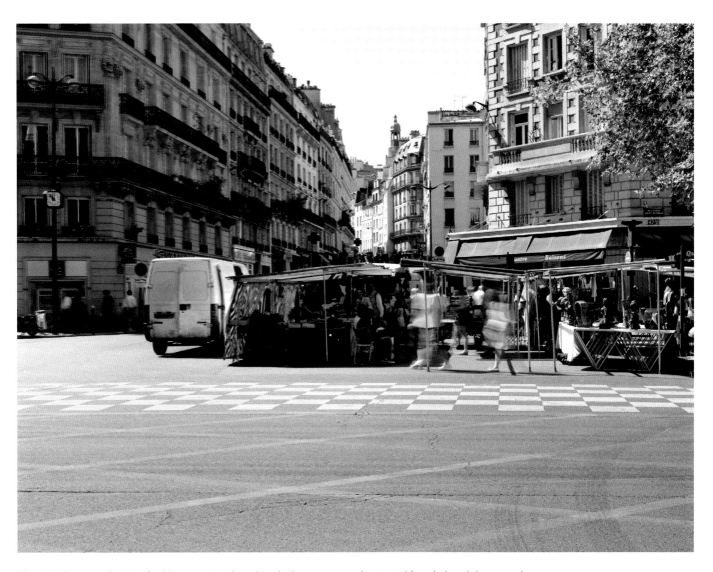

Place Maubert, once the site of public executions, has a lengthy history as a market site. Although the solid stonework of the Marché des Carmes is no longer in existence, there continue to be market shops and an open area for regular market days next to the traffic of *boulevard Saint-Germain*.

Rue de la Montagne-Ste-Geneviève (from Place Maubert across Boulevard St-Germain), Sramek, 15.08.2009.

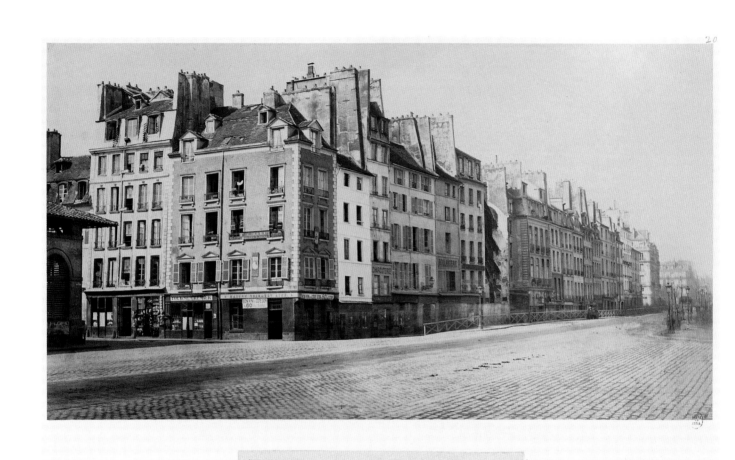

Rue des Noyers
(de la place Maubert)

4.28. *Rue des Noyers, (de la place Maubert)*, Marville, 1865 (CAR/RV).

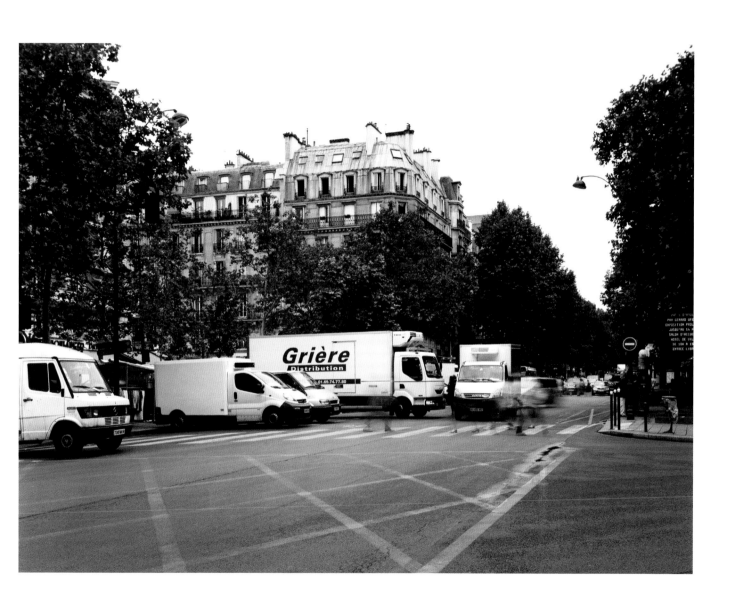

Boulevard St-Germain (looking west across Place Maubert), Sramek, 29.06.2010.

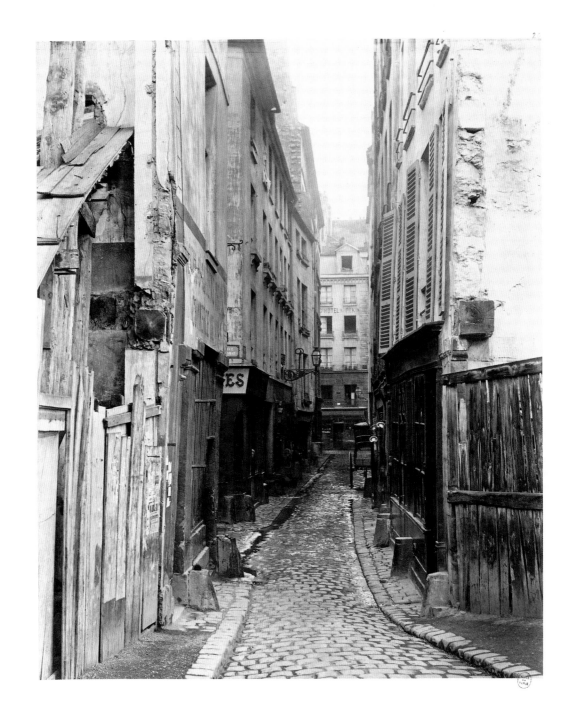

4.29. *Rue des Anglais (du B^{ard} S^t Germain)*, Marville, 1865 (CAR/RV).

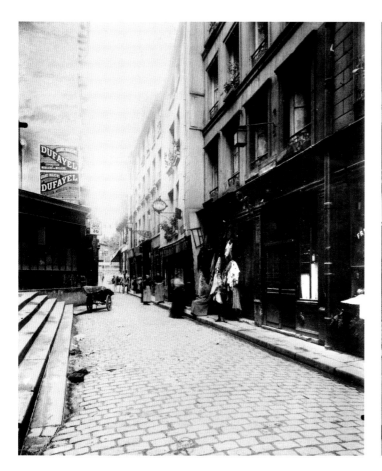

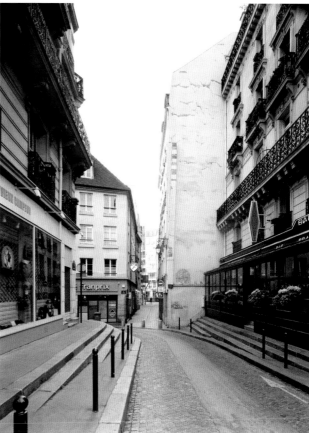

Atget, 1902 (BnF).

Rue des Anglais (from Boulevard St-Germain), Sramek, 17.05.2011.

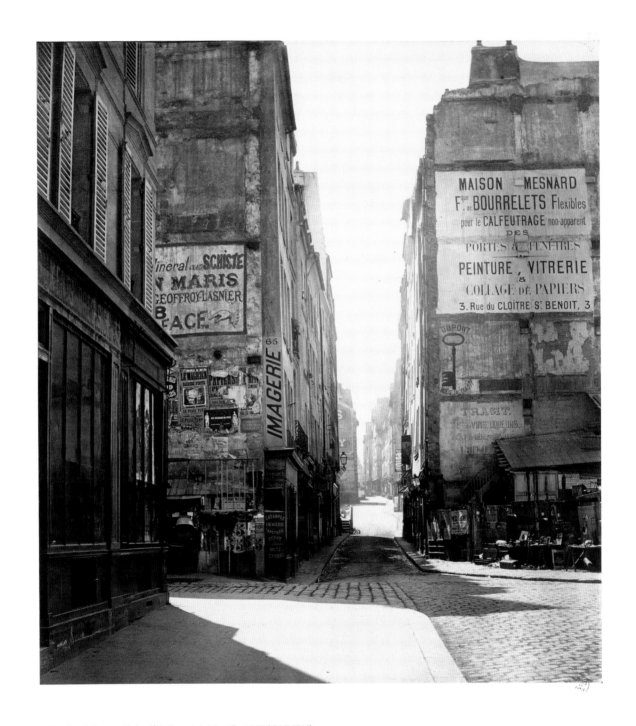

4.30. *Rue St Jacques (du bould St Germain)*, Marville, 1865 (CAR/RV).

On this site, I met a resident from the building on the immediate left who knew the Marville images, but did not believe this one was of his section of the street. Close examination of the signage in the photograph and reference to the old maps both show that this is indeed the site and that the narrow one-block section in *rue Saint-Jacques* did indeed exist as seen in Marville's photograph. Today, the confusing detail is a medieval façade which exists exactly where the narrowing occurred. One assumes that this is the 'original' position of the street front and wonders how there could have been the narrowed passage seen in Marville's time. However, as commonly found, the old entrance must have been buried within the jutting constructions which have now been removed, an example of how the city had developed with structures built on structures.

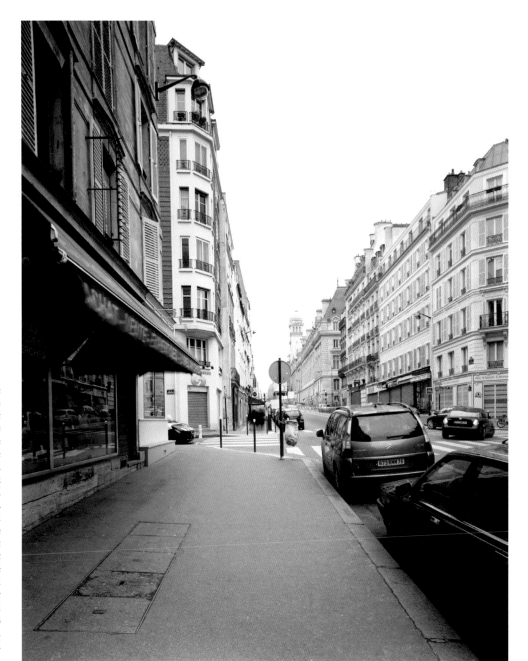

Rue Saint-Jacques (looking south from Boulevard St-Germain), Sramek, 20.02.2011.

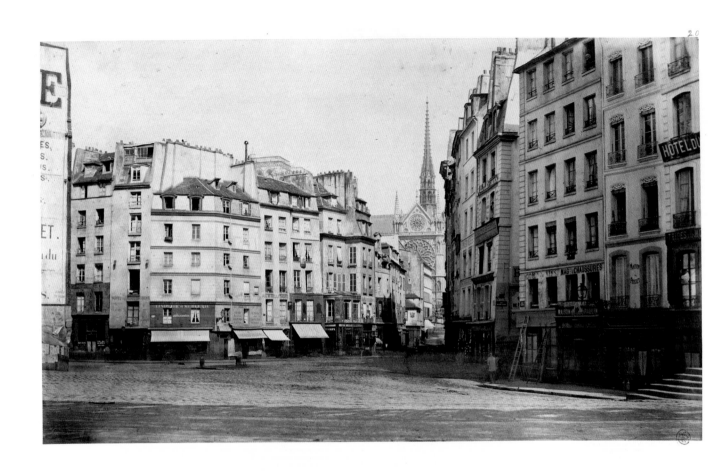

4.31. *Place Maubert (du Marché des Carmes), Marville, 1865 (CAR/RV).*

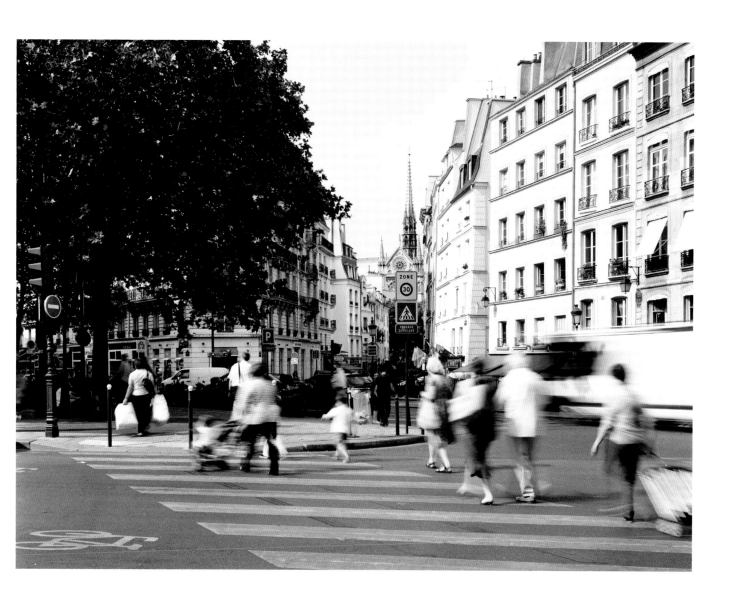

Place Maubert (towards Notre-Dame), Sramek, 28.06.2010.

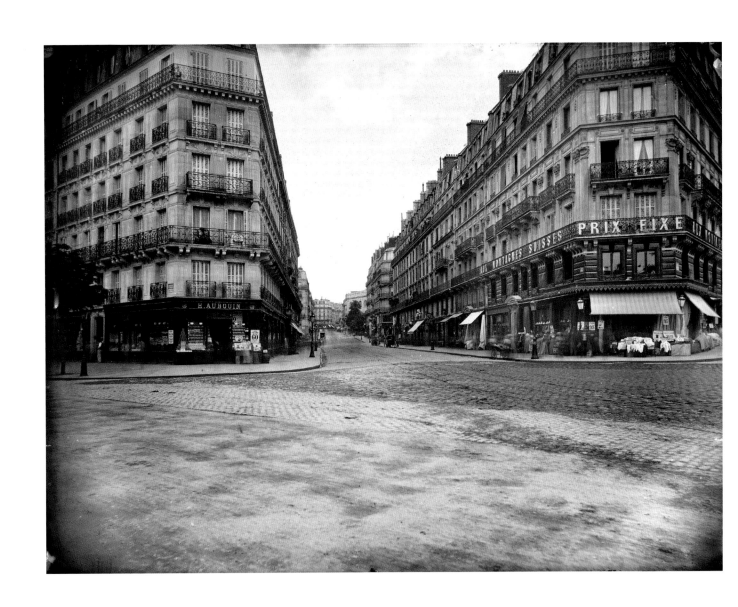

4.32. [*Rue Monge (vue prise du boulevard Saint-Germain)*], Marville, c.1877 (BHVP/RV).

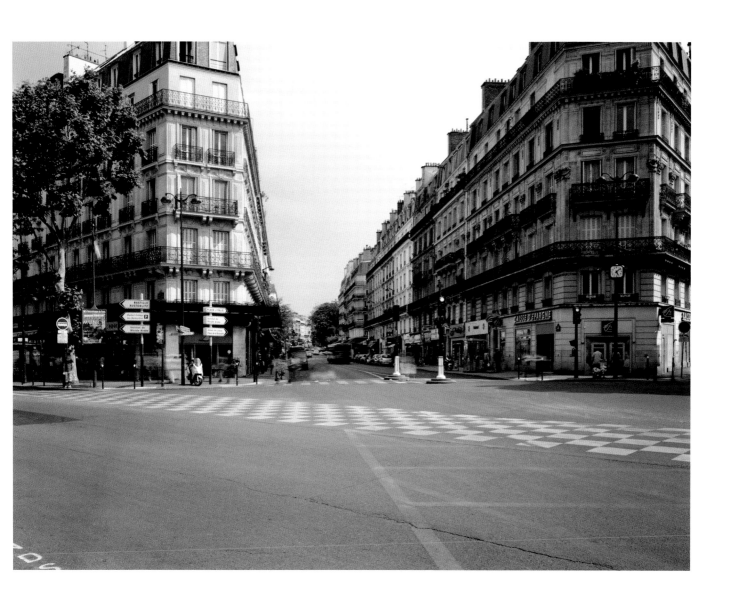

Rue Monge (from across Boulevard St-Germain), Sramek, 28.06.2010.

Montagne-Sainte-Geneviève

Fig. 45. Locations (overleaf)
Atlas Administratif, 1868
(sites1865-68),
Paris-Atlas, c. 1900
(sites c.1877).

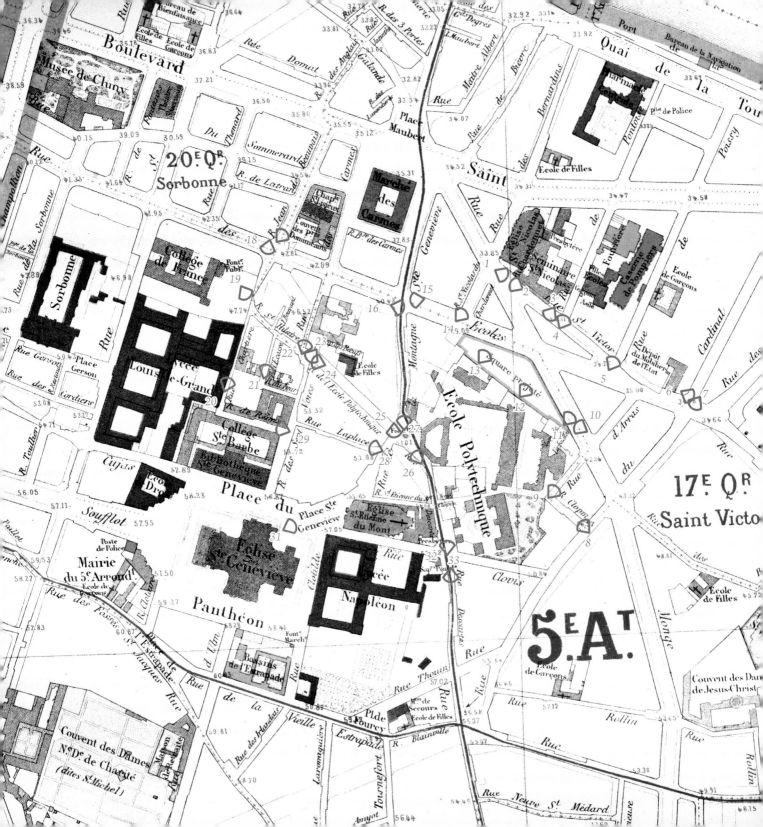

BOULEVARD

Musée de Cluny

Théâtre de Cluny

Square du Cluny

20

SORBONNE

Place de la Sorbonne

Rue de la Sorbonne

Rue des Écoles

Ec. Spéle des Trav. Publ.

École

R. du Dante

R. Domat

R. Galande

Lagrange

Place Maubert

St. d'Etienne Dolet

SAINT

Marché des Carmes

Egl. Roumaine

R. des Carmes

Rue

Rue de la

Rue Bernard

Rue Monge

Square Monge

Pharmacie Centrale des Hopitaux Civils

École

Eglise St Nicolas

Séminaire

Caserne des Pompiers de Poissy

École

Rue St. Victor

Écoles

Collège de France

Place du Collège de France

Lycée Louis le Grd.

Collège Ste Barbe

Bibliothèque Ste Geneviève

École de Droit

Place du Cujas

Pas du Clos Bruneau

R. des Bœufs

Rue de l'Éc. Polytechn.

Rue Laplace

Rue Valette

Rue Montagne Ste

École

Polytechnique

Écoles

d'Arras

Rue Lemoine

Rue Cujas

Rue Souffiot

Champollion

R. Victor Cousin

Rue Cousin

Mairie du 5e Arrond.

PANTHÉON

Panthéon

Place Ste Geneviève

Egl. St Étienne du Mont

Tour de Clovis

Lycée Henri IV

Rue Clotilde

Rue Descartes

Rue Clovis

Rue Cardinal

Rue Thouin

École

Rue Bottin

Rue Malebranche

Boyer Collard

R. Paillenne

R. Fos. St Jacques

Place de l'Estrapade

Rue de l'Estrapade

Bassins de l'Estrapade

Rue des

Rue Blainville

Place Contrescarpe

École

Couvt d Dames N.D. de Charité (dites St Michel)

Musée Pédagogique

Gay

Séminaire des Irlandais

École Protestante

Rue St Médard

R. Racine

Rue Médecine

Lycée Louis

SAINT

R. Pre Sacrazin

QUAI

Port

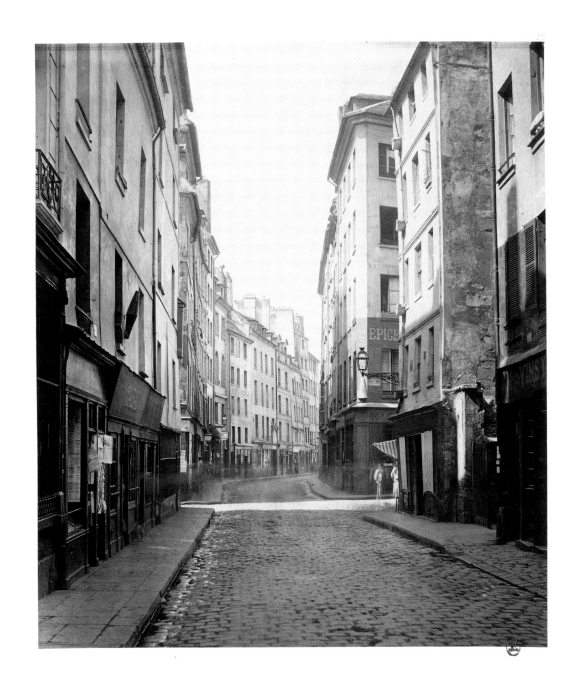

5.01. *Rue St Victor (de la Place Maubert)* [ed. incorrect – this is looking west towards Place Maubert], Marville, 1865 (CAR/RV).

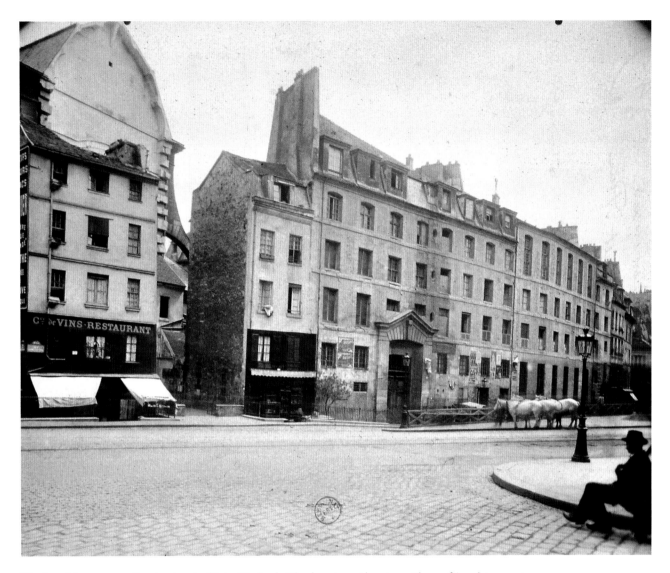

The demolitions surrounding the church of *Saint-Nicolas-du-Chardonnet* provide prime evidence of Atget's interest in following such changes. The location changed dramatically with the construction of *rue Monge* and Atget made at least five photographs of the front of the church at various stages of the demolitions (1898, 1901, 1909, 1922). Three of them are from more or less the same angle (also see pl. 5.14).

In Marville's time, the church was hidden behind houses built right up to its walls. This was common practice and one can just make out the entryway on the right in the photograph. Marville made two photographs in this location, looking in either direction along *rue Saint-Victor*. The first (pl. 5.01) is one of a number of instances where the label on the mounted Marville print is incorrect, in this case suggesting the opposite direction (a similar error is found in Plate 2.04). Past curators have corrected most of these errors in pencil on the mounts, although not this one.

Eglise St-Nicolas-du-Chardonnet, Atget, 1901 (BnF).

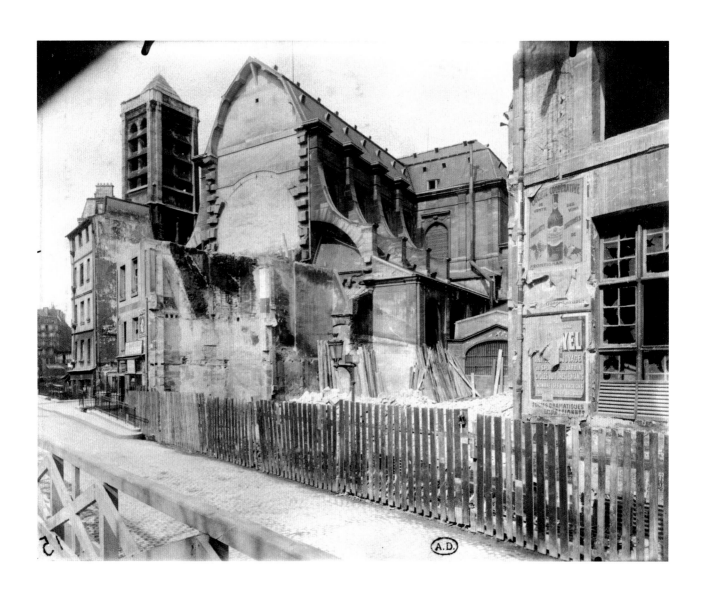

Eglise St-Nicolas-du-Chardonnet, Atget, c. 1901 (ArtsDeco).

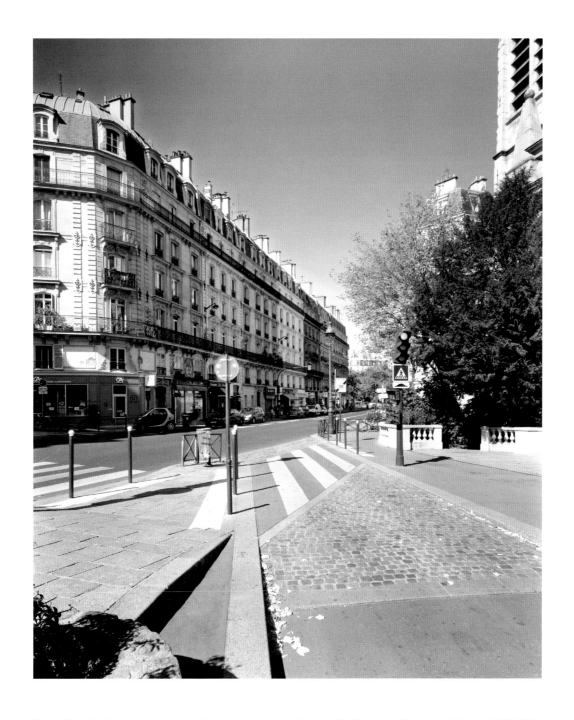

Rue St-Victor (looking west towards Rue Monge, on the right, the Church of St-Nicolas-du-Chardonnet), Sramek, 20.09.2010.

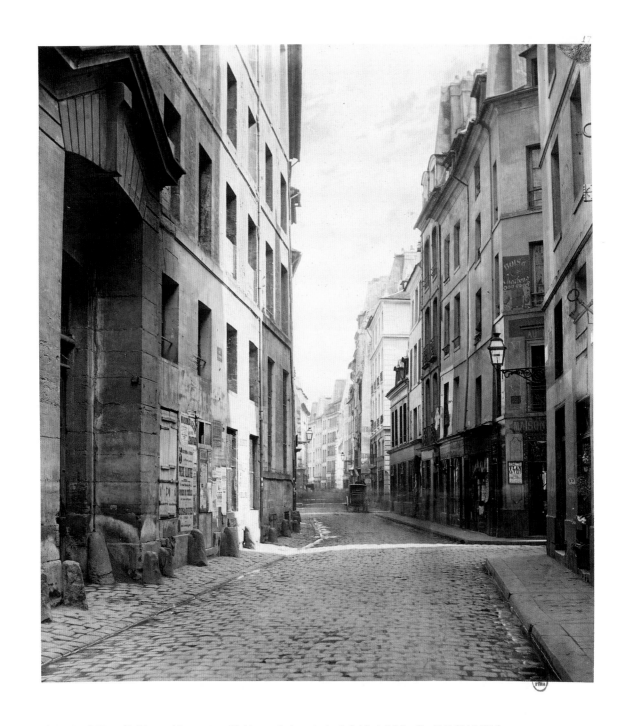

5.02. *Rue Sᵗ Victor (de l'Entrepôt)* [correction added in pencil: *du seminaire de St Nicolas*], Marville, 1865 (CAR/RV).

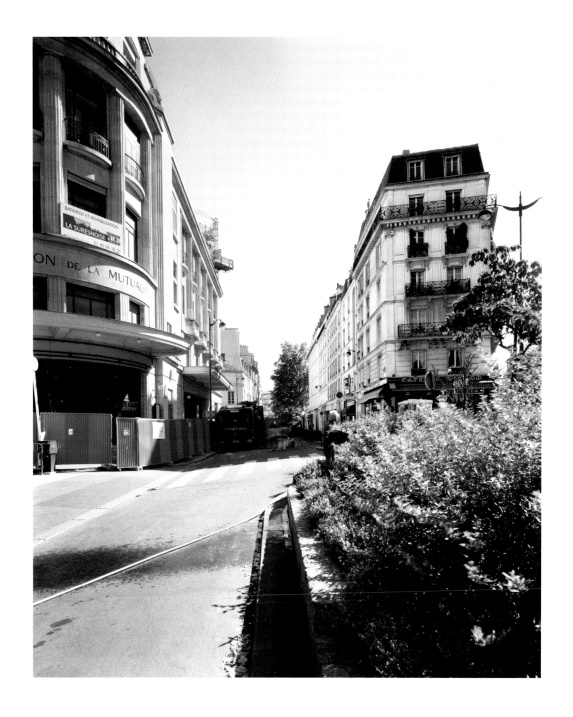

Rue Saint-Victor (looking east), Sramek, 20.09.2010.

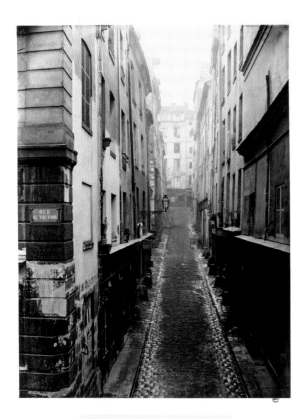

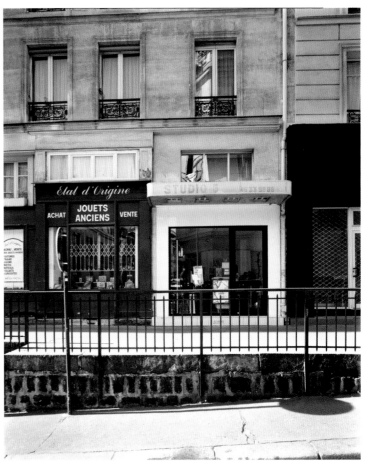

5.03. *Rue de Paon (de la rue S^t Victor)*, Marville, 1865 (CAR/RV). No. 5 Rue St-Victor, Sramek, 20.09.2010.

While making the rephotographs in *rue Saint-Victor,* I spoke with an 80-year-old woman who had moved to Paris from Italy as a child. When she was 24, she was hired to take photographs of people in the street. She would take down their names and deliver the film to the shop for processing. At first she knew nothing about photography, but the studio owner taught her what to do. She spoke to me about her life growing up in Paris and it was conversations such as this that suggested the idea of interviewing residents about their personal experiences of the city and how they perceived it changing.

It was primarily in the 5th *arrondissement* that I recorded interviews in the street as it makes up the larger portion of this project. People spoke of an attachment to their neighbourhood, the depth of family roots, even though this might be slowly shifting with the encroachment of gentrification into working-class neighbourhoods. Built around a stable population rooting itself in a particular *quartier*, Parisian identity has been affected by the greater mobility of people. They commented on how Paris, like most large cities, has been changing economically and commercially and they told stories of the past. They were concerned with the loss of an authentic heritage in this oldest part of the city. Many of those interested in talking were my age, over 50, while Melissa, born in the *quartier*, was the youngest. In her twenties, she showed an infectiously positive attitude towards her *arrondissement*.

Melissa: Since 1997, I have lived in *rue de Pontoise*. I have moved, but in the same street. I don't want to leave because I love this *quartier*. It feels a little like a small village – for the most part, everyone knows each other, the whole family lives here, we were in school here, our parents grew up here and one has everything here – the small markets, the shopkeepers who know everyone and besides, it is pleasant … It is difficult to leave the 5th when one has begun here. Here, everyone stays. When one was born here, has grown up here, one stays…

For the students, they have everything. One has the chance to have a future – do something. There is the Sorbonne [and other schools]. It is true that there are a lot of young people who come here for the schools … It is the best *quartier*…

The *rue de Pontoise* is much calmer. In *rue Mouffetard*, it is alive night and day, 24 hours and 7 days a week. [In *rue de Pontoise*] there are restaurants, but no agitation. It is quiet, and in fact, in the buildings there are gardens in the interior. There are beautiful gardens. There is not too much noise and that is the advantage … Mouffetard is a poor neighbourhood, but still, it is pretty … It is true that it was very cosmopolitan before. There was a broad mix of social categories and it has now become more elitist. That is to say, it is now less cosmopolitan in the 5th in terms of inhabitants. One is losing the sense of the village. It is a shame. And, it has become more expensive, much more expensive.

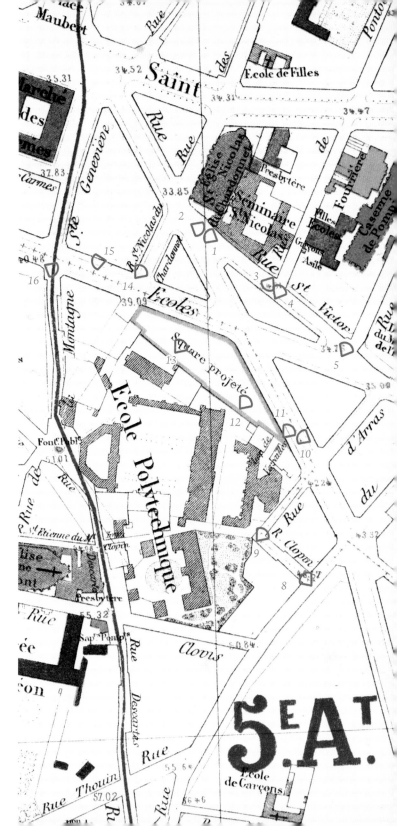

Fig. 46.
Atlas Administratif, 1868.

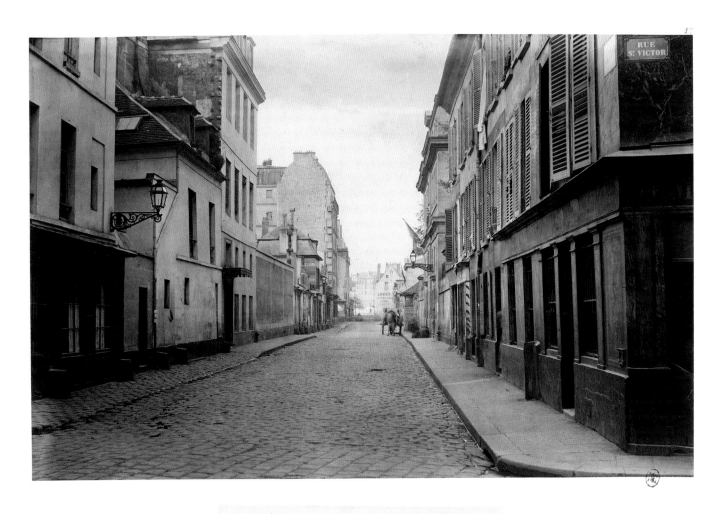

5.04. *Rue de Pontoise (de la rue Saint Victor)*, Marville, 1865 (CAR/RV).

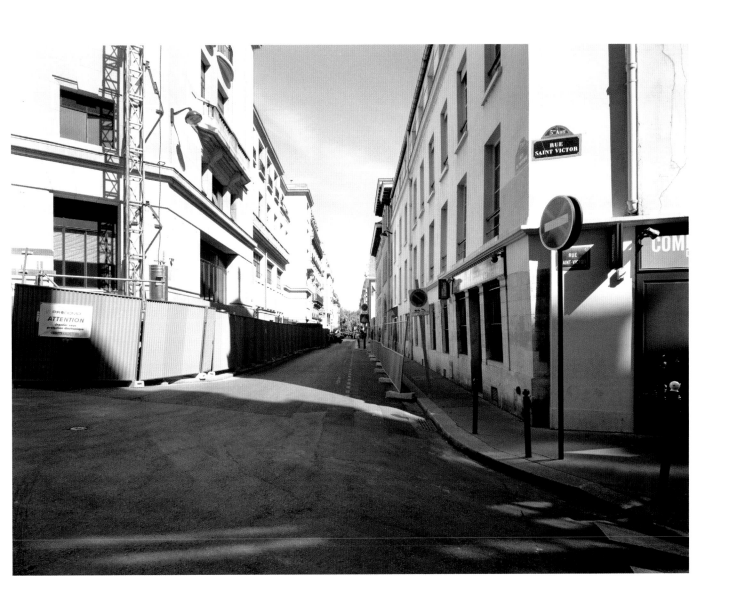

Rue de Pontoise (from Rue Saint-Victor), Sramek, 20.09.2010.

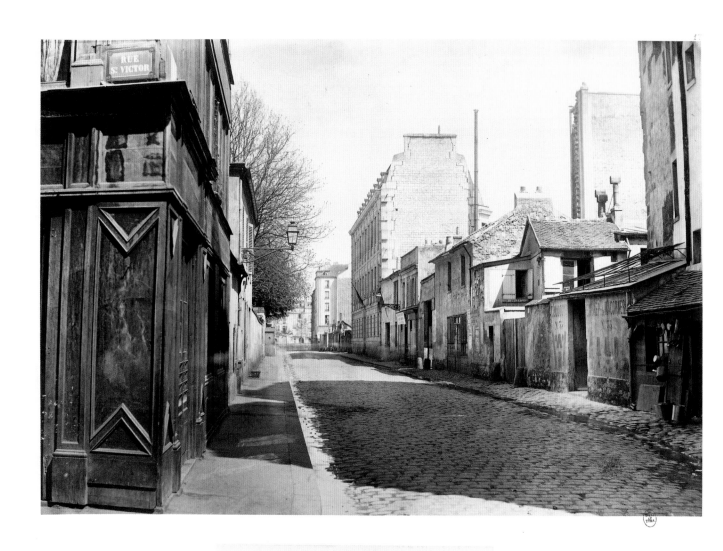

5.05. *Rue de Poissy (de la rue St Victor)*, Marville, 1865 (CAR/RV).

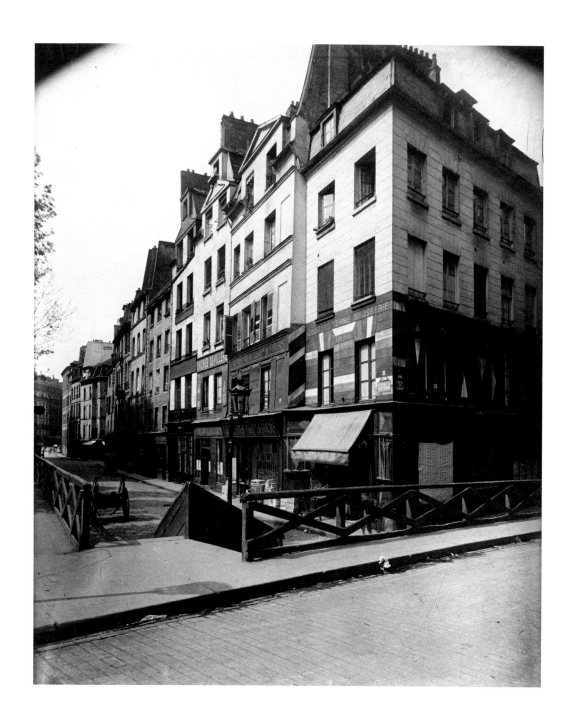

L'angle de la cour Saint-Victor et la rue de Poissy, Atget, 1909 (CAR/RV).

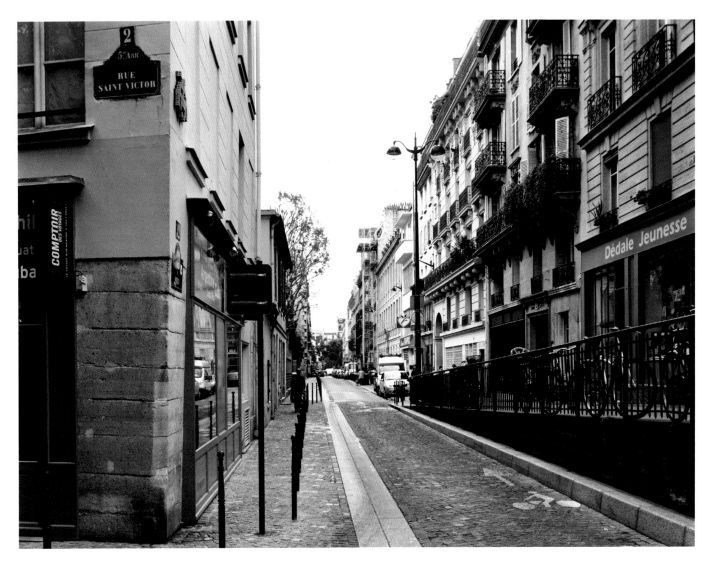

Throughout old Paris it is not an uncommon sight to see old house fronts and sidewalks sitting below the current roadway. This location where *rue Saint-Victor* now terminates provides a good example of how street levels were altered with the construction of new roadbeds. At one time, *rue Saint-Victor* was the main street. Today, it is cut-off and sits a few metres below *rue des Ecoles* as the newer road angles down towards *rue du Cardinal Lemoine*. Along much of *rue Saint-Victor's* length, one sidewalk now runs higher than the street (pl. 5.03) where the new buildings were constructed level with *rue des Ecoles*. At the corner, steps were introduced for pedestrians and *rue de Poissy* is split to meet both levels, with a ramp built on one side. The Atget photograph (previous page), with its more distant view clearly shows the difference in levels. *Rue Monge* now cuts across *rue des Ecoles* on an even newer trajectory, creating three historical layers of intersecting pathways in this vicinity.

Rue de Poissy (from Rue Saint-Victor), Sramek, 29.06.2010.

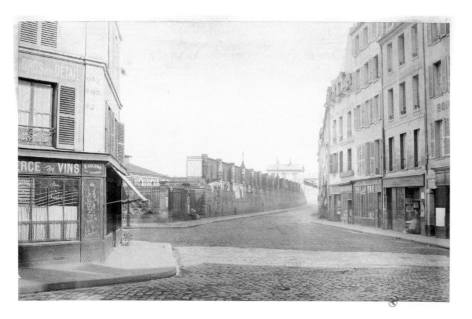

The Halle aux Vins (the wine market), originally from 1664 and rebuilt in 1808-19, was demolished in the 1960s to make way for the new University of Paris, Faculty of Sciences (Jussieu).

[It] illustrates the verity of situationist claims that urbanisme represented a drive to rationalize, homogenize, and commercialize the socioeconomic diversity of Paris… The attentive pedestrian can still find pieces of the walls of the Halle aux Vins on the fringes of the new Université, where cash to finish the demolition of the old and construction of the new dried up. Here is the Paris ravaged by Cartesian excess. Exactly as the situationists seemed to be warning us, the social is implicated in the aesthetic: Jussieu's nightmarish corridors, vertiginous stairwells and campus deserts, fashioned from *bêton brut* to meet the demand for popular higher education, barely conceal an indifference for their users (Sadler 1999: 61-2).

Across from the now crumbling concrete of 'Jussieu' another modern intervention was being constructed in 2011 (pl. 6.07). This time, the glass of the façade reflects the sky along with the older architecture around, as if intending itself to disappear.

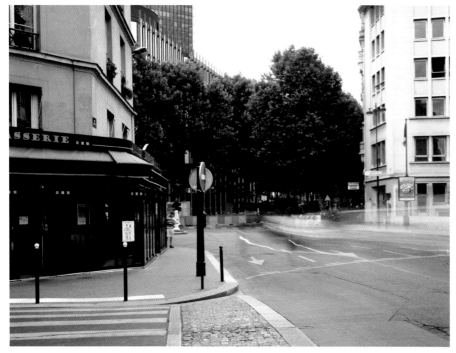

5.06. *Entrepôt des vins (de la rue du Cardinal Lemoine)*, Marville, 1865 (CAR/RV) (above).
Intersection of Rue Jussieu, Rue des Fossés-St-Bernard, Rue des Ecoles and Rue du Cardinal Lemoine, Sramek, 13.08.2009 (below).

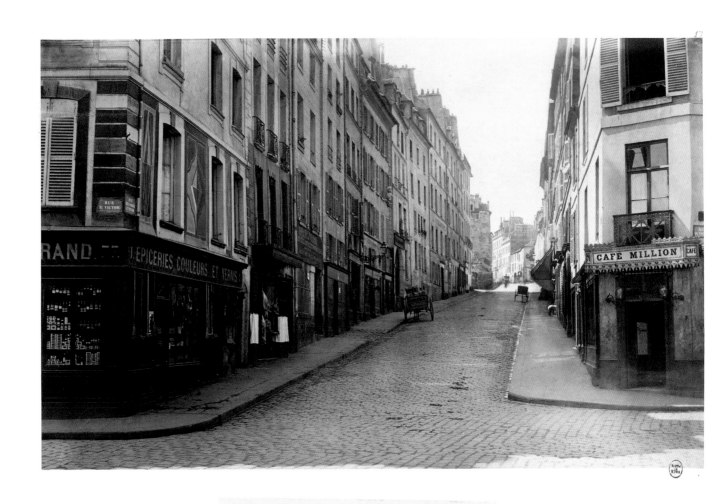

5.07. *Rue des Fossés St Victor (de la rue du Cardinal Lemoine)*, Marville, 1865 (CAR/RV).

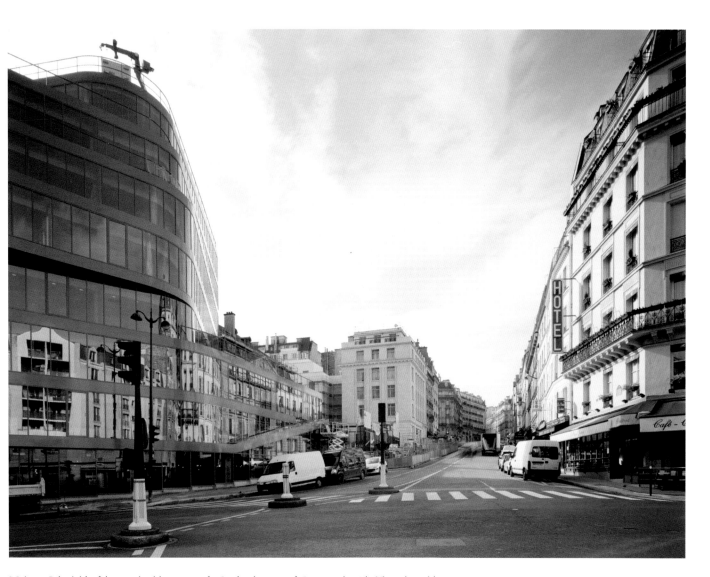

Melissa: I don't like [the new building in *rue du Cardinal Lemoine*]. It is not the 5th. The 5th is old – it is picturesque. This doesn't fit. At the same time, there is Jussieu opposite and that is also recent. Personally, I prefer the old buildings and the small shops. These are beautiful. The new construction is not romantic, it's cold, of glass. Still, they saved the building next door and that is good. That is what I prefer. But, everything changes.

Rue du Cardinal Lemoine, Sramek, 22.02.2011.

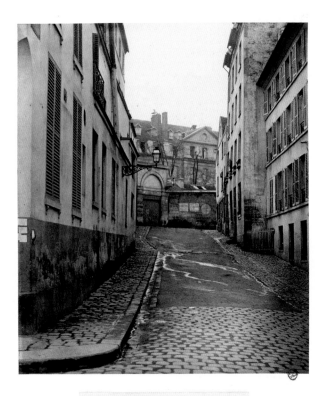

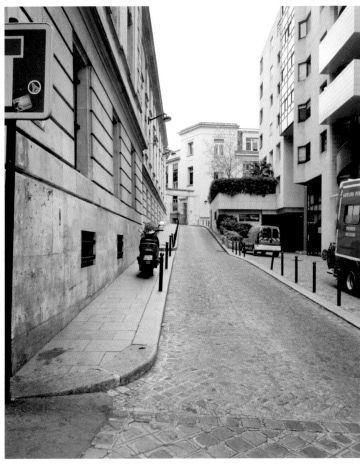

5.08. *Rue Clopin (de la rue des Fossés S.t Victor)*, Marville, 1865 (CAR/RV). Rue Jacques-Henri-Lartigue (from Rue du Cardinal Lemoine), Sramek, 13.08.2009.

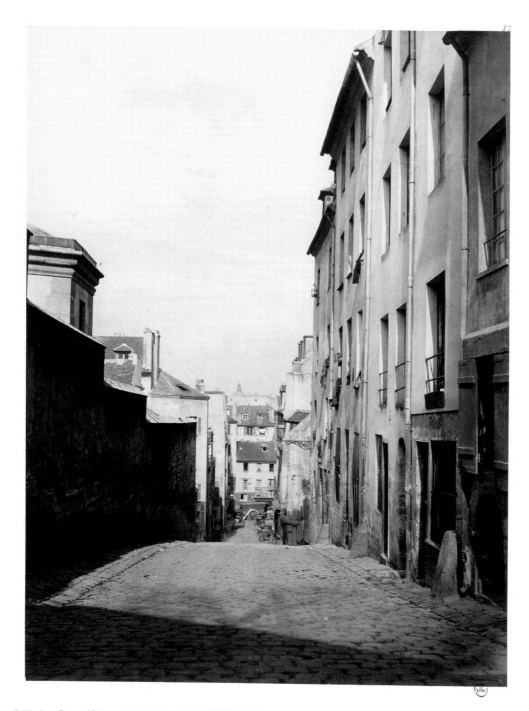

5.09. *Rue d'Arras (de la rue Clopin)*, Marville, 1865 (CAR/RV).

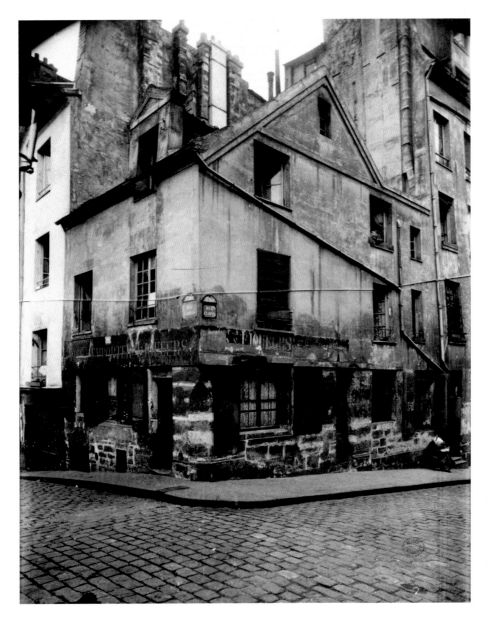

In addition to this photograph by Atget of the corner of *rue d'Arras* and *rue Clopin*, there is another which he took in 1923 that frames the identical composition (CAR/RV). The location itself had changed very little. Maybe his intrigue with the crisscrossing angles of linear elements brought him back to the exact view. In a way, the modern addition to this corner recreates the angling effect, where the steeply-canted street has been altered into a set of zig-zag stairs.

Vieille maison au coin des rues d'Arras et rue Clopin, Atget, 1909 (CAR/RV).

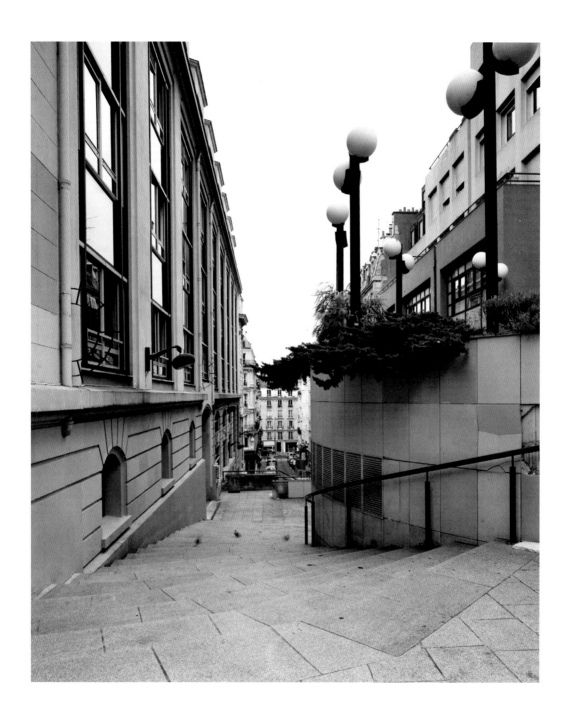

Rue d'Arras (from the corner with Rue Jacques-Henri-Lartigue), Sramek, 13.08.2009.

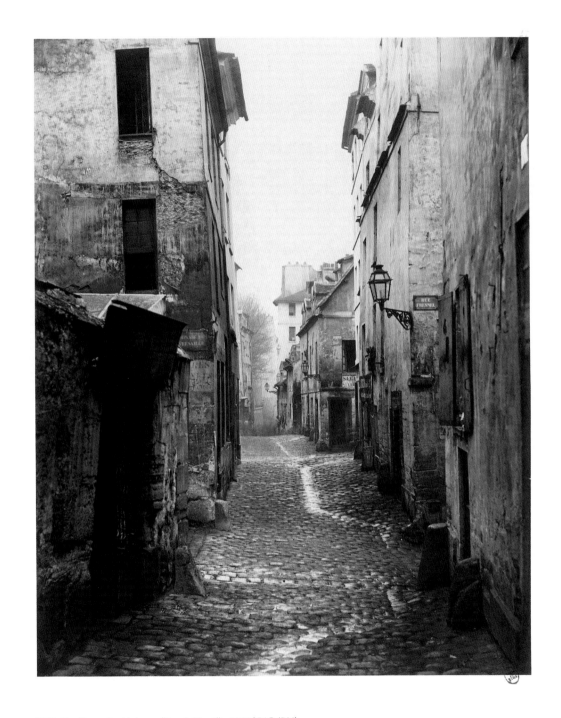

5.10. *Rue Traversine (de la rue d'Arras)*, Marville, 1865 (CAR/RV).

266

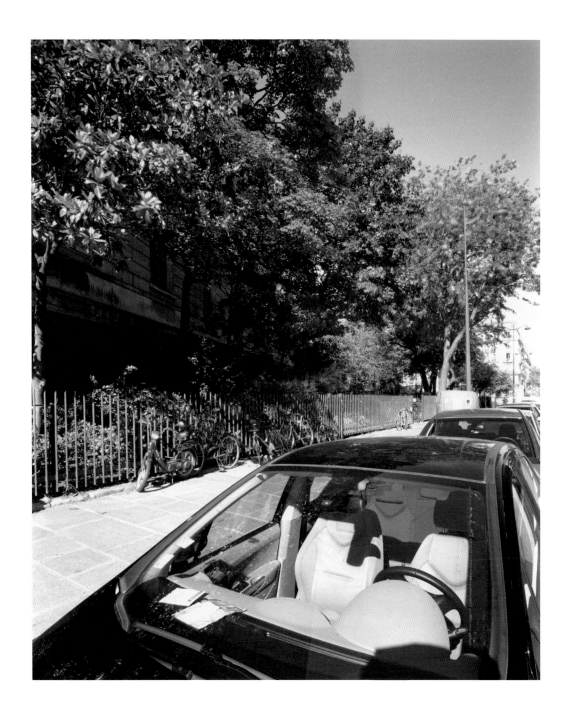

Rue Monge (corner of the park), Sramek, 20.09.2010.

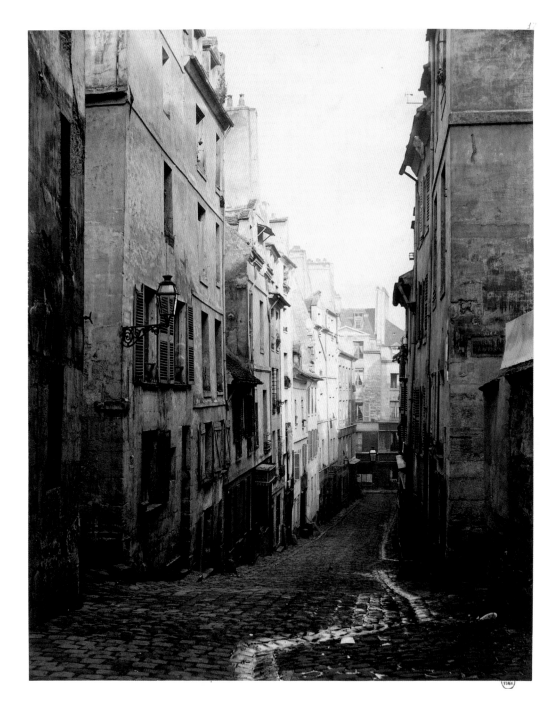

5.11. *Rue Fresnel (de l'Impasse de Versailles)*, Marville, 1865 (CAR/RV).

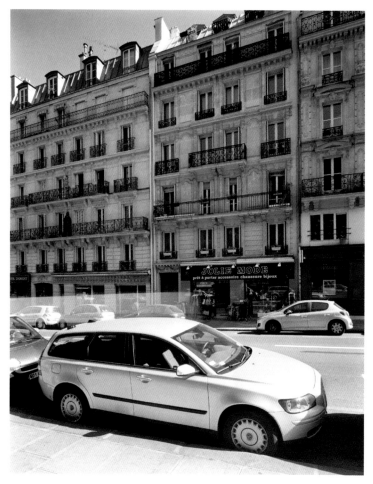

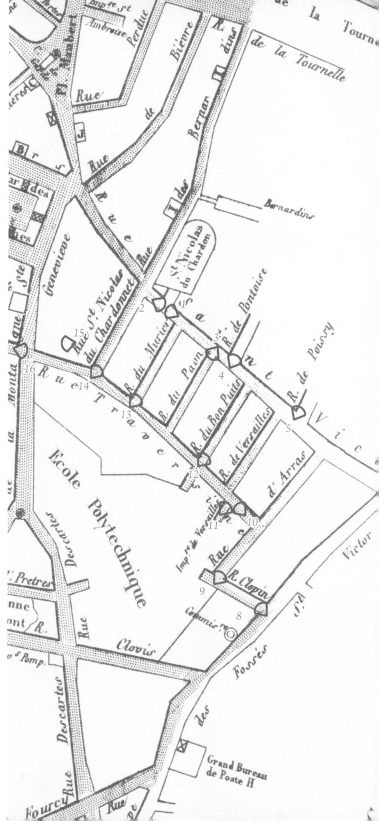

Rue Traversine, as narrow as it was, once provided the main route across this side of the *Montagne Ste-Geneviève*. It was superseded under the Second Empire, first by *rue des Ecoles* and later *rue Monge* (Pitt 2008: 86). The latter two now cross over in what was first called *square Monge* and now *square Paul Langevin*, while *rue Traversine* itself has disappeared, encompassed within the triangular park of the square. The small streets of old houses in Marville's photographs, seen running downhill between *rue Traversine* and *rue Saint-Victor* are gone, subsumed by the crossing of *rue des Ecoles* and *rue Monge*. As Michaël Darin articulates, these piercings brought not only roadways, but also major new housing construction on the sides. 'La percée n'est pas seulement une voie, une route; elle est aussi les deux rangées de bâtiments qui bordent la chaussée. En effet … le percement est souvent une gigantesque opération immobilière qui permet d'introduire de nouvelles habitations dans les parties anciennes des villes françaises' (Darin 2009: 301).

No. 23 Rue Monge, Sramek, 20.09.2010.

Fig. 47.
Petit Atlas Pittoresque (1834)
No. 45 St-Jacques (detail).

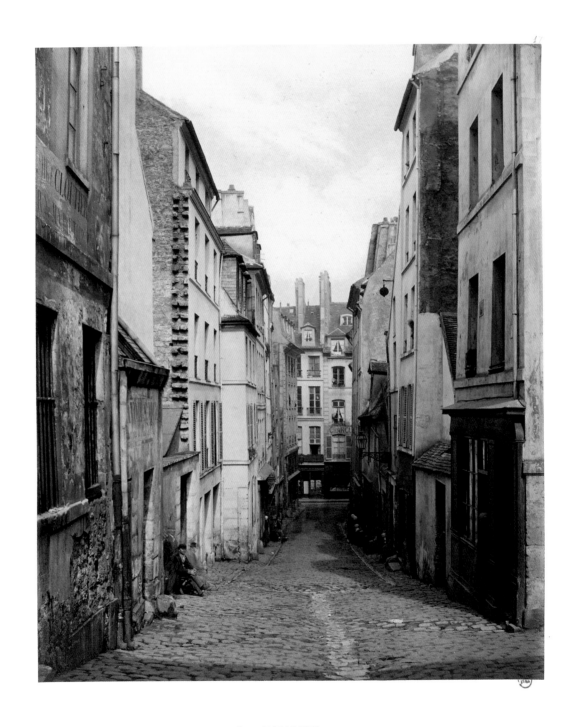

5.12. *Rue du Bon puits (de la rue Traversine)*, Marville, 1865 (CAR/RV).

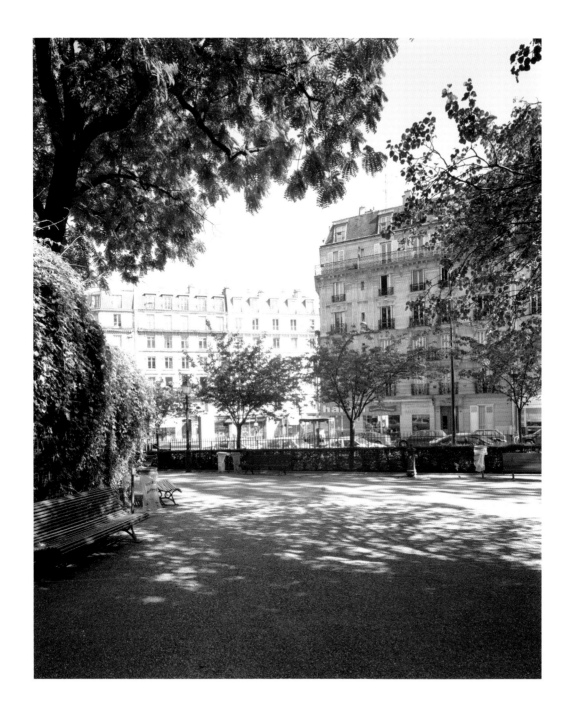

Square Paul Langevin, Sramek, 20.09.2010.

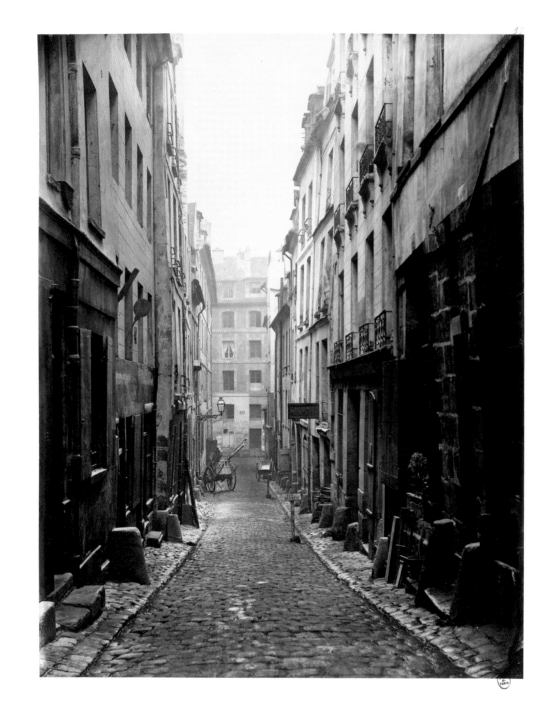

5.13. *Rue du Murier (de la rue Traversine),* Marville, 1865 (CAR/RV).

Square Paul Langevin, Sramek, 20.09.2010.

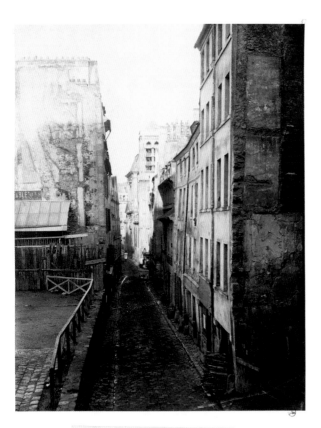

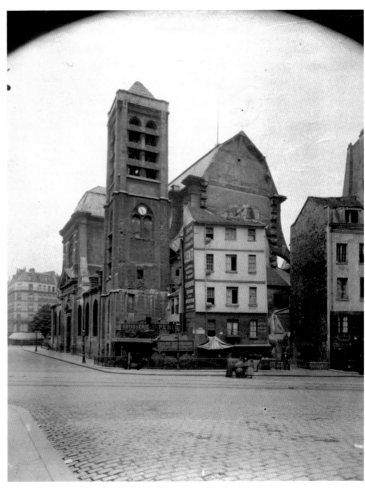

5.14. *Rue S* Nicolas du Chardonnet (de la rue Traversine)*, Marville, 1865 (CAR/RV).

Eglise Saint-Nicolas-du-Chardonnet (vers rue Saint-Victor de la rue des Bernardins, 23), Atget, 1898 (CAR/RV).

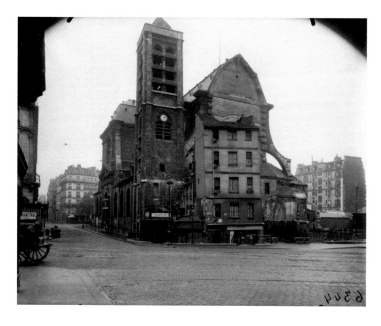

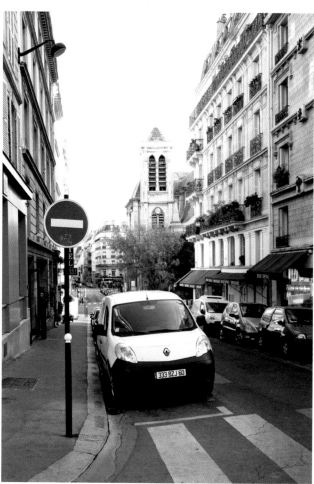

Eglise Saint-Nicolas-du-Chardonnet (vers rue Saint-Victor de la rue des Bernardins, 23),
Atget, 1898 (CAR/RV).

Rue des Bernardins (from Rue des Ecoles), Sramek, 16.08.2009.

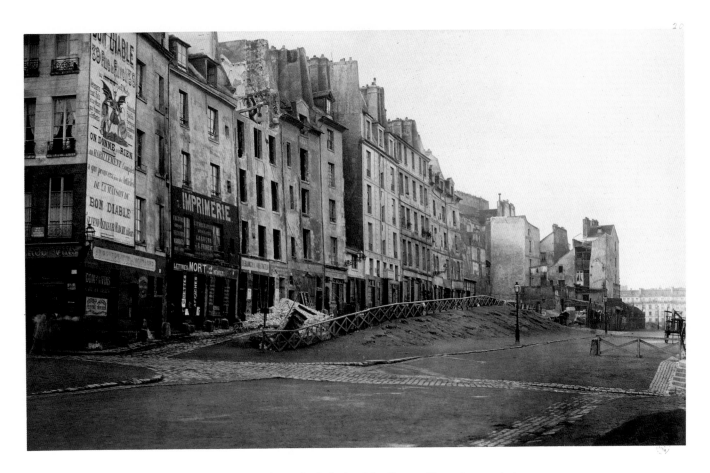

Today we can see the buildings which eventually lined the *rue des Écoles*, but Marville was able to photograph the new development partially completed. One can see the path of *rue du Clos-Bruneau* behind the fencing, a small section of which still exists behind and inside the block of new construction. There is, now a small entryway with stairs from *rue des Ecoles* opposite the low house-front seen in Marville's image, and this low building still exists. The newer corner building sits on what once was the beginning of *rue du Clos-Bruneau* opposite the end of *rue Traversine*. Here there is now a hardware store with a traditional flair and the owner has a framed print inside showing the building in the early twentieth century. Proud of his establishment, he posed for me with his assistant for a new photograph. Such merchants are a reminder of a local commercial culture which people speak about losing.

5.15. *Rue du Clos Bruneau (de la rue des Ecoles)*, Marville, 1865 (CAR/RV).

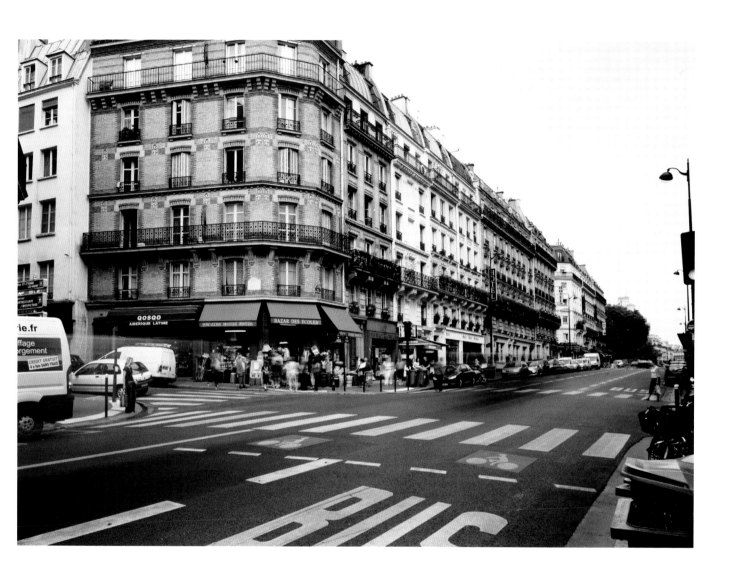

Intersection of Rue des Ecoles and Rue de la Montagne-Ste-Geneviève, Sramek, 28-06-2010.

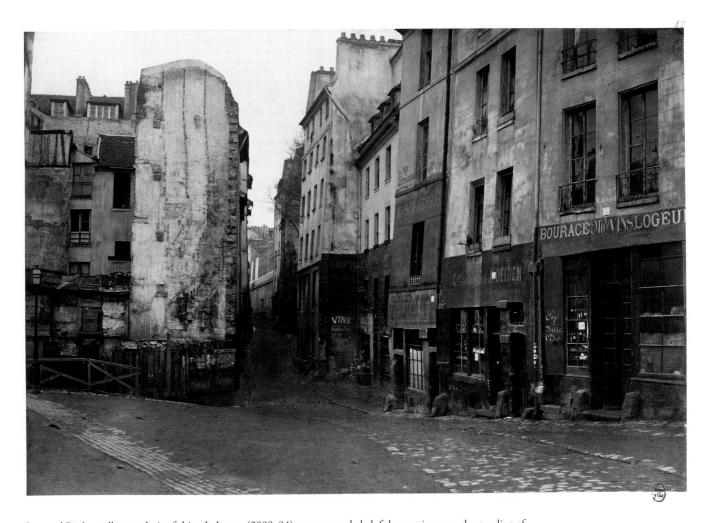

Leonard Pitt's excellent analysis of this whole area (2008: 94) was extremely helpful to me in my understanding of the history of these street configurations. Still, the rephotograph for Plate 5.16 is not perfectly executed. The angle is incorrect. In Marville's image one is looking into *rue Traversine* which is now gone and the progressive demolition is evident on the left, as is the angle of the path of the new *rue des Ecoles*. The top of *rue des Bernardins* may run along the truncated end of the building row and this short piece of the street now a dead end extending south of *rue des Écoles*. Coming in from behind the photographer on the right was *rue du Clos-Bruneau*, which is also gone, having been cut off at this point by new buildings. The various historical maps depict differently the exact intersection of *rue Traversine* and *rue de la Montagne-Sainte-Geneviève* and the actual intersection is not in the frame, as Marville was standing at its edge.

5.16. *Rue Traversine (de la rue du Clos Bruneau)*, Marville, 1865 (CAR/RV).

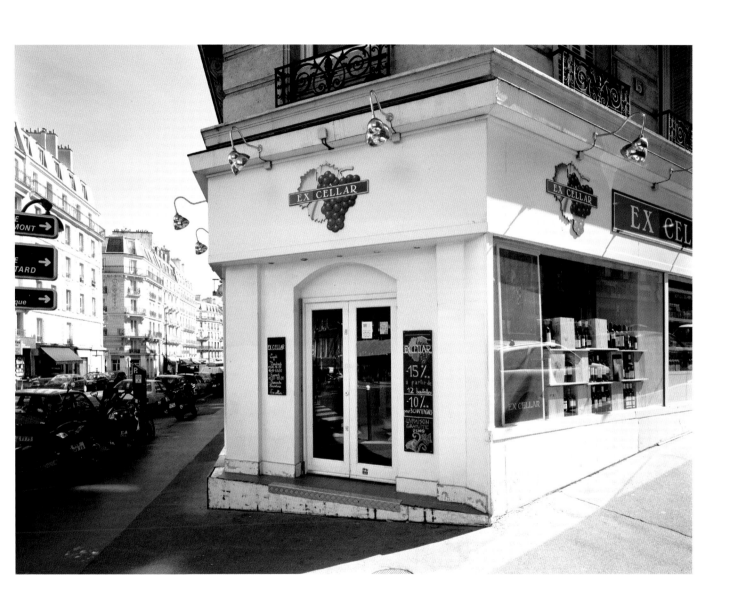

Intersection of Rue des Ecoles and Rue de la Montagne-Ste-Geneviève, Sramek, 20.09.2010.

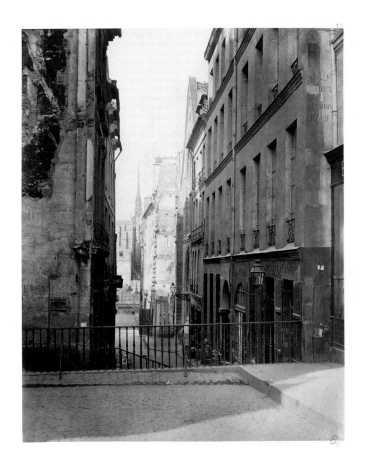

5.17. *Rue Jean de Beauvais (de la rue des Ecoles)*, Marville, 1865 (CAR/RV). Rue Jean-de-Beauvais, Sramek, 20.02.2011.

5.18. *Rue Jean de Beauvais*, Marville, 1865 (CAR/RV). Rue Jean-de-Beauvais, Sramek, 20.02.2011.

5.19. *Agencement des rues Fromentel, S^t Hilaire, Jean de Beauvais, Charretière et Mont-de-Marsan*, Marville, 1865 (CAR/RV).

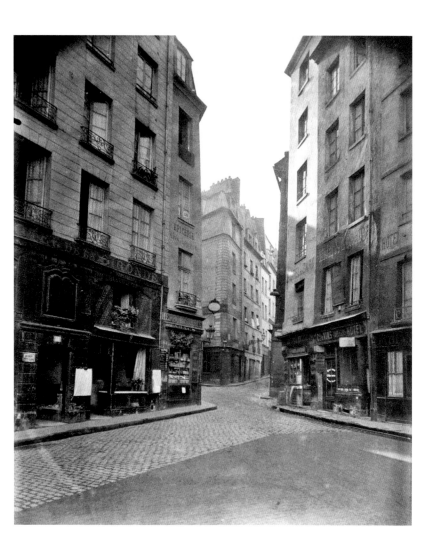

The intersection of today's *impasse Chartière* with *rue de Lanneau* provides another location which Atget photographed over two decades of progressive demolition. It was in the 1920s in particular, that he recorded the disappearance of *rue Fromental* and the buildings seen on the right side of the photographs. This series may be found in the Museum of Modern Art's collection of Atget prints (Morris Hambourg 1982).

In *rue de Lanneau*, renamed from *rue Saint-Hilaire*, one can still experience the atmosphere of the old Paris, which predates Haussmann, but everything to the west has changed. In fact, major demolitions and renovations to the grey structure on the right of the contemporary photograph were underway in 2012.

Atget, 1899-1900 (BnF).

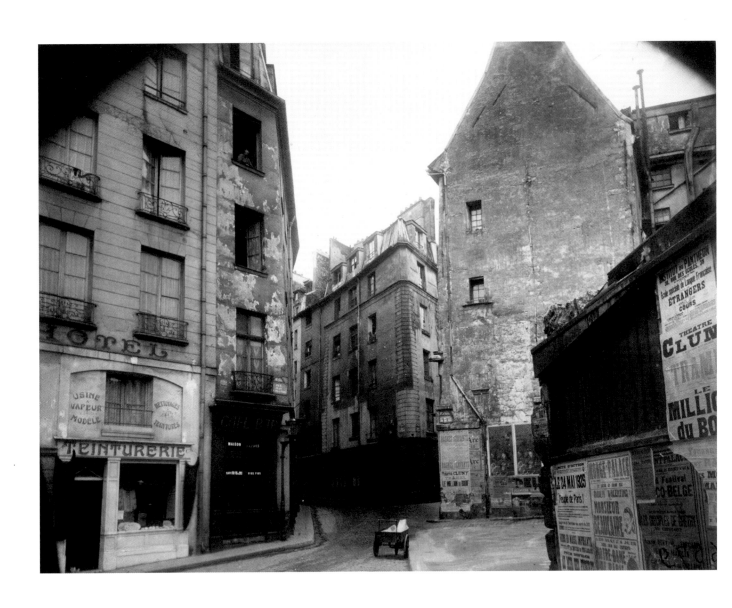

Atget, May-June 1925 (MOMA).

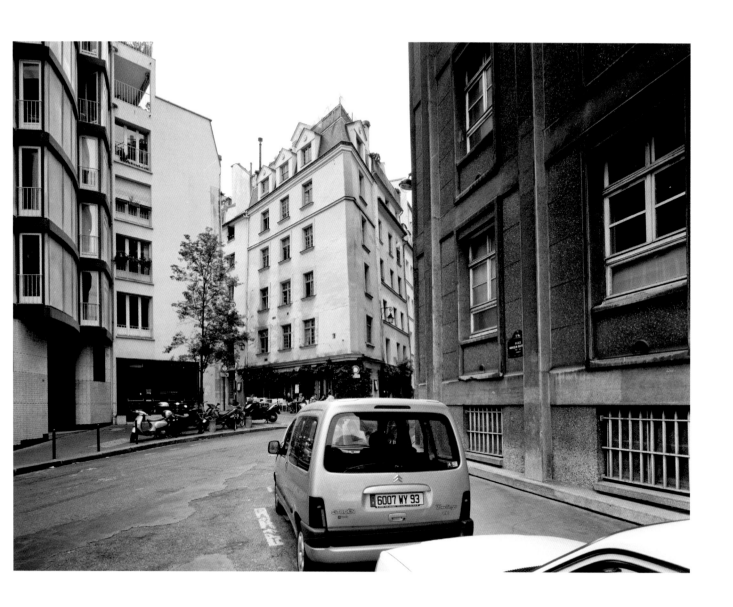

Intersection of Rue de Lanneau, Rue Jean-de-Beauvais and Impasse Chartière, Sramek, 20.09.2010.

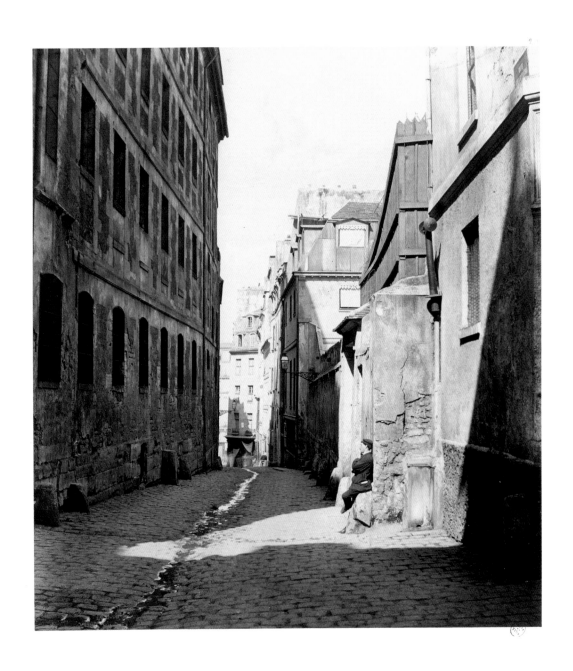

5.20. *Rue Charretière (de la rue de Reims)*, Marville, 1865 (CAR/RV).

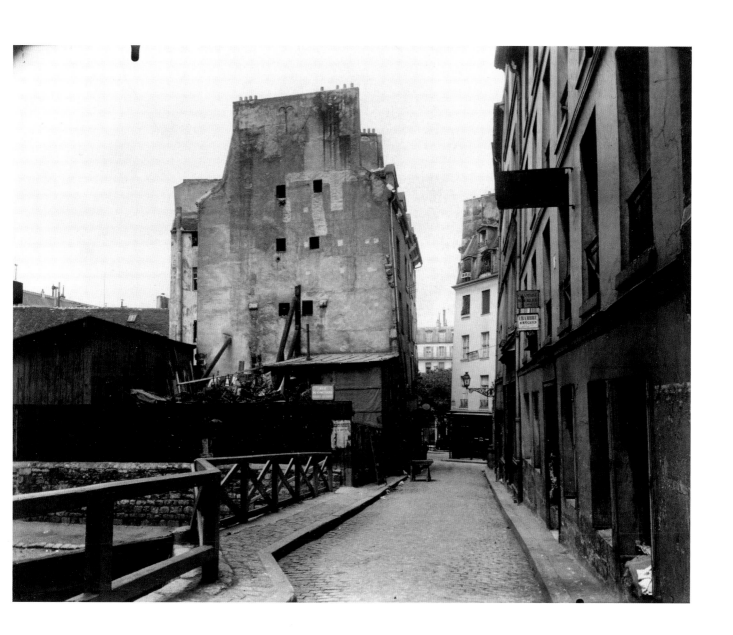

Impasse Chartière, Atget, 1909 (CAR/RV).

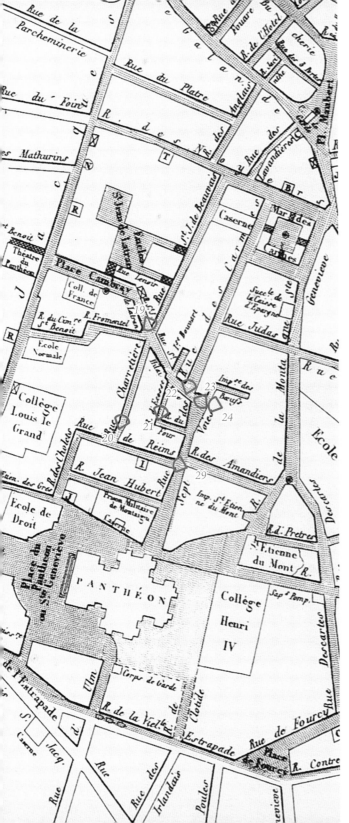

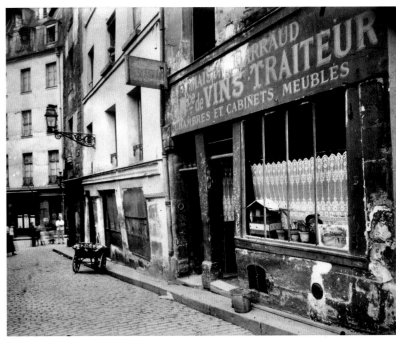

A study of the 1835 map reveals the earlier street plan, which saw many changes with the growth of the educational institutions in this area. Both *rue Chartière* and *rue d'Ecosse* have become dead ends while *rue Fromental* is gone, as is the *rue de Rheims*. *Rue Saint-Hilaire* has been renamed as have other streets. Missing from the map of 1835 is *rue de l'Ecole Polytéchnique*. By Marville's time it was in place, providing a direct path to the square in front of the school.

Fig. 48.
Petit Atlas Pittoresque (1834)
No. 63 Ste-Genviève (detail).

Vieilles maisons, Impasse Chartière,
Atget, 1915 (BnF).

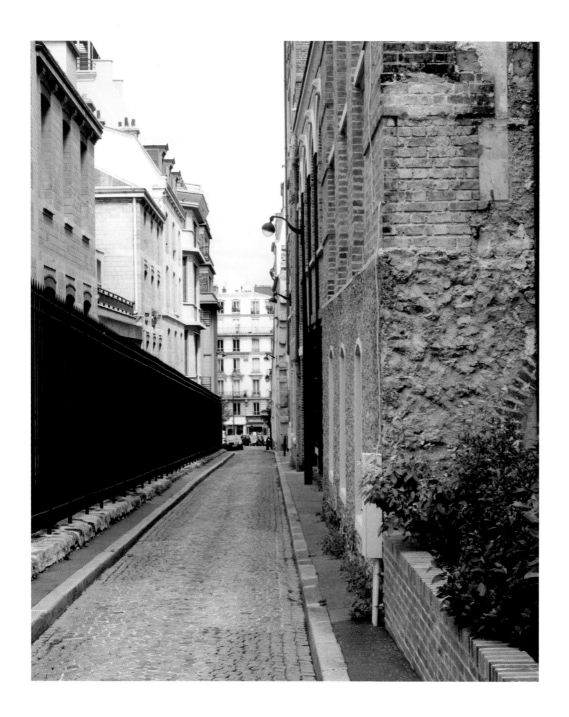

Impasse Chartière, Sramek, 13.08.2009.

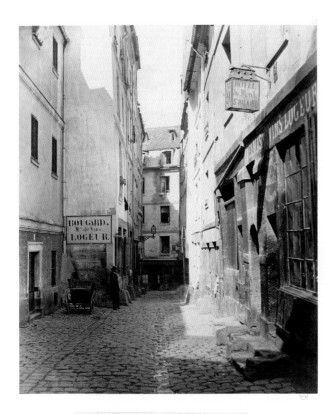

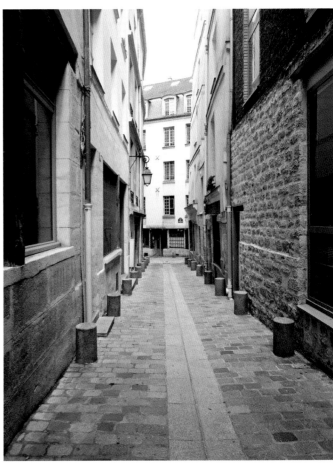

5.21. *Rue d'Ecosse (de la rue du Four St Jacques),* Marville, 1865 (CAR/RV).

Rue d'Ecosse, Sramek, 13.08.2009.

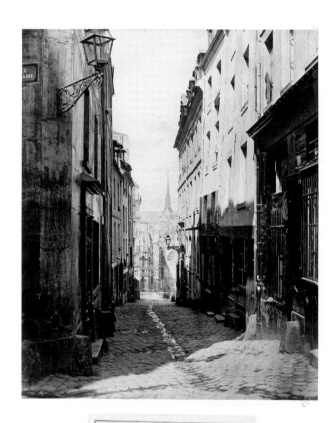

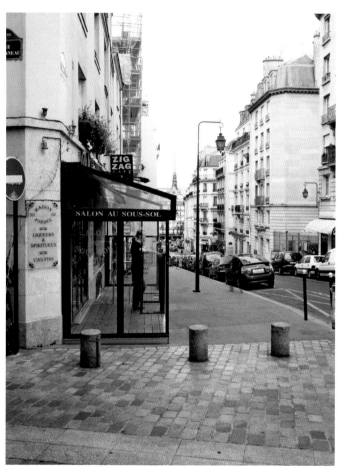

5.22. *Rue des Carmes (de la rue St Hilaire)*, Marville, 1865 (CAR/RV). Rue des Carmes (from Rue de Lanneau), Sramek, 13.08.2009.

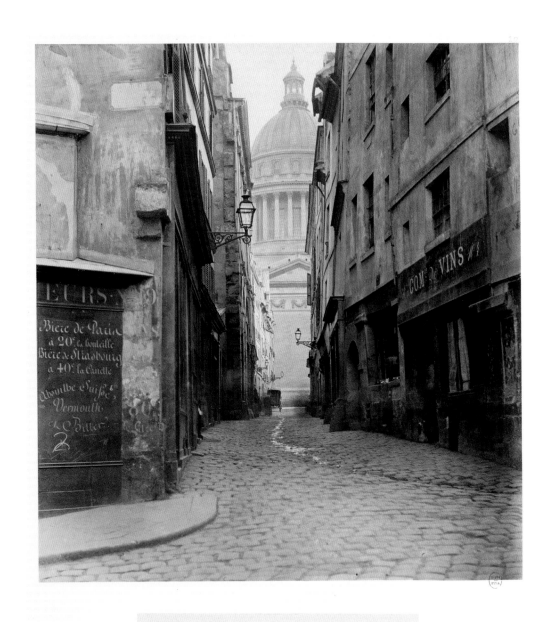

5.23. *Rue des Sept-voies (de la rue S[t] Hilaire)*, Marville, 1865 (CAR/RV).

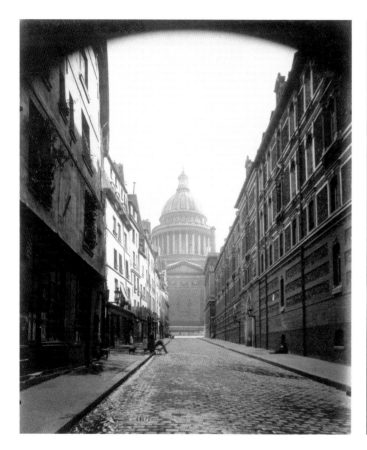

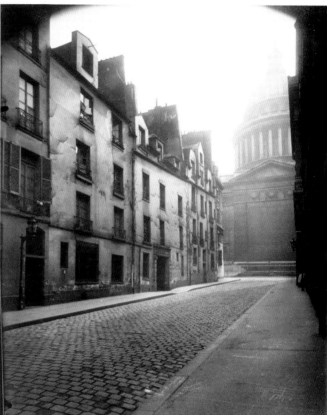

Rue Valette - le Panthéon, Atget, 1898 (CAR/RV).

Atget, c.1923 (CAR/RV).

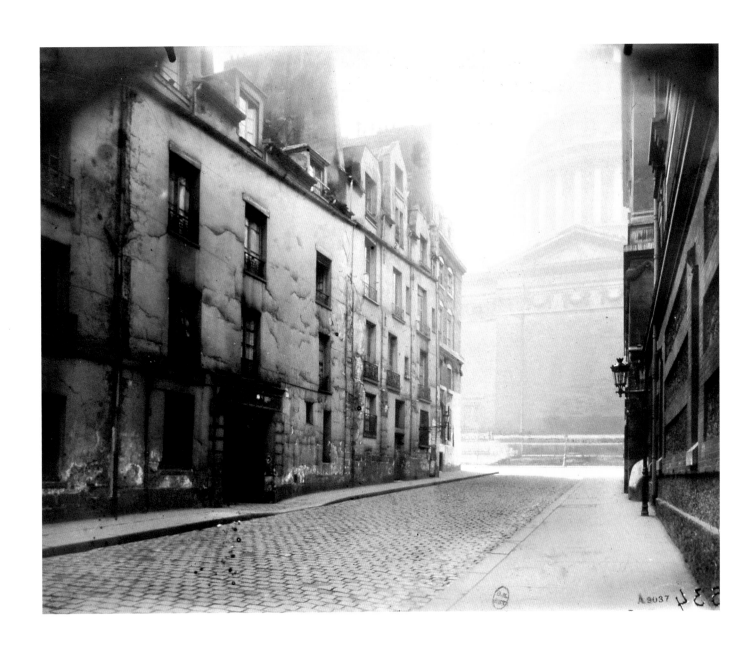

Atget, 1924 (BnF).

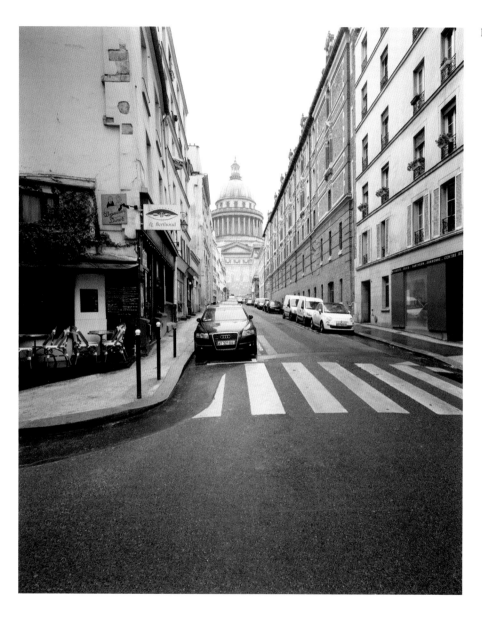

Rue Valette (from Rue de Lanneau), Sramek, 20.02.2011.

Brieuc: I live in *rue de Lanneau* … Thirty-five years ago, I lived in *rue Gay-Lussac* just opposite the *Panthéon*. Essentially, I came here [to the corner of *rue de Lanneau* and *rue des Carmes*] for my work because I lived in the *quartier*. I stumbled across the space one day. It was empty and I asked to rent it and now it is 15 years that I have worked here. Twelve years ago I found another place that was in ruins in *rue de Lanneau* and I bought it and renovated. Now it is a small three-room apartment … The street is called *impasse Bouvart* – it shows in the land registry. It is in the *rue de Lanneau*, but it is a dead end, very, very old. When one enters this alleyway, there is one-and-a-half-metres width maximum …

I have known this *quartier* for a long time and it is an agreeable neighbourhood which I like very much. The whole area has its young people, with the universities and schools. It has its history – the history of the Latin Quarter – the events of 1968 – that is important. So, for us it is symbolic of many things.

My family was Breton, but my grandfather travelled. He went to China. My father was born in China, my mother in Tunisia. They returned in the 1950s and I was born in the suburbs of Paris. I started my university studies and I was at Jussieu. I also had friends in this *quartier*, close to *le Panthéon*. In fact, when I met my wife, she lived in *rue Gay-Lussac*, so I moved in with her. I am not, what you would call 'a native', but for me it makes no sense to say 'native' because, in fact, when people were not born here – that does not necessarily mean very much to me.

Travel is simpler, easier now and, it doesn't disturb anything to have people who come from all over. Besides, something important happened in my generation and that is Europe. For me it is very important to say, for example, that I can go to Prague, to England, or Spain more easily – to share the Euro – the same money and share also the same histories, the same values. And so, for me, the people who are born somewhere and who cling to it, for me, that is looking back towards a form of nationalism, towards something which I think doesn't make good sense. Today I feel, in fact, more European than Breton or French.

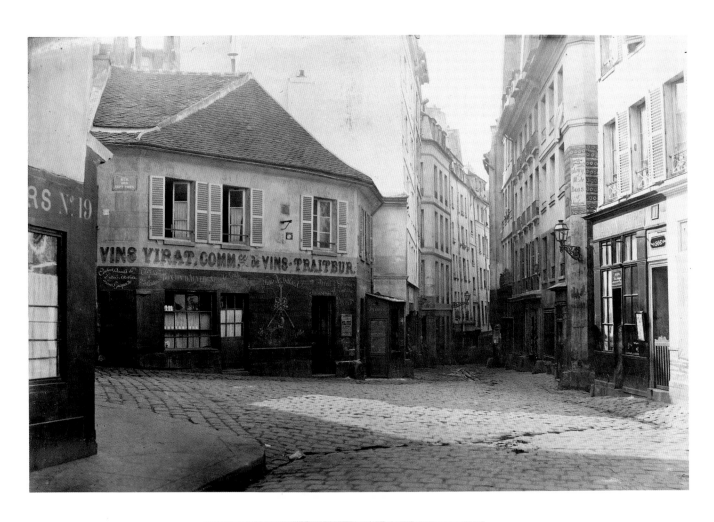

5.24. *Rue St Hilaire (de la rue de l'Ecole Polytechnique)*, Marville, 1865 (CAR/RV).

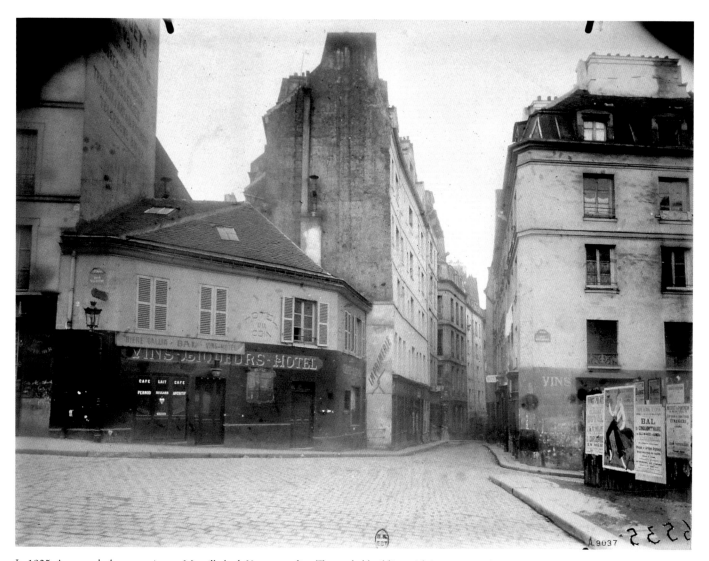

In 1925, Atget took the same view as Marville had 60 years earlier. The angled building with its wine merchant no longer announced prepared foods but rather hotel lodging. The Atget image is one of two he made from this angle and it shows the hoarding where the building on the corner of *rue des Carmes* was demolished. Two years later, he returned to the same spot to remake the image (see Morris Hambourg 1982). Here. the hoarding had moved down as demolition progressed. In Marville's image one hardly notices the narrow street entering on the right, while today, *rue des Carmes* provides a wide view, both down towards Notre Dame and up to the Pantheon (pls. 5.21-5.22).

Rue des Carmes [to the right], Atget, 1925-27 (BnF).

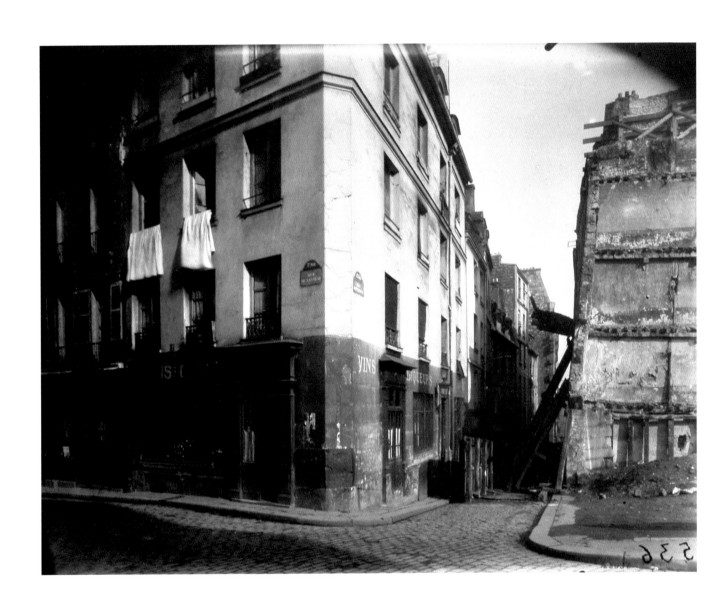

Rue de Lanneau [to the left, Rue des Carmes on the right], Atget, 1924 (BnF).

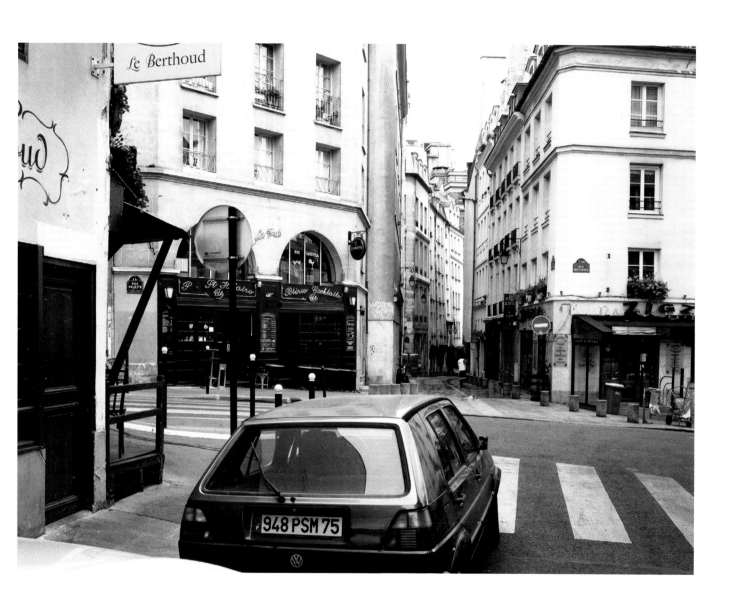

Rue de Lanneau (from Rue de l'Ecole-Polytechnique), Sramek, 13.08.2009.

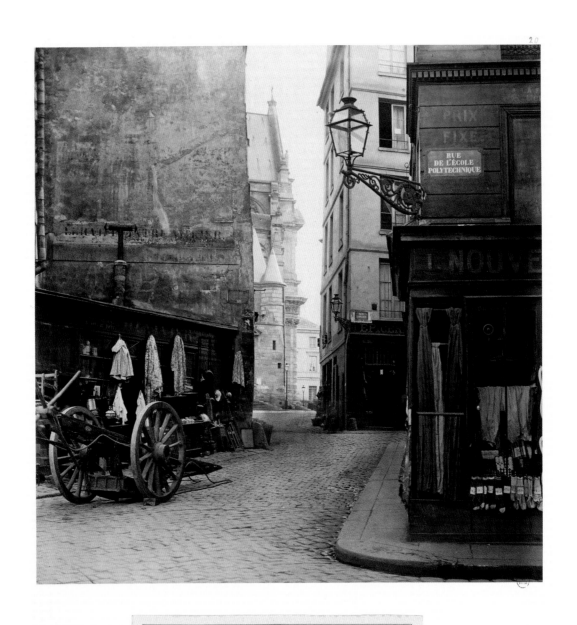

5.25. *Rue de la Montagne S^{te} Geneviève*, Marville, 1865 (CAR/RV).

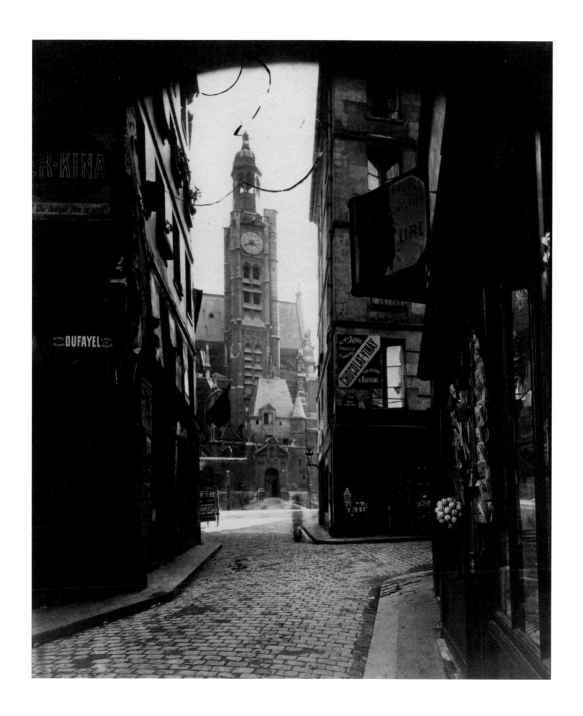

Eglise Saint-Etienne-du-Mont, rue de la Montagne Sainte-Geneviève, Atget, 1898 (CAR/RV).

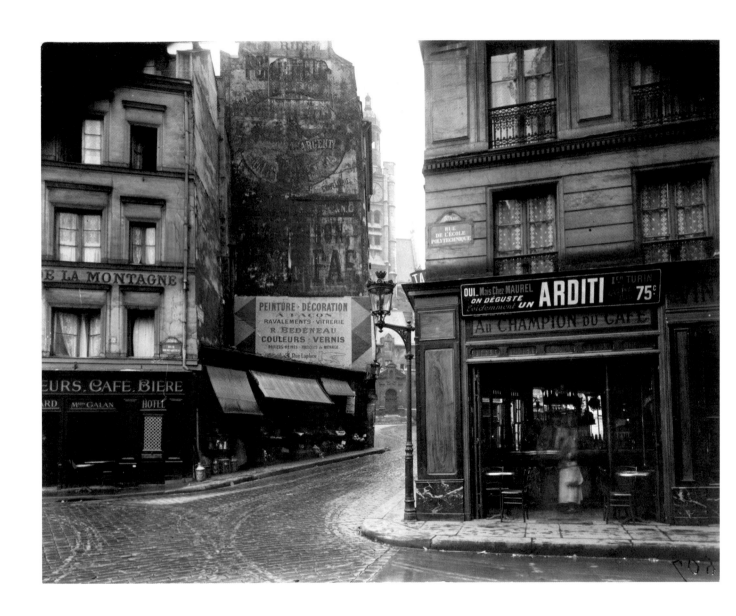

Rue de la Montagne-Sainte-Geneviève, Atget, 1922 (MOMA).

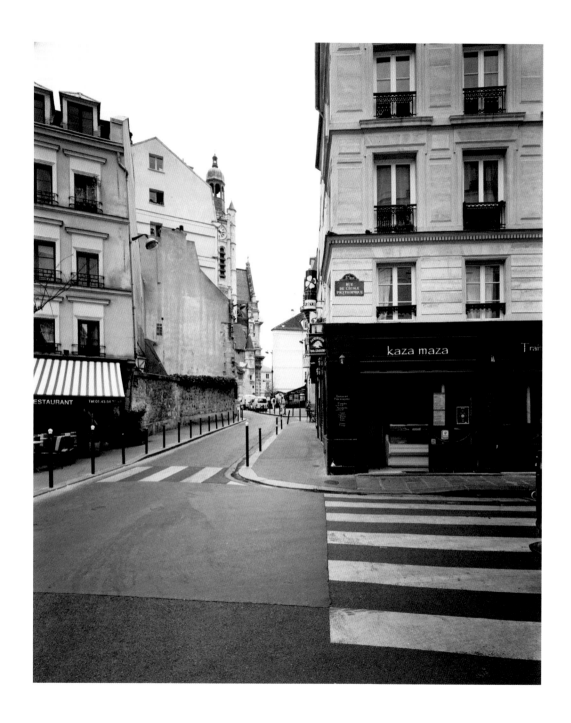

Rue de la Montagne-Sainte-Geneviève and Rue de l'Ecole Polytechnique, Sramek, 13.08.2009.

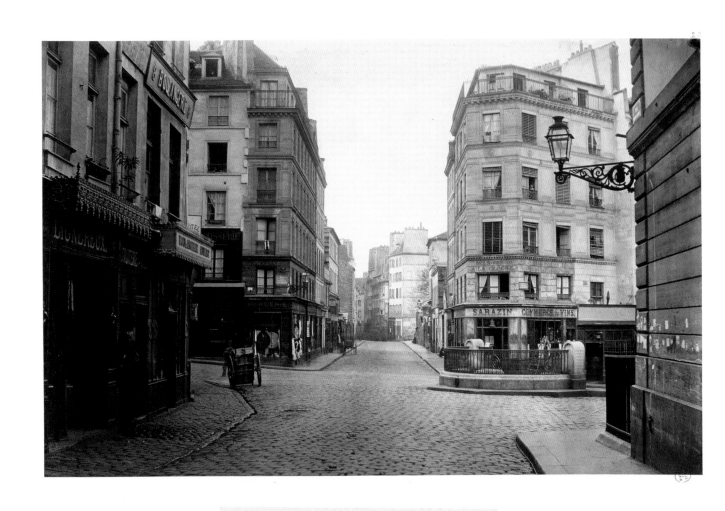

5.26. *Place et rue de l'Ecole Polytechnique*, Marville, 1865 (CAR/RV).

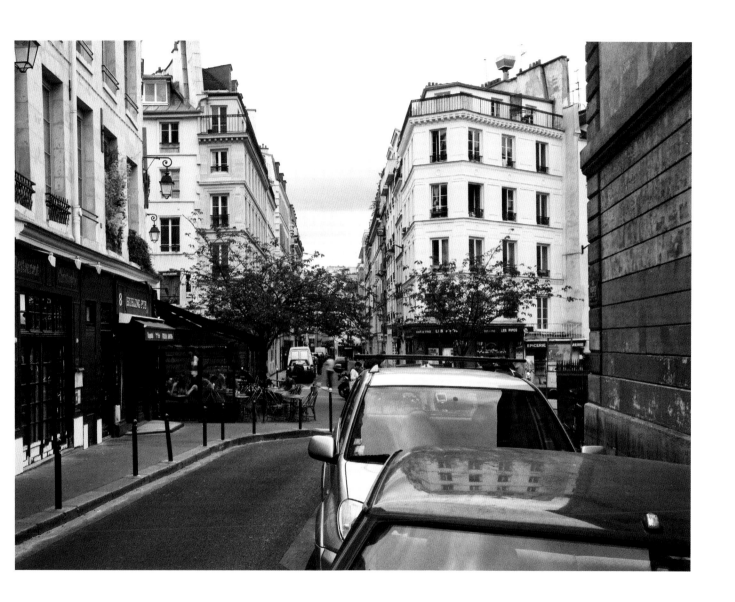

Place de l'Ecole-Polytechnique (from Rue Descartes), Sramek, 13.08.2009.

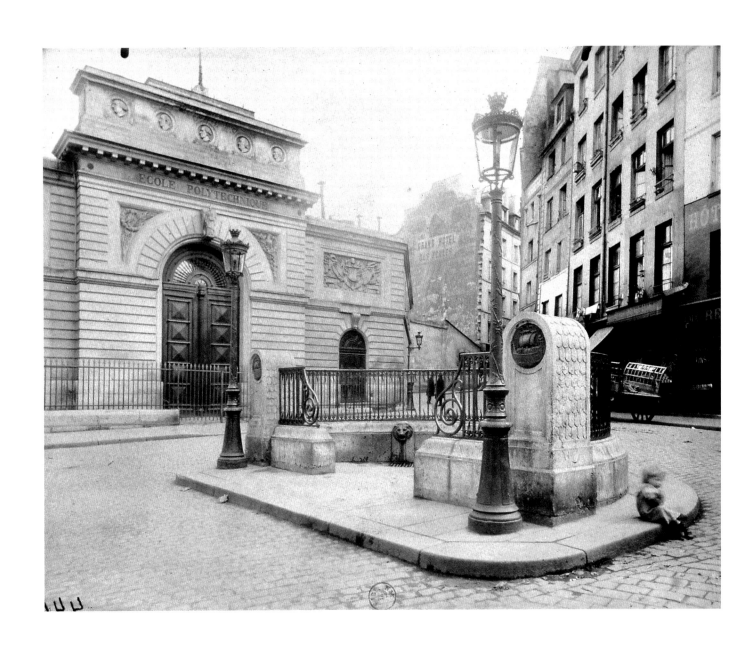

Fontaine et l'Ecole-Polytechnique, Atget, 1902-03 (BnF).

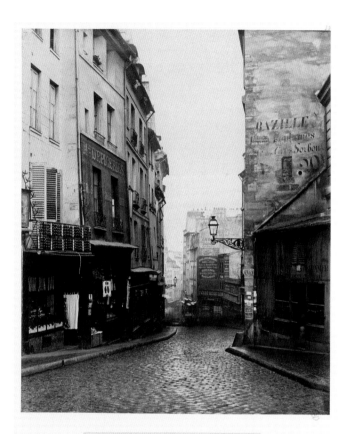

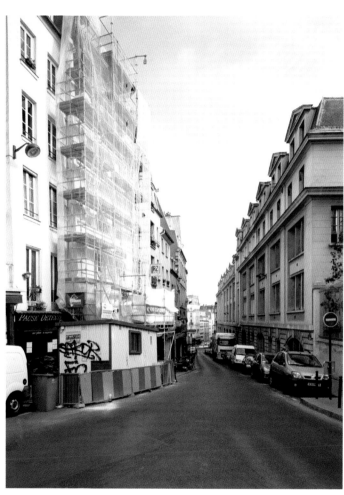

5.27. *Rue de la Montagne S^{te} Geneviève (de la rue de l'Ecole Polytechnique)*, Marville, 1865 (CAR/RV).

Rue de la Montagne-Ste-Geneviève (from Place de l'Ecole-Polytechnique, towards the north), Sramek, 17.05.2011.

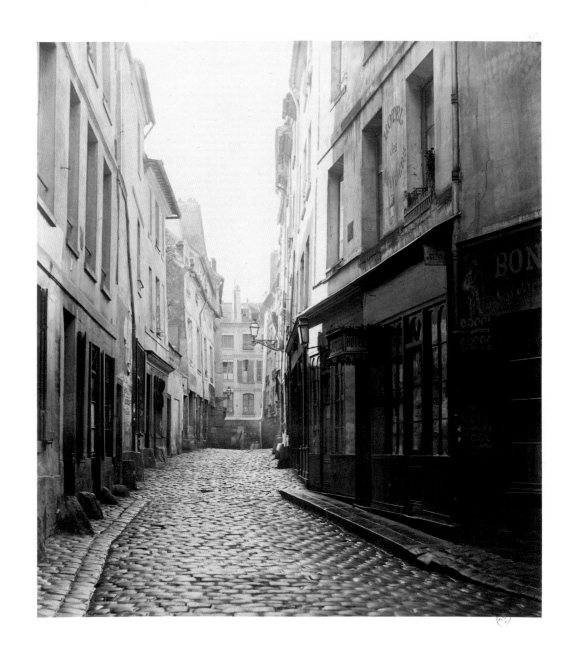

5.28. *Rue Laplace (de la Montagne Sᵗᵉ Geneviève)*, Marville, 1865 (CAR/RV).

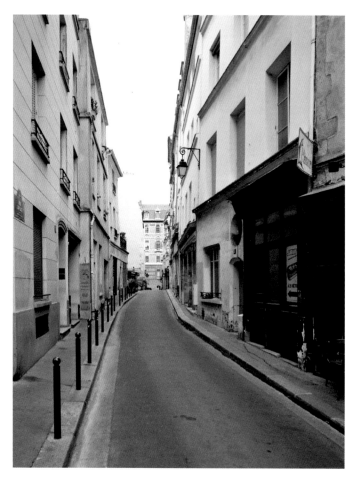

Rue Laplace, Sramek, 13.08.2009.

Maryse: I come from Pointeau-Charente. I have lived in this quarter for eleven years. I have seen a lot. Not a lot of change ... Because there have been small resistances, many things have been preserved. Over the past ten years, in terms of architecture, I find it has not changed very much. Of course, there is always tourism and this is *rue Mouffetard* which is all about history ...

It is very interesting. And, for example in the square over there, where artists used to come when they finished their shows – they came to have a drink here because the two cafés which face each other used to stay open very late. And that is why there also used to be many *clochards* (tramps) because they knew it would be lively, even at four o'clock in the morning. And so they enjoyed coming here. There is still a little left of this history ...

In *rue Laplace* there is the Piano Vache where many young students go and where they have free jazz. And just about opposite there is an old building and in the basement, M. Luczek, who was a great Russian musician who had formed a troupe which toured the world, created a restaurant called the Balalaika. This was an important location in the history of *rue Laplace*. But then it closed and is now a night club. But there are beautiful photos which were made at that time because this musician left us two years ago and he wanted to create a memory and keep a trace of his friends. ... He chose photographs and I made a portrait of him along with some photos of the musicians. It is important in the history of traditional Russian music ... and is a moment in the history of Paris.

If I think, I can tell you what has changed. What has changed is the relationship between people in the quarter. For example, the artists that I knew ten years ago find that today we are in a sad period. Before, at Les Espagnols, at four in the morning, there used to be a party with all of the musicians who came, having finished. They came to relax and they played and sang. It was super – I knew that time. Now it is over because of the restrictions on smoking and noise at night. Everyone should be in bed by two o'clock. It is not good and that changes the spirit of the place and what it meant before to find oneself – because there were things that happened here, a moment of birth in the night. And now today, it is sad.

It is true that for me this quarter is associated with music, because I met people at Les Espagnols. The restaurant is still there and there are still musicians – there is still life to experience. Someone said to me, 'It will return,' but I don't know. It is hard.

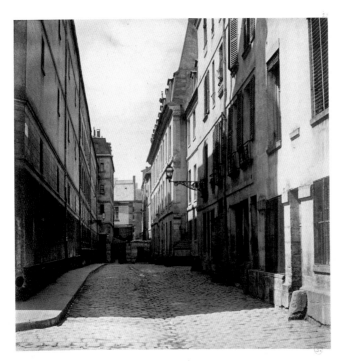

5.29. *Rue de Reims (de la rue des Sept-voies)*, Marville, 1865 (CAR/RV). No. 4 Rue Valette, Sramek, 24.02.2011.

Brieuc: I love images. I work in photography and for me the old photos tell stories. When I see what you have done here, for example the act of comparing photos from different periods, I am very interested in seeing the details, of seeing exactly what has changed, what has disappeared, what has been modified. Here, typically, it is the *pavés* (the cobble stones) with the central gutter that allowed for drainage and to have sewers during that period ... The appearance of vehicles – it is important in the modern photographs – they are everywhere. In the old photos one never sees them, or if one does, they are the horse-drawn vehicles ... This is something which shows an evolution, and also allows one to imagine ... Because, in fact, today's photographs in 50 years ... well Paris will have changed completely...

What often fascinates me in these documents is the speed at which change occurs. That is to say, I have the impression that at the scale of one generation, say 30 or 40 years, there are many things which change, but little by little. And from one generation to the next, one forgets, in fact. People have a capacity to forget which is at once extraordinary, but at the same time one remembers because of photographs and other such records. Even if I have no memory of all that I see in the photographs, it reminds me that everything changes very rapidly.

At the time when they demolished Les Halles, the Pavillons Baltard, many people protested against this because it is really an image of old Paris. And at the same time it was absurd. Myself, I participated, but at the same time it was necessary that I find it normal that it should evolve. What they did, in my opinion, was not necessarily very successful (and they are in the middle of reconstructing it now) but this whole *quartier* was completely changed.

But, the Pavillons Baltard belonged to a very old era and it was absurd to keep them in the contemporary context. It was absolutely necessary to move Les Halles, but there was a certain spirit of Paris which was lost with that. Still, that is part of the normal evolution of a city.

Pierre: The Roman Arena of Lutetia was known in the twelfth and thirteenth centuries. The name *'arènes de Lutece'* existed, but there was no known trace of it. During the work under Haussmann it was rediscovered – that is to say remnants of the arena. However, the land belonged to a bus company – horse-drawn omnibuses. They wanted to destroy everything to create a terminal for organizing the vehicles. There was an association formed to protect the arena, but still there was much damage. It was Victor Hugo, along with others, who succeeded in protecting the arena and so there is now something of the Arènes de Lutece remaining. Hugo wrote a very beautiful speech. Otherwise, it would all have disappeared.

In the *rue Soufflot* there was the Roman Forum. The Forum was larger than the street and ran from the Pantheon to the Luxembourg Gardens. The location was known already in the nineteenth century – they had plans. There was an archaeologist, the first modern archaeologist around 1860 and he did the excavation. When they were building the underground parking, they dug it all up and the last vestiges of the Roman Forum were destroyed to create the parking. It is worse than for the arena. The arena was saved, but now economics goes ahead of all else and so there is nothing left of the Roman Forum which was beneath the surface.

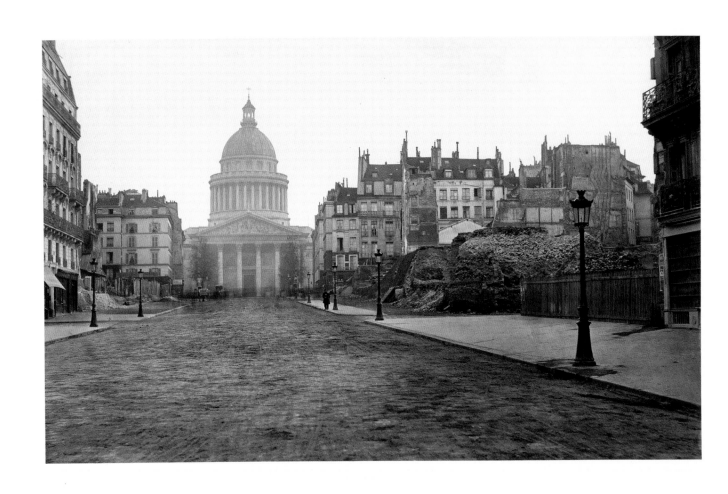

LA RUE SOUFFLOT ET LE PANTHÉON

5.30. *La rue Soufflot et le Panthéon*, Marville, c.1876.

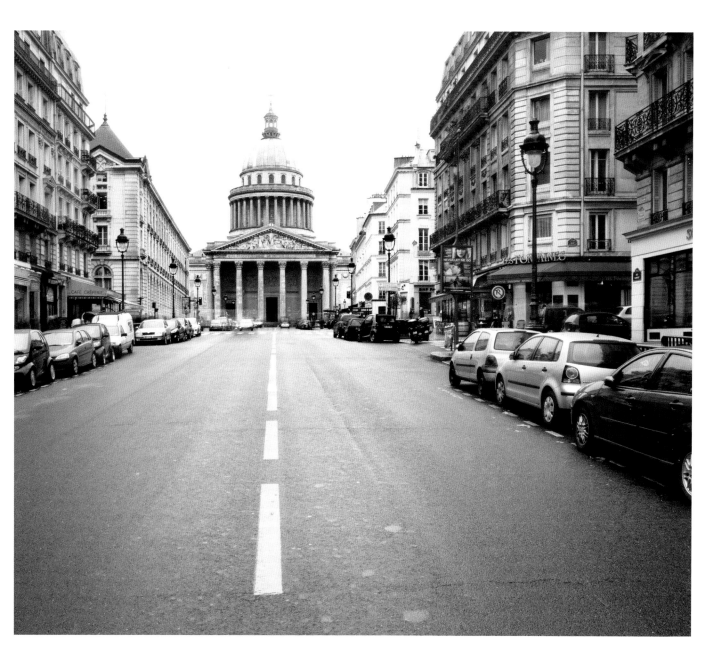

Rue Soufflot, Sramek, 23.02.2011.

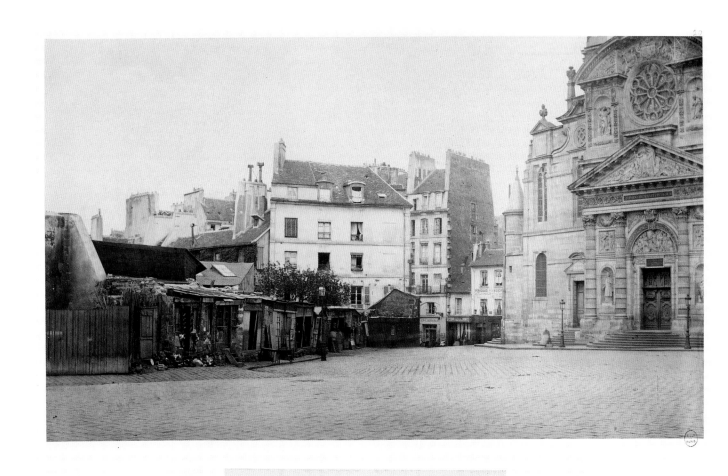

5.31. *Carré St Etienne du Mont (du Panthéon)*, Marville, 1865 (CAR/RV).

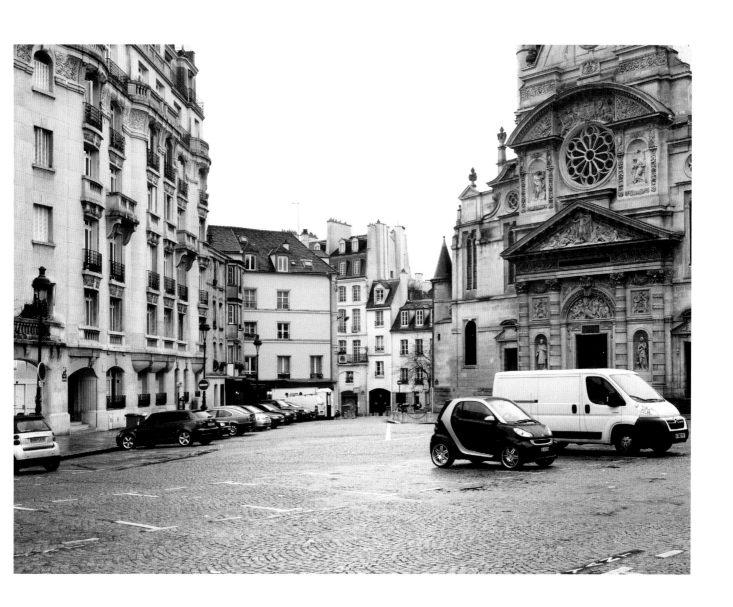

Place du Panthéon, Sramek, 23.02.2011.

5.32. *Rue Descartes (de la rue Clovis)*, Marville, 1865 (CAR/RV).

Vieilles maisons au coin des rues Saint-Etienne-du-Mont et rue Descartes, Atget, 1906 (CAR/RV).

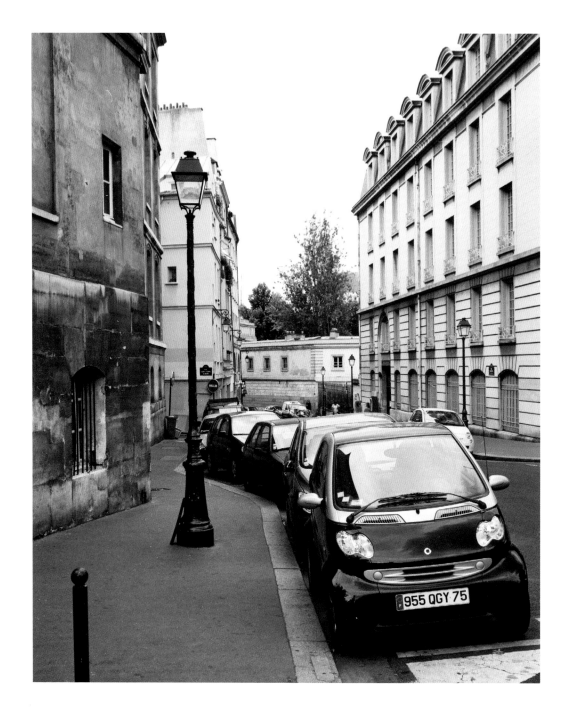

Rue Descartes (from Rue Clovis), Sramek, 13.08.2009.

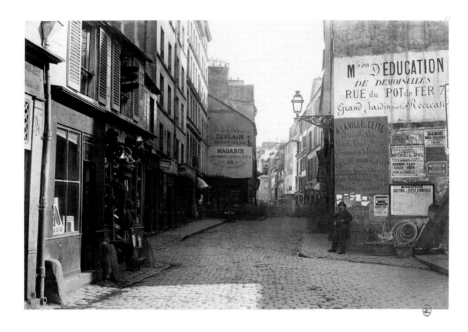

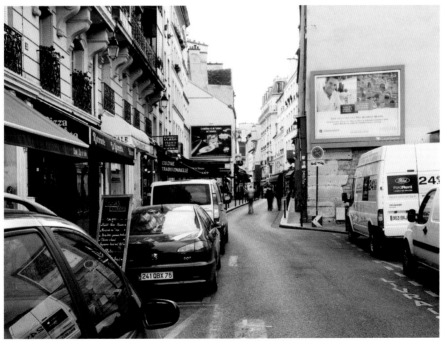

5.33. *Rue Descartes (de la rue Mouffetard)* [incorrect – this is towards Rue Mouffetard], Marville, 1865 (CAR/RV) (above).
Rue Descartes (towards Place de la Contrescarpe), Sramek, 13.08.2009 (below).

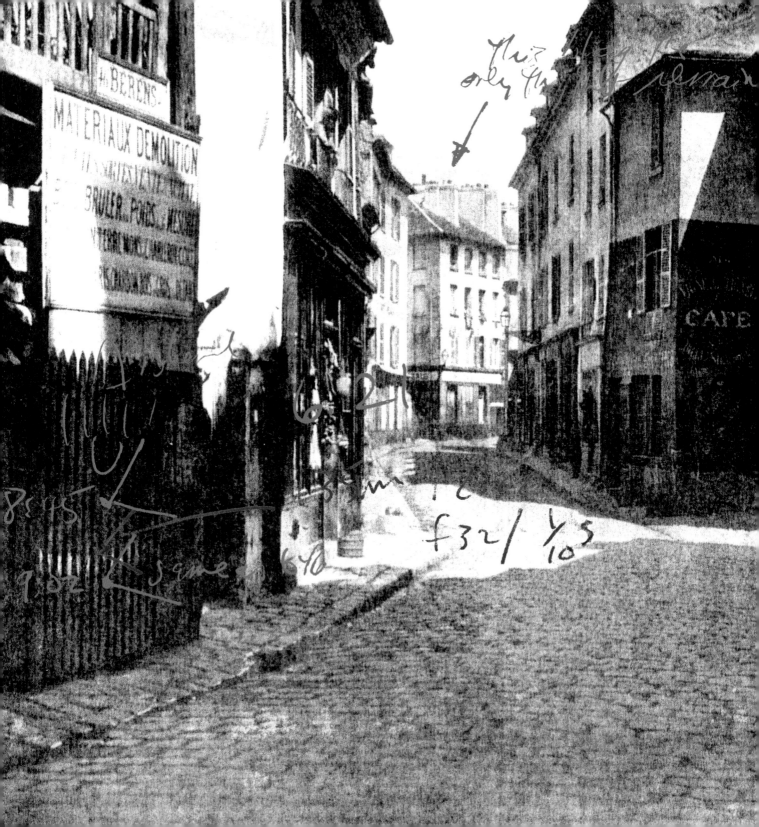

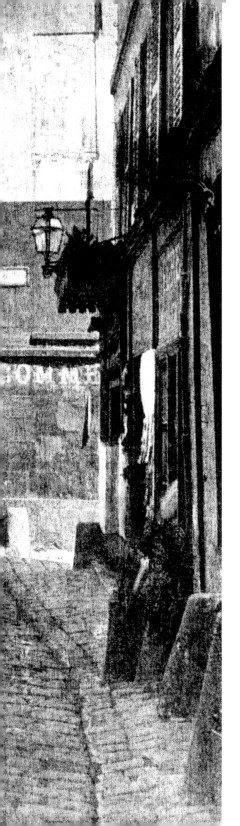

La Bièvre - Rue Monge

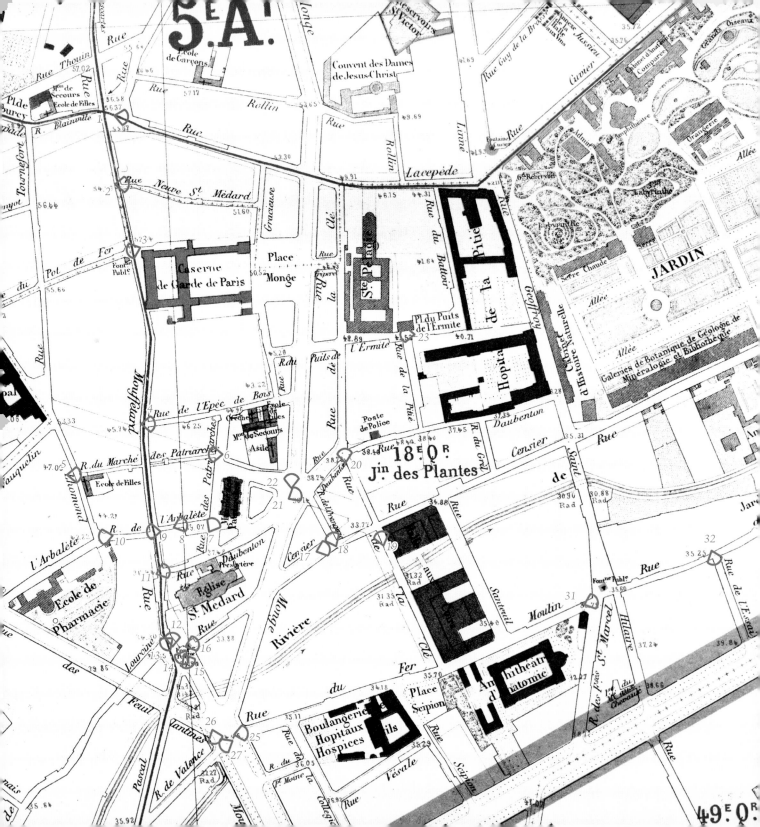

Thouin

Rue

Ecole

Rue

Rotlin

Ecole

Rue

Ecole

Place

R. Blainville

Contrescarpe

Rue

Cie des Omnibus

S.t Victor

Réservoirs

Victor

Arènes

Square
des Arènes
de Lutèce

Rue Guy de la Brosse

Jussieu

Vie

Rue

Rue

de

Rue

Navarre

Linné

Rue

Cuvier

Cab d'Anatomie

Mais. de Cuvier

G.s Oiseaux

Amphithéâtre

Orangerie

Allée

Ecole
Protestante

Rue

St Médard

Rue St. de Rue

Ortolan

Rue

Monge

Malus

Lacépède

Rue Quatrefages

Hôpital de la Pitié

Rue

Labyrinthe

Serre
Tempérée

Ecole

Allée

JARDIN

Caserne de
la Garde Rép.

L. Blanc
Place
Monge

Gracieuse

R. Larrey

R.

Dolomien

de

Serre Chaude

Galeries de
Zoologie

Allée

Mouffetard

Rue

Rue

Pesta-

lozzi

Rue du Puits de l'Ermite

Pl. du
R. de l'Ermite

Geoffroy

Maison de Cat.ie de Géologie

Botanique

Ecole

de

Bois

de

la

Clef

Rue

Buffon

Rue

du Pot de Fer

Rue de l'Epée

Rue des Postes

Ecole

Rue

Daubenton

Rue

Tournefort

Pas des Postes

Pas des Patriarches

Rue de l'Arbalète

24

Rue de

benton

Rue

Censier

Saint

de

Jardin

Lhomond

R. de

Marché

Rue des Patriarches

Rue de Daub-

Mirbel

Rue

18

Rue

R. de l'Essai

l'Arbalète

Mouffetard

Rue Candolle

R. de

Censier

Rue

Rue

Halle aux Cuirs

de

Santeuil

R. des Fossés St Marcel

Hilaire

Institut
gronomique

Eglise
St Médard

Rue

Monge

R de la Photograp.

Rivière

la

Clef

Moulin

à

Bernard

Rue

R. de Bazeilles

28 29 30

AV. DES G.

Rue

R. du
P.t Moine

du

Rue

Boulangerie
des Hopitaux
& Hospices Civils

Place
Scipion

Rue

de la Coll

Amphithéâtre
d'Anatomie

Rue Scipion

Ecole

ST MARCE

Marché

Vesale

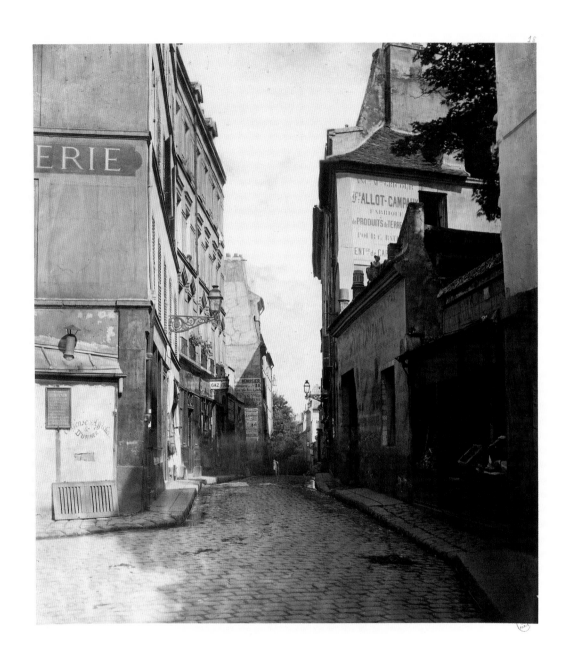

6.01. *Rue Lacépède (de la rue Mouffetard)*, Marville, 1865 (CAR/RV).

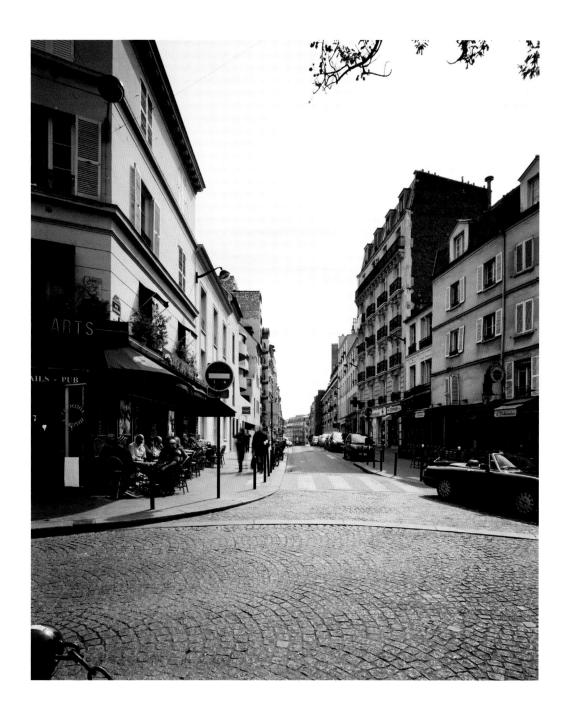

Rue Lacépède (from Place de la Contrescarpe), Sramek, 25.04.2010.

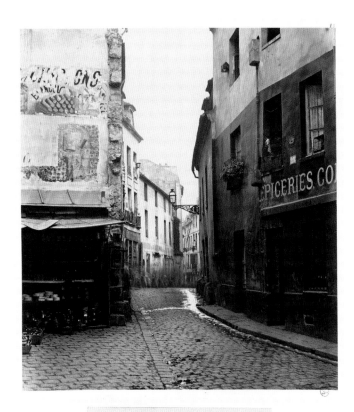

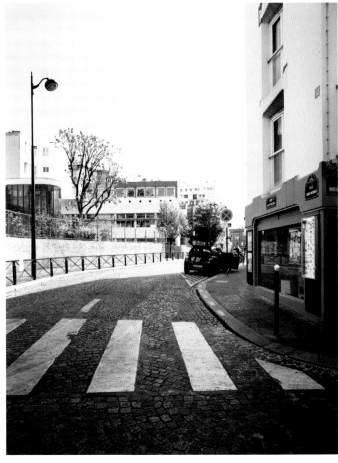

The **5th** *arrondissement* and the path of images made between *place Maubert* and *place Saint-Médard* provide an example of how change continues in Paris. Here one finds an overlapping of historical continuity with architectural alteration from various eras. At the top of *rue Mouffetard* near where it meets *place de la Contrescarpe*, I met Cécile Claris. I was standing with my back to her storefront to make the photograph of *rue Saint-Médard* (pl. 6.02) and we began to talk. Passionate about the people and history of the *'cinquième'* and *rue Mouffetard*, she was helpful throughout the project. I spoke about interviewing residents and she organized for me to meet people at the annual 'empty attic' street market, the *Vide Grenier*. That day, hundreds of people come to stroll, chat and hunt for bargains and, at her suggestion, I had my book for people to look through and I recorded our conversations. Whether born in the *quartier* or coming to settle there, people's experience of the shifting character of their neighbourhood reflects the continued pressures of urban development. The process that saw the wholesale destruction of poor and working-class neighbourhoods under Haussmann continues more quietly through renovation and upgrading, impacting on Parisian life. The collision, so significant in Haussmann's Paris, of civic improvement and real-estate economics with local identity and community life continues to be expressed by local residents.

6.02. *Rue N^ve S^t Médard de la rue Mouffetard*, Marville, 1865 (CAR/RV). Rue Saint-Médard (from Rue Mouffetard), Sramek, 25.04.2010.

Anna: One calls Paris the City of a Hundred Villages.

Ferval: The population has changed enormously. The people who inhabited Paris are a stable population who have lived there for generations. Myself, I was born in the 20th *arrondissement* and my parents still live in the 20th. It is a kind of village. I think this holds for all of the neighbourhoods of Paris. People do not move.

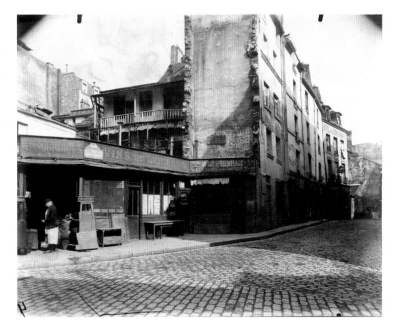

Brigitte: This is a very working-class *quartier*. Mouffetard had many old buildings where there were rented rooms. Then, there were many of those who were called *clochards* [tramps] – there were *charbonniers* [coal sellers] … There were only artisans here and there were many who sold from wagons – fruits and vegetables … and we used to buy our fruits and vegetables this way … And it was full of hotels, cafes, bistros and cabarets. My mother was born here, the mother of my mother. That makes three generations who have lived in the 5th (four now, with my daughter Melissa) … My mother is French and my father is Algerian … My grandfather was the first Imam of the mosque. It is true that things change and that should be honoured … but things [should] still remain a little working-class … The *quartier* remains familial all the same. One always says it is like a village, the 5th, because we know everyone. Our children were all in school together. It is important to protect somewhat this spirit of the village…

Pierre: I have lived here since 1960. At the time, this was a working-class street – real working class. That is to say 'the people' and now it is not the same thing. It is a street which is pleasant up until ten o'clock in the evening and after that becomes very unpleasant because people drink and yell in the street until four o'clock. One cannot sleep. That is the transformation of this street. The real Paris, here, has disappeared. It is not the true Paris. Little by little, the ordinary people have been chased away. For example, in the *place Contrescarpe*, where there is now a lot of tourism, there were modest tenants. They were not owners, although sometimes owners as well. They were chased away, even by removing the stairs. There is the story of one woman who lived on the top floor and could not get down because the developers had destroyed the stairs. And little by little, they succeeded in chasing out all of the working-class people. Opposite to me was a building … On each floor there were Algerians and people spoke together from the windows. One knew them and conversed from the window. If one of the children who lived there lost a toy which fell out of the window, quickly someone would go down to retrieve it. And then, it was decided that these buildings should be destroyed to construct a garden. So everyone was chased out and the garden was never built because the building was re-sold. The apartments were restored and the price was multiplied by ten. In the building where I live, there were large apartments and when Haussmann built *rue Monge* there were many workers who needed to be housed. When I arrived, the apartments had been cut into tiny spaces to house them.

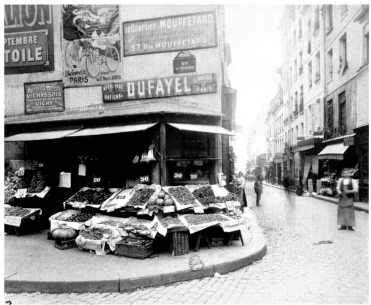

Hôtel meublé des bons enfants, cour de la rue Mouffetard et la rue Saint-Médard, Atget, 1909 (CAR/RV) (above).
Coin, rue Saint-Médard et Mouffetard, Atget, 1905 (BnF) (below).

I began in 1970 to buy one room, and then another, and I have now reconstituted the large apartment of before. [With Haussmann], there were good things and bad. The good was that Paris was very unhealthy. There were neighbourhoods, such as Ile-de-la-Cité – this was terrible, completely miserable. Here in Mouffetard there was also misery. At the bottom of the street, it was one of the most miserable *quartiers* in Paris.

○

Henri: I am an old resident of the *quartier*. I am 73 years old … I travelled a lot, but I came back. I began in the 4th *arrondissement* … I lived in the 15th and was away for years and came back in the 1960s. At that time I lived all over – *la rue du Pot-de-Fer, la rue Rolande* – and I worked in the cabarets in the time of the cabarets of the Left Bank … Here [at the corner of *rue St-Médard* and *rue Mouffetard*] there was an empty lot and there was a bus and in the bus they made a cabaret. And a little further down … in a bakery in a basement with stairs to enter and go down – there they made a cabaret. At that time it was the paradise of the Left Bank cabarets, *le chanson Rive gauche*. And then, after '68 … there remained only one in four in the whole *quartier* … Now, there are no more cabarets. The people seldom came and it is now all restored, taking away much of the character, in my opinion. It is more unified … it is clean, but …

○

Fabienne: I arrived in the 1950s-1960s. At the time, it was a part of the city which was not at all like it is now. It was relatively poor and not good and, how to say it, a population which was a bit difficult. And it was not clear that children should go there. And I came for theatre because there was a group of Scouts. I was a Scout in those days and there was some vacant land [in *rue Mouffetard*] where there was an old tram wagon. And in using this theatre … I used to play here. My parents were a little afraid that I used to come here. [Fabienne was pleased to know that I had heard about the cabaret in the tram wagon, that it had actually existed, as she was not certain if her memory was correct and if she had only imagined it] … And then it changed … There were great difficulties to make the old people leave in the end … There were old people who were made to leave in a manner somewhat – military – disagreeable – they nailed shut doors and placed people somewhere in the outskirts in homes. And they made a financial operation in the *rue Mouffetard* and it is now a renovated quarter, very different.

○

Brigitte: Now it has become a little more deluxe apartments. It is unfortunate because the *cinquième* is losing some of its heart. It was better when it was somewhat mixed. It used to be more cosmopolitan and there were many intellectuals, professors from the faculties, writers and people like that. It was very nice and I find that now it has become a bit too bourgeois. There are those who arrive who do not want to mix with others. They wish to live apart and that is not good. One should speak with people. And some spontaneity is missing. It's too clean. Everything has to be clean, little flowers, nothing but beauty – but some of the character is missing. It was wonderful when there were street merchants and all, calling in the street. I loved that. It was pleasant. It's a shame. All of the apartments which are sold, they are a fortune here. They are limited to a certain category … Now it is more that people are shut off. They stay in their small cocoons.

G.: Also in the bistros – they don't really exist anymore. You see the place over there – it no longer has a counter … and they put TVs in the bistros.

Brigitte: Before, when you went to the counter, people spoke. Now, if you say anything, people look at you.

G.: People have 400 friends on Facebook, but they really don't have friends.

Brigitte: It's the Internet. It's regrettable, particularly for a quarter which is known to be a *'quartier populaire'*, where people mix and 'rub shoulders' … still, there are a lot of students here, many faculties and also the big high schools so there are a lot of young people and this is good. It brings a life into the *quartier*.

○

Alain Roy: They say that the Paris of today is the Paris of the wealthy. There aren't many working people who live in Paris. It is people who are relatively rich. In the past, Paris had many industries, small factories. Now, that's over.

○

Brieuc: Paris, like all of the great capitals, is becoming a place where only rich people can live. I am lucky to be able to live here. Today I couldn't buy anything in Paris, because I don't have the means … The small artisan workshops in many parts of the city are disappearing because of this real estate phenomenon. It is an economic problem…

○

Ferval: Truthfully, by end of the era, Paris will become a *décor* – a *décor* occupied, on the one hand, by rich people of all countries. People who make money throughout Europe or elsewhere, buy apartments, but don't really live here. These are people passing through, without real roots. And then, on the other hand, there are the students who stay here only for the year because it is so expensive – just time for their studies and afterwards they leave. But, the real Parisian will disappear very quickly.

Anna: Paris has become an 'idea'.

Ferval: [People] go to find the signs of this idea which is not really there, so they go and buy souvenirs – an Eiffel Tower with snow inside – and they believe this is Paris. But it is not Paris. It is just *décor* – an idea of *décor* – and well, what can one do? … Still there is a real life here.

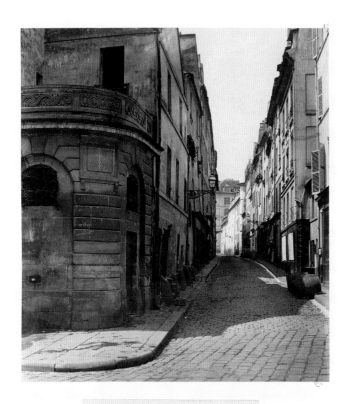

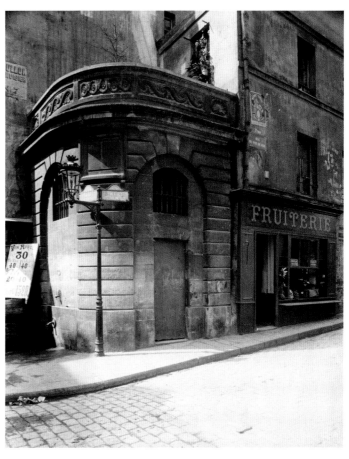

Rue du Pot-de-Fer could be described as one of the top touristic corners of Paris with its row of sidewalk restaurants and its picturesque rounded building at the corner of *rue Mouffetard*. *Rue Mouffetard* itself is usually described as having become overly touristic and yet it is also the centre of a vibrant community. It seems paradoxical that traditional, everyday life can be so mixed with touristic spectacle and yet it is precisely the economic value of the historical and 'colourful' which can so often protect locations from modern redevelopment (see Tung 1999 for an in-depth discussion of this world-wide urban paradox). In the meantime, a traditional community with a local identity continues. One can note the difference in focus between Marville, who pays attention to the street, and Atget who centres on the unusual structure. In this one pair of images, the intentions of their projects clearly manifest themselves.

6.03. *Rue du Pot de fer Saint Marcel de la rue Mouffetard,*
Marville, 1865 (CAR/RV).

1 rue du Pot-de-Fer : fontaine monumentale de 1671, Atget, 1901 (CAR/RV).

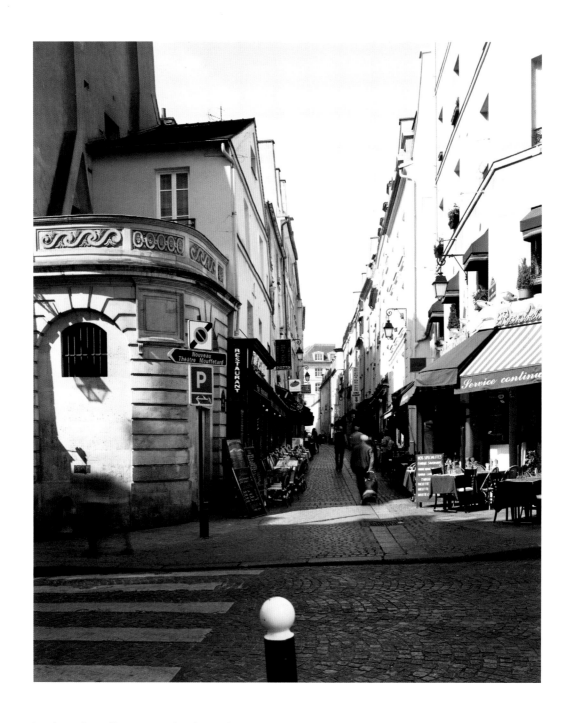

Rue du Pot-de-Fer (from Rue Mouffetard), Sramek, 25.04.2010.

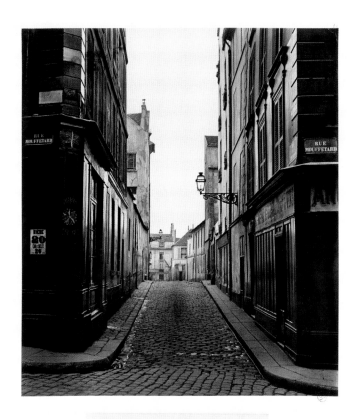

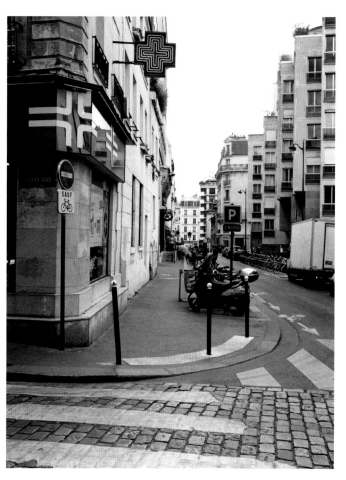

6.04. *Rue de l'Epée-de-bois (de la rue Mouffetard)*, Marville, 1865 (CAR/RV). Rue de l'Epée-de-Bois (from Rue Mouffetard), Sramek, 14.05.2011.

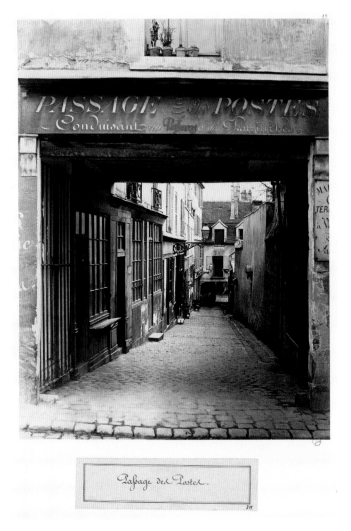

Passage des Postes.

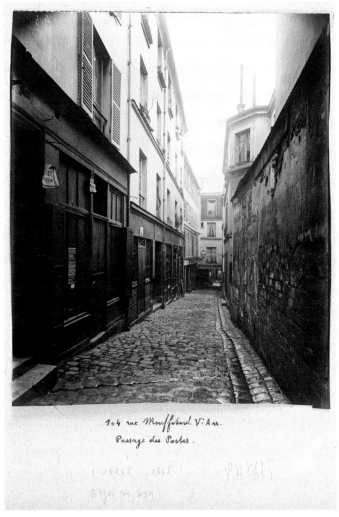

104 rue Mouffetard V.ᵉ Arr.
Passage des Postes.

6.05. *Passage des Postes*, Marville, 1865 (CAR/RV). Atget, 1909 (CAR/RV).

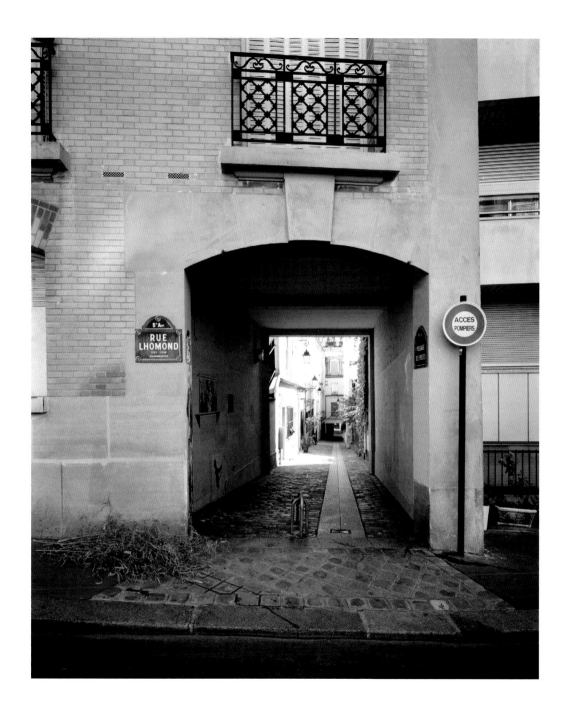

Passage des Postes (from Rue Lhomond), Sramek, 12.04.2009.

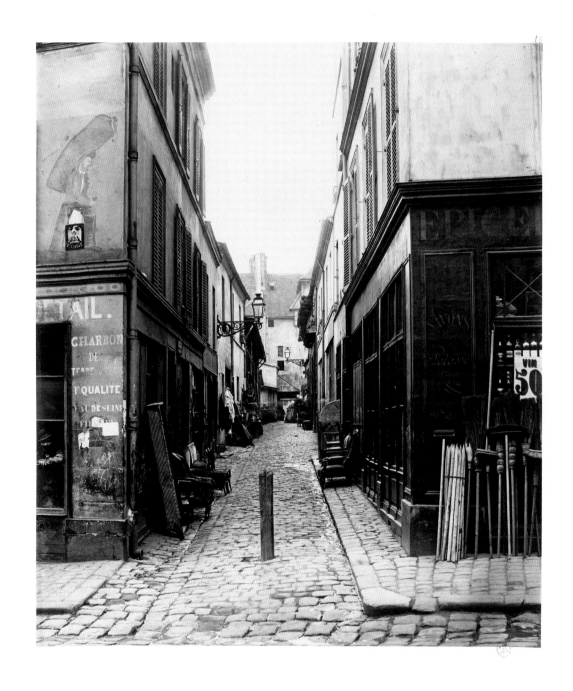

6.06. *Passage des Patriarches*, Marville, 1865 (CAR/RV).

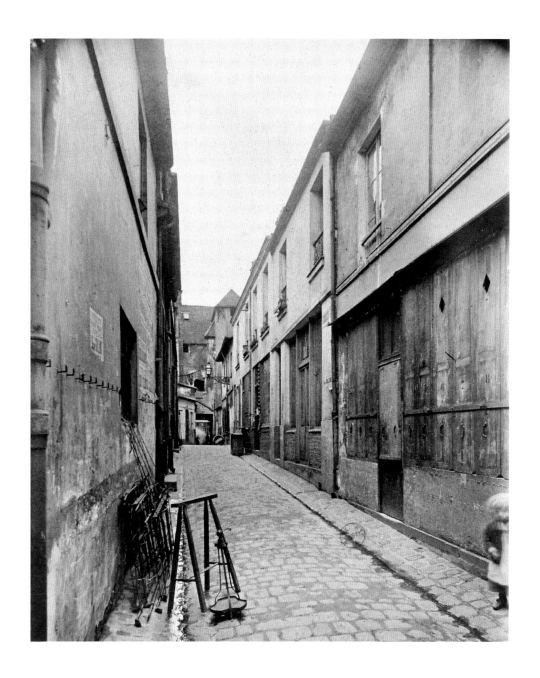

Atget, 1899 (BnF).

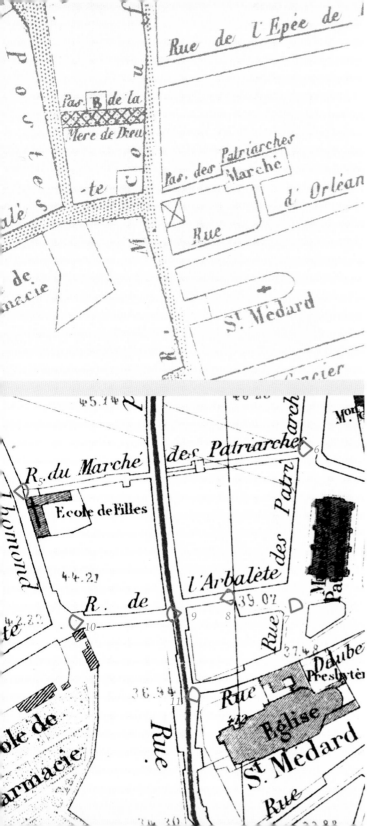

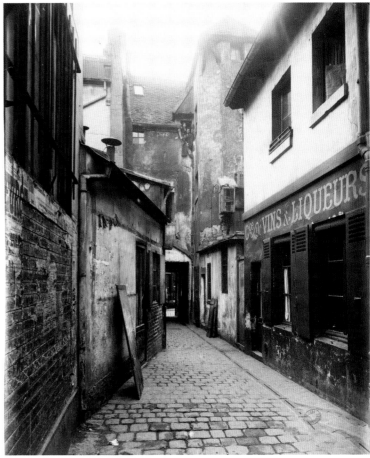

To follow Marville's path, the history of street names must be unravelled, which is at times confusing. The caption, 'Passage des Patriarches' appears twice in Marville's folios, but these are images of different streets. The current passage des Postes (pl. 6.05) and passage des Patriarches (pl. 6.06), running in a line as they do, appear in the 1868 atlas as rue du Marché des Patriarches, however Marville labels them both with their modern names, as does Atget. A second street, labelled as the passage des Patriaches in the 1835 atlas (pl. 6.08) changes in the 1868 atlas to rue de l'Arbalète, of which it is the continuation, and yet Marville uses the older name. The result is that the same label is applied to photographs of two different streets. The occasional confusions such as this cause one to wonder how Marville's locations for so many images were tracked, what sources were used to determine street names and who provided the labeling. Was there confusion about where the actual photographs were taken when the prints were finally produced and labelled? These are not major issues, but do suggest thinking about the processes of documentation and our dependence on archival information which, in contrast to its intentions, may be misleading or unclear.

Fig. 50. (details) Atget, 1908 (CAR/RV).
Petit Atlas Pittoresque (1834)
No. 48 Observatoire (above),
Atlas Administratif, 1868 (below).

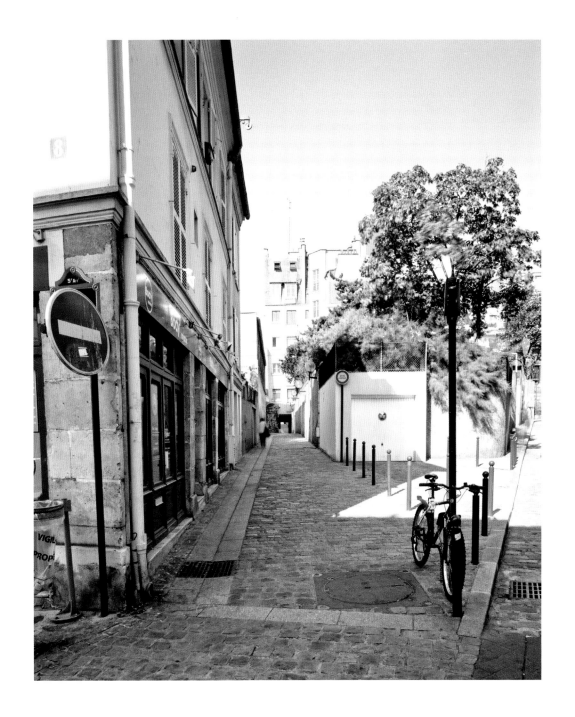

Passage des Patriarches, Sramek, 16.08.2009.

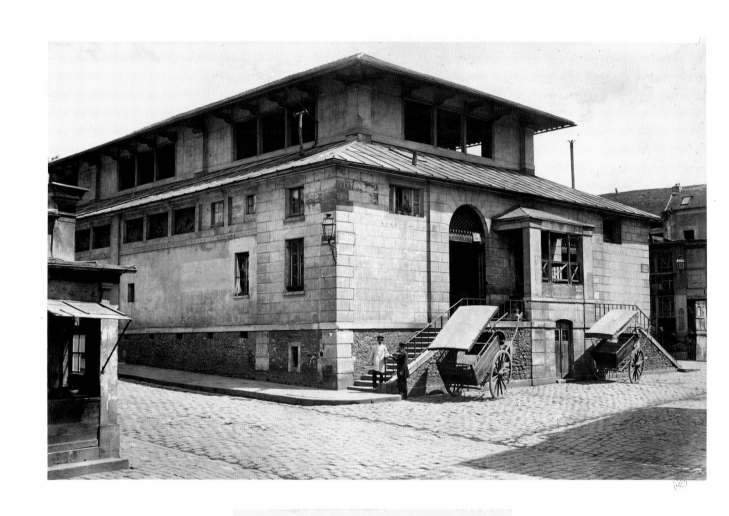

Marché des Patriarches

6.07. *Marché des Patriarches*, Marville, 1865 (CAR/RV).

Ferval: The *Mouffetard* market was important as a food market … It has disappeared. There are maybe ten times fewer food stores than existed before, because from *Saint-Médard* to *Contrescarpe* it was nothing but shops 70 or 80 years ago. Real food – real products … It is disappearing very fast.

Anna: Ferval is very nostalgic ... [but] in the *rue Mouffetard*, the people of the *quartier* avoid it a little because it is too expensive – it is not as authentic. We, for example, shop in *place Monge* at the market … This is still a real market … But, one goes to the bottom of Mouffetard and there is still a dairy, still a fishmonger, still a butcher.

Ferval: There are many stores which I have known at the bottom of *Mouffetard* which have disappeared just now. There was a butcher, which was very, very good … It closed for the month of August and in September there was no one – just disappeared. Now it is a Mexican restaurant that makes *tapas*. For me it is pathetic.

Alain Romard: The *quartier* has completely changed. Since the time I was born, I have lived in the *rue du Fer-à-Moulin* and the *quartier* has changed completely. There are no longer small businesses because the large stores have cheaper prices and when the people went to the large stores, the small shops all closed. And now in the large stores the prices are going up. There are no more small shops. There are no more small artisans in the *quartier*. In my street of *Fer-à-Moulin*, there was a fishmonger, a flower shop – there was everything and now there is nothing. But it is renovated. The *quartier* is renovated, but for me it is dead.

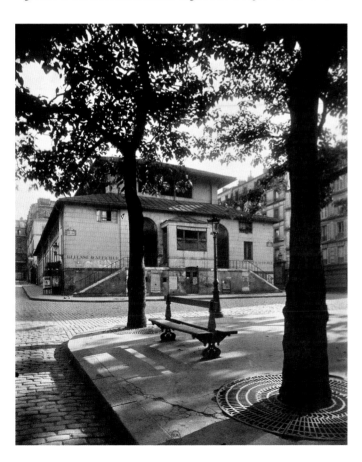

Atget, 1899-1900 (BnF).

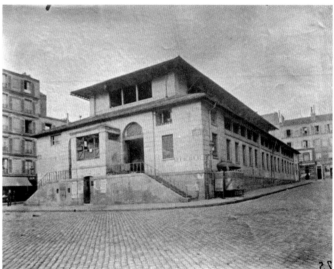

Atget, 1924, (CAR/RV).

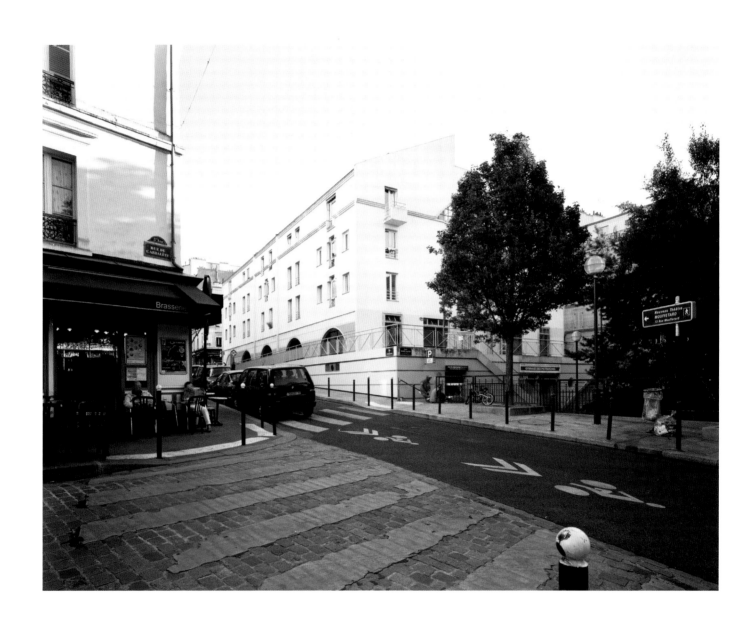

Place Bernard-Halpern, Sramek, 21.09.2010.

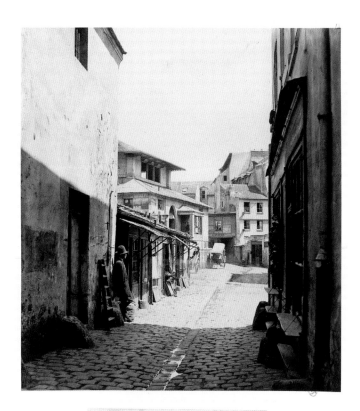

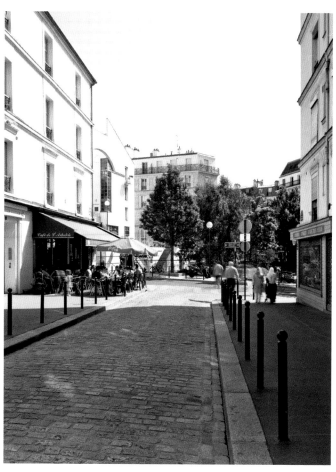

6.08. *Passage des Patriarches*, Marville, 1865 (CAR/RV). [This is named *'Rue de l'Arbalète'* on the 1868 map and labeled *'Passage des Patriarches'* in the atlas from 1835. It is not the same lane as in pl. 6.06.]

Rue de l'Arbalète (towards Place Bernard-Halpern), Sramek, 16.08.2009.

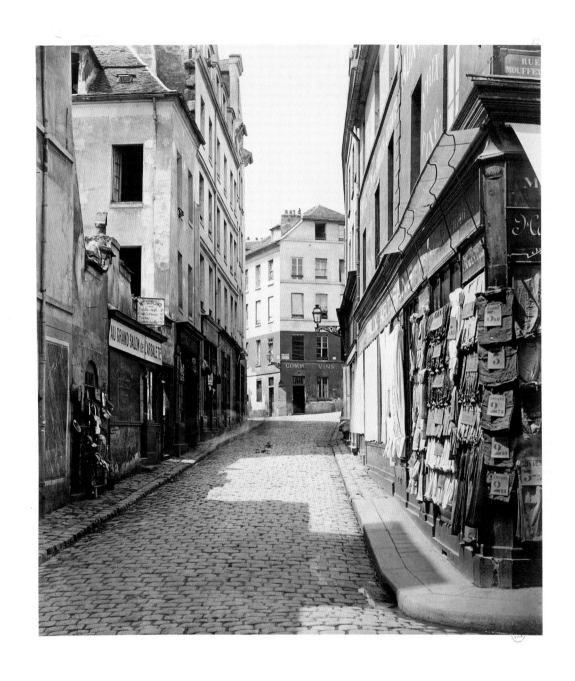

6.09. *Rue de l'Arbalète (de la rue Mouffetard)*, Marville, 1865 (CAR/RV).

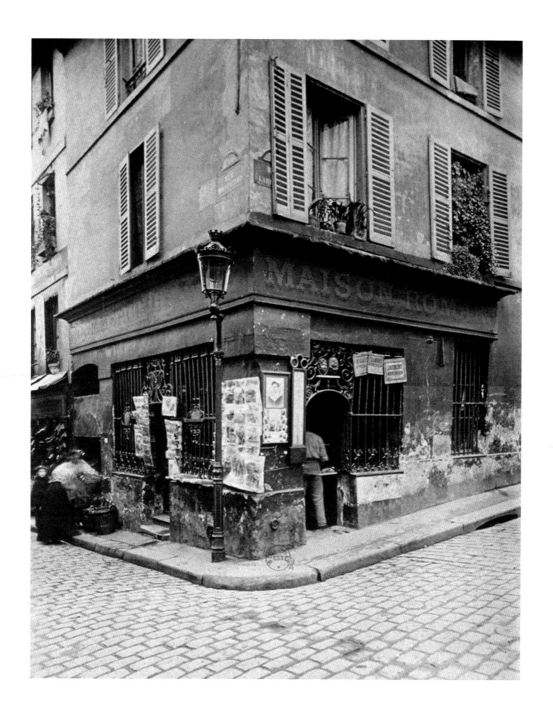

Cabaret, Rue Mouffetard, Atget, 1898-1900 (BnF).

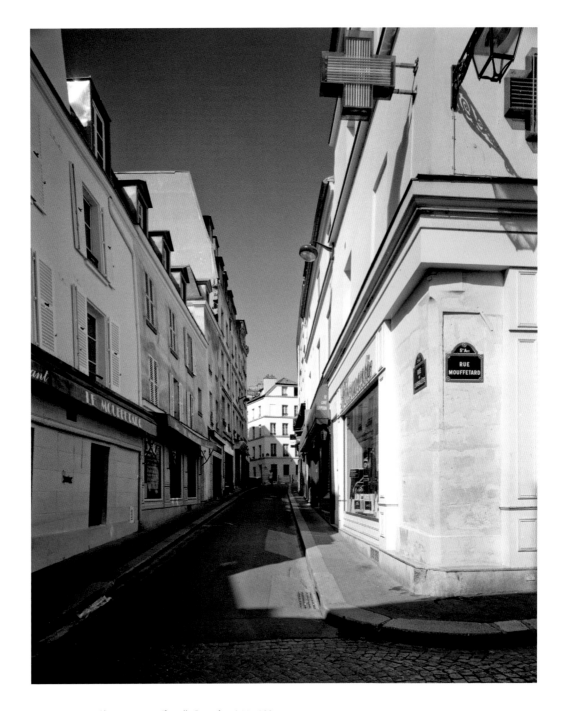

Rue de l'Arbalète (from Rue Mouffetard), Sramek, 16.08.2009.

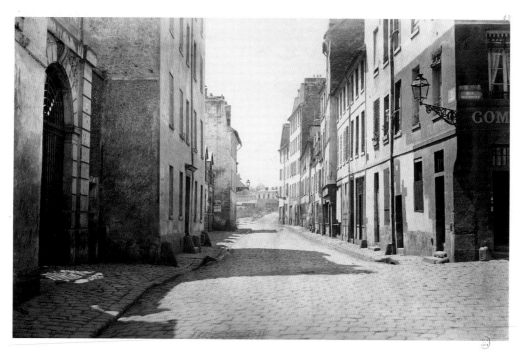

6.10. *Rue de l'Arbalète (du coin de la rue des Postes)*, Marville, 1865 (CAR/RV) (above).
Rue de l'Arbalète (on the right, Rue Lhomond), Sramek, 16.08.2009 (below).

The Marville and Atget collections left us an archive which guards against the disappearance of the past, even as the physical city itself changes. The photographs provide a record of what once was, putting a face to history. But how do they figure in contemporary culture? With the speed of life today and the ubiquity of global commercial media, one has to wonder if the past of the city is still important for everyday life. Generally, those who stopped to talk with me expressed a strong connection to Parisian history, some of them energetically recounting details and anecdotes. One was a collector of old photos and postcards. Another was connected to the Archaeological Office. I asked if they thought younger people were interested in keeping this historical heritage alive. They were not sure that the average person would share their passion.

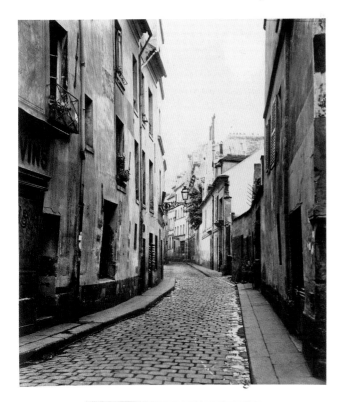

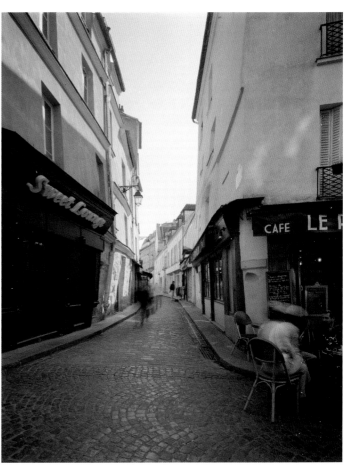

6.11. *Rue Daubenton (de la rue Mouffetard)*, Marville, 1865 (CAR/RV).

Rue Daubenton (from Rue Mouffetard), Sramek, 25.04.2010.

Ferval: [Young people?] Not really. It is more the people who are 40 years old because we have known the other era. It is 30 years already that it has been different. Myself, I did not know Marville's era of course, but one already can compare the life in Paris 30 years ago with today.

Anna: It is more people like us.

°

Fabienne: There is a generation in the process of disappearing which lived through things that were very different … Unfortunately, it is often too late [to capture these stories]. I never did this with my parents and they have now passed away. And I regret it because there are things which I don't know now. I am finding some of it because there are libraries which are doing this – that is to say that people have provided histories and actually quite a lot … It is not really a French habit [to record such stories] and that is a shame because there are many people who have a lot to tell.

°

Michel: In the past there were many amazing things. After the war I lived with my grandmother in *place d'Italie* and in going down to *rue Mouffetard* there were big wagons which had been re-routed from *les Halles* … It was after the war, in '48 or '50. The dress was so typical and I imagine Doisneau's photos – the beret on the head, the socks and so on. There were leeks and potatoes – one didn't find anything else, but we were content. We collected cashews to roast the pieces. In the *rue Mouffetard*, there was much that was lost. Of note was the sign at the *Vieux Chêne* which was destroyed, although that was vandalism. It had to be replicated. [This sign was in the shape of an oak tree, carved out of wood and was simply destroyed by workers who were renovating the building. This was not discovered until it was too late. A copy was made and now sits in its place].

°

Melissa: The history of the 5th? Why [important]? Because it is our families. All of our families live here. Definitely for that reason.

°

In my interviews, I specifically asked people about the importance of the old photographs, what they saw in them and what they can mean for people today.

Marie: Well, all I can say is that I love the old photos … What I love is that it appears more alive, and it seems – unfortunately – more intimate. It is wonderful to see how it was.

°

Alain Roy: I find Marville's photos interesting for their connection with the era. That is to say, for the discovery of Paris of that era. It is phenomenal. Fortunately, they thought to make these photographs at that time. For me, it is for the beauty of the architecture and also to become familiar with the past … It is part of the heritage of the city of Paris. It is important to keep a trace of the past – to keep a record…The advertising on the walls from that time is very interesting. From it one can learn a lot of things. And then, how people were dressed. He captured them. They were waiting until the photograph was finished … There were not a lot of people in the street and not all of the cars, like today …As for young people, I think there are those who are interested, just as there are of our age. There are those our age who like to look at the old photographs and also those who have no interest at all.

°

Ferval: [They give] evidence of a vanished era where life appeared more difficult but also more calm.

Anna: Yes, but it was certainly very miserable as well.

Ferval: But the people were happy in their misery, in my opinion. They had a solidarity, not everyone looking out for themselves like today…

Anna: But before, [*Contrescarpe*] was considered to be a *quartier* more or less dangerous in the middle ages. It was outside Paris – one was in the countryside…

°

Melissa: [This photo of *rue Traversine*] this is in fact right by *rue de la Montagne-Sainte-Geneviève*. It is a small street they called 'Cut-throat'. They made these streets disappear because they were very dangerous in the evening. There was no light…

°

Pierre: The *quartier Mouffetard* was one of the most miserable in Paris. When one sees certain of these old streets [in the photos], one sees that these are the real working people (this man for instance is not a rich person) although it is rare that there is a person in the photograph. The streets are empty because, and you know well, one had to stage a photo. The photograph was an event, with the ladder, etc. – it was a spectacle.

°

Ludovic: With the photos one has a precise image of an era that is clearly not the other, and one makes the transfer between eras and, in that way, a voyage in time. And also, one arrives at a perception of how people of that era could live and how society in general has evolved. So, on the one hand, through the photo, one has something very individual, almost intimate, while also an overall impression … the changes in technology and architecture. And that is what pleases me in the photographic record. One can create a real story between two epochs.

[Looking at the old photos] it is astonishing because one has the impression of being in the city and also in a rural environment. One senses that nature is still present in the city and that it is completely interwoven. Man is now very detached from nature. We create a theatre to isolate ourselves from it … [In the photos of 1877] it is very urbanized, very structured, but nature is always present. Even with the cobblestones, one sees a little earth – there is still something alive.

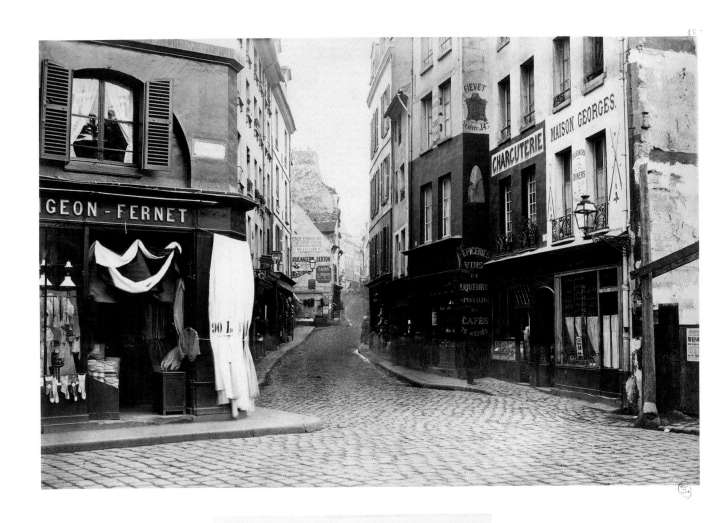

6.12. *Rue Mouffetard (de la rue de Lourcine)*, Marville, 1865 (CAR/RV).

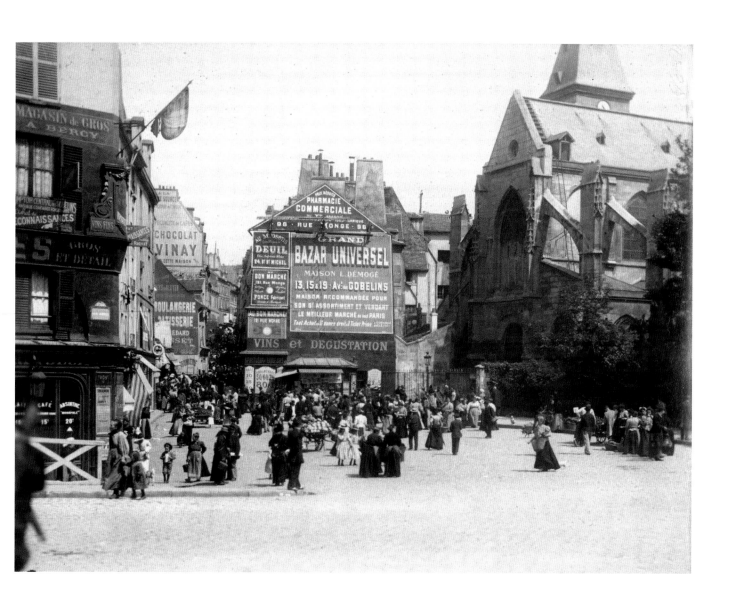

Place Saint-Médard, le matin, Atget, 1898 (CAR/RV).

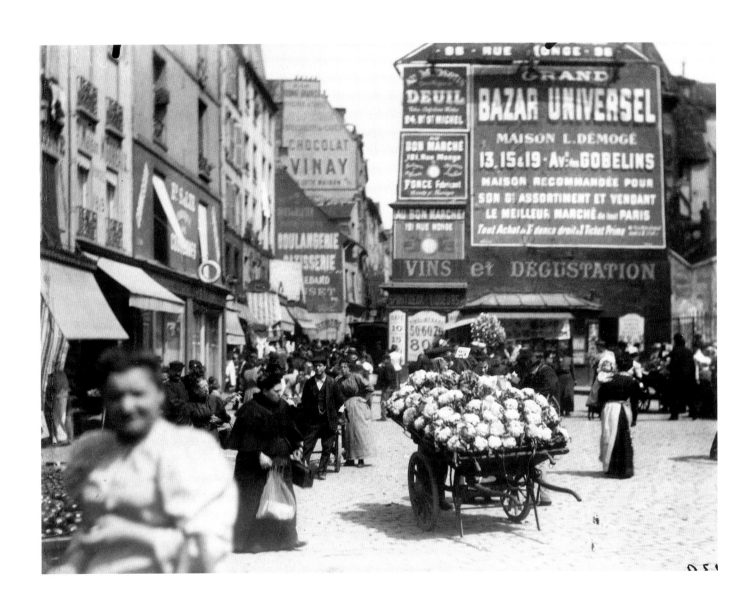

Église Saint-Médard, Atget, 1899-1900 (BnF).

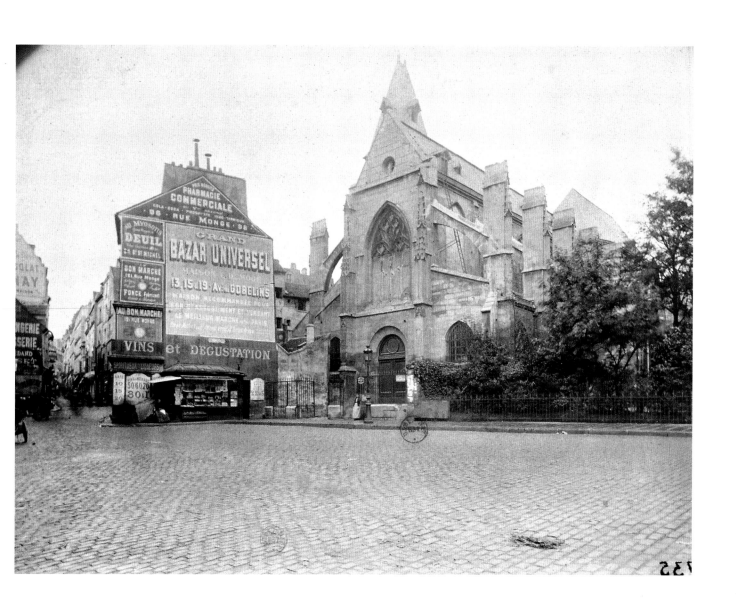

Petit marché, place Saint-Médard, Atget, 1898 (CAR/RV).

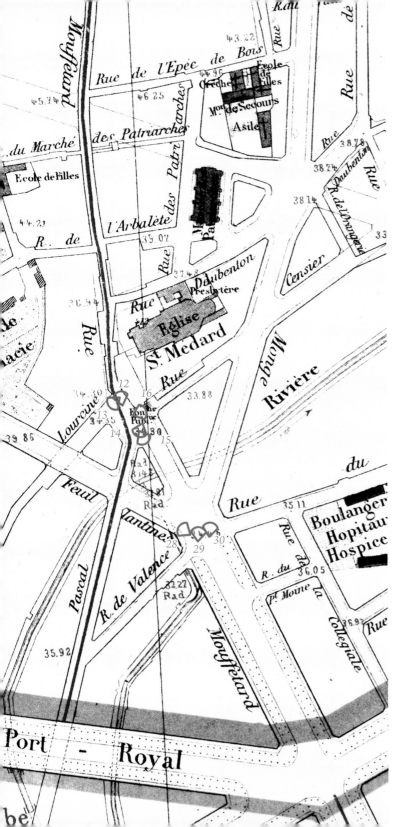

Square Saint-Médard at the low point of *rue Mouffetard* was the lively hub of this part of Paris with its market and its leather industry. Although *rue Mouffetard* had long been one of the main paths into Paris from the south, it was circumvented in the 1870s by new, much larger thoroughfares. With the construction of *rue Monge* and the *avenue des Gobelins* (which replaced the southern section of *rue Mouffetard* up to *place d'Italie*), traffic could move around rather than over *Montagne-Sainte-Geneviève*. However, unlike in many locations where the new Parisian roadways erased old commercial and social patterns, here there still exist two separate intersections: one filled with traffic speeding between the centre and the outskirts, and the older one, which is still a focal point of local activity with its entrance to the market street, pedestrian shoppers, delivery trucks, a bakery, cafes and a fountain at the centre. Both spaces were documented by Marville. There are five photographs of the converging streets at the bottom of *rue Mouffetard* made in 1865 (pls. 6.12-6.16), while at the site of the new intersection, where six streets now meet, Marville photographed in 1865 and in 1877 (pls. 6.25-6.30). One would be hard-pressed to identify the old *rue Mouffetard* seen in image 6.26 with the *avenue des Gobelins* which replaced it.

In the early 1900s, Atget photographed the market goers, street peddlers and pushcart vendors. His photographs show the open square of *Saint-Médard* in front of the church which did not exist yet in Marville's photographs (pls. 6.12; 6.16). Today, as the commentaries attest to here, this once poverty-ridden part of the city is being renovated and gentrified and, although the river Bievre no longer flows above ground and the commercial activity is much less than it has been, there is still a proud local population with a strong sense of identification with the *quartier*.

Fig. 51. *Atlas Administratif*, 1868
(two groups of sites – 1865-68 and 1877).

Rue Mouffetard (from Rue Eduard-Quenu), Sramek, 16.08.2009.

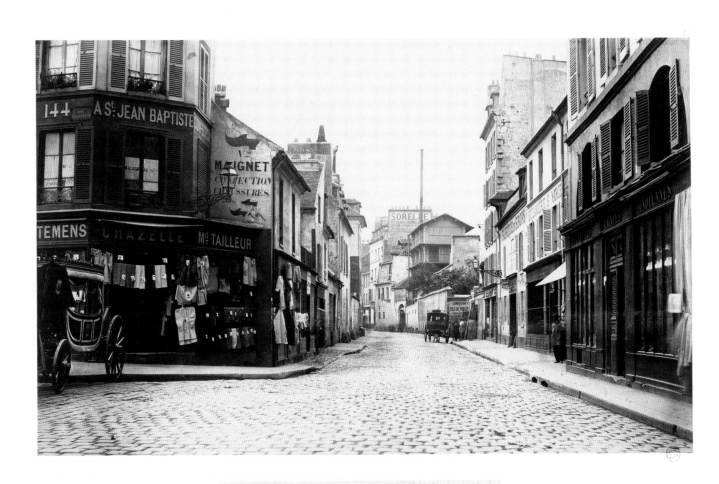

6.13. *Rue de Lourcine (de la rue Mouffetard)*, Marville, 1865 (CAR/RV).

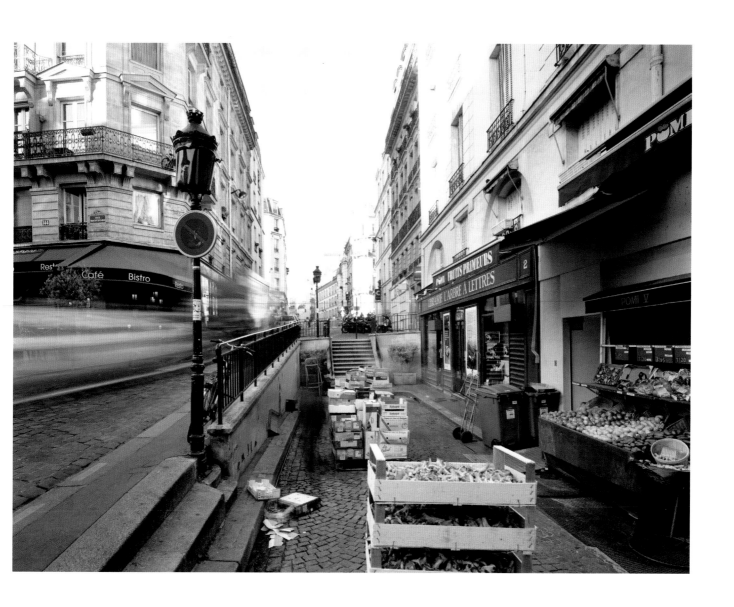

Rue Eduard-Quénu (previously Rue de Lourcine and then Rue Broca in Atget's time), Sramek, 21.09.2010.

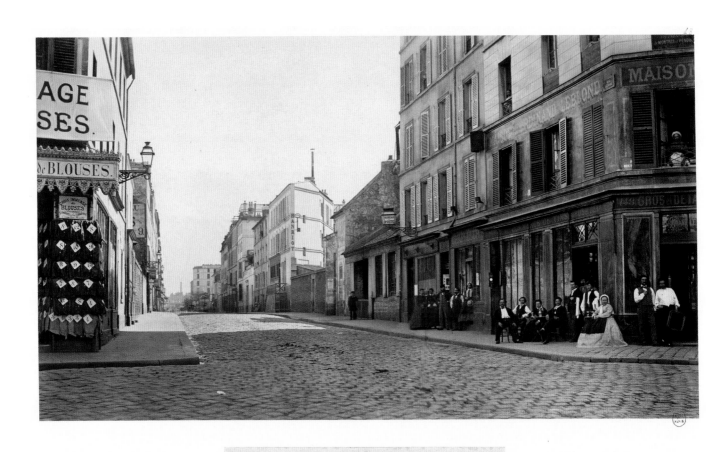

6.14. *Rue Pascal (de la rue Censier)*, Marville, 1865 (CAR/RV).

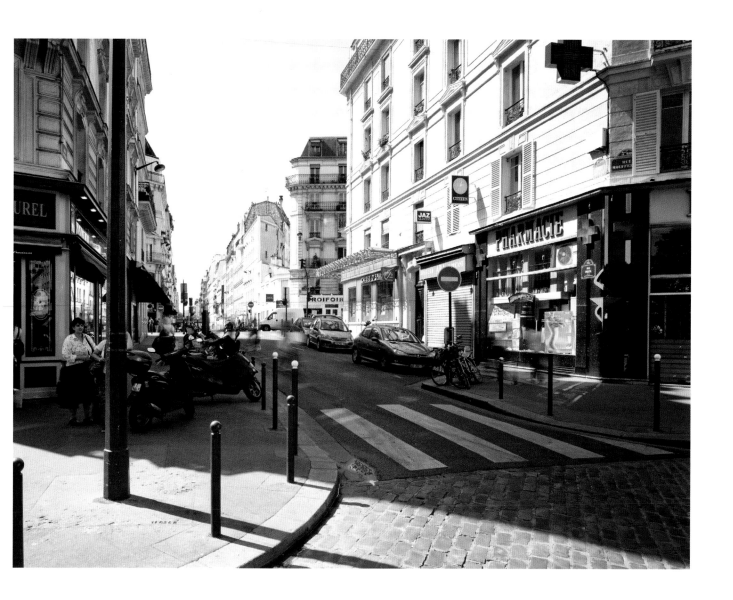

Rue Pascal, Sramek, 16.08.2009.

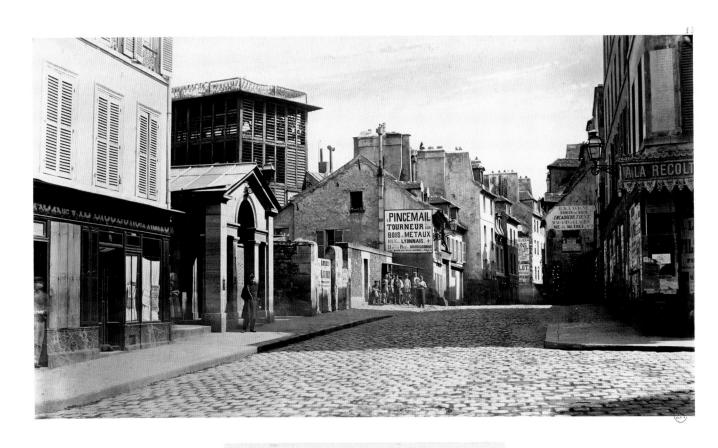

6.15. *Rue Mouffetard (de la rue Censier), Marville, 1865 (CAR/RV).*

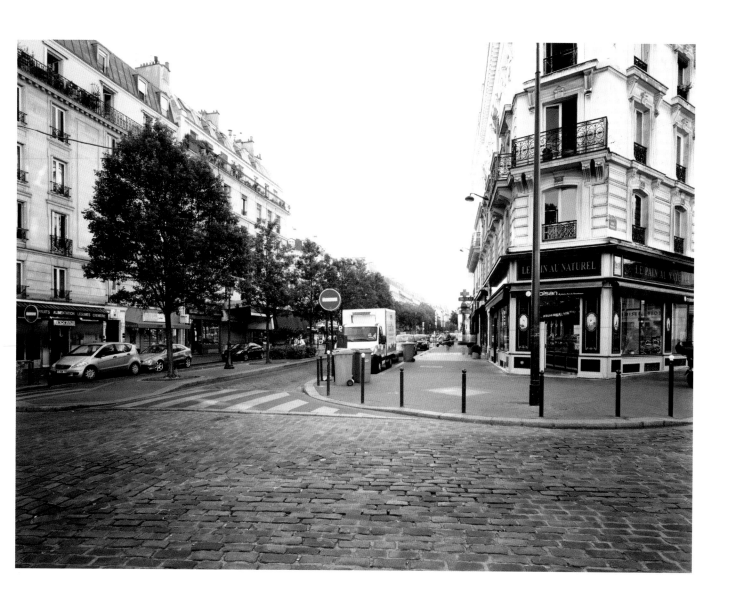

Rue de Bazeilles, Sramek, 30.06.2010.

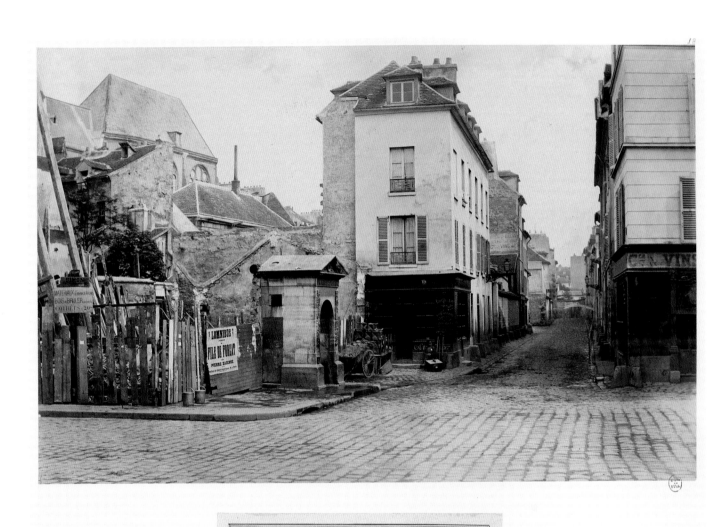

6.16. *Rue Censier (de la rue Pascal)*, Marville, 1865 (CAR/RV).

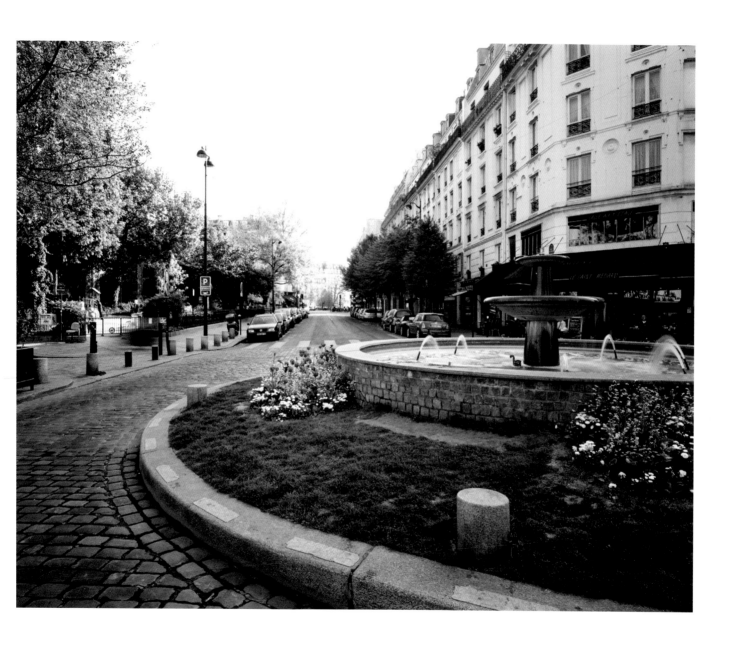

Rue Censier, Sramek, 25.04.2010.

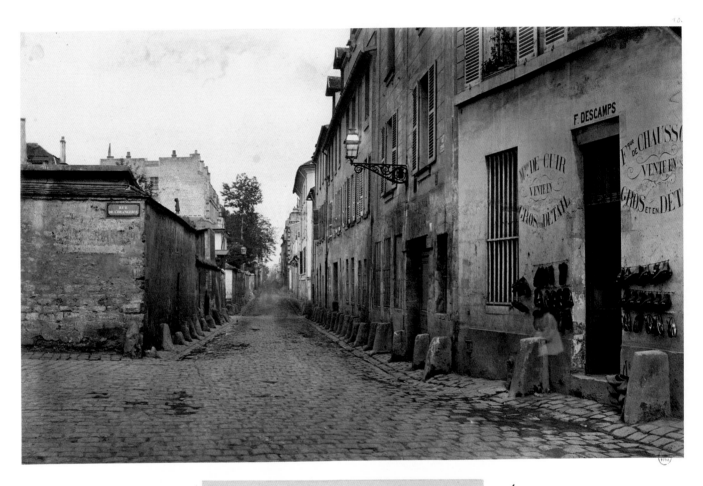

6.17. *Rue Censier (de la rue de l'Orangerie),* Marville, 1865-1868 (CAR/RV).

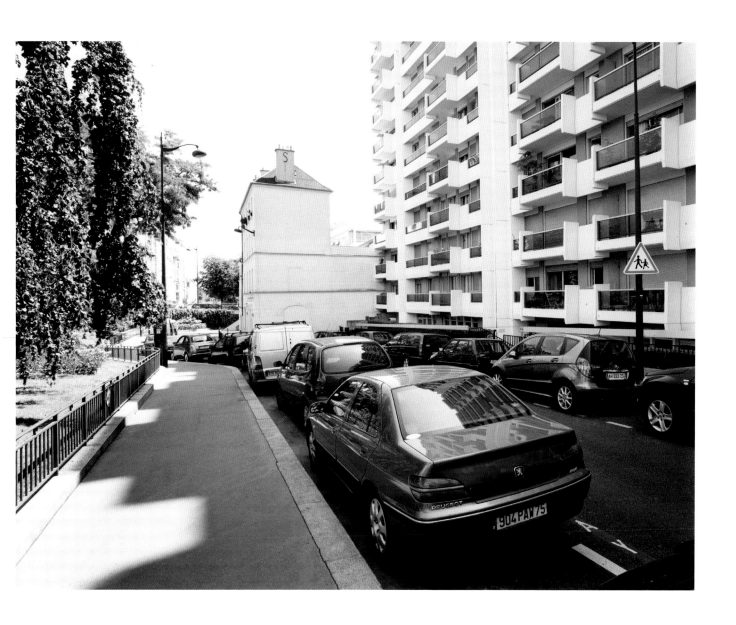

Rue Censier (lower section, east of Rue Monge), Sramek, 30.06.2010.

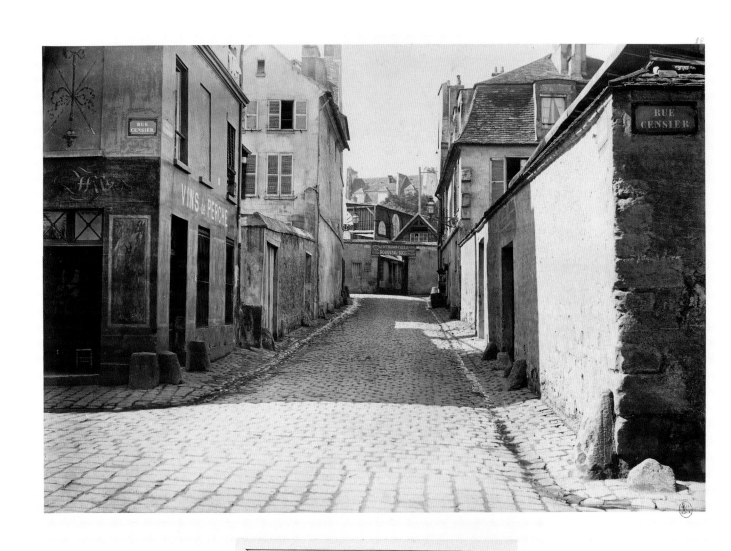

6.18. *Rue de l'Orangerie (de la rue Censier), Marville, 1865 (CAR/RV).*

Towards No. 24 Rue Censier, Sramek, 30.06.2010.

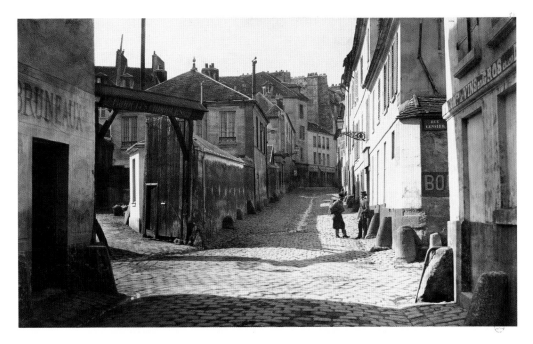

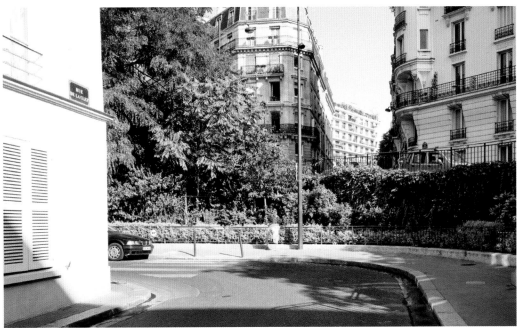

6.19. *Rue Vieille N^tre Dame (de la rue du Pont-aux-biches),* Marville, 1865 (CAR/RV) (above).
Rue de la Clef (lower section), Sramek, 16.08.2009 (below).

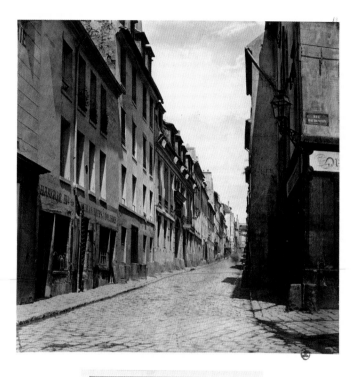

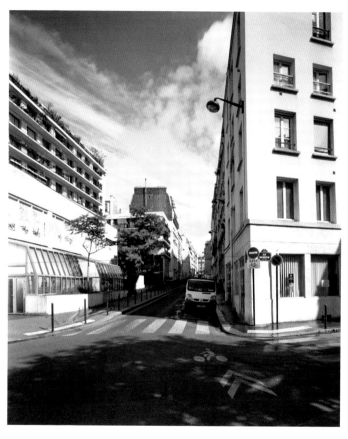

6.20. *Rue de la Clef (de la rue Vieille N. Dame)*, Marville, 1865 (CAR/RV).

Rue de la Clef (looking north from Rue Daubenton), Sramek, 14.5.2011.

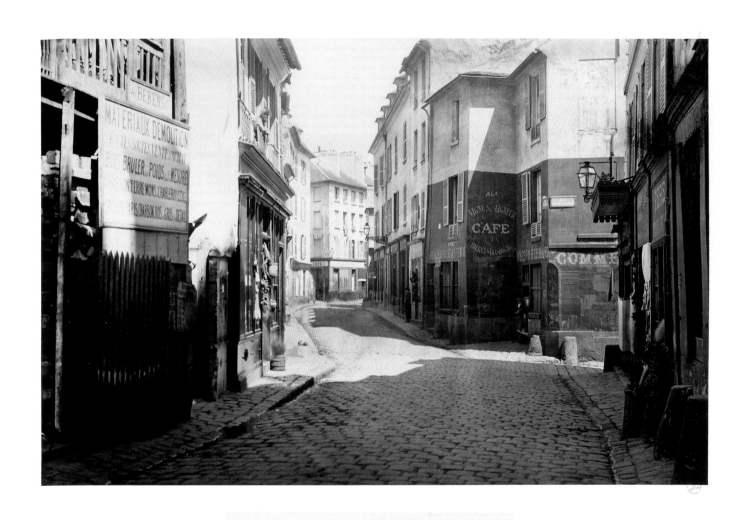

Rue Daubenton
(de la rue Gracieuse)

257

6.21. *Rue Daubenton (de la rue Gracieuse)*, Marville, 1865 (CAR/RV).

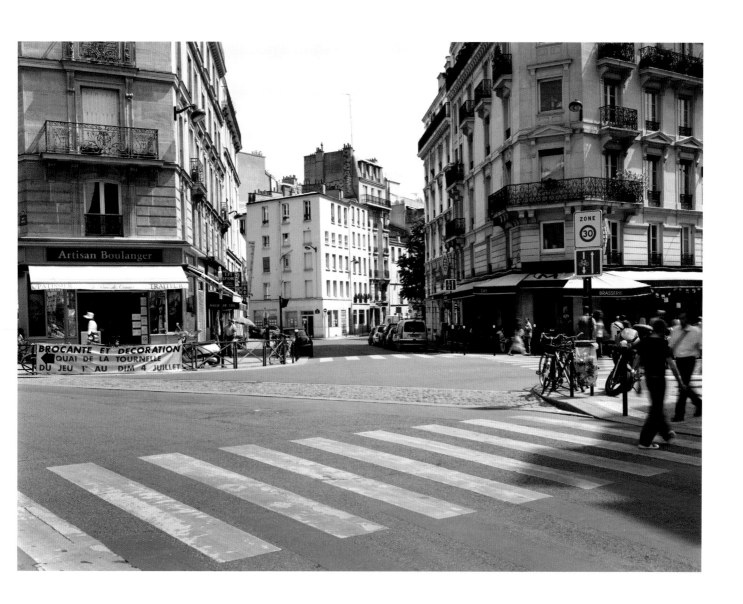

Rue Daubenton (looking east from Rue Monge), Sramek, 30.06.2010.

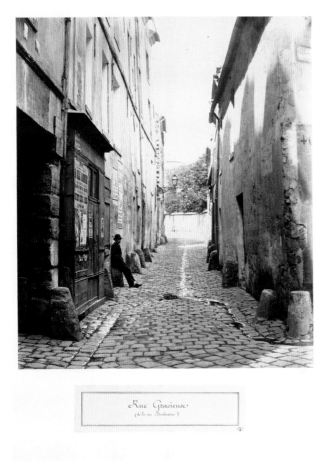

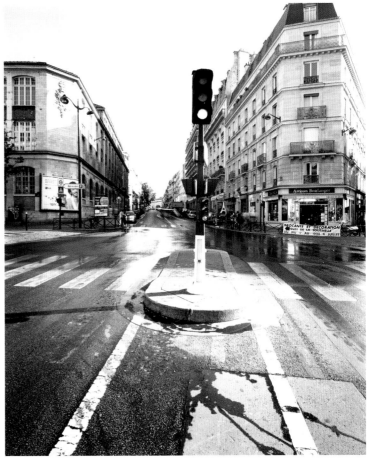

6.22. *Rue Gracieuse (de la rue Daubenton)*, Marville, 1865 (CAR/RV). Rue Monge (looking north from Rue Daubenton), Sramek, 30.06.2010.

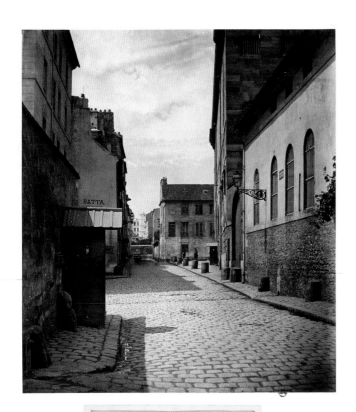

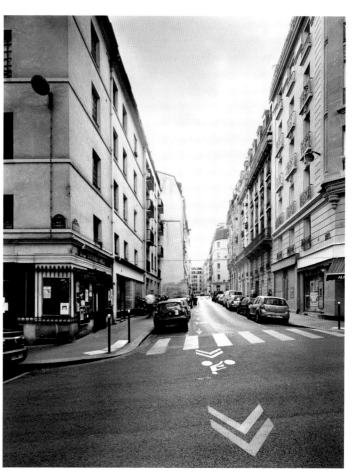

6.23. *Rue du Puits de l'Ermite (prison de Sᵗᵉ Pélagie),* Marville, 1865-1868 (CAR/RV).

Rue du Puits-de-l'Ermite, Sramek, 17.05.2011.

371

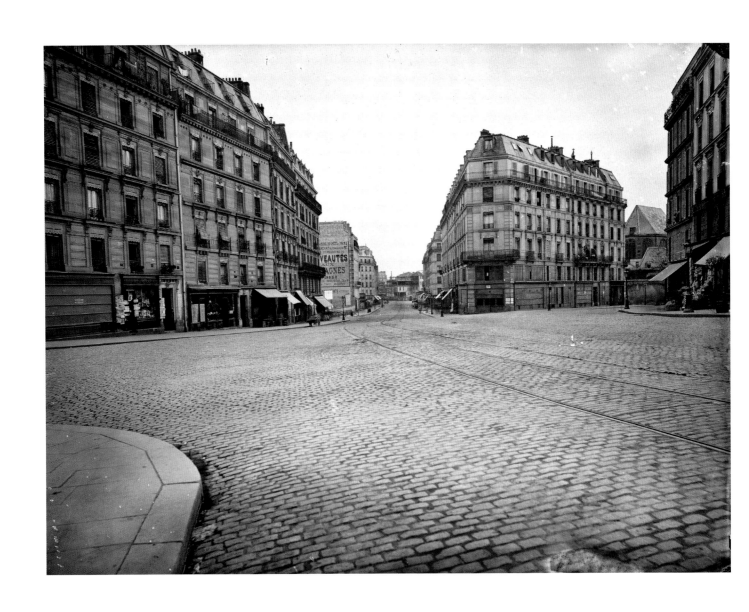

6.24. [*Rue Monge*], Marville, 1875-1877 (BHVP/RV).

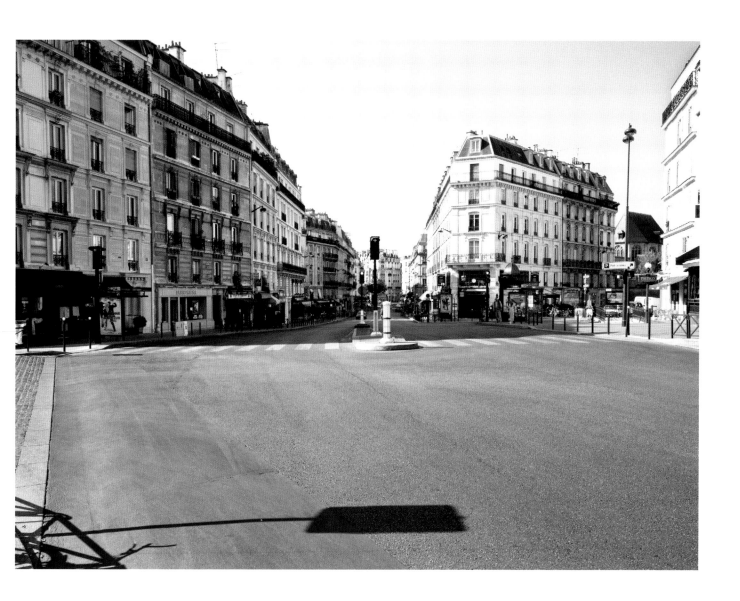

Rue Monge (towards the south across Rue Daubenton), Sramek, 16.08.2009.

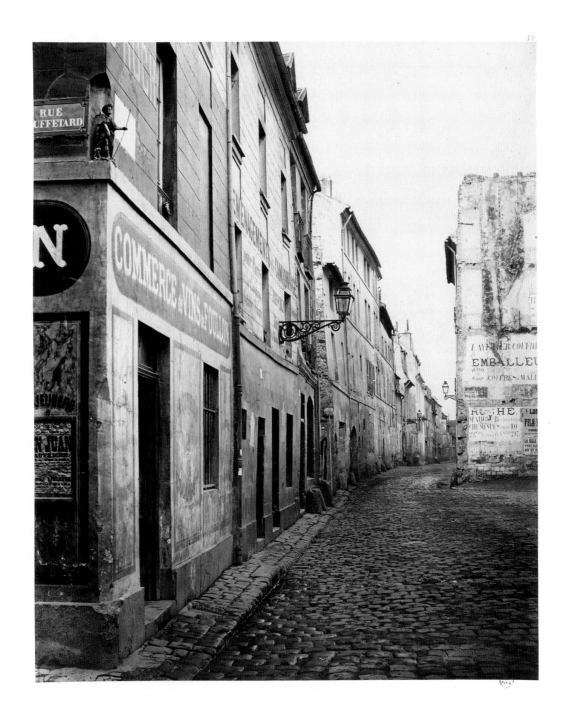

6.25. *Rue du Fer-à-Moulin (de la rue Mouffetard), Marville, 1865 (CAR/RV).*

Rue du Fer-à-Moulin (from Avenue des Gobelins), Sramek, 30.06.2010.

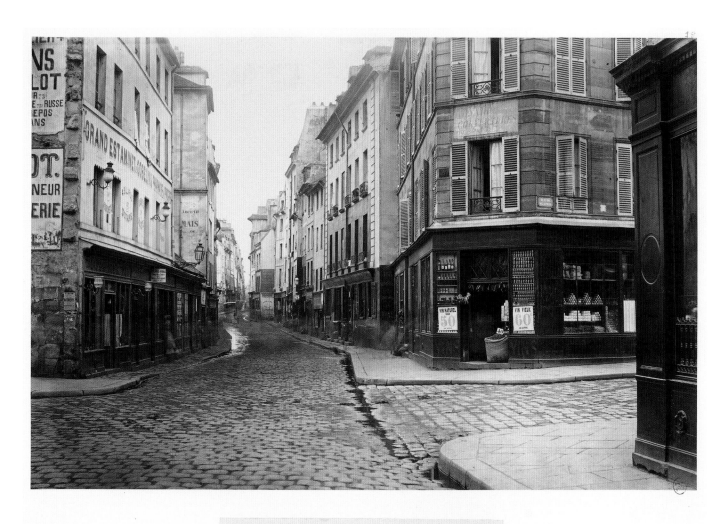

6.26. *Rue Mouffetard (de la rue de Valence)*, Marville, 1865 (CAR/RV).

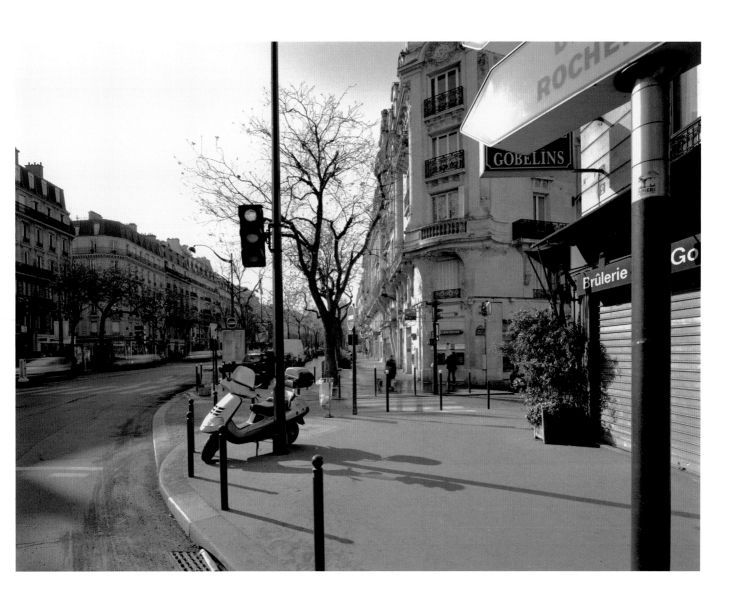

Avenue des Gobelins (to the right, Rue de Valence), Sramek, 25.04.2010.

6.27. *Rue de Valence (de la rue du fer à moulin)*, Marville, 1865 (CAR/RV).

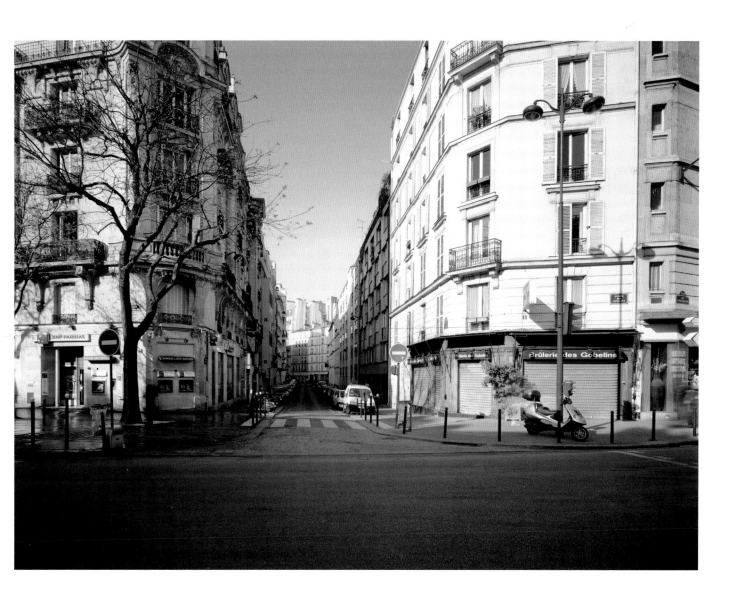

Rue de Valence, Sramek, 25.04.2010.

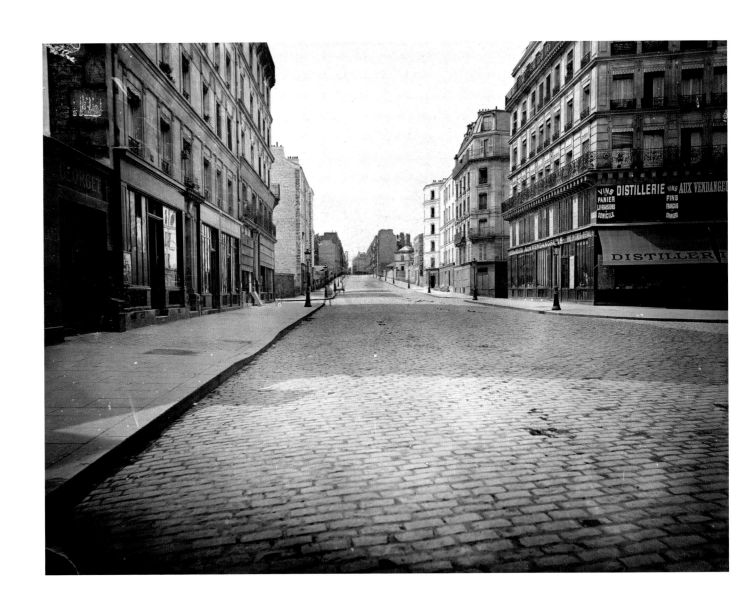

6.28. [*Rue des Feuillantines*], Marville, c.1877 (BHVP/RV).

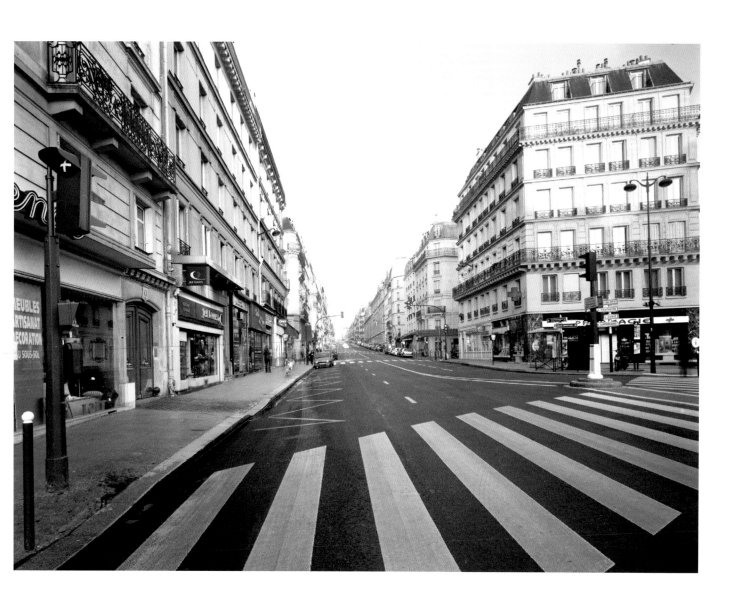

Rue Claude-Bernard, Sramek, 21.02.2011.

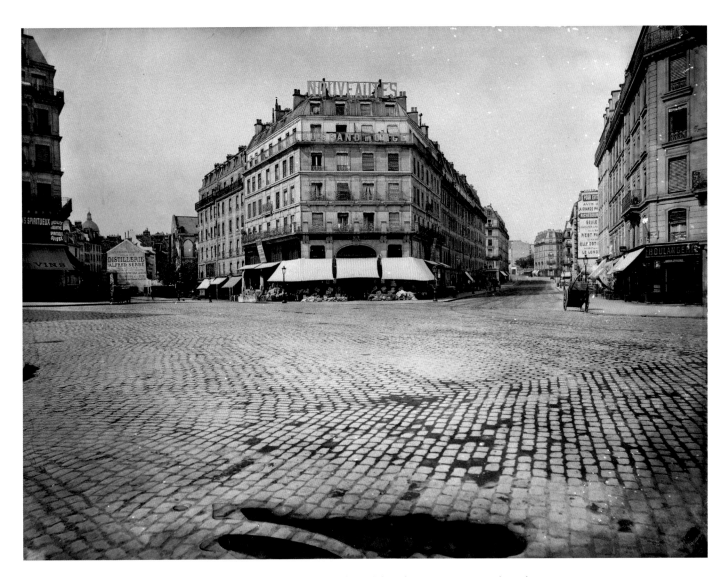

At the point where *rue Monge* and *rue Claude-Bernard* meet the *avenue des Gobelins*, the intersection completes the two paths around *Montagne-Sainte-Geneviève*, with citybound traffic veering left or right on its way to the centre. Today, the place itself has no intimacy as compared to *square Saint-Médard*, which is seen in the distance. Although there is a typical café with outdoor seating immediately facing the busy thoroughfare, it provides little ambiance. In Atget's photographs of this site there are strollers on the new avenue and market vendors at the foot of *rue Monge*.

6.29. [*Rue Monge. Carrefour des Gobelins*], Marville, c.1877 (BHVP/RV).

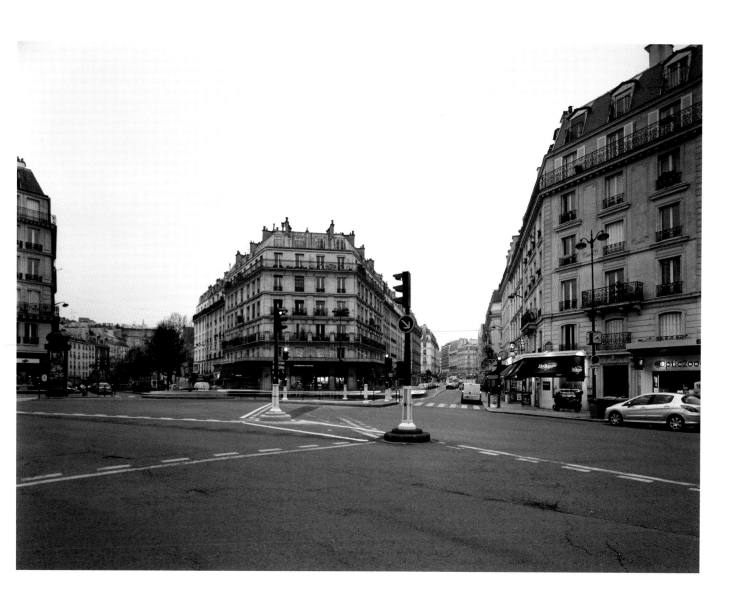

Intersection of the Rues des Feuillantines (to the left, Rue de Bazeilles, to the right Rue Monge), Sramek, 21.02.2011.

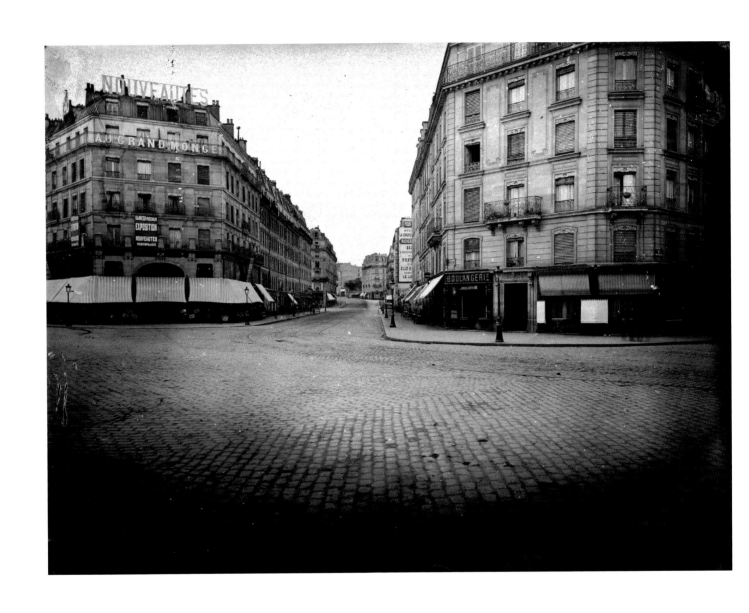

6.30. [*Carrefour des Gobelins*], Marville, c.1877 (BHVP/RV).

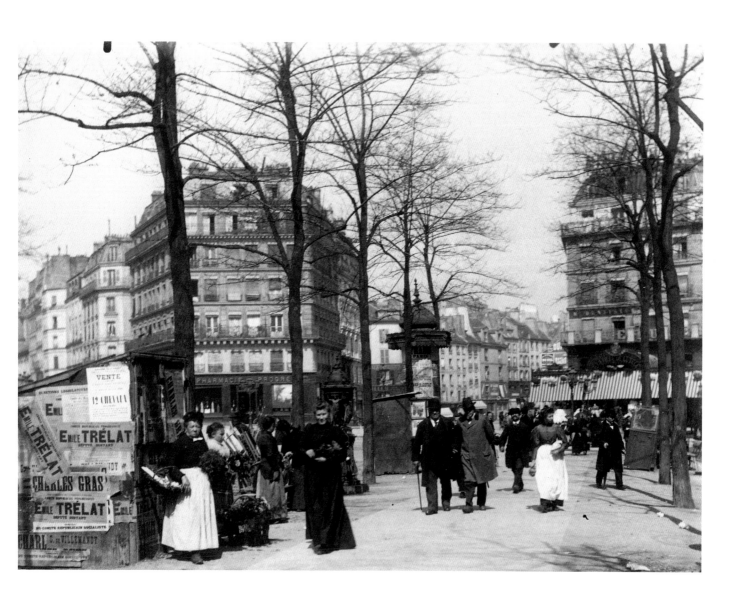

Avenue des Gobelins (vers Saint-Médard), Atget, 1898 (CAR/RV).

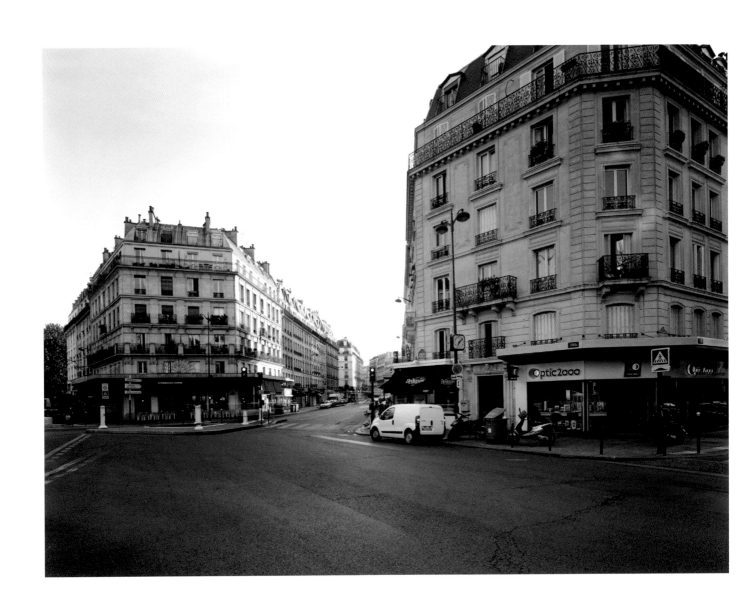

Rue Monge (looking north from Avenue des Gobelins), Sramek, 30.06.2010.

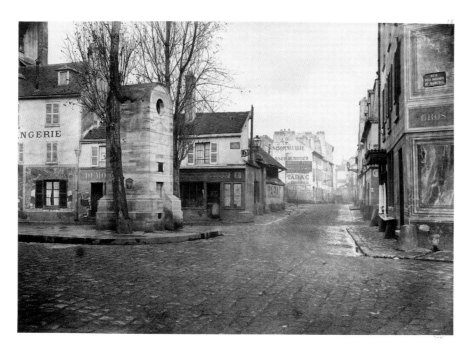

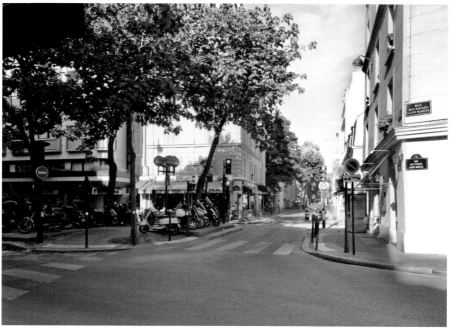

6.31. *Rue Poliveau (de la rue du Fer-à-moulin)*, Marville, 1865-1868 (CAR/RV) (above).
Rue Poliveau (from Rue du Fer-à-Moulin and Rue Geoffroy-St-Hilaire), Sramek, 12.08.2009 (below).

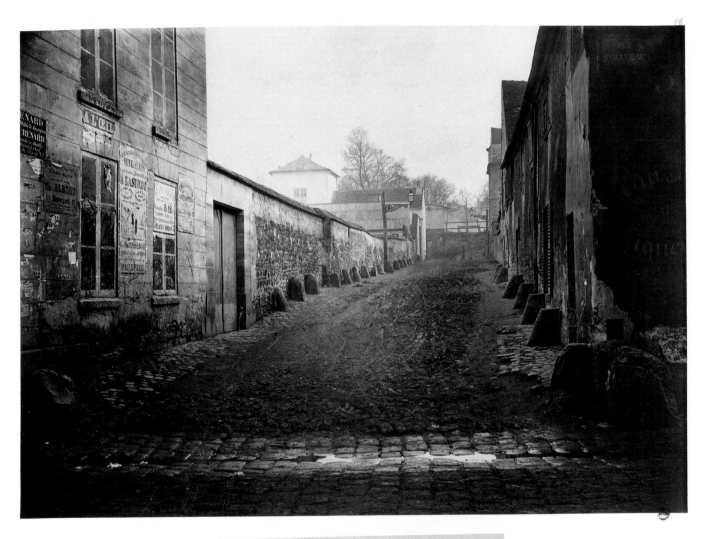

Rue de l'Essai (de la rue Poliveau)

6.32. *Rue de l'Essai (de la rue Poliveau)*, Marville, 1865-1868 (CAR/RV).

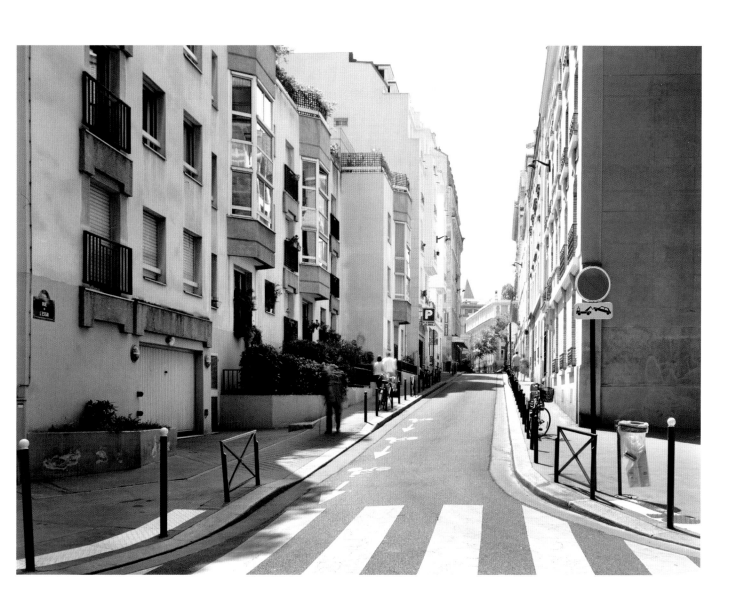

Rue de l'Essai (from Rue Poliveau), Sramek, 30.06.2010.

Saint-Marcel - Gobelins

St. Médard

Rue

Rue

R. du P. aux Biches

Moulin Marcel

Marché aux Chevaux

R. du Fer

Boulangerie
des Hopitaux

Pl. de
Scipion

R. de Scipion

Imp. des Sœurs

Fossés S. Marcel

Com. J.

Tom. Pl.
Imp. Marché
aux Chev.

Rue du

R. du Mé. aux

R. du P. Moine

Cr. R. du P. Moine

I. Dandrolas

R. Pre Lombard

Pl. des Fres

I. Bourg

R. de la Collégiale

M. des 3
Couronnes

Rue des Mers

Rue Pierre Assis.

R. des Mers des Gobelins

R. de la Reine Blanche

R. des Fossés S. Marcel

des Cornes

R. du Banquier

R. des Fossés S. Marcel

Hypolite

R. S. Hypolite

R. Pascal

Rue des Gobelins

Ruelle des Gobelins

R. Julienne

Asile des Enfs.

Ms Veneriens
pour Femmes

Corps de Garde

Manufre des
Gobelins

R. des Fossés

R. du

R. des Vignes

R. du Pt Banquier

R. d'Ivry

C. de G.

Ce R. d'Austerlitz

R. du Chn des etroites Ruelles

R. des

R. de l'Hopital

Abattoir
de Villejuif

Pl. des
2 Moulin

R. Valence

Bievre

R. de Croulebarbe

R. du Petit Gentilly

Bd des Gobelins

R. de la Bre des Rigol.

R. de Villejuif

Corps de Garde

Bre d'Italie

Boulevard de

acques

lebarbe

l'Alouette

R. Pascal

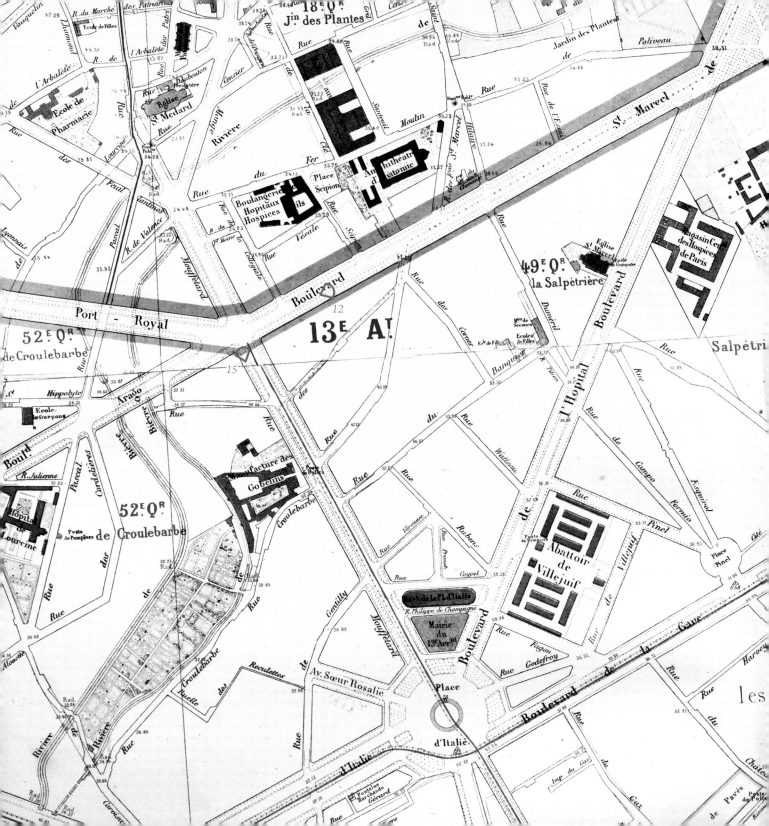

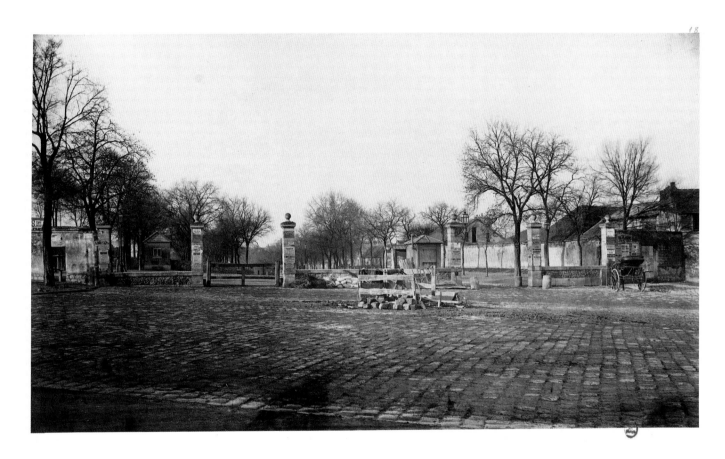

The neighbourhood of *Saint-Marcel* and the *Marché aux Chevaux* experienced major reconstruction with the eventual removal of the horse market and the creation of *boulevard Saint-Marcel*, which obliterated both the *place Collégiale* and the smaller streets and squares between the new *avenue des Gobelins* and the *boulevard de l'Hôpital*. The new boulevard ran from the eastern entrance to the horse market but at a slightly different angle. A close view of the atlas from 1835 shows just how much was reconfigured. By the time Haussmann's atlas of 1868 was printed, the new boulevard was drawn in place. When Marville returned in 1877 to a few of these sites, the new boulevards seem spacious, but empty (pls. 7.12; 7.15). Today the crowded traffic fills these streets with noise and motion.

In the image of the *'Impasse de l'Essai'* (pl. 7.02), the elbow where it angled up to meet the open space of the horse market has been filled-in. The old market avenue itself, with its riding oval, is completely gone, replaced by housing which borders the new *boulevard Saint-Marcel*. The view of the western entrance of the *Marché aux Chevaux* (pl. 7.03) serendipitously juxtaposes Marville's photo of the gate of the old horse market with a different kind of gate.

7.01. *Marché aux Chevaux*, Marville, 1865-1868 (CAR/RV).

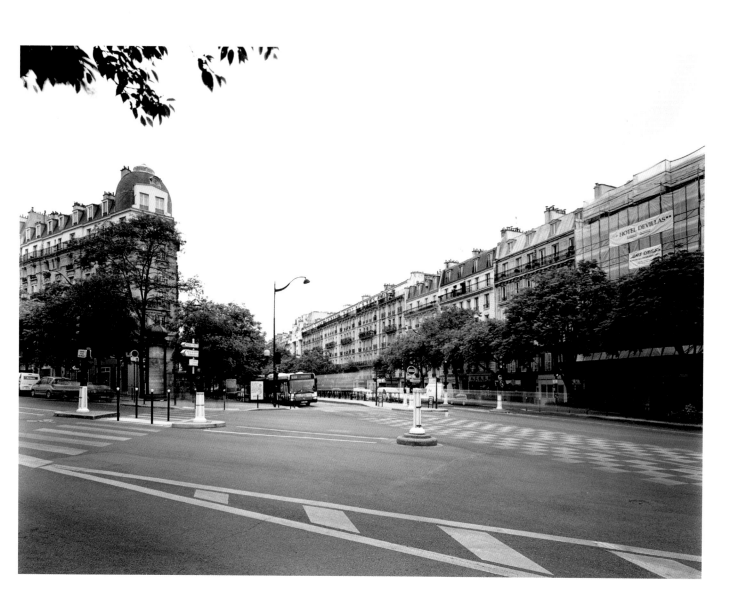

Boulevard Saint-Marcel (looking across Boulevard de l'Hôpital), Sramek, 14.05.2011.

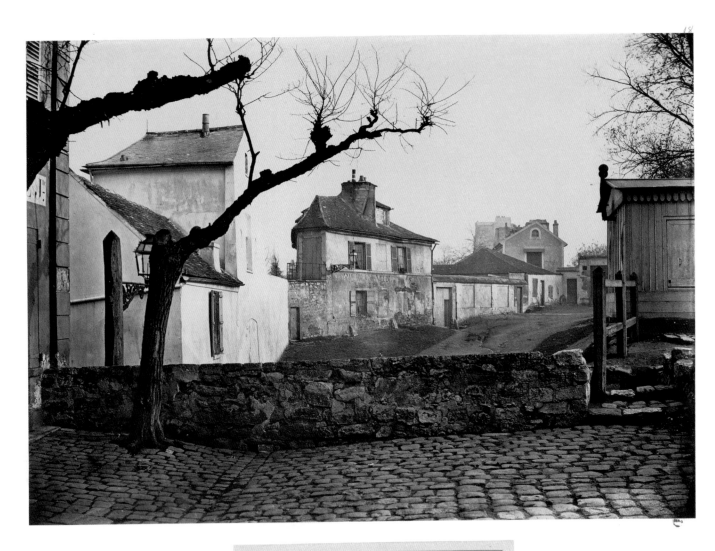

7.02. *Impasse de l'Essai (du Marché aux chevaux)*, Marville, 1865-1868 (CAR/RV).

No. 4 Rue de l'Essai, Sramek, 21.02.2011.

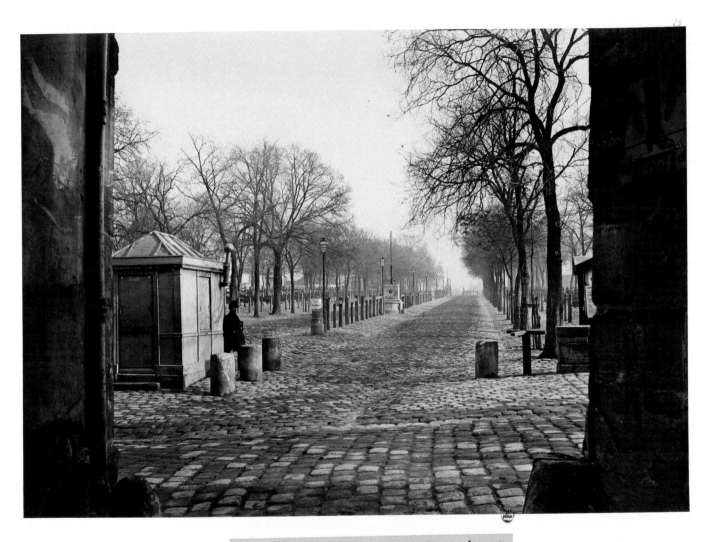

Marché aux chevaux.

7.03. *Marché aux chevaux* [from Rue Geoffroy-St-Hilaire], Marville, 1865-1868 (CAR/RV).

No. 6 Rue Geoffroy-St-Hilaire, Sramek, 17.05.2011.

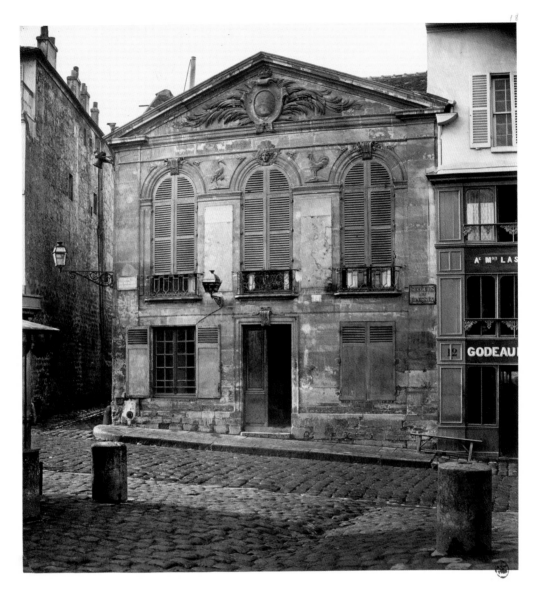

7.04. *Maison Louis XV habitée par le Commre de police du Marché aux Chevaux*
[added in pencil: Rue du Marché aux Chevaux], Marville, 1865-1868 (CAR/RV).

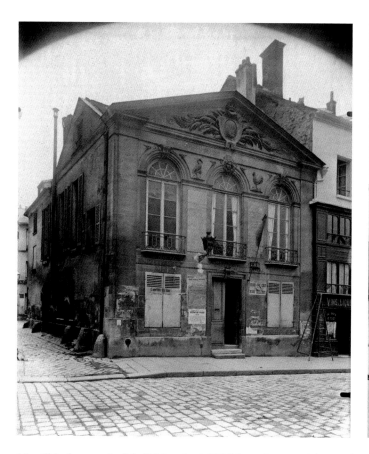

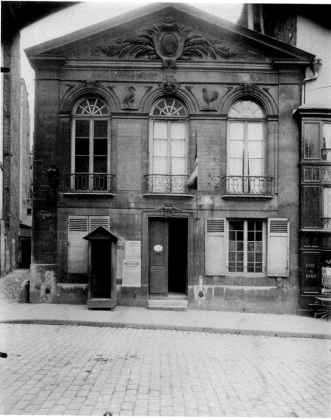

Marville's photograph of the '*Maison Louis XV*' (pl. 7.04) is one of the very few directly monumental photographs in this commission, (another being a photograph of the Fontaine des Innocents). Considering that this historic building would not be disturbed by the *boulevard Saint-Marcel*, it is curious as to why he made the photograph and included it in the series. Atget clearly found it of interest, returning three times to document it.

Atget, 1899 (CAR/RV). Atget, 1909 (CAR/RV).

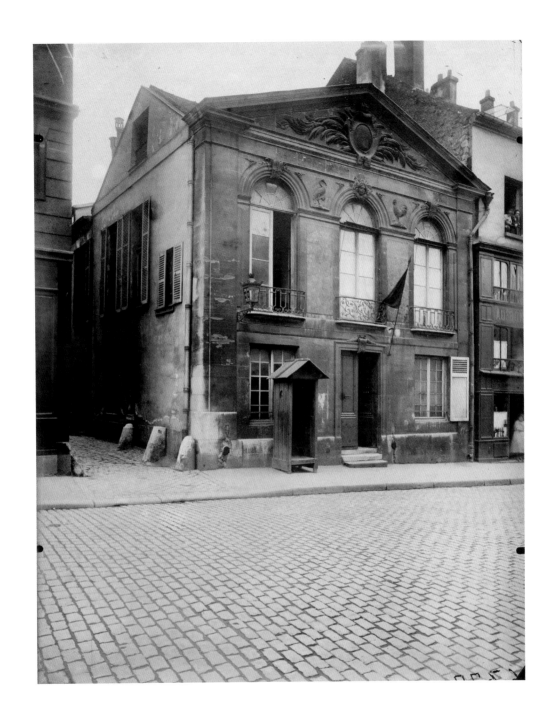

Atget, 1922 (CAR/RV).

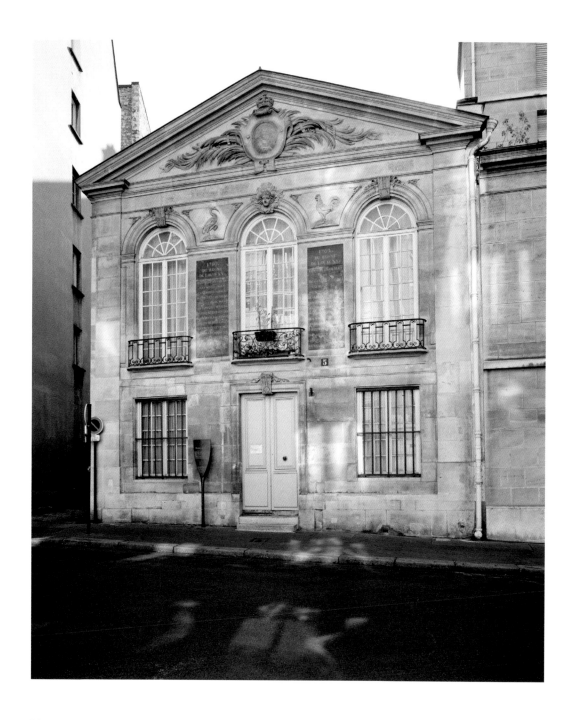

Maison Louis XV, No. 5 Rue Geoffroy-St-Hilaire (occupied by the Police Commissioner for the horse market), Sramek, 12.08.2009.

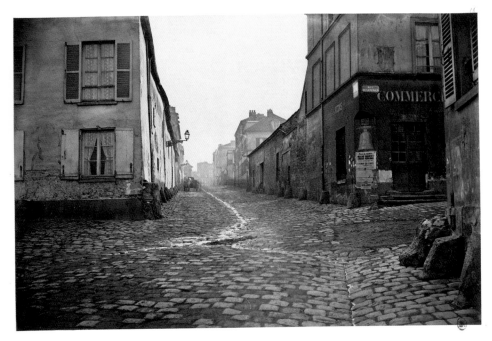

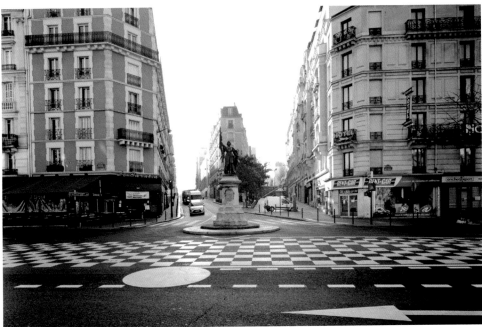

7.05. *Rue Duméril (de la rue du Marché aux Chevaux),* Marville, 1865-1868 (CAR/RV) (above).
Rue Duméril (from Rue Geoffroy-St-Hilaire), Sramek, 21.02.2011 (below).

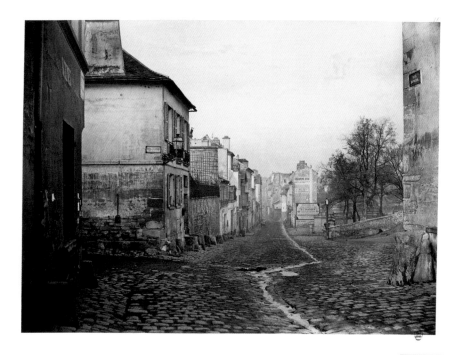

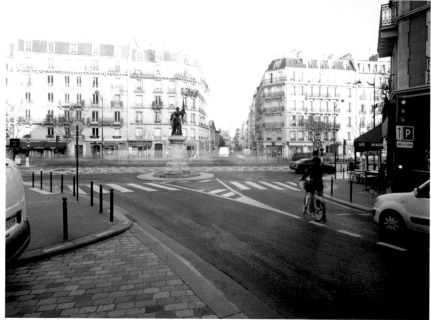

7.06. *Rue du Marché aux Chevaux (de la rue Duméril)*, Marville, 1865-1868 (CAR/RV) (above).
Rue Geoffroy-St-Hilaire (from Rue Duméril), Sramek, 21.02.2011 (below).

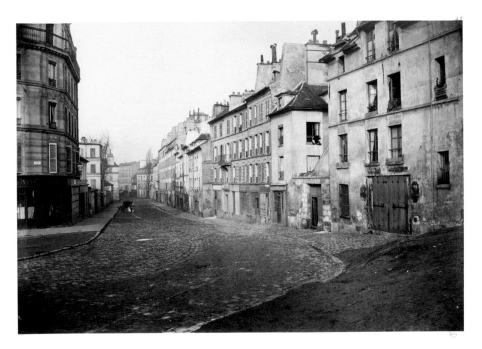

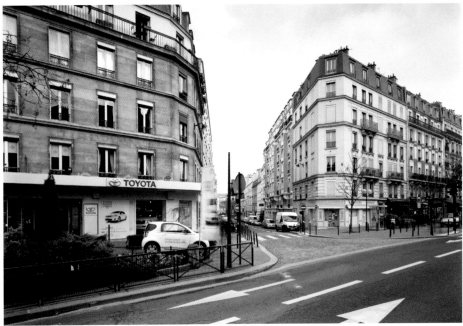

7.07. *Rue des Fossés St Marcel (de la rue du Cendrier)*, Marville, 1865-1868 (CAR/RV) (above).
Rue des Fossés-St-Marcel (from Boulevard St-Marcel), Sramek, 21.02.2011 (below).

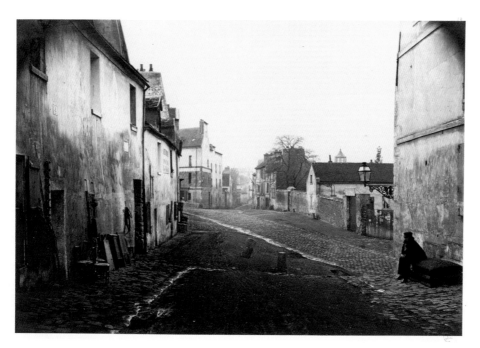

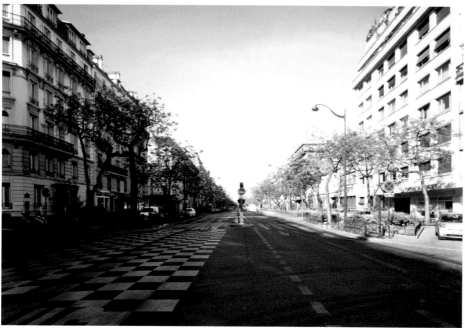

7.08. *Rue des Francs-Bourgeois Sᵗ Marcel*, Marville, 1865-1868 (CAR/RV) (above).
Boulevard St-Marcel (looking west from Rue des Fossés-St-Marcel), Sramek, 28.04.2010 (below).

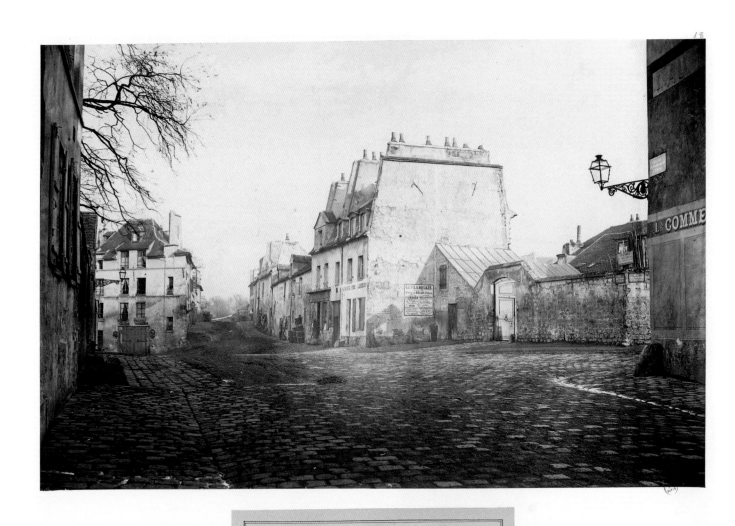

Rue du Cendrier (de la rue des francs-bourgeois)

7.09. *Rue du Cendrier (de la rue des francs-bourgeois)*, Marville, 1865 (CAR/RV).

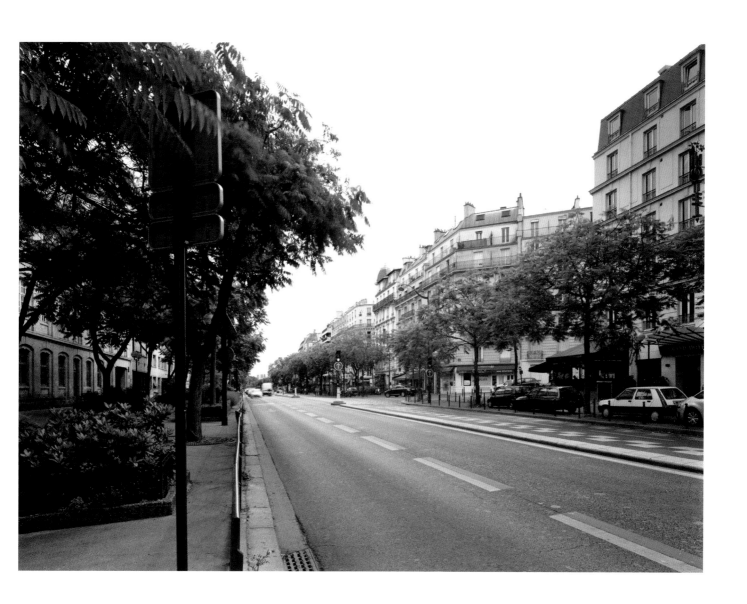

Boulevard St-Marcel (looking east from Rue Scipion), Sramek, 14.05.2011.

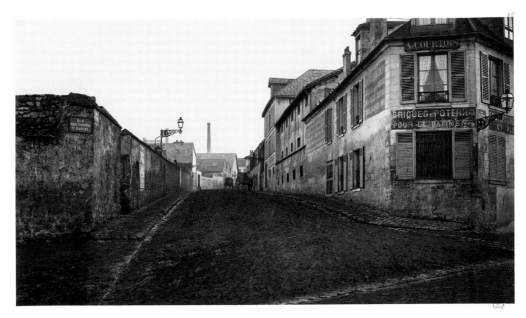

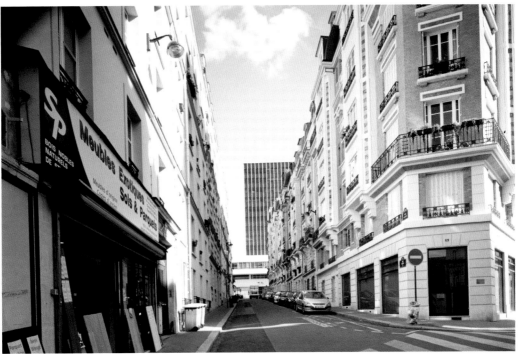

7.10. *Rue des Cornes (de la rue des Fossés S^t Marcel)*, Marville, 1865-1868 (CAR/RV) (above).
Rue Oudry (from Rue Lebrun), Sramek, 12.08.2009 (below).

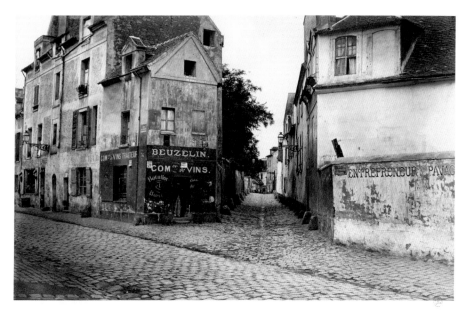

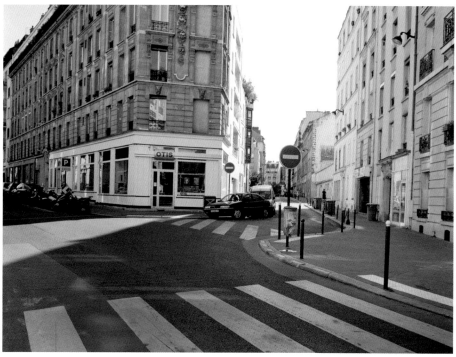

7.11. *Rue de la Reine Blanche (de la rue St-Marcel)* [actually from Rue des Fossés-St-Marcel], Marville, 1865-1868 (CAR/RV) (above).
Rue de la Reine-Blanche (from Rue Lebrun), Sramek, 12.08.2009 (below).

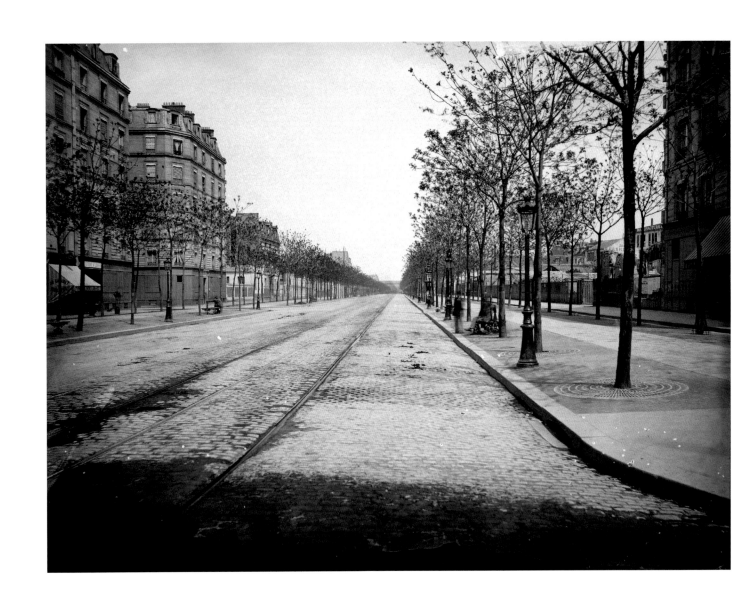

7.12. [*Boulevard Saint-Marcel, au nord de la rue Scipion et vers le boulevard de l'Hôpital*], Marville, c.1877 (BHVP/RV).

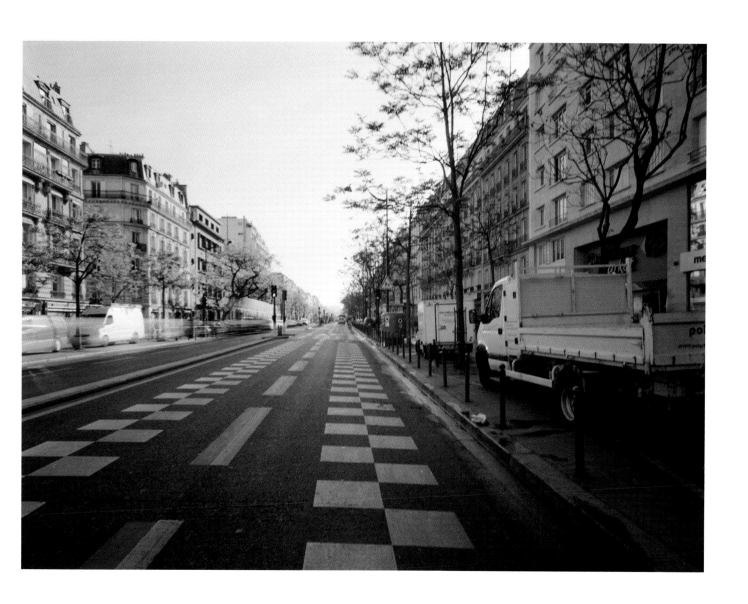

Boulevard St-Marcel (looking east towards Rue Scipion and Boulevard de l'Hôpital), Sramek, 29.04.2010.

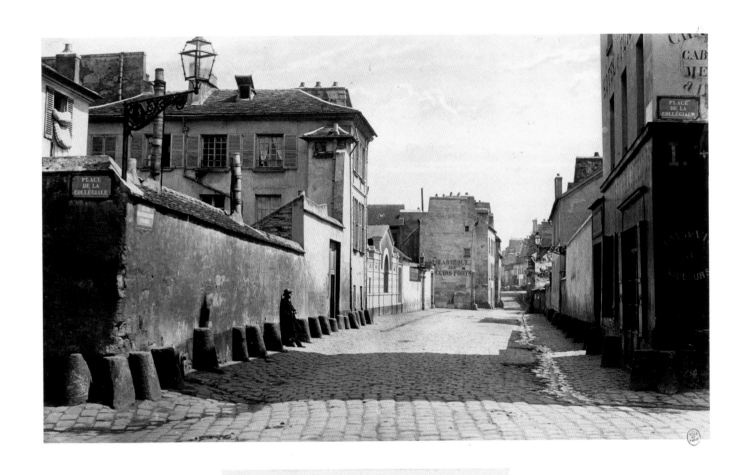

7.13. *Rue des Francs-bourgeois S^t Marcel (de la place Collegiale)*, Marville, 1865 (CAR/RV).

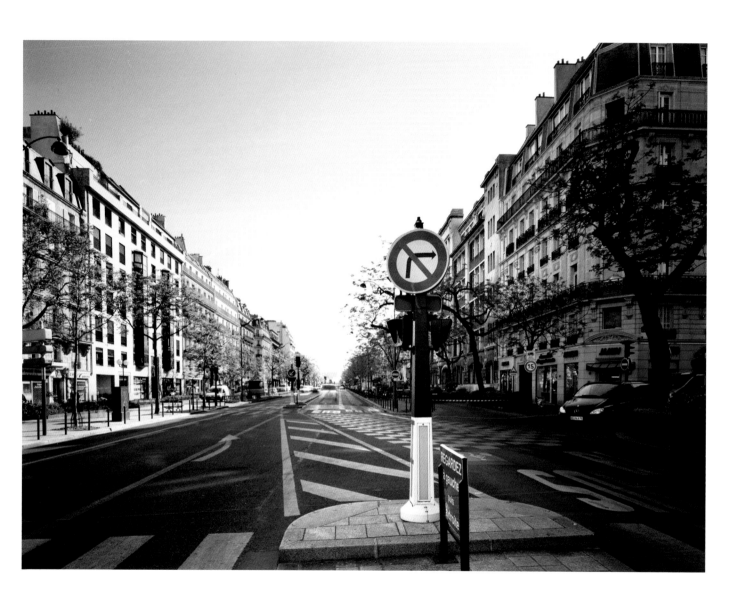

Boulevard St-Marcel (looking east from Rue Michel-Peter), Sramek, 28.04.2010.

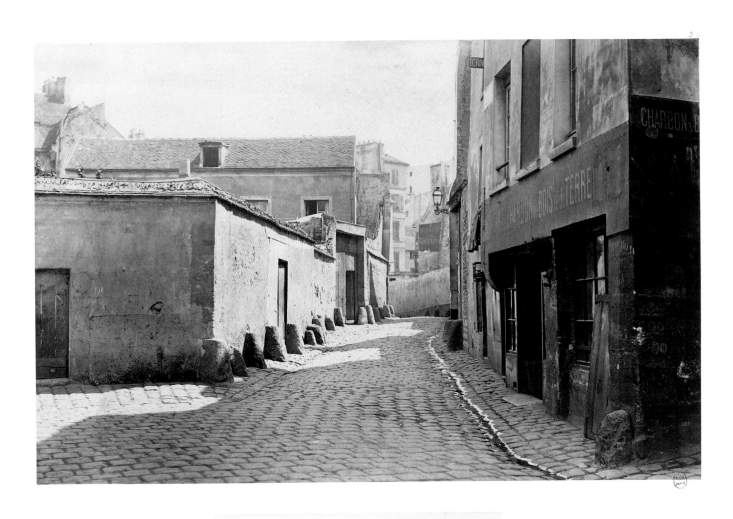

7.14. *Rue Pierre-Assis (de la rue S.^t Hippolyte)*, Marville, 1865 (CAR/RV).

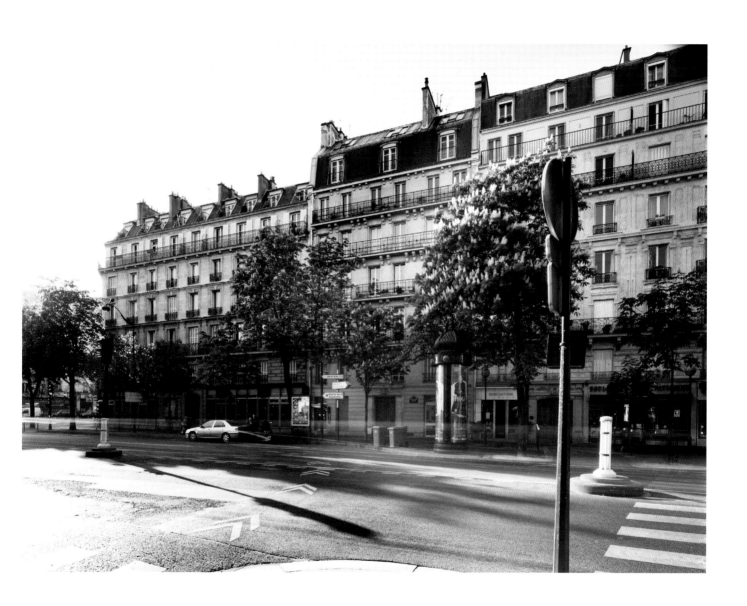

Boulevard Arago (towards Avenue des Gobelins), Sramek, 28.04.2010.

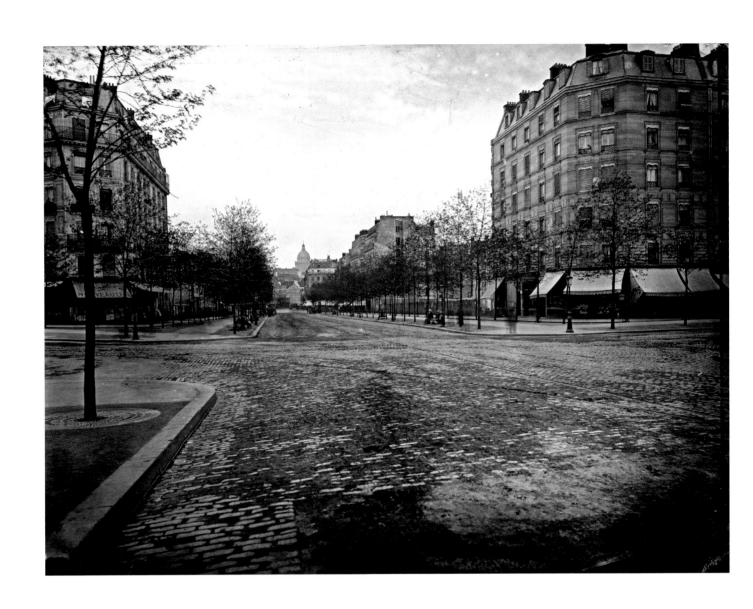

7.15. [*Avenue des Gobelins*], Marville, c.1877 (BHVP/RV).

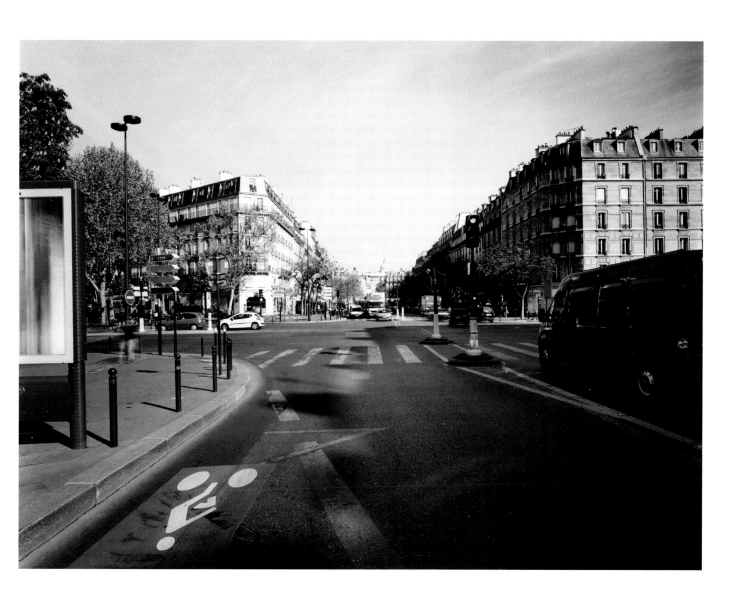

Avenue des Gobelins, (from the intersection with Boulevard St-Marcel towards the Pantheon), Sramek, 29.04.2010.

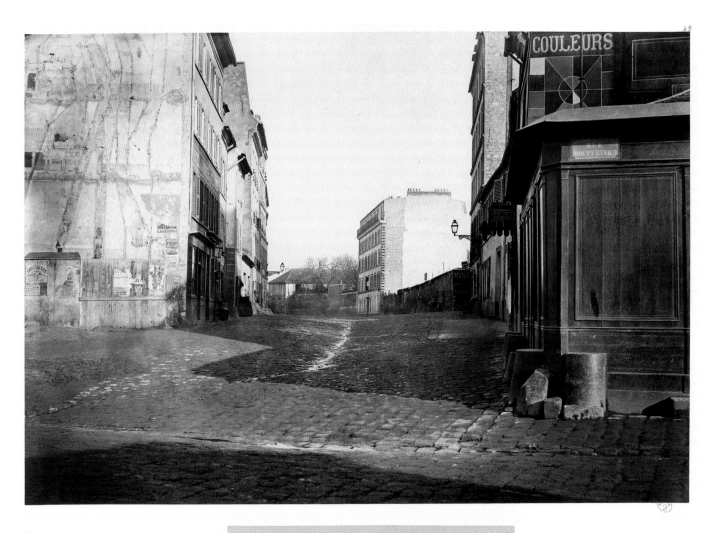

Rue des Fossés S. Marcel (de la rue Mouffetard)

7.16. *Rue des Fossés S.ͭ Marcel (de la rue Mouffetard)*, Marville, 1865-1868 (CAR/RV).

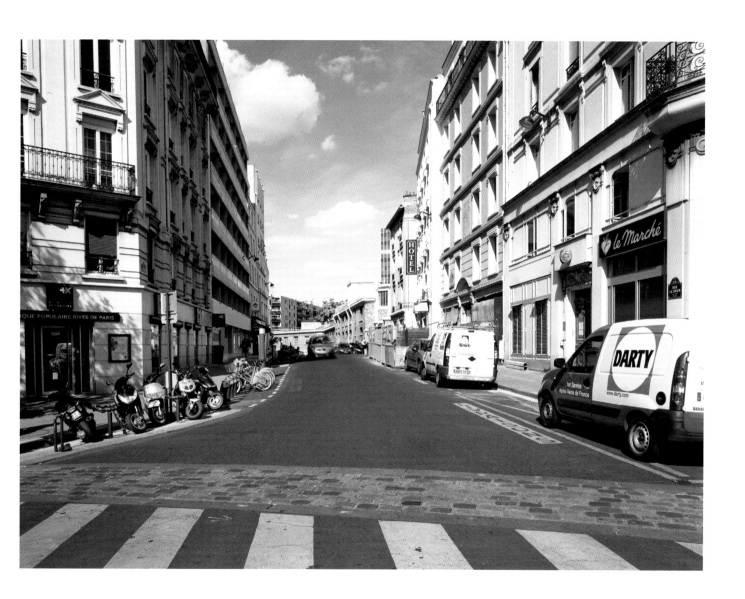

Rue Lebrun (from Avenue des Gobelins), Sramek, 12.08.2009.

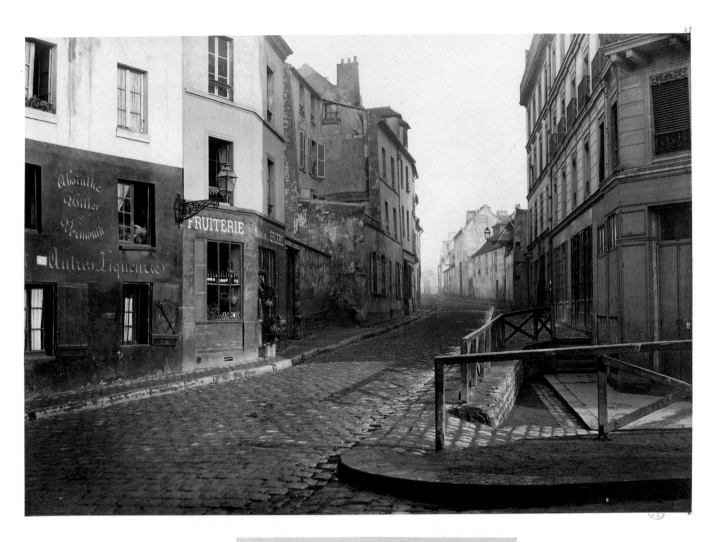

Rue du Banquier (de la rue Mouffetard).

7.17. *Rue du Banquier (de la rue Mouffetard),* Marville, 1865-1868 (CAR/RV).

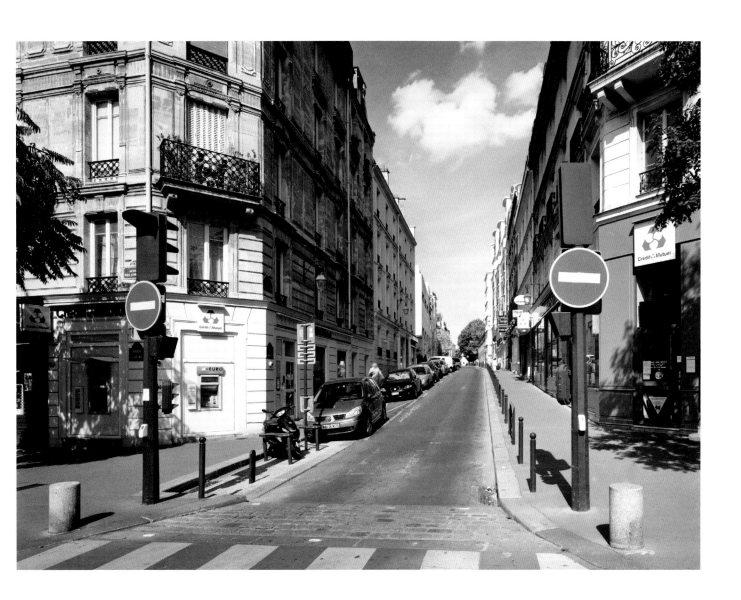

Rue du Banquier (from Avenue des Gobelins), Sramek, 12.08.2009.

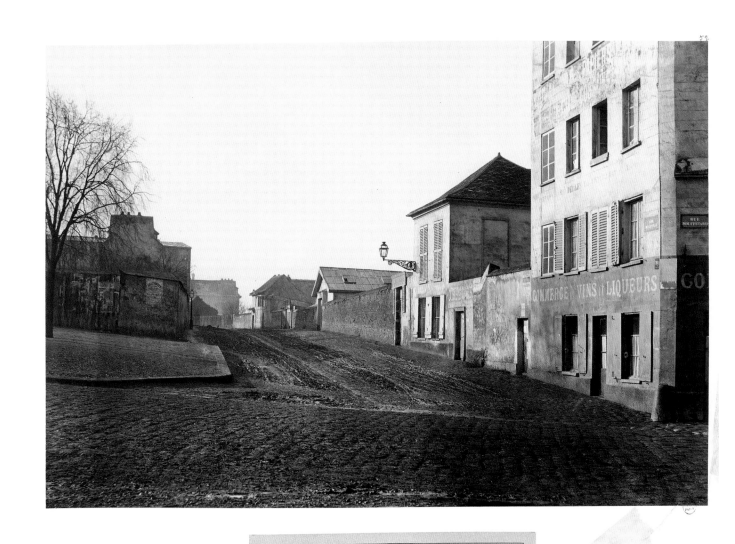

Rue de Gentilly (de la rue Mouffetard)

7.18. *Rue de Gentilly (de la rue Mouffetard)*, Marville, 1865-1868 (CAR/RV).

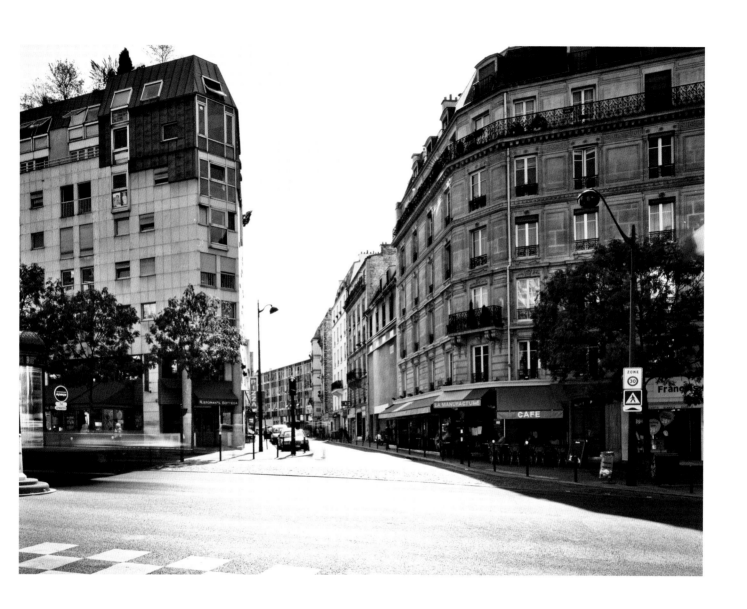

Rue Abel-Hovelacque (from Avenue des Gobelins), Sramek, 12.08.2009.

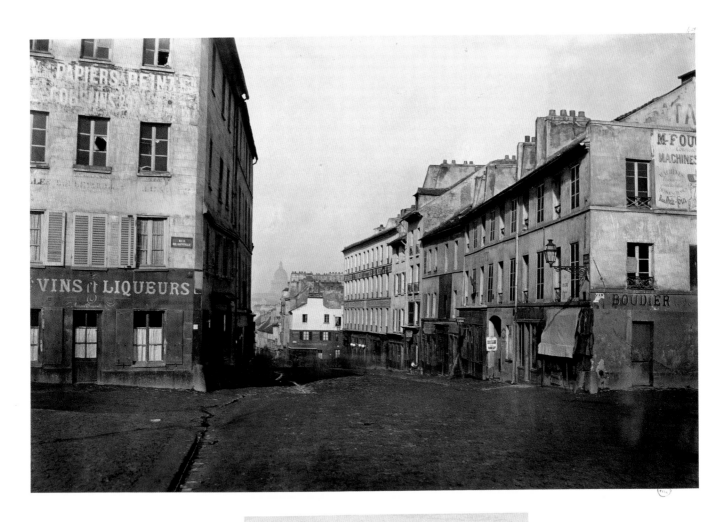

Rue Mouffetard (de la barriere d'Italie)

7.19. *Rue Mouffetard (de la barriere d'Italie)*, Marville, 1865-1868 (CAR/RV).

Avenue des Gobelins (towards the Pantheon, on the left Rue Abel-Hovelacque), Sramek, 12.08.2009.

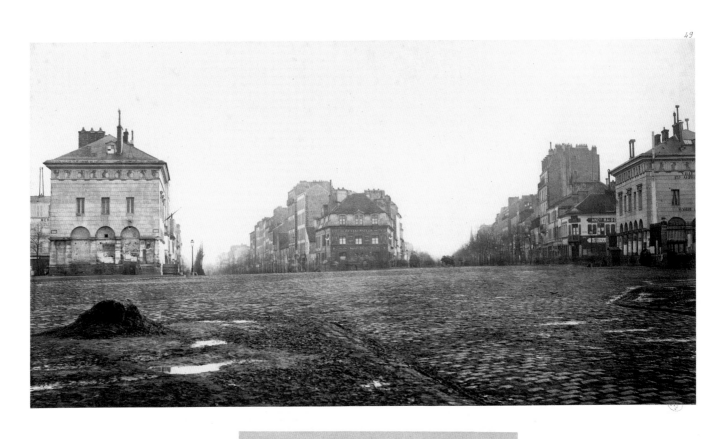

Place d'Italie.

7.20. *Place d'Italie*, Marville, 1865-1868 (CAR/RV).

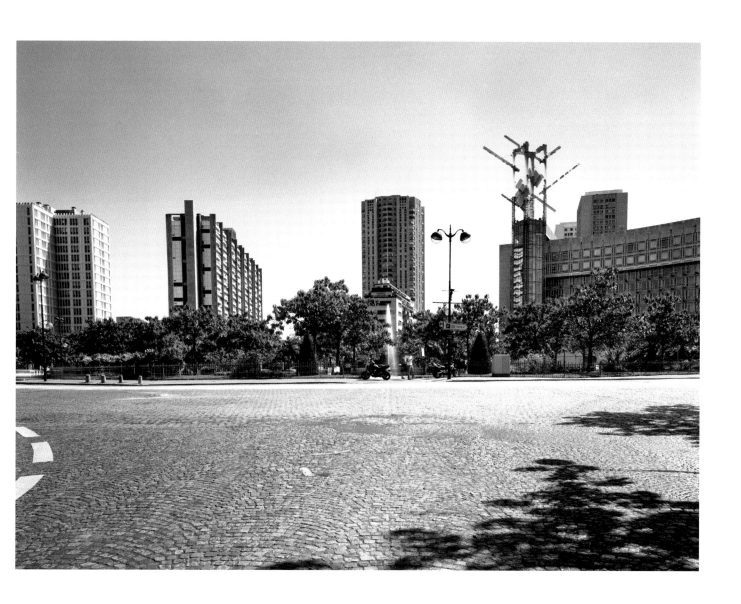

Place d'Italie (from Avenue des Gobelins), Sramek, 12.08.2009.

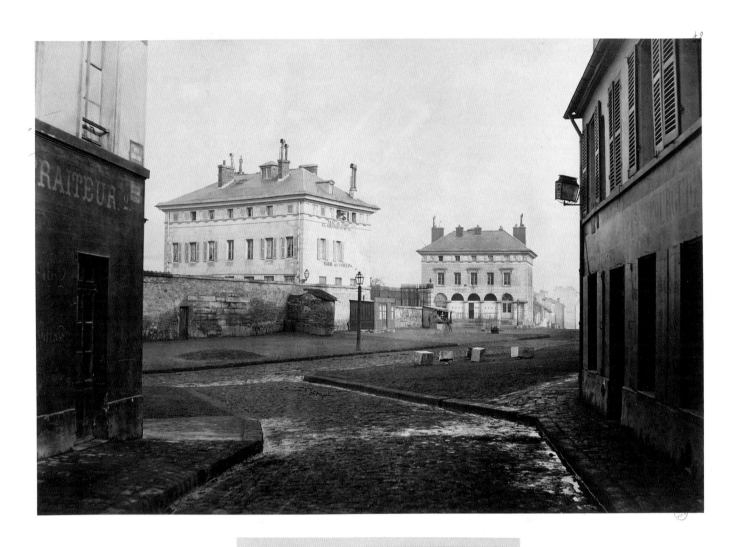

Barrière d'Italie (de la rue Gérard)

7.21. *Barrière d'Italie (de la rue Gérard), Marville, 1865-1868 (CAR/RV).*

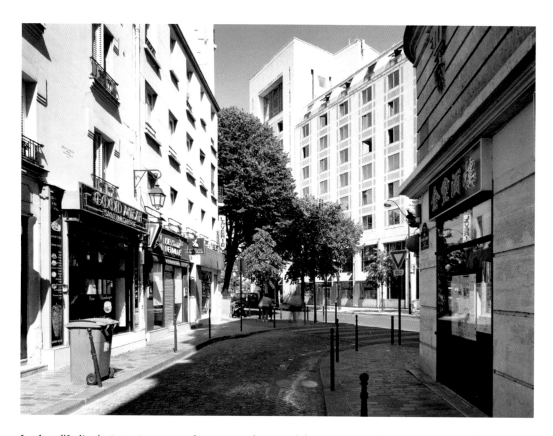

In *place d'Italie*, the imposing customs houses once dominated the open space of the square. A new architecture now looms over the turning traffic. The barrier controlled goods entering the city and, although today's city extends further and further beyond its old borders, *place d'Italie* continues to define a transitional point where the world of the pedestrian is entirely overtaken by that of the motor vehicle. The small *rue du Père Guérin* (pl. 7.22) lies just outside the old barrier and Marville's photograph presents us with the entrance to Paris seen between the customs houses. Reviewed in reverse, the series in this volume takes one down into the city and through its various *quartiers* into its heart. The repeated sightings of the Pantheon and then the spire of Notre Dame remind one that these avenues were constructed with such monumental views in mind. And yet, Marville's series also diverts us to examine more slowly the side streets and lanes, the architectural remnants and anomalies which break a rationalist conception of the urban structure. The textured layers of time prevail and the photographs provide markers to pierce its surface.

Rue du Père-Guérin (towards Place d'Italie), Sramek, 12.08.2009.

431

The Marville Archive
Peter Sramek

This project is based on the collection of Marville photographs in the Musée Carnavalet, a site which itself was purchased at the instigation of Baron Haussmann in 1866 to house a museum of the city of Paris (carnavalet.paris.fr). Much of the following discussion is based on conversations with Françoise Reynaud and Jean-Baptiste Woloch of the Musée Carnavalet. Most of the Marville photographs in this volume come from their collection and were printed and purchased in the mid-1870s in order to replace a set which was destroyed in the 1871 fire at the Hôtel de Ville. They primarily represent Marville's first topographic commission made under Haussmann and were eventually housed in the new Carnavalet museum. Some of the later images from 1877 were not deposited there and are instead in the collection of the Bibliothèque Historique de la Ville de Paris (BHVP). These are clearly noted in the captions and index. The Eugène Atget images are from the Musée Carnavalet and the Bibliothèque Nationale de France or sourced from a number of other collections as indicated. Many of the photographs reproduced here may be viewed through the catalogue at Parisienne de photographie/Agence Roger Viollet (www.parisiennedephotographie.fr) or that of the Bibliothèque Nationale de France (www.bnf.fr).

The nineteenth-century albumen prints by Marville housed in the Carnavalet are mounted onto larger cardstock with pasted calligraphic labels. By contrast, the reproductions in the book *Marville Paris* (de Thézy 1994) are taken from modern prints made by contact from the negatives in the Bibliothèque Historique de la Ville de Paris (BHVP) and present the full image. These were printed in 1978 by Albert Séeberger directly from the glass plate negatives. In some instances, the de Thézy book reveals significant degradation of the glass plates since the making of the prints housed in the Musée Carnavalet. These original albumen prints themselves exhibit a range of print qualities, with many exquisite examples and some quite faded. Curiously, a few later Marville photographs in the collection have typewritten labels, rather than the usual calligraphic label. For the purposes of this book, the reproductions of the mounted prints are variously cropped, some shown with labels and some without. This is done to allow for appreciation of the archival captioned print object while also presenting variety in the layout. However, it should be noted that the entire collection is mounted on standard sized card with an applied label as seen here opposite.

In comparing the mounted and fullframe versions, one can consider how the contact printed images were cut in the mounting process. Primarily the foregrounds of the vertical compositions, and sometimes the sky areas, were trimmed. One can ask what this cropping indicates about Marville's thinking and one conclusion may be that this was done for practical reasons to maintain the format on the mounts with space below for the attached labels. At the same time, it may reflect a focused interest in the subject content, where the foreground was deemed unnecessary. However, it appears as though compositional issues were not considered for the final product. With the elimination of the foreground, the composition often loses its balance and, from an aesthetic point of view, becomes awkward. The cropping is most often done

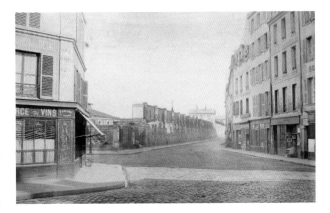

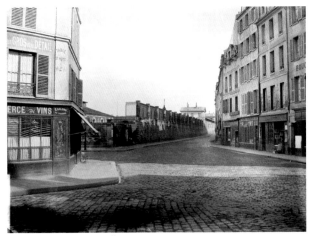

Fig. 53. *Halle aux Vins*, Marville, 1865,
Musée Carnavalet (albumen print)
BHVP (fullframe plate) (pl. 5.07).

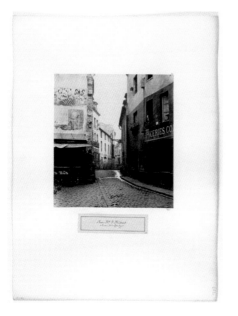

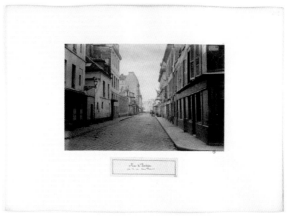

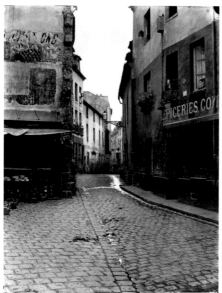

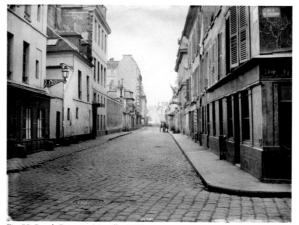

Fig. 54. *Rue Lacépède*, 1865,
Musée Carnavalet (mounted), BHVP (fullframe plate)
(pl. 6.01)

Fig. 55. *Rue de Pointoise*, Marville, 1865,
Musée Carnavalet (mounted), BHVP (fullframe plate) (pl. 5.04).

433

with the verticals, but also occurs in the horizontal images, as in the example of the *rue de Poissy* where the foreground space is uncomfortably eliminated. Some horizontals become very narrow in comparison with the more common proportions used in the series. Additionally, cropping is not to a consistent format, indicating that decisions were being made for individual prints. Who was responsible for these decisions is unknown, but there is one original negative (fig. 54; pl. 1.10, *Percement de l'avenue de l'Opéra*) which has lines which may indicate some form of marking or masking related to cropping decisions but these post-date Marville's printing of the plate. Unfortunately, we have no written documents to consult and such conclusions must be tentative. What is abundantly clear in viewing the full frame reproductions is Marville's ability to elegantly render space. This can be seen in the modern reproductions made from the plates for *Marville: Paris* (de Thézy 1994), while many new scans are currently being placed online in the Parisienne de Photographie/Roger-Viollet catalogue.

When Marville's original set of prints were lost, he fortunately had his original negatives stored elsewhere and proposed in 1873 to reprint the plates. The letter from Marville in which he proposes the new edition is one of the few documents related to the 1865 topographic commission that still exists. In approximately 1900, Pierre Émont's studio was involved in a reprinting effort (de Thézy 1994: 723). Today, various sets of prints are housed in different Paris collections. As has been pointed out by Françoise Reynaud, Curator of the collection, there seem to be a number of Émont's own images placed within the Marville series in the Musée Carnavalet, mounted and labelled in the same manner yet differing in camera, lens, and image detail. Some examples bear the stamp of his studio. This may have been when the vertical photograph of *'Rue du Haut-Pavé'* (see p. 21) entered the collection.

The sequence followed in this book is my own invention based on a walking route through the city. Although the prints in the Marville collection of the Musée Carnavalet for the most part follow a topographic sequence, it is not clear in what order he made the photographs. Understanding this would add to our knowledge of his methods. The sequence is organized by Carnavalet catalogue numbers, which are different from the negative numbers which Marville ascribed to them and, thus, the ordering of the collection may simply have been the curator's doing on receiving the prints. The sequence follows logically and topographically in segments, with a few major jumps to other areas of the city and then back. Within these return jumps, one finds a number of repeated images, suggesting that maybe the groups of images were delivered at different times, and those few images that are repeated came in the different deliveries. It then makes sense that the catalogue follows the delivery order,

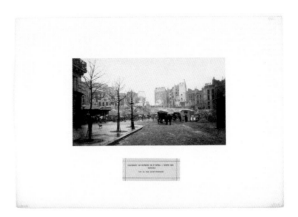

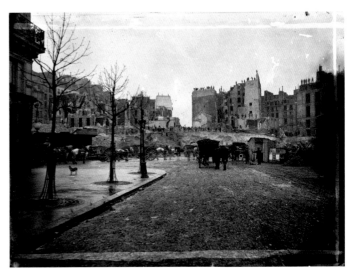

Fig. 56. *Percement de l'avenue de l'Opéra*, Marville, c.1877, Musée Carnavalet (mounted), BHVP (fullframe plate) (pl. 1.10).

resulting in the occasional break in topographical sequence. This is speculation in wishing to understand Marville's thinking about structuring his representation of the city, but it would make sense to have sequenced them topographically whether they were shot this way or not. The prints did have numbers on the reverse but this was hidden when the prints were mounted. The plates themselves do have labels, but analysis of Marville's negative numbers was not undertaken during this project and awaits future research. For now, museum catalogue numbers are used in the index.

There do exist folios of mounted prints which were re-organized in the 1960s alphabetically by street name. This makes it easier to find a particular street by name, but the images are then out of order in terms of location, disrupting the notion of mapping, which seems so central to the collection. This points to two alternate conceptions of archive management and usability. Of course, today, with electronic databases and given the right tools, one can sort and explore the images in various ways. With the addition of geolocation data, the images can be linked to their mapped sites. Capturing this information has been part of the process of making this contemporary series and it will be added to the museum catalogue.

Just as Marville's concept of sequencing is not clear, the chronology and dating of the photographs is problematic. The institutions which house his collections give a range of dates to many images as there is no definitive documentation available. Some of the first commission images are dated 1865, but many only 1865-1868. Other than de Thézy's publication, the few books which do exist on Marville seem quite unreliable as references. Errors occur in captioning the locations and although a variety of specific years for images may be given, these seem questionable. Philippe Mellot (2001) for example, does give exact years for Marville's images of Paris streets, but these are suspect because of obvious errors. They range from 1854 (clearly wrong) to 1876 (a typographic transposition?) and he dates at 1860, various groupings which are part of the commission and dated between 1865 and 1868 by the museum collections. Unfortunately, he also gives Marville's studio address as 86 *boulevard Saint-Jacques* when the number 66 is clearly seen in the photograph, which does not inspire confidence. Other publications on Marville have errors in captioning which seriously misidentify locations, likely due to the similarities of the compositions and a lack of careful editing. As noted previously, occasional errors occured in the actual labelling of the Marville prints, where one must presume that the person creating the label was not familiar with the specific site or making of the photograph. In these instances, the mistake is primarily as to the direction of the view.

At the same time as there may be a lack of definitive publications, there is excellent work now being done to bring awareness to Marville's documentation of urban transformation. Rémy Castan (2010) provides an extensive and accurate rephotographic series based on the Marville collection and with Sarah Kennel's current curatorial work for a major Marville exhibition at the National Gallery in Washington (2013), new light will be shed on the broad range of his archive. It is hoped that *Piercing Time* will also add a useful piece to the historical record which Charles Marville and Eugène Atget have bequeathed us.

Technical Notes

Technical and physical requirements have always affected how photographers work with their subject matter and considerations related to all three photographic eras naturally come into play when analyzing these collections and working methods. For both Marville and Atget, the technology required a great deal of physical effort. However, the lack of hard data, especially in Marville's case, is problematic and one is not sure to what extent each approach to documenting the city was affected by the means available.

Still, a consistent difference between Marville and Atget is Marville's restriction to views from street intersections. This suggests a systematic conceptualizing of the documentation as a networked mapping problem, consistent with Min Lee's articulation of the scientific representation of the cityscape. At the same time, it also provides an economical solution by limiting the number of images required. Marville's wet-plate collodion process was laborious, requiring the coating, exposure and development of each glass negative on the spot. This meant that he had to be judicious in his work, restricted by the number of exposures he could make in a day. It did help that with each negative processed, he would have seen the final plate onsite and so might have been secure in making a minimal number of exposures. He may also have wiped off unsuccessful exposures on the spot in order to clean and re-coat the glass for another attempt. This is possible with the wet-plate process. Still, we do not know how many plates may have been made of a site and later destroyed, although it appears clear that one angle of view and one negative was all that Marville required for each direction of a street.

By the time Atget was photographing, he used dry plates, still of glass and housed in heavy wooden holders. Although he was dependent on the availability and quality of the commercially produced plates, this process was much faster than the older, wet plate collodion, and this would have assisted him in shooting more extensively. Conveniently for him, all development took place in the studio. He still had a cumbersome load to carry as he walked through Paris with his big camera and a limited number of plates, but he possibly was freer to make more exposures within one street or take more than one angle of a subject.

Today, despite film photography being less common and the camera appearing to be outdated, there was relative ease compared to these earlier procedures. Working with a Cambo 4x5 view camera, four or more sheets of film were exposed for each image, allowing for choice in reviewing the results later, primarily based on blurred movements of people and traffic during the exposure which ranged from a half second to 2 minutes with 5 seconds most often used. Occasionally, I returned later to reshoot, needing to adjust camera position or often to hope to find fewer vehicles in the scene.

A 90mm Schneider-Kreuznach Super-Angulon lens was used along with Ilford FP4 film. The extra-wide angle of view pushed the distance further away so that, although taken from where Marville stood, the photographs show much more of the scene and with an altered perspective. This was done to capture a greater sense of the space, both as an aesthetic preference and from a desire to show the broad environment out of which Marville selected his framing. Details of position, time of day and length of exposure were carefully recorded and particular architectural changes noted. Of special interest was the determination of the exact locations so that geotags will become part of the archived data attached to the Marville collection.

Bibliography

Anon (2000), 'Drifting with the Situationist International', *Smile #5*, http://library.nothingness.org/articles/SI/en/display/238. Accessed 11 January 2013.

Arce, Nadia Arroyo et al. (2012), *Eugène Atget*, Alcobendas, España: TF Editores.

Atget, Eugène and Beaumont-Maillet, Laure (1992), *Atget Paris*, Corte Madera CA: Gingko.

Barberie, Peter (2007), 'Conventional Pictures: Marville in the Bois de Boulogne', Ph.D. thesis, Princeton, NJ: Princeton University.

Bárta, Jaroslav, et al.(2006), *Praha: Letem po sto letech, 1898-1998*, Lomnice nad Popelkou CZ: Jaroslav Barta Studio JB.

Benjamin, Walter (1999), *The Arcades Project*, trans. H. Eiland and K. McLaughlin, Cambridge, MA: Harvard University Press.

Bonami, Francesco (2001), *Gabriele Basilico*, London: Phaidon.

Castan, Rémy and Marville, Charles (2010), *Paris et son Double: Paris avant Haussmann; Paris aujourd'hui*, Paris: Nicolas Chaudun.

Christ, Yvan (1967), *Les métamorphoses de Paris*, Paris: André Balland.

Darin, Michaël (2009), *La Comédie Urbaine, voire la ville autrement*, Gollion CH: Infolio.

Debord, Guy (1955), 'Introduction to a critique of urban geography', *Les Lèvres Nues*, #6, http:library.nothingness.org. Accessed 11 January 2013.

Debord, Guy (1959), '*Sur le passage de quelques personnes à travers une assez courte unité de temps*' [On the Passage of a Few People Through a Rather Brief Unity of Time], France (film).

De Moncan, Patrice and Marville, Charles (2010), *Paris: Avant \ Après 19e siècle – 21e siècle*, Paris: Editions de Mécène.

De Moncan, Patrice and Marville, Charles (2009), *Paris Photographié au Temps d'Haussmann*, Paris: Editions de Mécène.

De Thézy, Marie (1994), *Marville: Paris*, Paris: Éditions Hazan.

Gershfield, N. (2010), 'Simon Sadler: The Situationist City (1999)', *Architecture and Urbanism*, [book review], http://architectureandurbanism.blogspot.ca/2010/06/simon-sadler-situationist-city-1999.html. Accessed 11 January, 2013.

Gluck, Mary (2005), *Popular Bohemia – Modernism and Urban Culture in Nineteenth-Century Paris*, Cambridge, MA: Harvard University Press.

Harris, David (1999), *Eugène Atget: Unknown Paris*, NYC: The New Press.

Haussmann, Georges-Eugène (1893), *Mémoires, Tôme III*. in Françoise Choay, ed. (2000) *Haussmann Mémoires: l'édition integrale*. Paris: Editions du Seuil.

Hazan, Eric (2010), *The Invention of Paris: A history in footsteps*, London: Verso.

Hugo, Victor (1831), *Notre-Dame de Paris*, Project Gutenburg ebook: translated by Isabel F. Hapgood (2009).

Hussey, Andrew (2006), *Paris: The Secret History*, NYC: Bloomsbury.

Klett, Mark (1990), *Second View: the Rephotographic Survey Project*, Sante Fe NM: University of New Mexico Press.

Klett, Mark et al. (2004), *Third Views – Second Sights: A rephotographic survey of the American West*, 1st ed. Sante Fe NM: Museum of New Mexico Press.

Knabb, Ken (1981), *Situationist International Anthology*, Berkeley: Bureau of Public Secrets

Krieger, Martin (2012), 'Re-photographing and re-viewing Charles Marville's Paris of 1865-1877', http://1000eyes.usc.edu/martin/KriegerParisT&C.pdf. 15 August, 2012.

Lee, Min. K. (2012), 'An objective point of view: the orthogonal grid in eighteenth-century plans of Paris', *The Journal of Architecture*, RIBA 17: 1, Critical Perspectives on Landscape (February 2012), 11-32.

Levere, Douglas (2005), *New York Changing: Revisting Berenice Abbott's New York*, NYC: Princeton Architectural Press.

Levine, Neil (2012), 'The template of photography in nineteenth-century architectural representation', *Journal of the Society of Architectural Historians*, 71(3), pp. 306-31.

Maciejewski, Andrzej (2003), *After Notman: Montreal Views, a century apart = D'Après Notman: Regards sur Montréal, un siècle plus tard*, Willowdale ON: Firefly Books.

Marrinan, Michael (2009), *Romantic Paris, Histories of a cultural landscape, 1800-1850*, Stanford CA: Stanford University Press.

McGregor, James H. S. (2009), *Paris from the Ground Up*, Cambridge, MA: Harvard.

Mellott, Philippe (2001), *Paris sens dessus-dessous: Marville Photographies 1852-1877*, France: Editions de Lodi.

Morris Hambourg, Maria (1982), *The Work of Atget Vol.II: The art of old Paris*, NYC: The Museum of Modern Art.

Nesbit, Molly (1992), *Atget's Seven Albums*, New Haven: Yale University Press.

Pinder, David (2000), ' "Old Paris is no More": Geographies of Spectacle and Anti-spectacle', *Antipode*, 32:4, pp.357-86, Oxford: Blackwell.

Pinon, Pierre and Le Boudec, Bertrand (2004), *Les Plans de Paris: histoire d'une capital*, Paris: Le Passage / Bibliothèque Nationale de France.

Pitt, Leonard (2006), *Walks Through Lost Paris, A journey into the heart of historic Paris*, Berkeley CA: Counterpoint.

Pitt, Leonard (2008) *Un Voyage dans le Temps, Images d'une ville disparue*, Paris: Parigramme.

Plant, Sadie (1992), *The Most Radical Gesture: The Situationist International in a Postmodern Age*, Oxford: Taylor Francis.

Rauschenberg, Christopher (2007), *Paris Changing: Revisiting Eugène Atget's Paris*, NYC: Princeton Architectural Press.

Reader, John (2005), *Cities*, London: Vintage, Random House.

Rice, Shelley (1997), *Parisian Views*, Cambridge, MA: MIT Press.

Robb, Graham (2010), *Parisians: An adventure history of Paris*, London: Norton.

Sadler, Simon (1999), *The Situationist City*, Cambridge MA: The MIT Press.

Sartre, Josiane (2002) *Atget in Detail*, Paris: Flammarion.

Sramek, Peter (2009), *A Passion for Cities: Alinari's Florence, Atget's Paris, Sudeks' Prague Rephotographed*, Toronto: Book°Sequence Press.

Sudek, Josef (1959), *Praha Panoramatická*, Prague: Odeon.

Travis, David (2005), *Paris: Photographs from a time that was*, Chicago: Art Institute of Chicago.

Tung, Anthony (2001), *Preserving the World's Great Cities – The destruction and renewal of the historic metropolis*, NYC: Three Rivers Press.

Zola, Emile (1877), *L'Assommoir*, London: Penguin, 2001.

Index to Photographs by Charles Marville

The titles given here provide Marville's original labelling on the mounted prints, including punctuation and any corrections made on the label by successive curators. Catalogue numbers (CARPH000xxx) refer to the collection of the Musée Carnavalet. Those Marville images not from the Musée Carnavalet come from the Bibliothèque Historique de la Ville de Paris (BHVP) and the description used in the BHVP catalogue is given in parentheses to indicate that it does not reflect a label on a mounted print. One variant plate comes from the Bibliothèque de l'Hôtel-de-Ville (see page 21). Where appropriate, a reference is given to the page in the book *Marville Paris* by Marie de Thézy for referral to a fullframe view. Many of the Marville images may also be researched on the Parisienne de Photographie/Roger-Viollet website at *www.roger-viollet.fr*.

Avenue de l'Opéra

1.01. *AVENUE DE L'OPÉRA (Espace compris entre la rue Louis-le-Grand et la rue d'Antin, vers l'Opéra).* [typed label]. c.1877. CARPH000940 (ref. de Thézy 447).

1.02. PERCEMENT DE L'AVENUE DE L'OPÉRA: BUTTE DES MOULINS *(de la rue Saint-Roch)* [typed label]. c.1877. CARPH000938 (ref. de Thézy 446).

1.03. *Rue des Orties S' Honoré (de la rue d'Argenteuil)* [ed. actually towards *rue d'Argenteuil*]. 1865-1868. CARPH000469 (ref. de Thézy 443).

1.04. *Rue des Moineaux (de la rue des Orties).* 1865-1868. CARPH000470 (ref. de Thézy 443).

1.05. *Rue des Moulins (de la rue des Orties).* 1865-1868. CARPH000471 (ref. de Thézy 440).

1.06. *Rue de l'Evêque (de la Butte des Moulins).* 1865-1868. CARPH000475 (ref. de Thézy 441).

1.07. *Rue des Orties S' Honoré (de la rue S'e Anne).* 1865-1868. CARPH000468 (ref. de Thézy 438).

1.08. *Rue du Clos-Georgeau (de la rue S'e Anne).* 1865-1868. CARPH000467.

1.09. PERCEMENT DE L'AVENUE DE L'OPÉRA: *Chantier de la Butte des Moulins du Passage Molière* [typed label]. c.1877. CARPH000939 (ref. de Thézy 446).

1.10. PERCEMENT DE L'AVENUE DE L'OPÉRA: BUTTE DES MOULINS *(de la rue Saint-Honoré)* [typed label]. c.1877. CARPH000935 (ref. de Thézy 444).

1.11. *Rue de l'Evêque (de la rue des Frondeurs).* 1865-1868. CARPH000474 (ref. de Thézy 437).

1.12. *Rue d'Argenteuil (de la rue des Orties).* 1865-1868. CARPH000472 (ref. de Thézy 442).

1.13. *Rue d'Argenteuil (de la rue des Frondeurs).* 1865-1868. CARPH000473 (ref. de Thézy 436).

1.14. *Rue Fontaine Molière (de la rue des Frondeurs).* 1865-1868. CARPH000476 (ref. de Thézy 435).

Halles - Auxerre

2.01. [*Rue de Rivoli*]. c.1877. BHVP NV-004-C-0304 (ref. de Thézy 333).

2.02. *Rue de Viarmes (de la rue Mercier).* 1865-1868. CARPH000537.

2.03. *Rue de Viarmes et Observatoire de Catherine de Médicis.* 1865-1868. CARPH000509.

2.04. *Rue J.J. Rousseau (de la rue de Grenelle)* [changed in pencil to: ~~de Grenelle~~ *Coquillière*]. 1865-1868. CARPH000505 (ref. de Thézy 386).

2.05. *Rue Coquillière (de la Banque)* [changed in pencil to: ~~de~~ *vers la Banque de la rue J.J. Rousseau*]. 1865-1868. CARPH000504 (ref. de Thézy 385).

2.06. *Rue de Grenelle S' Honoré (de la rue J.J. Rousseau)* [changed in pencil to: *ancienne Rue de Grenelle S' Honoré (~~de la~~ actuelle rue J.J. Rousseau) de la rue Coquillière (vers le Louvre)*]. 1865-1868. CARPH000506 (ref. de Thézy 384).

2.07. *Rue de Sartine (de la rue Coquillière).* 1865-1868. CARPH000507 (ref. de Thézy 378).

2.08. *Rue Coquillière (de la rue Jean Jacques Rousseau)* [added in pencil: *vers les Halles*]. 1865-1868. CARPH000519 (ref. de Thézy 387).

2.09. *Carrefour du Jour.* 1865-1868. CARPH000521. (ref. de Thézy 369).

2.10. *Pointe S' Eustache et rue Montorgueil.* 1865. CARPH000522 (ref. de Thézy 363).

2.11. *Rue de la Grande Truanderie (de la rue Montorgueil).* 1865. CARPH000531 (ref. de Thézy 363).

2.12. *Rue Mondétour (de la rue de Rambuteau).* 1865. CARPH000530 (ref. de Thézy 361).

2.13. *Rue du Cygne (de la rue Mondétour).* 1866. CARPH000532 (ref. de Thézy 354).

2.14. *Rue du Cloître Saint Jacques. (de la rue de la G'e Truanderie).* 1865. CARPH000539 (ref. de Thézy 354).

2.15. *Rues de la Petite et de la Grande Truanderie.* 1865. CARPH000502 (ref. de Thézy 355).

2.16. *Rue Mauconseil (du B'rd Sebastopol)* [incorrect: this is looking towards Blvd. Sebastopol]. 1865. CARPH000535 (ref. de Thézy 357).

2.17. *Rue Mauconseil (de la rue Montorgueil)* [changed in blue ink to: *au fond ~~(de la~~ rue Montorgueil)*]. 1865. CARPH000534 (ref. de Thézy 356).

2.18. [*Boulevard de Sébastopol*]. c.1875-1877. BHVP NV-004-C-0346 (ref. de Thézy 339).

2.19. *Rue des Lavandières S'e Opportune.* 1865. CARPH000543 (ref. de Thézy 341).

2.20. *Rue du Plat d'Etain (de la rue des Lavandières).* 1865. CARPH000542 (ref. de Thézy 342).

2.21. *Rue des Déchargeurs (de la rue de Rivoli).* 1865. CARPH000550 (ref. de Thézy 340).

2.22. *Carrefour S^te Opportune (de la rue des Halles)*. 1865. CARPH000545 (ref. de Thézy 343).

2.23. *Carrefour S^te Opportune*. 1865. CARPH000544 (ref. de Thézy 344)

2.24. *Rue de l'Aiguillerie (de la rue des Lavandières)*. 1865. CARPH000541 (ref. de Thézy 345).

2.25. *Rue S^t Honoré (de la rue de la Ferronnerie)*. 1865. CARPH000549 (ref. de Thézy 348).

2.26. *Rue Tirechape de la rue S^t Honoré*. 1865. CARPH000557 (ref. de Thézy 351).

2.27. *Rue de la Lingerie (des Halles)*. 1865. CARPH000528 (ref. de Thézy 364).

2.28. *Rue de la Tonnellerie (de la rue de la Poterie)*. 1865. CARPH000526 (ref. de Thézy 365).

2.29. *Rue du Four (Côté regardant S^t Eustache)*. 1865. CARPH000527 (ref. de Thézy 370).

2.30. *Rue du Four (Côté regardant la rue S^t Honoré)* [added in pencil: *Vauvilliers*]. 1865. CARPH000518 (ref. de Thézy 371).

2.31. *Rue Sauval (de la Halle au Blé)*. 1865-1868. CARPH000515 (ref. de Thézy 375).

2.32. *Rue Sauval (de la rue S^t Honoré)*. 1865-1868. CARPH000514 (ref. de Thézy 372).

2.33. *Rue S^t Honoré (de la rue de l'Arbre sec)*. 1865-1868. CARPH000560 (ref. de Thézy 372).

2.34. *Tourelle de la rue des Prêtres S^t Germain l'Aux^ois*. 1865-1868. CARPH000481 (ref. de Thézy 331).

2.35. *Place de l'École (du quai)*. 1865. CARPH000486 (ref. de Thézy 329).

2.36. *Place des Trois Maries (du Pont-Neuf)*. 1865. CARPH000487 (ref. de Thézy 328).

2.37. *Rue de la Monnaie (de la place des Trois Maries)*. 1865. CARPH000488.

2.38. *Rue des Prêtres S^t Germain l'Auxerrois*. 1865. CARPH000482 (ref. de Thézy 327).

2.39. *Rue S^t Germain l'Auxerrois (de la rue des Prêtres)*. 1865. CARPH000490.

2.40. *Rue de la Monnaie (de la rue de Rivoli)*. 1865. CARPH000489 (ref. de Thézy 334).

2.41. *Rue de l'Arche-Marion (du quai de la Mégisserie)*. 1865. CARPH000484 (ref. de Thézy 326).

Île-de-la-Cité

3.01. *Place Dauphine* [looking east]. 1865 CARPH000888 (ref. de Thézy 317).

3.02. *Place Dauphine* [looking west]. 1865. CARPH000887.

3.03. *Rue Constantine (du B^ard du Palais)*. 1865. CARPH000899 (ref. de Thézy 313).

3.04. *Rue de la Colombe (du côté du quai)*. 1865. CARPH000913 (ref. de Thézy 302).

3.05. *Rue Basse des Ursins*. 1865. CARPH000912 (ref. de Thézy 302).

3.06. *Rue Chanoinesse (de la rue des Chantres)*. 1865. CARPH000924 (ref. de Thézy 303).

3.07. *Rue du Cloître-N. Dame du Parvis*. 1865. CARPH000923 (ref. de Thézy 296).

3.08. [*Boulevard du Palais (vue prise du pont Saint-Michel)*]. c.1873-1877. BHVP NV-004-C-0297 (ref. de Thézy 314).

Saint-Séverin - Place Maubert

4.01. *Rue de La Harpe (de la rue de la Huchette)*. 1865. CARPH000767 (ref. de Thézy 571).

4.02. *Rue de la Parcheminerie (de la rue de La Harpe)*. 1865. CARPH000758 (ref. de Thézy 570).

4.03. *Rue de La Harpe (du B^ard S^t Germain)*. 1865. CARPH000766 (ref. de Thézy 570).

4.04. *Rue des Prêtres S^t Séverin (de la rue Boutebrie)*. 1865. CARPH000760 (ref. de Thézy 572).

4.05. *Rue S^t Séverin (de la rue de La Harpe)*. 1865. CARPH000764 (ref. de Thézy 573).

4.06. *Rue Zacharie (de la rue S^t Séverin)*. 1865. CARPH000765 (ref. de Thézy 574).

4.07. *Rue du Chat qui pesche (de la rue de la Huchette)*. 1865. CARPH000769 (ref. de Thézy 575).

4.08. *Rue de la Huchette (de la rue de la Bucherie)*. 1865. CARPH000768 (ref. de Thézy 577).

4.09. *Rue S^t Séverin (de la rue Galande)*. 1865. CARPH000761 (ref. de Thézy 576).

4.10. *Rue Galande (de la rue du Petit-pont)* 1865. CARPH000742 (ref. de Thézy 579).

4.11. *Rue S^t Julien le pauvre (de la rue Galande)*. 1865. CARPH000762 (ref. de Thézy 578).

4.12. *Rue du Fouarre (de la rue Galande)*. 1865. CARPH000755 (ref. de Thézy 590).

4.13. *Rue de l'Hôtel Colbert (de la rue Galande)*. 1865. CARPH000746. (ref. de Thézy 588).

4.14. *Rue des Grands degrés (de la rue de la Bucherie)*. 1865. CARPH000625 (ref. de Thézy 595).

4.15. *Rue de la Bucherie (du Cul-de-sac Sᵗ Ambroise)*. 1865. CARPH000753 (ref. de Thézy 594)

4.16. *Cul-de-sac Sᵗ Ambroise (de la rue du Haut-pavé)* [added in pencil: *d'Amboise*]. 1865. CARPH000629.

4.17. *Rue du Haut pavé (du Quai de Montebello)*. 1865. CARPH000628 (ref. de Thézy 596).

4.18. *Rue Maître-Albert (du quai de la Tournelle)*. 1865. CARPH000630 (ref. de Thézy 597).

4.19. *Quai de Montebello (du quai de la Tournelle)*. 1865. CARPH000633 (ref. de Thézy 598).

4.20. *Rue des Bernardins (du quai de la Tournelle)*. 1865. CARPH000608 (ref. de Thézy 599).

4.21. *[Boulevard St Germain (vue prise de la Halle aux Vins)]*. 1877. BHVP NV-004-C-0345 (ref. de Thézy 602).

4.22. *Rue de Bièvre (du boulevard Sᵗ Germain)*. 1865. CARPH000612 (ref. de Thézy 614).

4.23. *Rue des Trois portes (de la place Maubert)*. 1865. CARPH000745 (ref. de Thézy 587).

4.24. *Rue Galande (de la place Maubert)*. 1865. CARPH000743 (ref. de Thézy 585).

4.25. *Rue des Lavandières (de la place Maubert)*. 1865. CARPH000737 (ref. de Thézy 586).

4.26. *Rue Maître-Albert (de la place Maubert)*. 1865. CARPH000631.

4.27. *Rue de la Montagne Sᵗᵉ Geneviève (de la place Maubert)*. 1865. CARPH000740 (ref. de Thézy 582).

4.28. *Rue des Noyers, (de la place Maubert)*. 1865. CARPH000736 (ref. de Thézy 583).

4.29. *Rue des Anglais (du Bᵃʳᵈ Sᵗ Germain)*. 1865. CARPH000738 (ref. de Thézy 581).

4.30. *Rue Sᵗ Jacques (du boulᵈ Sᵗ Germain)*. 1865. CARPH000763 (ref. de Thézy 579).

4.31. *Place Maubert (du Marché des Carmes)*. 1865. CARPH000741 (ref. de Thézy 584).

4.32. *[Rue Monge (vue prise du boulevard Saint-Germain)]*. c.1877. BHVP NV-004-C-0342 (ref. de Thézy 623).

Montagne Sainte-Geneviève

5.01. *Rue Sᵗ Victor (de la Place Maubert)* [ed. incorrect – this is looking west towards place Maubert]. 1865. CARPH000626.

5.02. *Rue Sᵗ Victor (de l'Entrepôt)* [correction added in pencil: *du seminaire de St Nicolas*]. 1865. CARPH000602.

5.03. *Rue de Paon (de la rue Sᵗ Victor)*. 1865. CARPH000620 (ref. de Thézy 604).

5.04. *Rue de Pontoise (de la rue Saint Victor)*. 1865. CARPH000607.

5.05. *Rue de Poissy (de la rue Sᵗ Victor)*. 1865. CARPH000603 (ref. de Thézy 603).

5.06. *Entrepôt des vins (de la rue du Cardinal Lemoine)*. 1865. CARPH000601 (ref. de Thézy 602).

5.07. *Rue des Fossés Sᵗ Victor (de la rue du Cardinal Lemoine)*. 1865. CARPH000618.

5.08. *Rue Clopin (de la rue des Fossés Sᵗ Victor)*. 1865. CARPH000619 (ref. de Thézy 625).

5.09. *Rue d'Arras (de la rue Clopin)*. 1865. CARPH000617.(ref. de Thézy 624).

5.10. *Rue Traversine (de la rue d'Arras)*. 1865. CARPH000616.

5.11. *Rue Fresnel (de l'Impasse de Versailles)*. 1865. CARPH000624 (ref. de Thézy 621).

5.12. *Rue du Bon puits (de la rue Traversine)*. 1865. CARPH000614 (ref. de Thézy 620).

5.13. *Rue du Murier (de la rue Traversine)*. 1865. CARPH000613 (ref. de Thézy 619).

5.14. *Rue Sᵗ Nicolas du Chardonnet (de la rue Traversine)*. 1865. CARPH000609 (ref. de Thézy 605).

5.15. *Rue du Clos Bruneau (de la rue des Ecoles)*. 1865. CARPH000733 (ref. de Thézy 618).

5.16. *Rue Traversine (de la rue du Clos Bruneau)*. 1865. CARPH000615 (ref. de Thézy 618).

5.17. *Rue Jean de Beauvais (de la rue des Ecoles)*. 1865. CARPH000735 (ref. de Thézy 607).

5.18. *Rue Jean de Beauvais*. 1865. CARPH000759.

5.19. *Agencement des rues Fromentel, Sᵗ Hilaire, Jean de Beauvais, Charretière et Mont-de-Marsan*. 1865. CARPH000732 (ref. de Thézy 611).

5.20. *Rue Charretière (de la rue de Reims)*. 1865. CARPH000728 (ref. de Thézy 617).

5.21. *Rue d'Ecosse (de la rue du Four Sᵗ Jacques)*. 1865. CARPH000729 (ref. de Thézy 615).

5.22. *Rue des Carmes (de la rue Sᵗ Hilaire)*. 1865. CARPH000734 (ref. de Thézy 613).

5.23. *Rue des Sept-voies (de la rue Sᵗ Hilaire)*. 1865. CARPH000725.

5.24. *Rue Sᵗ Hilaire (de la rue de l'Ecole Polytechnique)*. 1865. CARPH000593 (ref. de Thézy 612).

5.25. *Rue de la Montagne Sᵗᵉ Geneviève*. 1865. CARPH000722 (ref. de Thézy 633).

5.26. *Place et rue de l'Ecole Polytechnique.* 1865. CARPH000726 (ref. de Thézy 626).

5.27. *Rue de la Montagne S^te Geneviève (de la rue de l'Ecole Polytechnique).* 1865. CARPH000723 (ref. de Thézy 630).

5.28. *Rue Laplace (de la Montagne S^te Geneviève).* 1865. CARPH000724 (ref. de Thézy 632).

5.29. *Rue de Reims (de la rue des Sept-voies).* 1865. CARPH000727 (ref. de Thézy 614, but this shows an incorrect photo).

5.30. LA RUE SOUFFLOT ET LE PANTHÉON [typed label]. c.1876. CARPH000934 (ref. de Thézy 567).

5.31. *Carré S^t Etienne du Mont (du Panthéon).* 1865. CARPH000719 (ref. de Thézy 634).

5.32. *Rue Descartes (de la rue Clovis).* 1865. CARPH000623 (ref. de Thézy 632).

5.33. *Rue Descartes (de la rue Mouffetard)* [ed. incorrect – this is towards *rue Mouffetard*] 1865. CARPH000622 (ref. de Thézy 631).

La Bièvre - Rue Monge

6.01. *Rue Lacépède (de la rue Mouffetard).* 1865. CARPH000583 (ref. de Thézy 638).

6.02. *Rue N^ve S^t Médard de la rue Mouffetard.* 1865. CARPH000671 (ref. de Thézy 639).

6.03. *Rue du Pot de fer Saint Marcel de la rue Mouffetard.* 1865. CARPH000708 (ref. de Thézy 638).

6.04. *Rue de l'Epée-de-bois (de la rue Mouffetard).* 1865. CARPH000647.

6.05. *Passage des Postes.* 1865. CARPH000707 (ref. de Thézy 641).

6.06. *Passage des Patriarches.* 1865. CARPH000669 (ref. de Thézy 640).

6.07. *Marché des Patriarches.* 1865. CARPH000667 (ref. de Thézy 642).

6.08. *Passage des Patriarches.* 1865. CARPH000668. [This is now '*Rue de l'Arbalète*' and named this way on the 1868 map, but labelled '*Passage des Patriarches*' in the atlas from 1835. It is not the same lane as in pl. 6.06.] (ref. de Thézy 643)

6.09. *Rue de l'Arbalète (de la rue Mouffetard).* 1865. CARPH000592 (ref. de Thézy 644).

6.10. *Rue de l'Arbalète (du coin de la rue des Postes).* 1865. CARPH000705 (ref. de Thézy 645).

6.11. *Rue Daubenton (de la rue Mouffetard).* 1865. CARPH000644.

6.12. *Rue Mouffetard (de la rue de Lourcine).* 1865. CARPH000662 (ref. de Thézy 652).

6.13. *Rue de Lourcine (de la rue Mouffetard).* 1865. CARPH000701.

6.14. *Rue Pascal (de la rue Censier).* 1865. CARPH000657 (ref. de Thézy 653).

6.15. *Rue Mouffetard (de la rue Censier).* 1865. CARPH000660 (ref. de Thézy 652).

6.16. *Rue Censier (de la rue Pascal).* 1865. CARPH000656 (ref. de Thézy 653).

6.17. *Rue Censier (de la rue de l'Orangerie).* 1865-1868. CARPH000658 (ref. de Thézy 649).

6.18. *Rue de l'Orangerie (de la rue Censier).* 1865. CARPH000659 (ref. de Thézy 648).

6.19. *Rue Vieille N^tre Dame (de la rue du Pont-aux-biches).* 1865. CARPH000665 (ref. de Thézy 650)

6.20. *Rue de la Clef (de la rue Vieille N. Dame).* 1865. CARPH000642.

6.21. *Rue Daubenton (de la rue Gracieuse).* 1865. CARPH000645 (ref. de Thézy 646).

6.22. *Rue Gracieuse (de la rue Daubenton).* 1865. CARPH000646 (ref. de Thézy 647).

6.23. *Rue du Puits de l'Ermite (prison de S^te Pélagie).* 1865-1868. CARPH000643 (ref. de Thézy 651).

6.24. *[Rue Monge].* 1875-1877. BHVP NV-004-C-0475 (ref. de Thézy 661).

6.25. *Rue du Fer-à-Moulin (de la rue Mouffetard).* 1865. CARPH000648 (ref. de Thézy 655).

6.26. *Rue Mouffetard (de la rue de Valence).* 1865. CARPH000589 & 661 (ref. de Thézy 654).

6.27. *Rue de Valence (de la rue du fer à moulin).* 1865. CARPH000673 (ref. de Thézy 654).

6.28. *[Rue des Feuillantines].* c.1877. BHVP NV-004-C-0437 (ref. de Thézy 660).

6.29. *[Rue Monge. Carrefour des Gobelins].* c.1877. BHVP NV-004-C-0295 (ref. de Thézy 661).

6.30. *[Carrefour des Gobelins].* c.1877. BHVP NV-004-C-0444 (ref. de Thézy 660).

6.31. *Rue Poliveau (de la rue du Fer-à-moulin).* 1865-1868. CARPH000649 (ref. de Thézy 664).

6.32. *Rue de l'Essai (de la rue Poliveau).* 1865-1868. CARPH000639 (ref. de Thézy 665).

Boulevard Saint-Marcel - Gobelins

7.01. *Marché aux Chevaux* [ed. from Boulevard de l'Hôpital]. 1865-1868. CARPH000636.

7.02. *Impasse de l'Essai (du Marché aux chevaux).* 1865-1868. CARPH000640 (ref. de Thézy 666).

7.03. *Marché aux chevaux* [ed. from rue Geoffroy St-Hilaire]. 1865-1868. CARPH000635 (ref. de Thézy 667).

7.04. *Maison Louis XV habitée par le Comm^{re} de police du Marché aux Chevaux* [added in pencil: *Rue du Marché aux Chevaux*]. 1865-1868. CARPH000638 (ref. de Thézy 669).

7.05. *Rue Duméril (de la rue du Marché aux Chevaux)*. 1865-1868. CARPH000641 (ref. de Thézy 668).

7.06. *Rue du Marché aux Chevaux (de la rue Duméril)*. 1865-1868. CARPH000637 (ref. de Thézy 668).

7.07. *Rue des Fossés S^t Marcel (de la rue du Cendrier)*. 1865-1868. CARPH000676 (ref. de Thézy 664).

7.08. *Rue des Francs-Bourgeois S^t Marcel*. 1865-1868. CARPH000651 (ref. de Thézy 671).

7.09. *Rue du Cendrier (de la rue des francs-bourgeois)*. 1865. CARPH000654 (ref. de Thézy 670)

7.10. *Rue des Cornes (de la rue des Fossés S^t Marcel)*. 1865-1868. CARPH000677 (ref. de Thézy 674)

7.11. *Rue de la Reine Blanche (de la rue S^t Marcel)* [ed. actually from *rue des Fossés-St-Marcel*]. 1865-1868. CARPH000652 (ref. de Thézy 675).

7.12. [*Boulevard Saint-Marcel, au nord de la rue Scipion et vers le boulevard de l'Hôpital*]. c.1877. BHVP NV-004-C-0439 (ref. de Thézy 689).

7.13. *Rue des Francs-bourgeois S^t Marcel (de la place Collegiale)*. 1865. CARPH000653 (ref. de Thézy 677).

7.14. *Rue Pierre-Assis (de la rue S^t Hippolyte)*. 1865. CARPH000687 (ref. de Thézy 677)

7.15. [*Avenue des Gobelins*]. c.1877. BHVP NV-004-C-0439 (ref. de Thézy 689)

7.16. *Rue des Fossés S^t Marcel (de la rue Mouffetard)*. 1865-1868. CARPH000675 (ref. de Thézy 686)

7.17. *Rue du Banquier (de la rue Mouffetard)*. 1865-1868. CARPH000678 (ref. de Thézy 686)

7.18. *Rue de Gentilly (de la rue Mouffetard)*. 1865-1868. CARPH000683 (ref. de Thézy 687)

7.19. *Rue Mouffetard (de la barrière d'Italie)*. 1865-1868. CARPH000679 (ref. de Thézy 687)

7.20. *Place d'Italie*. 1865-1868. CARPH000681 (ref. de Thézy 690)

7.21. *Barrière d'Italie (de la rue Gérard)*. 1865-1868. CARPH000680 (ref. de Thézy 690

Additional Charles Marville Photographs Reproduced in the Figures

Fig. 2. *Un coin du Boulevard S^t Jacques (N^o 66)* [Marville's studio]. 1865-1873. CARPH000715. Marville/ Musée Carnavalet/ Roger-Viollet.

Fig. 13. *Rue du Fouarre (de la rue Galande)*. 1865. RV 33000-4. Marville/ BHdV/ Roger-Viollet.

Fig. 20. [*Percement de l'avenue de l'Opéra: Chantier de la rue d'Argenteuil, près de la rue du Faubourg-Saint-Honoré*]. c. 1877. RV 26261-1. Marville/ BHVP/ Roger-Viollet.

Fig. 22. [*Percement de l'avenue de l'Opéra: Butte des Moulins (de la rue d'Argenteuil)*]. c. 1877. RV 26177-2. Marville/ BHVP/ Roger-Viollet.

Fig. 24. *TRACÉ DE L'AVENUE DE L'OPÉRA DE L'AVENUE MÊME. (Espace compris entre la rue d'Antin et la rue Neuve Saint-Augustin*. [typed label]. c. 1877. CARPH000941. Marville/ Musée Carnavalet/ Roger-Viollet.

Fig. 27. [*Boulevard Saint-Michel, vers le sud*], looking south from Place Saint-Michel. 1870-77. BHVP NV-004-C-0693. Marville/ BHVP/ Roger-Viollet.

Fig. 28. [*Place Edmond-Rostand du boulevard Saint-Michel*], looking north. c.1877. NV-004-C-0337. Marville/ BHVP/ Roger-Viollet.

Fig. 35. [*Fragments des Piliers*]. GP-02-0022. Marville/ BHVP/ Roger-Viollet.

Fig. 53. *Entrepôt des Vins*. Marville, 1865. NV-004-C-0008. Marville/ BHVP/ Roger-Viollet.

Fig. 54. *Rue Lacépède*. 1865 Marville, 1865. NV-004-C-0184. Marville/ BHVP/ Roger-Viollet.

Fig. 55. *Rue de Pontoise*.1865. NV-004-C-0009. Marville/ BHVP/ Roger-Viollet.

Fig. 56. *Percement de l'avenue de l'Opéra*.1865. BHVP NV-004-C-0380. Marville/ BHVP/ Roger-Viollet.

Photographs in the Marville Collection possibly attributable to Pierre Emonts

Fig. 14. *Rue du Haut-Pavé*. Pierre Emonts. c. 1869-1902. BHVP GP-17-0091. © Pierre Emonts/Musée Carnavalet/Roger-Viollet.

Fig. 36. *Rue Antoine Carême: Halles centrales*. Charles Marville and Pierre Emonts. n.d. (printed 1880-89). BHVP GP-02-0024R. © Marville/ Pierre Emonts/ BHVP/ Roger-Viollet.

Index to Photographs by Eugène Atget

The photographs by Eugène Atget were selected to reflect the topographic overlap with the Marville sequence and as examples of his working methods in order to provide a comparison with those of Marville and to support the discussion on rephotography.

The images are from a variety of collections, including the Musée Carnavalet and the Bibliothèque Nationale de France, with a few examples from the Museum of Modern Art (NY) and the Bibliothèque des Arts Décoratifs. Atget's prints vary greatly in quality and colouration and are reproducd here with reduced saturation to avoid the visual distraction this would create.

The images are listed with Atget's negative numbers and collection catalogue numbers where possible. The plate numbering reflects the site location in the book. As noted elsewhere, all images are the property of their respective institutions.

5.26. *Fontaine et l'Ecole polytechnique*, Atget, 1902-03, AT:4469 (BnF).

5.32. *Vieilles maisons au coin des rues Saint-Etienne-du-Mont et rue Descartes*, Atget, 1906, AT:512, Ph:6556 (CAR).

La Bièvre - Rue Monge

6.02. *Hôtel meublé des bons enfants, cour de la rue Mouffetard et la rue Saint-Médard*, Atget, 1909, AT:441, Ph:3698 (CAR).

Coin, rue Saint-Médard et Mouffetard, Atget, 1905, AT:5156 (BnF).

6.03. *1 rue du Pot-de-Fer : fontaine monumentale de 1671*, Atget, 1901, AT:4288, Ph:6653 (CAR).

6.05. *Passage des Postes (de la rue Lhomond)*, Atget, 1909, AT:439, Ph:6665 (CAR).

6.06. *Passage des Patriarches*, Atget, 1899, AT:3584 (BnF).

Passage des Patriarches (99 rue Mouffetard), Atget, 1908, AT:5728, Ph:3909 (CAR).

6.07. *Marché des Patriarches*, Atget, 1924, AT:6502 (CAR).

Marché des Patriarches, Atget, 1899-1900, AT:3775 (BnF).

6.09. *Cabaret, rue Mouffetard*, Atget, 1898-1900, AT:3726 (BnF).

6.12. *Eglise Saint-Médard*, Atget, 1899-1900, AT:3745 (BnF).

Petit marché, place St-Médard, Atget, 1898, AT:3139, Ph:1171 (CAR).

Place St-Médard, le matin, Atget, 1898, AT:31--, Ph:1133 (CAR) [Atget's negative number is only partially visible].

6.30. *Avenue des Gobelins (vers Saint-Médard)*, Atget, 1898, AT:--84, Ph:1139 (CAR) [Atget's negative number is only partially visible].

Boulevard Saint-Marcel - Gobelins

7.04. *Pavillon de surveillance de l'ancien marché aux chevaux, Maison Louis XV habitée par le commissaire de police du marché aux chevaux, 5 rue Geoffroy St-Hilaire*, Atget, 1899, AT:3637, Ph:6744 (CAR).

Pavillon de surveillance, Atget, 1909, AT:5707, Ph:4716 (CAR).

Pavillon de surveillance, Atget, 1922, AT:6377, Ph:3787 (CAR).

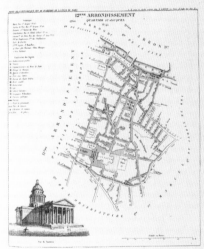

Fig. 57. *Petit atlas pittoresque des quarante-huit quartiers de la ville de Paris (1834)*. A.-M. Perrot. 1835. Musée Carnavalet.

Index to Cartography and Illustrations

Three main atlases are used to illustrate the streets and image locations. Haussmann's 1868 *Atlas Administratif* provides the primary source used from Marville's time, while the earlier Perrot atlas from 1835 often shows streets that Marville photographed, but which were already not shown in the 1868 street plan. The 1900 maps are shown to give both the post-Haussmann street configuration and to indicate what Atget would have encountered in his documentation of Paris.

The atlases and documents reproduced are listed below with reference to figure numbers. Details from the main sources are excerpted throughout the book as given. The images are for the most part assembled from atlas pages to show the necessary sectors of the city as can be seen in Figure 1.

Fig. 1. *Atlas Administratif des 20 Arrondissements de la Ville de Paris, publié d'après les ordres de M. le baron G.E. Haussmann, Sénateur, Préfet de la Seine. 1868.* Musée Carnavalet (also figs. 16, 25, 42, 43, 44, 45, 46,49, 50, 51, 52, 58).

Fig. 1a. *Paris-Atlas.* Fernand Bournon. c. 1900. Paris: Larousse. Musée Carnavalet (also figs. 16, 25, 41, 44, 45, 49, 59).

Fig. 8. *Plan d'Ensemble des Travaux de Paris.* Andriveau-Goujon. 1868. BnF GE D-933. © Bibliothèque Nationale de France.

Fig. 17. *Petit atlas pittoresque des quarante-huit quartiers de la ville de Paris (1834).* A.-M. Perrot. 1835. Facsimile edition 1987. Service des Travaux Historiques de la ville de Paris. Musée Carnavalet (also figs. 26, 40, 41, 42, 43, 47, 48, 50, 52, 57).

Fig. 29. *Plan des percées voulues par Napoléon III.* in *Souvenirs de l'Hôtel de Ville de Paris, 1848-1852.* Charles Merruau. © Musée Carnavalet/Roger-Viollet.

Fig. 30. *Etude du percement de la rue de Rivoli entre la rue Saint-Martin et l'Hôtel de Ville.* © Musée Carnavalet/Roger-Viollet.

Fig. 32. Frontispiece in Claude Perrault, *Les dix livres d'architecture de Vitruve* (Paris: J.B. Coignard, 1673). Engraving by Sébastien Leclerc. Musée Carnavalet © FA/ Roger-Viollet.

Fig. 33. Pierre-Antoine de Marchy, *Clearing the Area in front of the Louvre Colonnade,* c. 1760, oil on canvas, 60 x 92 cm. Musée Carnavalet © FA/ Roger-Viollet.

Fig. 37a. *Halles centrales de Paris - plan général des anciennes halles.* Victor Baltard, architect. © FA/ Musée Carnavalet/ Roger-Viollet.

Fig. 37b. *Halles Centrales de Paris - plan général des nouvelles Halles.* Victor Baltard and Félix-Emmanuel Callet, architects. 1854. © FA/ Musée Carnavalet/ Roger-Viollet.

Fig. 37c. View of the covered markets. Victor Baltard and Félix-Emmanuel Callet, architects. 1854. FA-29868. © FA/ Musée Carnavalet/ Roger-Viollet.

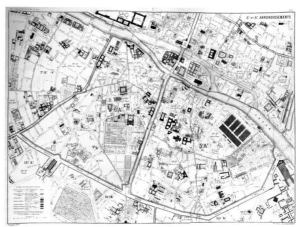

Fig. 58. *Atlas Administratif des 20 Arrondissements de la Ville de Paris, publié d'après les ordres de M. le baron G.E. Haussmann, Sénateur, Préfet de la Seine. 1868.* Musée Carnavalet.

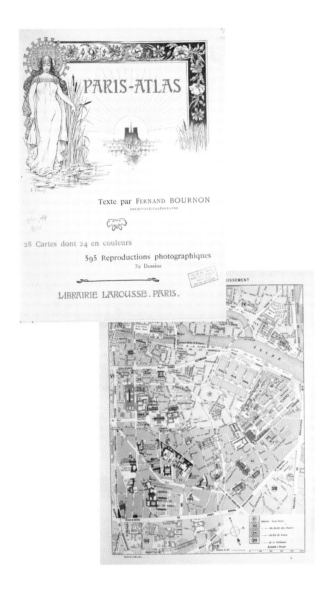

Fig. 59. *Paris-Atlas*. Fernand Bournon. c. 1900.
Paris: Larousse. Musée Carnavalet.

Index to Locations

Streets are listed under both old and new names with cross-references indicated in parentheses. Page numbers in italics indicate related photographs (although not all street names are mentoned in the captions). Non-italicized page numbers refer to text-only references. Streets and locations in red, no longer exist.

About the Authors

Peter Sramek studied photography at the Massachusetts Institute of Technology under Minor White, graduating in 1976, and is currently Chair of Photography in the Faculty of Art at OCAD University in Toronto, Canada. In the late 1970s, he helped found Gallery 44 Centre for Contemporary Photography, one of Canada's leading artist-run institutions and he continues an active art practice which incorporates photography, digital imaging, handmade books and installation. Represented by the Stephen Bulger Gallery in Toronto, he is included in collections such as the National Gallery of Canada, National Library of Canada, Musée Carnavalet (Paris), MOMA (NYC), Art Gallery of Hamilton and the Toronto Archives. He is recipient of many research grants for his rephotographic projects, including a Google Research Award and has exhibited these series, most notably at the French Institute of Prague. In the past few years he has been involved with partners around the globe in developing international art collaborations between students.

Min Kyung Lee is a historian of architecture and urban planning, and currently holds a position as Post-doctoral Fellow of Modern Architecture at Swarthmore College. She earned her MA and PhD from Northwestern University and a BA from the University of Pennsylvania in art and architectural history and urban studies. She is currently working on a manuscript based on her dissertation about the relations between cartography and the built environment of nineteenth-century Paris, the research of which has received support from several institutions, including the Ecole des Hautes Etudes en Sciences Sociales, Humboldt Universität, the Deutsches Forum für Kunstgeschichte, The Getty Research Institute, the Bourse Chateaubriand, the Camargo Foundation, and the Fulbright. Recently, her writings on architectural and urban representations have appeared in the Journal of Architecture RIBA, and the Le Journal Spéciale Z.

Shalini Le Gall is an art historian specializing in nineteenth-century Europe. Since receiving her PhD from Northwestern University, she has taught classes in nineteenth and early twentieth-century art, and given lectures on Orientalist painting, art of the Silk Road, and Victorian religious imagery. She has published articles in Perspective: la revue de l'INHA, Museum Studies, and various exhibition catalogues, and has been funded by the Woodrow Wilson Foundation and the Paul Mellon Centre for Studies in British Art. She is currently preparing a study on William Holman Hunt to appear in *Subjectivités, image, pouvoir*, to be published by Europhilosophie, and teaching at New York University in Paris, France.

Photography Credits

This project was produced with the kind support of the collecting institutions, principally the Musée Carnavalet in cooperation with the services of Parisienne de Photographie/Agence Roger-Viollet.

All historical images are used under licence and are protected by pertinent copyrights. Digital copywork for the collections in the Musée Carnavalet, Bibliothèque Historique de la Ville de Paris and Bibliothèque de l'Hôtel de Ville collections are licensed from Parisienne de Photographie/Agence Roger Viollet. The images from the Museum of Modern Art (NY) are licensed from SCALA/Art Resource, NY. Images from the Bibliothèque Nationale de France and the Bibliothèque des Arts Décoratifs are provided by the respective Department of Reproductions.

The Charles Marville photographs come for the most part from the Photography Collection of the Musée Carnavalet, Paris; however, many of the 1877 images were not deposited there and these come from the Bibliothèque Historique de la Ville de Paris (BHVP) with digital files prepared from Marville's original plates. One variant print comes from the Bibliothèque de l'Hôtel de Ville, Paris (BHdV). All photographs by Charles Marville are copyright as indicated by the relevant catalogue numbers:

© Charles Marville/ Musée Carnavalet (CAR)/ Roger-Viollet
© Charles Marville/ BHVP/Roger-Viollet
© Charles Marville/ BHdV/ Roger-Viollet

Photographs by Eugène Atget have been sourced from the Musée Carnavalet (CAR), the Bibliothèque Nationale de France (BnF), the Bibliothèque des Arts Décoratifs (ArtsDeco) and the Museum of Modern Art, NY (MOMA). The source is noted in the captions and references are provided in the indexes. All photographs by Eugène Atget are copyright as indicated:

© Eugène Atget/ Musée Carnavalet (CAR)/ Roger-Viollet.
© Eugène Atget/ Biblithèque Nationale de France.
© Eugène Atget/ Bibliothèque des Arts Décoratifs.
© Eugène Atget/ Museum of Modern Art/ Scala Art Resource (NY).

Photographs by Peter Sramek are copyright of the artist © 2009-2012.

All other illustrations are copyrighted as indicated in the indexes.